In Montparnasse

In Montparnasse

The Emergence of Surrealism in Paris, from Duchamp to Dalí

SUE ROE

FIG TREE
an imprint of
PENGUIN BOOKS

Fig Tree is part of the Penguin Random House group of companies whose
addresses can be found at global.penguinrandomhouse.com.

Penguin
Random House
UK

First published 2018
001

Copyright © Sue Roe, 2018

The moral right of the author has been asserted

The List of Illustrations on p.vii constitute an extension of this copyright page

Set in 12/14.75 pt Dante MT Std
Typeset by Jouve (UK), Milton Keynes
Printed in Great Britain by Clays Ltd, St Ives plc

A CIP catalogue record for this book is available from the British Library

ISBN: 978–0–241–25559–9

www.greenpenguin.co.uk

MIX
Paper from
responsible sources
FSC
www.fsc.org FSC® C018179

Penguin Random House is committed to a
sustainable future for our business, our readers
and our planet. This book is made from Forest
Stewardship Council® certified paper.

Contents

List of Illustrations

Introduction: Nude Descending a Staircase

Introducing painter and future conceptualist Marcel Duchamp,
metaphysical painter Giorgio de Chirico and poet and art critic
Guillaume Apollinaire – artistic experimentation before
the evolution of surrealism.

A female nude is walking downstairs, towards the (unseen) viewer waiting at the foot of the staircase. This is no ordinary painted nude. Part Futurist, part cubist, at first glance this early wood-coloured painting by Marcel Duchamp is an arrangement of lines and planes, joints and cantilevers, geometrically constructed. Still staring up at her, the viewer begins to make her out as she makes her way downstairs, head high, shoulders back, hips *en avance*, moving like a model; perhaps those forms at her feet are even gar-ments she is stepping out of, kicked aside as she descends. We can see her – can't we?

The young artist himself (twenty-four when he painted it, in Janu-ary 1912) didn't think so. 'This final version of the *Nude Descending a Staircase* was the convergence in my mind of various interests including the cinema, still in its infancy . . .' In the first variant of the painting (*No. 1*) Duchamp had articulated the joints of the figure (dis-tinguishable as human, and female, only from a distance) in a manner inspired by the photographs of Muybridge, the nineteenth-century photographer who discovered that the way to depict movement was to juxtapose separate successive photographic images. In that first version we can still see the joins, but according to the artist *Nude . . . No. 1* was 'only a rough sketch in my search for a technique to treat the subject of motion'.

Nude . . . No. 2 is more fluid – Duchamp finessed the

construction and added some gestural marks to the side of the figure. Although seldom willing to discuss exactly how his works came about, he did later reveal that when he painted the *Nudes* he had been applying himself consistently to the problem of depicting movement. He did not deny, either, the influence of cubism, with cubist paintings being exhibited throughout the small galleries of Paris at the time. His own interpretation of cubism was that it amounted to 'a repetition of schematic lines, without any regard for anatomy or perspective – a parallelism of lines describing movement through the different positions of a moving person'. One of his aims had been to paint a cubist nude – a challenge that had already defeated most of the cubists, including Picasso. But in *Nude . . . No. 2*, Duchamp claimed, 'the anatomical nude does not exist, or at least cannot be seen, since I discarded completely the naturalistic appearance of a nude, keeping only the abstract lines of some twenty different static positions in the successive action of descending'. Oh, but for the viewer she does exist, emerging from the artist's architectural draughtsmanship like an articulated mannequin coming to life. The stepping motion animates her, rendering her at the same time geometrical and dreamlike – both an articulated wooden construction and uncannily super-real.

Duchamp was satisfied with *Nude . . . No. 2* and sent it to the 1912 Salon des Indépendants, where it was exhibited by a reluctant committee of cubists. After displaying it for a few weeks they admitted they found it disturbing, and appealed to Duchamp's brothers (a painter and a sculptor) to persuade him to at least change the title, whereupon Duchamp withdrew the work from the exhibition. In October he showed *Nude . . . No. 2* again, this time exhibiting with his brothers at Galerie la Boétie. Here it was admired by Apollinaire, who had already seen Duchamp's work in earlier shows and noted that the youngest Duchamp brother was producing interesting work, including some '*vilains*' nudes.

Always on the lookout for new talent, Apollinaire had also spotted another young artist new to the Parisian scene, the Italian Giorgio de Chirico, painter of strange urban scenes – deserted

piazzas and stations sparsely littered with apparently unconnected objects, fragments of masonry, statues, archways, trains disappearing into the distance. When his work appeared at the 1913 Salon, it caught the attention of both Apollinaire and Picasso. De Chirico, too, was an artist whose work seemed to reach beyond the parameters of cubism. (Before long it was being dubbed 'surrealist' – by everyone but de Chirico himself.)

From about 1911 onwards the artistic centre of the French capital had begun to shift from Montmartre, when the artists who grouped themselves around Picasso left the world of the Moulin Rouge and the Folies-Bergère to gather instead in the galleries, studios and cafés of Montparnasse. Following the success of cubism, young dealers had arrived on the Left Bank and opened new galleries, mostly clustered around the rue de Seine. The district soon became a hotbed of entertainment and a destination for those leading liberated lifestyles, as well as the place where painters and writers would meet, in the Café de la Rotonde, the Café du Dôme and the Bal Bullier, until then the haunt of typists and shopgirls but now frequented by artists and poets dancing the foxtrot and the tango – women cheek to cheek, careful not to disturb their obligatory hats, wearing dresses created from contrasting scraps of fabric by Sonia Delaunay, designer, artist and friend of Apollinaire – until he fell out with her husband. (In 1912 and 1913 she painted four pictures depicting the Bal Bullier on mattress ticking, because it was cheaper than canvas.) The cafés of Montparnasse between 1913 and 1929 played host to encounters and conversations that would change the face of modern art, as the artists sought new friendships and love affairs and different ways of experimenting and opportunities to show their work. When the surrealists put their revolutionary ideas into practice, in many respects the scene was already set.

Surrealist art as it gradually emerged in Paris unleashed the irrational and released the erotic, transforming the depiction of reality so that it became not filtered and restricted but exhilaratingly uncivilized, releasing marvels on to canvas, the stage and in a variety of other media. On canvas, and in their readymades and other

artworks, the surrealist artists juxtaposed objects never before seen together, to confound viewers with the ordinary, presenting them with fantastical connections they somehow, in the darkest regions of their minds, felt they had already made but had never expressed. The original surrealists also tapped into other, darker emotions, of terror, horror, disgust or fear, depicting limbs detached from bodies, heads that were also machines, massive birds in flight above tiny landscapes, partially constructed (or devastated) aeroplanes hurtling perilously low through landscapes or seascapes littered with scattered objects. The impact of the First World War in their work cannot be ignored. Two lumps of bread and a chess piece could appear provocative, caged birds frightening, forest scenes dystopian and women (and female body parts) weirdly menacing. Still later there were melting watches, a chest of drawers fashioned from a woman's torso and cups and saucers covered with fur.

By the time André Breton's first *Surrealist Manifesto* appeared in 1924, surrealism had become identified as a way of making art that privileged the imaginative over the rational, realizing a kind of dream language in paint and celebrating the apparent nonsense generated by the unconscious and the disruptions of the erotic. The author wrote that, although 'we are still living under the rule of logic', change was afoot. Values had shifted: the chaotic drives of the unconscious had become the source of contemporary art; and in painting and writing, lawlessness was being embraced rather than repressed.

The lure of the decadent, the uncensored expression of chaotic, disruptive, erotic drives and the power of the unconscious to direct the artist's work (a subtler encounter for the artist than simply making paintings of dreams) – all these things together added up to what the artists in this book understood by surrealism. For Gertrude Stein (whose *Tender Buttons* appeared in 1914), surrealism was simply 'ordinary' life, far more interesting to her than mysticism or the occult (which the surrealists sporadically explored). While it may have been Apollinaire who first used the word in print, Picasso subsequently claimed to have invented it, and he was not the only one.

As surrealist art evolved during those early years in Montparnasse, who was in, who out? What did the world of Montparnasse feel like in those years in which surrealism as an art movement evolved? The crowd of respectful viewers moving attentively through the *Dalí/Duchamp* exhibition at London's Royal Academy of Arts in 2017 would have been unimaginable in 1917. If surrealism changed the way we see things, surrealist ideas evolved gradually, into a world very different from ours. What were the correspondences, during that extraordinary period, between the various artists now regarded as surrealist? What was the impact on the emerging new ideas of Duchamp's conceptualist and de Chirico's metaphysical art? Why was Picasso wary of Breton? Why was Diaghilev always on the social margins of the art scene, despite the path-breaking impact of his work? Why did Breton loathe Cocteau? What part did the women (including the artist's model, nightclub singer and Man Ray's muse Kiki de Montparnasse), the time, the place play in the development of ideas that have had such a lasting impact on the way we view a work of art? Today's artists include many whose work is overtly influenced by surrealism. How did it all begin?

Café Life, Performances and Fancy-dress Balls

In 1913, when Diaghilev's Ballets Russes performs in the theatres of the
Right Bank, the artists of the more bohemian Left Bank are, as yet,
conspicuous by their absence. The district of Montparnasse seems to be
under construction. Picasso is already celebrated as a cubist; Modigliani
is carving stone heads; Apollinaire praises Marcel Duchamp's *Nude
Descending a Staircase*; and de Chirico's work looks (to the jury of the
Salon des Indépendants) like backdrops in a theatre.

From her box in the Théâtre des Champs-Élysées Gertrude
Stein glanced down and noticed Apollinaire moving around the
auditorium – the first time she had seen any artist from Mont-
parnasse in evening dress. She watched as he slid between the seats,
shaking hands as he went with the fashionable women of the Right
Bank. It was 29 May 1913, the opening night of the Ballets Russes
production of Stravinsky's *Le Sacre du printemps* (*The Rite of Spring*).
Paris adored the Ballets Russes. The *gratin* of Paris had gathered for
the premiere. The curtain rose; the performance was about to start.
What happened next has gone down in history. With the primitive
jug-jug of the opening notes on the horns, the first glimpse of the
dancers in their rough, peasant costumes jumping with their feet
turned inwards, the hissing began. This, surely, was not ballet but
a display of unrestrained and uncensored primitive emotion. The
costumes were coarse, the dancers' moves were ugly, the music was
unmistakably lewd. It immediately dawned on some that whatever
the joke was supposed to be, it was clearly – insultingly – on them.
In her box, old Comtesse de Pourtalès rose to her feet, coronet

askew, brandishing her fan, protesting, 'This is the first time in sixty years anyone has dared insult me!' Supporters of Diaghilev hastily applauded, loudly, hoping to drown out the jeers. As Gertrude Stein recalled, 'We could hear nothing . . . one literally could not, throughout the whole performance, hear the sound of music.' The man in the box next to hers brought down his cane on an obvious enthusiast in the box to the other side of him. Marcel Duchamp was also in the tumultuous auditorium; he later remarked that the performance of the audience had made more of an impression on him than that of the dancers. Mayhem ensued. The dancers danced on.

The audience (carefully cultivated by Diaghilev) consisted almost exclusively of inhabitants of the Right Bank, all fabulously wealthy members of high-ranking society, a milieu strikingly different from the more bohemian and even the bourgeois milieu on the other side of the river. In terms of the inflexible, deeply rooted hierarchy of France's Third Republic, the real thing was here on the Right Bank – the wealthy, cultured vicomtes and vicomtesses, princesses and countesses, the aristocrats and grande bourgeoisie who patronized the arts and on whose support Diaghilev depended if he wished to bring the avant-garde to the world of Parisian theatre. As for the social make-up of the corps de ballet, that was a different matter. The dancers were mainly classless Russian immigrants, among them the privately decadent, socially outrageous, temperamentally volatile and daringly (in those days, illegally) gay – an intoxicating mix to some followers, including twenty-four-year-old Jean Cocteau, who remarked on the conspicuous absence of any artist from Montparnasse. The involvement of Picasso and others with the Ballets Russes came a few years later, and only with the intervention of Cocteau. In 1913 the district's young painters showed no interest in the ballet, while the more senior ones still thought of it as the exclusive reserve of the beau monde. 'Montparnasse knew nothing of *Le Sacre du printemps* . . .'

Cocteau later claimed he had never been to Montparnasse until he met Picasso there in 1916, but he must have had some familiarity with the district. Our introduction to Montparnasse comes to us

instead through the eyes of Beatrice Hastings, a young writer who arrived in the district in May 1914 who soon became Modigliani's lover and reported her 'Impressions of Paris' for London's literary magazine the *New Age*. In Montparnasse she discovered café life, artists and fancy-dress balls. 'Much laughter, much applause for your frock if it is chic, three hundred people inside and outside the Rotonde, very much alive!' Everything seemed 'quick and fire-worky, impressionist'. With its preponderance of cafés, dance halls, small studios and newly built *cités des artistes* (blocks of purpose-built studios) the district was conducive to the bohemian way of life. In the new galleries still opening up, exhibitions of works by individual artists (a relatively recent strategy, initiated in the small galleries of Montmartre) had proved successful in pushing up prices; and for aspiring artists there were prospects of commercial success and opportunities to exhibit work that tested the boundaries of artistic experimentation. During the previous few years cubism had exploded upon the scene, filling the small galleries with avant-garde work (and heaving aside those artists – including Picasso's old friends from his Montmartre days, André Derain and Maurice de Vlaminck – for whom cubism held no appeal).

The wide boulevard du Montparnasse was flanked by a muddle of small streets where grass grew between the cobbles. In those days the district felt borderless, containing a mixture of architecture, and the geography of the area (then, as now) could be confusing; not long after arriving Beatrice discovered that 'the street I used to take two trams to get to is round the corner'. There was no obvious demarcation, since the *quartier* spanned both the 6th and 14th arrondissements and bordered on the district of St-Germain-des-Prés. It had long ago acquired the nickname Mount Parnassus from the students at the universities there. With the overlapping arrondissements came an eclectic social mix; writers, journalists, students, politicians, nuns and cab drivers could all be seen on the streets of Montparnasse, mingling with the bourgeois owners of the larger properties still under construction throughout the district. New buildings were going up everywhere, the noise of the works

9

competing with the rattle of the trams. The Rotonde had been refurbished in 1911, its terrace reduced following the instalment of the Métro line (begun in 1905, and continuing well into the 1920s), though the café had gained a smart new façade and an extended interior room. The locals kept to the old back room, where the models went, too, in the afternoons, the artists favouring the large new room at the front, where Modigliani could usually be found in heated debate and Picasso stood 'like a seigneur waiting for a train', keeping his distance from all the latest artistic disputes.

Beatrice's Baedeker guide recommended the Musée du Luxembourg and promised glimpses of artists' studios beneath 'trees that have leaves like fingers spread out' but, so far, she had seen neither. She had, however (within days of her arrival), met Modigliani, 'the bad *garçon* of a sculptor', in one of the small restaurants. When they met again in the Rotonde he invited her to the cinema. She doesn't say what they saw – the latest episode of *Les Mystères de New York* (*The Exploits of Elaine*), perhaps, with Pearl White, American darling of the silver screen, or the popular thriller *Les Vampires*, starring Musidora, with her seductively wild, black, undone hair. Or perhaps *Fantômas*, based on a popular crime series, whose hero, the 'genius of evil', rampaged across Paris robbing, torturing and killing his victims before escaping in scenes of daring. Whatever they saw, it would have been silent – talkies came to the Parisian screens only in the 1930s. Modigliani said he adored the cinema – before falling asleep on Beatrice's shoulder. ' "You mustn't go to sleep on my shoulder!" I objected – "all the world knows you." "Not a soul," he said, and waved anew to somebody else. "You mustn't fall in love with me," he said. "It's no use – yes, do! – no, don't – it's no use." ' Then they went for a walk around Montparnasse, through the Luxembourg Gardens, to where Gertrude Stein lived, in the rue de Fleurus, and held soirées for painters and writers. 'Ah!' said Modigliani. 'That is where *la belle Américaine* lives with her brother.' Beatrice asked to be taken to meet them. 'No,' he replied. 'She's as ugly as Fate. I have a horror of her.' (Since, over the previous few years, Gertrude Stein had purchased the work of virtually every

talented contemporary artist except Modigliani, the feeling may well have been mutual.)

At no. 216, boulevard Raspail, not far from where Picasso lived, in a large, modern apartment building at no. 242, Modigliani seemed to have taken up residence in a glass box, or perhaps a small, disused greenhouse, in a tiny courtyard reached by a short passageway. Its floor was littered with drawings, paintings and one or two sculpted heads roughly hewn of stone dramatic, boulder-like, emerging from the rock like primitive figures. But Modigliani never stayed anywhere for long. He roamed Montparnasse, borrowing or sharing other people's studios or sleeping on their floors, cutting a distinctive figure in his battered black corduroy suit, or the brown one he wore with a brownish-yellow cap, to look like Picasso. When not sculpting or painting he read the philosophers Nietzsche and Henri Bergson, or the cult novel of the moment, *Les Chants de Maldoror*, by the 'Comte de Lautréamont' (aka Isidore-Lucien Ducasse; he wrote it in 1868, and died two years later, at the age of twenty-four). Modigliani was a great exponent of *Maldoror* (it was also later championed by the surrealist artists), a fantasy of apocalyptic licentiousness, dark and dreamlike as a painting by Gustave Moreau, though more overtly pornographic. A naked woman and a glow worm appear at Maldoror's feet. 'This woman's name is *Prostitution*,' warns the glow worm (voice of morality and reason), whereupon Maldoror crushes it with a rock. 'The wind groans in its languorous tones through the leaves, and the owl intones its deep lament . . . Then dogs, driven wild, snap their chains . . .' Before the surrealists came to dominate the art world of Montparnasse, this was the closest art got to tapping the outlawed drives of the unconscious.

With Modigliani, Beatrice explored the art scene. He took her to one exhibition, a gathering consisting of starving artists, a few successful painters and the bourgeoisie of Montparnasse (unlike the Right Bank crowd, these were not, it seems, wealthy patrons of the arts so much as snobbish hangers-on, on the alert for any artist who seemed about to 'arrive'), at which paintings by Picasso and Henri

Rousseau were displayed above a table on which stood one of Modigliani's powerful stone heads. Everyone gathered round to admire Picasso's work – '*Superbe!*' '*Magnifique!*' '*Oui! Très joli!*' Nobody (except Beatrice) seemed to be paying any attention to Modigliani's. Not that he seemed to mind; he was always happy to give away a work for a few francs, as long as the purchaser stood him a drink or two.

In the art magazines, it seemed that virtually every exhibition of contemporary art was reviewed by Apollinaire. Rushing from exhibition to exhibition, soirée to soirée, he was a familiar figure in the streets of Montparnasse, always laden with rare or second-hand books (he was an enthusiastic bibliophile). When he did stop for a conversation he was an expressive listener, widening his eyes and crossing and uncrossing his arms as if to punctuate the dialogue. He seemed to know everyone, noticing every promising newcomer and making a point of mentioning young artists in the art press; he relished any kind of experimentation. He had been among the first admirers of Picasso's work, heaping praise on his early paintings of harlequins and clowns, beneath whose 'tawdry finery' he detected 'the presence of real . . . people – versatile, shrewd, clever, poor, and deceitful'. Before anyone had even thought of surrealism, Apollinaire had been looking for the next thing that would shake up the art world. In 1911 he still favoured the work of painters such as his friend Robert Delaunay – great, jagged forms painted in greens and yellows like vivid bursts of sunlight – until he and Delaunay fell out when Apollinaire referred to him as a fauvist. Other exciting young artists, though, were emerging.

Apollinaire had been keeping an eye on the young Marcel Duchamp (aged twenty-six in 1913) since being struck by the artist's work at the 1910 Salon des Indépendants. In Apollinaire's view the geometrical elements of Duchamp's painting broadly aligned him with cubism but seemed to suggest something more – there were aspects which Apollinaire could describe only as 'elements of real being' ('*ces traces d'êtres*').

In spring 1913 Duchamp was still living in his family home in Puteaux, a district just beyond the Bois de Boulogne, with his

brother and half-brother (painter Jacques Villon and sculptor Raymond Duchamp-Villon). All three artists were concerned with the geometrical element described by mathematicians as the 'golden section' (the Euclidean 'fourth dimension'), which introduced the element of velocity into a three-dimensional structure and thus elements of movement into two- and three-dimensional works of art. The three brothers were passionately committed to exploring the mathematical elements of pictorial art. Exhibiting together, they called themselves the Section d'Or, or Golden Section Group, the name they had used when they exhibited together in October 1912 at Galerie la Boétie, where Duchamp had shown *Nude Descending a Staircase, No 2*. (They were familiarly known as the Groupe Puteaux.)

Apollinaire was not the only one who found this particular painting arresting. Among others taking note of all three Duchamp brothers' work was the American Walter Pach, who had been in Paris since 1907. In late 1912 he and two associates had been exploring Paris for examples of French modern art to exhibit at the Armory show that was to take place in February 1913 and which was intended to be New York's most significant showcase of contemporary work to date. Pach introduced his visitors to all the artists he knew in Paris and took them to meet the Duchamp brothers in Puteaux, probably on the recommendation of Picasso, whose scribbled list of recommended artists, most of them cubist, including Duchamp (Picasso spelled it 'Duchan'), appears in the archives of the Armory show. Pach was so impressed by *Nude . . . No. 2* that he had the canvas shipped to New York for the exhibition. Nevertheless, by October 1912 Marcel Duchamp was already deeply disillusioned with the art world. In exhibiting with his brothers, he was making an exception – following his recent experience with the Salon des Indépendants he had 'lost interest in groups'. From now on he would resolutely keep his distance from the Parisian art scene.

Apollinaire moved from the suburbs to Paris in January 1913 to an apartment at no. 202, boulevard Saint-Germain. It was ideally located for café life, only about a hundred yards from Les Deux Magots and Café Flore, two other places popular with the artists of

the Left Bank. He filled his new home with treasured possessions –
rare books, ethnic carvings, wooden theatrical puppets and paint-
ings by Picasso, Matisse, Marie Laurencin (his first love) and other
contemporary artists – and began holding weekly soirées for
friends. Young painters, poets and scholars could be found draped
across the divans, smoking clay pipes or reciting poetry while Apol-
linaire presided, seated at his work table.

Among his first visitors was twenty-four-year-old Giorgio de
Chirico, sent along on the recommendation of Parisian friends
familiar with the artistic *'ambiance'* of Apollinaire's gatherings.
Apollinaire encouraged him to submit four works to the 1913 Salon
des Indépendants, where members of the selection committee
(including André Dunoyer de Segonzac and Moreau) told the artist
his paintings were like stage sets; he would probably make a good
set designer. As far as de Chirico was concerned, they had missed
the point entirely; in his opinion, his paintings were purely 'meta-
physical'. In one of his most striking works of 1913, *The Uncertainty
of the Poet*, a twisted torso of plaster or marble stands opposite a row
of arches which casts a deep shadow on the ground. The bust is
strongly lit, as is the steam train racing past the horizon, a cloud of
white smoke billowing behind it. On the ground in front of the
bust is an outsized bunch of bananas. The jury had clearly ignored
the 'exceedingly solitary and profound lyricism' of his work, as did
others (including, shortly, the surrealists), who persisted in reading
into it prophecies of catastrophe or cataclysm, 'a kind of atmos-
phere of terror, the air of a thriller or suspense film', which he had
had no intention of creating.

At the Salon des Indépendants both Apollinaire and Picasso
admired de Chirico's work, and one of Picasso's regular purchasers
bought one of his paintings. Picasso asked Apollinaire to introduce
him to the artist. Together they tracked him down to his basement
studio and introduced him to their friend Paul Guillaume. Guil-
laume was a former garage worker who had spotted an African
artefact amid a delivery of tyres; on the strength of this he had
established a reputation as a prospective dealer and was about to

open a gallery. After some persuasion Guillaume bought a few paintings and offered to make a contractual agreement with de Chirico which amounted to the monopoly of his work, a new practice among dealers in Paris which de Chirico thought despicable; he dismissed the offer as 'nefarious'.

That same spring Apollinaire had a book on art and artists published, *Les Peintres cubistes: Méditations ésthetiques* (*Cubist Painters: Aesthetic Meditations*), a mixture of previously published articles and new pieces on contemporary painters, including Marcel Duchamp. (Apollinaire's attempt in the preface to distinguish between four types of cubism succeeded only in irritating some artists, who grumbled that he might be a gifted poet but he obviously had no idea how to paint.) In a more persuasive piece for the arts magazine *Montjoie!* he described Picasso's attempts to test the boundaries of cubism by bringing 'real objects to the light . . . a real postage-stamp, pieces of newspaper . . .' in constructions juxtaposed in bas-relief on to canvas or free-standing wood, letting the connections between them speak for themselves. When he saw these new mixed-media collages Apollinaire predicted that the object, 'real or in *trompe-l'œil*', would become increasingly significant in the development of contemporary art, as artists went on finding ways to incorporate everyday things into the fabric of their work. (He might almost have been predicting the appearance of the earliest examples of surrealism.)

In the rue Christine, a small street in the 6th arrondissement not far from the place Saint-Michel, Apollinaire sat in a workmen's bar enjoying the movement of people and picking up random snatches of conversation: *'La mère de la concierge et la concierge laisseront tout passer/ . . . Je partirai à 20h/ . . . Le chat noir traverse la brasserie'* ('The concierge's mother and the concierge will let anything go by/ . . . I leave at 8 o'clock/ . . . The black cat crosses the bar'). These overheard fragments were incorporated into a poem he wrote that summer, *'Lundi rue Christine'* ('Monday rue Christine'), still one of his best-known, most highly praised works. He had just published his second volume of poetry, *Alcools* (*Alcohol*), and with it he made his most

significant contribution to the art world of 1913. In a literary climate still dominated by symbolism this work was truly avant-garde, creating a new kind of poetic intervention. *Alcools* was effectively a poetic collage, comparable with Picasso's visual collages; the poet is simply – as it were – passing on to the reader fragments of the city's café culture and street life. In *'Vendémiaire'* (the first month of the French Revolutionary calendar) the poet is deeply embedded in the life of the city, a mere vessel for words to pass through: *'Écoutez-moi je suis le gosier de Paris/Et je boirai encore s'il me plaît l'univers'* ('Listen to me I'm the throat of Paris/And if I want I'll drink the universe again').

Apollinaire was ahead of his time; one critic wrote of *Alcools* that 'nothing is more reminiscent of a junk shop'. However, the book did attract some enthusiastic young readers. Marcel Duchamp liked it, as did the seventeen-year-old schoolboy André Breton, then still living with his parents in the rue Étienne-Marcel, a district adjoining (in fact, barely distinct from) Montparnasse. On the point of discovering his own youthful desire for rebellion, he was reading the poetry of Rimbaud and Baudelaire and for the first time exploring the museums and galleries of Paris, including the Gustave Moreau museum in the rue de La Rochefoucauld, where he was riveted by Moreau's tantalizing ' "evil women" of history and mythology'.

2.

What is Art?

Duchamp continues to experiment. Apollinaire leaves for fashionable
Deauville to review the summer season (including a lecture on art and
neurosis) . . . and swiftly turns back to Paris as war breaks out.

By the time *Le Sacre du printemps* was staged in May 1913, Cocteau
had known Diaghilev and been designing artwork to publicize the
Ballets Russes for three years (they were introduced by a mutual
friend). He was living with his mother on the rue d'Anjou, separ-
ated from the Grand and Petit Palais (and from the Élysée Palace
itself) only by broad avenues of trees, ravishing in pastel-pink blos-
som in spring, a glorious profusion of yellow and gold in autumn.
White horses pulled closed carriages along the quiet cobbled
streets; the area was bathed in the unmistakable hush of wealth.
His friends included Marcel Proust, Jean Hugo (great-grandson of
the illustrious author of *Les Misérables*) and the fabulously well-off
Comte Étienne de Beaumont, who gave parties dressed in spec-
tacular drag; jewellery festooned his dresses and ornamental
headgear. Though Cocteau had seen performances by the Ballets
Russes before, *Le Sacre* had astounded him – and Cocteau enjoyed
being astounded. As a child he had watched, spellbound, as his
mother made her preparations for a night out at the theatre, an
enrapturing performance in itself, involving clouds of perfume and
mauve-tinted powder; she sometimes wore a long stiff red velvet
gown embroidered with jet beads, and long gloves that to the child
resembled 'dead skins' which 'came to life' as she pulled them over
each finger.

Cocteau adored the Ballets Russes. One of its attractions was of course Nijinsky (Diaghilev kept a close eye on him when Cocteau was around), but his real intoxication was with the behind-the-scenes world of rehearsal rooms, the dressing rooms, the regular, fascinating tantrums. Cocteau was familiar with Diaghilev's world. Even so, *Le Sacre* struck a new note with its revolutionary choreography and staging, the repetition of simple, apparently monotonous gestures, the shocking position of the dancers' inward-pointing feet. Cocteau was and remained convinced that what had really offended Diaghilev's wealthy audiences was not, as widely assumed, any perceived attack on prevailing standards of morality but rather the realization that, aesthetically, they were out of their depth. For Cocteau, the Ballets' radical aestheticism was heady, but it jarred with him that it was still being associated exclusively with the beau monde when there were artists in Montparnasse who would have been more in tune with the experimentalism of the company's productions.

In September that year Picasso moved from the boulevard Raspail to a vast apartment in an adjoining street at 5 bis, rue Victor-Schœlcher, where his studio overlooked Montparnasse Cemetery. Picasso's building was one of the new constructions Beatrice Hastings had seen going up and had a carpeted staircase lit by bulbs suspended by nymphs cast in bronze and decorated with plaster replicas of the Elgin Marbles. In somewhat stark contrast, his studio was a chaos of canvases and constructions – his recent work included assemblages and montages of guitar shapes mounted on wood, as well as paper collages embellished with sheet music, visiting cards and wallpaper integrated with various objects – cigarette packets, pipes, dice; in one, an entire journal. In his paintings he mixed pigment with plaster, grit, sand and coffee grounds – the 'real objects' presciently noted by Apollinaire.

In October Marcel Duchamp also arrived in Montparnasse, moving from the family home in Puteaux to a small apartment at 23, rue Saint-Hippolyte, near the Closerie des Lilas, in those days an ordinary café rather than the smart restaurant it is today, not far from Gertrude Stein's home in the rue de Fleurus. She met him,

and remarked that he looked like a young Englishman (he and his brothers were noticeably natty dressers in those days) and talked 'very urgently about the fourth dimension'. On a freshly plastered wall of his apartment (the building was still under construction), using precise calculations he had been working on for months, he made a full-scale perspective pencil drawing of what was to be his next major work, *The Large Glass*. For the next year and a half he continued to add new elements he had worked out in drawings and studies. But his disillusionment persisted. Was all this careful draughtsmanship really art? Nobody else (the judging panels, notably) seemed to think so.

He kept notes, sketches and jottings in a green box which eventually became a work of art in its own right. One jotting read, 'Can one make works of "art"?' Was art really the result of rational, calculated construction rather than a matter of unconscious intuition? Independently of his brothers, he began to address the question, working on a piece he called *3 Stoppages étalon*. This time without making any preliminary sketches or drawings, he stretched a metre-long length of wire sewing thread taut above a canvas he had painted Prussian blue and let it fall, anyhow, on to a separate canvas, then glued it down with drops of varnish to secure the shape it had made. He saw this novel working process as 'a first gesture liberating me from the past'; looking back later, he felt *Trois Stoppages étalon*, in particular, had 'tapped the mainspring of my future'. He was not the first artist to be concerned with chance – it was a subject Stéphane Mallarmé had already explored in poetry, most notably in *Un Coup de dés jamais n'abolira le hasard* (*A Throw of the Dice Will Never Abolish Chance*). But as Duchamp pointed out, everybody's chance is different: 'Your chance is not the same as mine, is it?'

His next work may have been a surreptitious challenge (or thumbs-down) to the exponents of the golden section and their preoccupation with not only calculation but velocity. To construct *Bicycle Wheel* he simply mounted the front wheel of a bicycle upside down on its fork on a kitchen stool. Asked later what he had had in mind, he said he had no particular intention, he just made it for

pleasure, 'something to have in my room, the way you have a fire, or a pencil sharpener, except that there was no usefulness. It was a pleasant gadget, pleasant for the movement it gave.' Nothing to do, then, with the mathematicians who had inspired theorists of the fourth dimension (and artists including the Duchamp brothers), who as far back as 1827 had experimented with vectors and ways of introducing rotation into three-dimensional points. Or perhaps his comment was a jokey reference to those ideas, since both a fire and a pencil sharpener are effective only in motion – their only similarity with a bicycle wheel. Art might be brought about, then (as the surrealists would soon discover), by undermining *art*. Nevertheless, it should also be noted that *Bicycle Wheel* has an unaccountable beauty, suspended on its judiciously proportioned stool like a dancer, perfectly balanced in space.

Two further interventions into the newly pressing question of what art was came about during the winter of 1913–14. Travelling by train one evening, Duchamp noticed two lit windows in the distance. The glow of artificial light in the darkness reminded him of the distinctive quality of colour he had noticed in the liquids used by pharmacists. In an art-supply shop he bought three copies of an unremarkable lithograph of bare trees and a winding stream then added to each copy two dots of bright red and green watercolour, like the fluids in pharmacists' jars. He called the total work (consisting of all three lithographs) *Pharmacy*.

If *Bicycle Wheel* and *Pharmacy* had come about with minimal intervention by the artist, *Bottle Rack* required virtually none at all. It was an ordinary cast-iron bottle rack, of the kind used at that time to dry empties before returning them to the local wine shop to be refilled, composed simply of five tiers of upward-pointing branches. Duchamp's idea this time was to inscribe his bottle rack as if signing a work of art, though with a phrase with no particular meaning, but somehow he never got around to doing it; for the time being, the bottle rack was forgotten. In the meantime, he took a course in library science and got a job as an intern at the Bibliothèque Sainte-Geneviève, the distinguished university library of rare books and

archives in the place du Panthéon. When not in the library reading the ancient Greek philosophers, in his Neuilly studio (which he had kept on) he continued work on *The Large Glass*, as well as making other constructions, including *Chocolate Grinder* (in two variants), made with roller-drums fashioned out of stretched threads glued down with varnish and sewn to the canvas at the point of intersection at the centre of the drum; and *Glider* (completed in 1914), built with very fine, malleable lead wire. Meanwhile, *Nude Descending . . . No. 2* had taken on a life of its own. It was already attracting a steadily growing crowd of admirers at the Armory show in New York.

In November 1913 Apollinaire was appointed director of *Les Soirées de Paris*, an arts magazine which regularly published his contributions. When the magazine moved offices to 278, boulevard Raspail the artists of the district acquired a new meeting place. Everyone gathered there when they were not in the Dôme or the Rotonde – Picasso and his friends, Modigliani, de Chirico and his curious pianist-brother Alberto Savinio, whose technique (according to Apollinaire) consisted of hurling himself in a frenzy at the keyboard. Under Apollinaire's directorship the 15 December issue of *Les Soirées* included 'Lundi rue Christine', together with photographic reproductions of four of Picasso's cubist constructions. For the same issue Apollinaire reviewed the autumn salons in both Berlin and Paris, noting of the latter that artists exhibiting included de Chirico, 'an awkward and very gifted painter . . . showing some curious landscapes full of new intentions'.

The French art scene was vibrant and exciting and the market was robust, with widening international prospects. French modern art was being introduced successfully into Germany, in galleries in Berlin, Cologne and Munich. Picasso's work had sold for record prices. By summer 1914 he was in Avignon, experimenting with new forms for still lifes and developing an idea he had been working on that spring, a wax model of an absinthe glass, complete with sugar cube on its slotted spoon. He had six bronzes cast, one thickly coated with what looks like demerara sugar but is in fact sand. The rest he painted inside and out in combinations of flat colour and

sprinkled dots. Each cast was different but all were faintly anthro-
pomorphic; some thought they looked like approximations of
human heads. Picasso himself insisted his absinthe glasses were
just that – absinthe glasses. (For the time being, there was no sur-
realist to contradict – or endorse – him.)

On 24 May 1914 Apollinaire reported in his daily column for
Paris-Journal that a young Russian artist (Natalia Goncharova) had
been appointed by Diaghilev to paint sets for the Ballets Russes's
next production. Though he hugely admired Goncharova (and had
organized an exhibition of her work), Apollinaire asked his readers
the question Cocteau had already asked – why didn't Diaghilev
employ French artists as his scene painters and costume designers?
That spring Apollinaire had already reported on the creative vital-
ity of Montparnasse, predicting that in addition to its painters and
poets the district would soon have its own nightclubs and singers;
he had even heard that someone was about to publish a local jour-
nal. By June he was announcing that, as the artistic hub of Paris,
Montparnasse was the new Montmartre. On a table in the Closerie
des Lilas, Beatrice Hastings noticed a copy of the first issue of '*Mont-
parnasse*, a weekly gazette of literature and the arts', produced
locally for the people of the district (a publication destined, as things
turned out, to be short-lived).

For the 14 July 1914 issue of *Paris-Journal* Apollinaire reported on
the emergence of new painters. He focussed primarily on de Chi-
rico's work, quoting Futurist painter Ardengo Soffici, who, in his
review in *Lacerba*, had noted that de Chirico's work, uniquely among
contemporary painting, could be 'defined as a language of dreams'.
Perhaps he had seen de Chirico's major painting of 1914, *The Song of
Love*, which depicts an apparently dislocated landscape of arches
with a train passing in the distance and in the foreground a Greek
sculpture (of Apollo), a green ball and one red surgical rubber glove
suspended from a nail. Had the ancient Greek 'midwife' of art – the
painter – hung up her gloves and abandoned her muse in favour of
a different kind of contemplation, and depiction, of the objects of
everyday life?

Apollinaire called the article he was writing for the 1 August issue of *Paris-Journal* 'Neurosis and Modern Art', the title of a lecture that was to be given at a 'university for bathing beauties' – his little joke; he was in Deauville, commissioned to review the summer season. Should he happen to meet the (unidentified) lecturer, Apollinaire promised his readers, he would urge him to 'take a good look at our modern painters', including Duchamp and de Chirico. After that, the learned gentleman would be in a position to decide for himself whether neurosis had anything to do with them. Art was on the brink of posing tantalizing questions – but no sooner had Apollinaire arrived in Deauville than he had turned around and was speeding back to Paris. France was about to go to war.

On 1 August 1914 posters appeared throughout Paris announcing mobilization. In Montparnasse everyone took to the streets. By the next day the atmosphere in the city was frenzied. On the boulevards huge processions formed, with people carrying banners and flags and marching through the streets shouting and chanting. Errand boys on bicycles, old gentlemen, working people, bourgeois and bohemians ran about, everyone roaring at the tops of their voices, 'To Berlin! To Berlin!' The French would finally (or so they thought) have their chance to avenge Napoleon's defeat, and the end of the Second Republic, in 1870–71. Artists left their studios and surged into the cafés; the Dôme and the Rotonde were mobbed. Shops lowered their shutters. In the intense heat, crowds gathered on the boulevard Saint-Michel to applaud the military procession, an emblematic Tricolore unfurled, music playing, as the soldiers filed out of the École Militaire on their way to the Gare de l'Est. Buses swayed under the burden of passengers, taxis lined up as if in preparation for sudden departure. As the light faded, the sputtering gas lamps cast their yellow glow across a city that seemed to have gone mad. There was a lull until midnight, then it all burst into life again. In the Bar du Panthéon the orchestra played the tango; soldiers with knapsacks danced awkwardly, staring fixedly ahead. By daybreak, military doctors were seen making their way in uniform to the Gare de l'Est on foot, since all the taxis had already been requisitioned and the

trams had stopped. Through the streets went horse patrols, and trucks full of arms and mounted batteries. An astonishing number of cannons were being rolled across the cobbles. In Berlin, cabaret singer Yvette Guilbert, in Germany that year with her Jewish husband, made a dash to return home to Paris, crammed into a blisteringly hot express train with hundreds of other French nationals racing through the night to reach the Belgian border before it closed. German artists rushed to do the same. In Cologne, Max Ernst, a young art student (and future surrealist *extraordinaire*) watched as his friend Hans Arp made it on to the last train to leave Germany. Ernst was to spend the next four years wishing he had done the same.

3.

Anticipation in Paris,
Readymades in New York

Who goes? Who stays? Those unfit or ineligible for war include Picasso, Modigliani, Duchamp and (initially) de Chirico. Cocteau joins the ambulance fleet being run by his flamboyant friend Comte Étienne de Beaumont; Apollinaire prepares to leave for the Western Front. The city of light is in darkness. Duchamp leaves for New York and creates his first American readymade.

Who went to the front, and who stayed behind? In Montparnasse, Picasso and Gertrude Stein stood to watch a camouflaged truck pass. 'We did this,' said Picasso. He had been in Avignon with his lover, Eva; a day or two before war was officially declared he had rushed back to join the thousands of people making a panic run on the Paris banks. Anticipating the collapse of the market for his work and the closure of the gallery of his principal dealer, Daniel Kahnweiler, Picasso withdrew all the money in his bank account. Kahnweiler fled to Switzerland (where, in exile in Bern, he registered as a dealer, hoping to sell whatever stock he could rescue from various associates). In Paris some foreigners were being summoned to the town hall; some were given fines, some had proceedings instigated against them, others were threatened with expulsion. Since he was not French, Picasso would avoid conscription, but there was no question of his deserting his life in Paris to return to provincial Spain. Having withdrawn his savings, he returned to Avignon. Gertrude Stein was distraught; she 'could not leave her room, she sat and mourned'. A friend of hers (Alfy Maurer) told her he had been sitting outside a café: 'Paris was pale, if you know what I

mean, said Alfy, it was like a pale absinthe . . . I noticed lots of horses pulling lots of big trucks going slowly by and there were some soldiers with them and on the boxes was written Banque de France. That was the gold going away . . .'

Duchamp was at his parents' rented villa in Yport, Normandy, when war was declared. Having already completed a year of military service, he was exempt from conscription; in any case, nobody expected the war to last more than a few months, let alone a year (or four). In summer 1914 he found himself in the company of Walter Pach, back in Paris to assemble a group of Raymond Duchamp-Villon's sculptures for exhibition in New York, following his success at the Armory show. (Raymond himself was already stationed as a medical officer in a military hospital.)

Cocteau was initially declared unfit for military service. He joined the Red Cross ambulance corps as a volunteer, until his high-society friend Misia Sert requisitioned all the delivery vans of the Paris couturiers to form her own makeshift ambulance unit, whereupon he had himself transferred to join her convoy. Apollinaire, though of Italian nationality, was determined to fight for France, the country he loved passionately and regarded as his own; he began proceedings to acquire French nationality so that he could enlist. Modigliani felt the same, but his advanced tuberculosis meant he would not be enlisting. He was forced to stop sculpting, since all construction work had ceased and the building sites had closed down, depriving him of his usual source of stone. The monthly allowance from his family in Italy which he relied on for subsistence would no longer be allowed into France. He resumed his old habit of sketching portraits in cafés and painted portraits of his friends (eyes closed, seated against abstract backgrounds), and Beatrice, who became his main source of support. Without her help, he would have been destitute, like many artists left in Paris after August 1914, their allowances from various sources at an end, all opportunities to show or distribute their work brought to an abrupt halt.

The treasures of the Louvre were packed away in crates. Canteens for artists were set up, run by volunteers. Cafés shut promptly

at 8 p.m., restaurants at nine thirty; at night, the city was in black-out. Public transport was restricted to a couple of Métro and tram lines. Paris had settled, Beatrice noted, into 'an especial kind of seriousness'. The Seine took on an eerie strangeness in the dark. De Chirico's *Gare Montparnasse (The Melancholy of Departure)*, painted in 1914, shows an imaginary railway station empty of people. Deep shadows suggest the time is early evening but the station clockface reads 1.27.

When German aircraft began testing Paris's defences with sporadic raids, first with *Taubes* (doves) then Zeppelins, everyone was thrown into a state of fear, but nobody had any real idea what was going on. Beatrice, hearing a noise outside, dashed out to find a street full of shrieking people. 'Crackle, tac, tac, borrrrorr!' The impact of an aircraft overhead brought the comb down out of her hair and the aeroplane swirled away in a cloud of smoke. 'We are all waiting, and only half fearing, the first sound of the enemy's cannon.'

The odd thing was that nobody knew whether or not the war was already over. The Battle of the Marne (September 1914) was fought, but the public at large knew nothing of it. 'Some news is expected to-night,' Beatrice reported on 15 October – but news had been expected the previous night, too. 'Ours are having a hard battle, and that's all the world knows.' Artist's models were employed in the factories – including Kiki de Montparnasse, a young girl up from Burgundy who had hitherto spent her mornings hanging around the Rotonde looking for artists to pose for in the afternoons (she would succeed in this; in the post-war years she would be Man Ray's lover and most recognizable model). She found employment in a shoe factory, repairing the shoes of dead soldiers, which were then sent back to the front.

The French press kept up the pretence that morale was high, the spirit of patriotism ubiquitous and that the markets were still abundant with produce (the hypocrisy of the press would later emerge as a significant source of the surrealists' anger, along with their fury about the carnage, and the physical and mental devastation of young lives). Beatrice Hastings angrily attacked the journalist Maurice

Barrès, formerly a symbolist novelist popular with young decadents for his libertine views, who appeared to have crossed over to the side of the patriotic authorities. (Later, the surrealists took up the cause of the decadents, and continued the attack on him.) She predicted that after the war nobody would be interested in Maldoror and his self-indulgent decadence any longer (she was wrong).

Picasso returned to Paris on the night train of 17 November and began an (unsuccessful) attempt to retrieve Kahnweiler's holdings of his cubist work, which had been seized by the authorities. Cocteau joined another team of ambulances, this time led by his flamboyant friend Étienne de Beaumont, his unit reputedly composed of such colourful characters that the convoy (as someone remarked) looked like 'a circus on the move'. While the newspapers reported that life in Paris had reverted to something resembling normality, Beatrice disagreed: 'all I can say is that three taxis all together on the Raspail still make you wonder whatever can be happening'. Nobody had any idea that by the end of 1914 France had lost three hundred thousand men, nor that nearly nine hundred destitute refugees had taken to the roads. As for the artistic renaissance some were gamely continuing to report, the best story Beatrice had heard was of an artist who had returned on leave from the front, entered his studio and seen again the work he had done before going to war. ' "No!" he exclaimed. "No, really! Haw, haw!" ' Paris, however, embarked on a cautious reawakening. Under cover of near-darkness, the cafés and bistros surreptitiously opened again. The first port of call for artists and poets on leave was the Rotonde, where the study of the occult (fashionable in the 1890s) was back in vogue, the raising of the dead having taken on a new significance. During and following the war those who studied it included the early surrealists, who were fascinated by its fundamental denial of rational thought, while the Rotonde became home to fortune-telling Russians, palmists, theosophists and spiritualists as the first returning wounded were seen making their perilous way through the streets.

By spring 1915 Apollinaire, André Breton and de Chirico had all been mobilized, Apollinaire willingly, de Chirico with apparent

resignation and Breton (just out of school, called up on 25 February 1915) sent off to Brittany for basic training at the end of March in a spirit of indignant fury. From the start, he was one of the most passionate dissenters against the war. Though he did not fight his enlistment, unlike Apollinaire he refused to condone the motives behind the creation of what he felt amounted to armed butchery. In the city hospital of Nantes he served as a medical orderly in the surgical ward, and he also assisted in the neurology and psychology departments, observing the devastating effects of shell shock; this latter experience would prove fundamental to the development of surrealism. Meanwhile, in Nantes he continued to read poetry, including Apollinaire's, which he discovered in literary journals, as well as his articles in the *Mercure de France* and his poetry. In mid-December he wrote to the poet, enclosing examples of his own work. He received a courteous reply; artistic revolution was still yet to come.

In spring 1915 Italy entered the war. De Chirico and his brother left Paris for Florence, where they reported for call-up. Among de Chirico's strangest works of 1914 is his *Portrait of Guillaume Apollinaire*. A head-and-shoulders statue (resembling de Chirico himself, and wearing sunglasses) seems to be contained in a box; dropped into the box is part of a lid, or an advertising hoarding – a simple plank – on which are superimposed a tin fish mould (for making fish mousse) and a baker's mould in the shape of a madeleine. Above the box the profile shadow of Apollinaire hovers, a ghostly figure. Perhaps the work itself, positioned within the painting, consists merely of the plank of wood bearing the fish and madeleine moulds (just a single fish, and one loaf – no biblical promises; and no chance, now, of a revival of any idyllic *temps perdu*), like a simple version of Picasso's relief constructions. That is the portion of the work that bears de Chirico's signature.

After training to join the artillery, Apollinaire took himself voluntarily to the front. From the trenches at Mourmelon he continued to write articles for journals and kept up his correspondence with friends, and with Madeleine Pagès, a woman he met on a

train. He was also still writing poetry; in June 1915 *Case d'armons* was published, a limited edition of twenty-five poems written from enemy lines. A few days later his regiment moved towards Lès Hurlus, where he found himself in a kind of infernal hive littered with decimated pine trees, perforated with dugouts, the landscape ruined, the drinking trough seven kilometres away and the latrine so distant that the work of hell seemed complete. What he thought at first were shadows were in fact putrefied flesh; rare trees, seen close up, turned out to be dead men standing. Another volume of poems written from the front (*Calligrammes*, 1918; the proceeds went to charity) included love poems to Madeleine. Their affair had been conducted largely by correspondence. (In August 1915 they became engaged.)

Paris was again being targeted by Zeppelins. 'Do not expect any thoughts from me,' Beatrice warned her *New Age* readers on 8 April 1915. 'I am become simply a suffering receptacle of the horrid comedy of things.' A week later she wrote, 'I am in a horrid state of soul, right down in a rut of the war . . . The blood of my ancestors no longer appeals to me. I don't care where or when they fought and bled.' In Modigliani's sketches of her from the time she looks dishevelled and shocked. In Montparnasse, everyone was woken by the sound of intermittent bombing, the sky 'all aeroplanes with their sound of tearing out your bowels – horrible machines, the ideal of mechanical efficiency, perfected in blood . . . Who will care any more to build beauty upon the earth?' Picasso received news that Georges Braque, his old 'partner' from his Montmartre days, was being returned from the front, badly wounded. For Gertrude Stein and Alice B. Toklas, Montparnasse had become terrifying. In 1916 they would leave for Mallorca, where they stayed for nearly a year.

Duchamp also left Paris, for New York. In April 1915 he shipped a number of Raymond's sculptures, together with three of his own works, including *Nude Descending a Staircase, No. 1*. He would 'willingly live in New York', he told friends; he was leaving only because Paris had become unbearable: '*I do not go to New York I leave Paris.*' On 6 June he left the keys to his studio in the rue Saint-Hippolyte

with a friend and took the train to Bordeaux, en route for the SS *Rochambeau*, taking with him his work in progress: *Nine Malic Moulds*, a 'final' study on paper for *The Large Glass*; and several other drawings. 'The *Rochambeau* . . . slipped out of the harbor late at night, all lights extinguished because of the submarine threat.' He arrived in New York on the 15th and stayed with Walter Pach and other friends, and eventually rented a makeshift studio in the Lincoln Arcade Building at 1947 Broadway. There he set up two large sheets of plate glass on sawhorses and continued his work on *The Large Glass*.

A group of Europeans regularly gathered in American photographer Alfred Stieglitz's tiny gallery, 291 (at 291 Fifth Avenue), the primary meeting place for New York's avant-garde, and Duchamp seemed to fit naturally into the scene – so much so that in years to come, as Gertrude Stein would report, 'it was a joke in Paris that when any american arrived in Paris the first thing he said was, and how is Marcel.' A Sunday feature in the *New York Tribune* of 12 September that year headed '*The Nude-Descending-a-Staircase* Man Surveys Us' was the first of many such articles about him. As for what Duchamp thought of New York, he marvelled at it. 'New York itself is a work of art, a complete work of art . . .'

In Paris, his sister Suzanne received news of his activities. In a hardware store in Columbus Avenue he and a friend had purchased a snow shovel from the thousands stacked up in the hardware stores ahead of winter. The friend carried it home, slinging it on his back, Duchamp noted, like a rifle, and marching off down the street. Back in his studio the artist inscribed it with a title, 'In Advance of the Broken Arm', signed it Marcel Duchamp and hung it by a wire from the ceiling. He had created his first American readymade. It put him in mind of the two he had already created before leaving Paris, which gave him another idea. If she went to his studio, he told Suzanne, she would see a bicycle wheel and a <u>bottle rack</u> (his underlining). 'I bought this bottle rack as a sculpture already made. And I have an idea about it: Listen. Here, in New York, I have bought objects in the same vein and I'm treating them as *readymade*. You

know English well enough to understand . . . I have signed them and given them an English inscription . . .' With Suzanne's help, the bottle rack, too, could become a readymade. He asked her to use an oil brush to paint an inscription – 'de Marcel Duchamp' – in small letters of silver and white and in the same handwriting at the base and on the inside. But it was too late. When she cleaned out her brother's studio just after he left Paris Suzanne had thrown out both *Bottle Rack* and *Bicycle Wheel*, thus consigning to oblivion Duchamp's first ever readymades.

In Paris that June Picasso and Cocteau met for the first time, introduced via friends of the latter, who had been working on another idea, to adapt Shakespeare's *A Midsummer Night's Dream* for the circus ring. He hoped to enlist Picasso (as France's most illustrious avant-garde artist) as set and costume designer. In many ways it was a good moment to approach him as he probably needed the distraction. His lover, Eva, was gravely ill and most of his friends were away at the front. In any case, Picasso was well disposed towards Cocteau. He liked his 'poet's sense of paradox . . . his ability to take an idea, turn it upside down, back to front, inside out, distort or transform it, make it vanish and reappear, as if he were a conjurer'. He accepted Cocteau's invitation to visit him in rue d'Anjou, where he listened to his plans for *A Midsummer Night's Dream*, but without committing himself. Shortly afterwards Cocteau turned up at rue Victor-Schœlcher wearing a harlequin costume beneath his overcoat, hoping to inspire Picasso to paint his portrait. Picasso did not commit himself to that either (though he did keep the costume while he thought about it). Perhaps, with his usual prescience, Picasso knew the days of harlequin portraits were over. The popularity of the works of his Blue and Rose periods and the craze for cubism were on the wane. There would be a new development that would shake up everyone's assumptions about what constituted meaningful art.

4.

Parade: Une sorte de sur-réalisme

Cocteau writes *Parade*, the first work to be called surrealist, for the Ballets Russes, with drop curtain and costumes by Picasso. News reaches Paris that, in Zurich, the first Dada group has formed. In New York, a urinal 'by Duchamp' is submitted for exhibition. It is rejected. A Parisian group (initially called the Parisian Dadaists, then Surrealists) is formed by a young poet, André Breton.

On 17 March 1916 Apollinaire was sitting in a trench reading the *Mercure de France* when splinters of flying shrapnel pierced his helmet. At two o'clock the following morning he was operated on in an ambulance, then returned to Paris, where he was admitted to the Val-de-Grâce, a military hospital. Transferred at his own request to Paris's Italian hospital, he asked for his stories and prose works to be brought to him, wanting to put some of them together for publication. Someone took him some watercolour paints. He painted strangely vivid, somewhat clumsy pictures of men on horseback and rough-looking sketches of women in lewd poses. By early May he was suffering from dizziness and had begun to lose the use of his left arm. He was moved to a nursing home, the Villa Molière (which served at the time as a surgical annexe to the Val-de-Grâce), where fluid was removed from his brain by trepanning. He regained the use of his arm and the surgery appeared to have been successful. After a while he was allowed to go out during the day, returning to the hospital overnight. On the boulevard Saint-Germain he ran into a woman, Jacqueline Kolb, whom he had met once, two years before. More or less instantaneously, she replaced Madeleine (and

other predecessors) in his affections. From his hospital bed he contacted both Breton and Cocteau, asking them to visit him.

That spring Cocteau was just back from Rheims, where he had been with Comte Étienne de Beaumont's ambulance corps. The comte had emerged as a model citizen in wartime, a man (as one of his ambulance crew remarked) 'in whom gallantry is a part of good breeding. He remains the same under shrapnel as under the chandelier of a ballroom' – the very model of the military gentleman. Since there were no well-equipped mobile hospitals, the wounded were driven miles across rough terrain to a surgeon, agonizingly rattled around in the back of a van (presumably the reason for Apollinaire's en route, perhaps emergency, surgery). Cocteau saw Rheims reduced to rubble, the cathedral shredded to 'a mountain of old lace', and witnessed terrible scenes of mutilation. The men were living beneath 'the canopy of our own shells, roaring overhead like express trains, and German shells punctuating their sinuous course with a sudden black ink-blot of death . . . Rheims was at the peak of its confusion, its nerves at breaking-point.'

Cocteau later wrote a novel about the war, *Thomas l'imposteur* (*Thomas the Impostor* (1923)), in which he describes scenes of horrifying carnage interspersed with contrasting episodes based around a character modelled on Diaghilev's close friend Misia Sert, also in the area with her own fleet of ambulances, who was organizing theatrical concerts for the troops and conducting heated arguments with others of her entourage about the allocation of wounded soldiers to lorries. Farce, horror and unthinkable suffering were hideously juxtaposed in the novel, as young men lost their lives or suffered appalling amputations. The scale of the carnage was kept from the public eye by the official censor, generically nicknamed Anastasia (after the ugly old woman of legend with spectacles and enormous scissors). Sections of reportage were whited out, so that the newspapers were printed with words obviously deleted, spattered with blank spaces. (The extent of the censorship varied from region to region; the censors themselves were under varying degrees of surveillance.)

When he saw Apollinaire in hospital on 10 May Cocteau

encountered a man who was a shadow of his former self. As well as having been hit by shrapnel Apollinaire had also at some stage been caught in the crossfire of a poison-gas attack. The man Cocteau saw now was a bloated figure in 'a pale blue uniform, [with] a shaven head and a scar on his temple like a starfish. His head was bound up in bandages and leather which formed a kind of turban or a little helmet . . . He looked like a captive balloon.'

Also that spring Duchamp, still in New York, constructed his first 'assisted' or 'rectified' readymade, a metal advertisement plate for Sapolin enamel paint, the letters adapted to read *Apolinère Enameled* [*sic*]. The advertisement shows a small girl carefully repainting a white bedhead; to the mirror on the dressing table in the background Duchamp added the reflection of a strand of her hair – in recognition of Apollinaire's broken head? The posts at the head and foot of the bed are painted different colours, as if some have been damaged and replaced. Three at the head and four at the foot still need repainting. On her head, the girl wears a large white ribbon – or perhaps a nurse's cap. (To his collection of readymades he had already added two other pieces, *Comb*, inscribing a metal dog-grooming comb with the initials MD, dating it FEB 17, 1916 AM and on the back adding the words, '3 or 4 DROPS OF *HAUTEUR* HAVE NOTHING TO DO WITH BRUTALITY'; and *The*, a single page of text in English, the word 'the' replaced throughout with an asterisk (in parody, presumably, of Anastasia).

In Paris, Cocteau had begun to draft out a new idea for the Ballets Russes, to be called *Parade: Ballet réaliste* – a theatrical work of mixed media, closer to vaudeville than to traditional ballet; he hoped it might appeal to a more bohemian audience. His idea was ingenious – to put on stage the short burlesque traditionally performed by a troupe of itinerant actors at the entrance to a show as a way of advertising the main event. A troupe of acrobats, a Chinese magician and a 'Little American Girl' would perform against the backdrop of a line of Parisian houses. Three 'managers' attempting to organize the parade would also be played by actors, announcing in colourful language that the audience had mistaken

the parade for the actual show, which, as a result, no one was watching. *Parade* itself would consist of three music-hall numbers. After the final one, the exhausted managers would collapse in a heap, falling on top of one another. The magician, acrobats and Little American Girl, having given up waiting for an audience, would then emerge from the empty theatre. Realizing what had happened, they would take over from the managers and attempt to explain that the show was about to take place inside.

Having given up on *A Midsummer Night's Dream*, Cocteau was hoping instead to persuade Picasso to design the sets for *Parade*. In Cocteau's eyes, Picasso was 'a rag-and-bone man of genius'. He understood Picasso's new bas-relief constructions and admired his way of collecting everyday odds and ends to use in his work. For this reason, Cocteau called his work realist. 'He uses everything that's old and makes something new which can cause surprise but fascinates through its realism. Let us understand what we mean by this word realism . . . He searches ferociously for a likeness and finds it in such a way that the object or the face at the origin of his work often loses relief and strength when compared to its represen-tation.' He contacted Picasso, who invited him to Montparnasse – for Cocteau (denying all knowledge of any previous visit), the district was a revelation; he was enchanted by its café life, with artists sit-ting about in their shirtsleeves, and considered himself to have crossed an artistic divide. 'The Rotonde was our mall, our haven, our domain,' he told his Right Bank friends. In Montparnasse, 'I disembarked from the far shore.' He spent all his April leave from the ambulance corps there, an eye-catching figure in the Rotonde in gloves, collar and with a cane (or sometimes his laced aviator's boots, red jodhpurs, black field-service tunic and steel helmet painted purple). Those abandoned on the 'far shore' found his desertion alarming. Cocteau had joined the cubists, went the rumour, which would surely be the undoing of him – although, by now, even the occasional Rive Droite socialite might be spotted in the cafés of Montparnasse. Cocteau himself had no qualms about the betrayal. He had crossed the river, he said, without a backward

glance. 'If I had looked back, I'd have been turned into a pillar of SUGAR. I was on the way to what seemed to me the intense life – toward Picasso, toward Modigliani . . .'

Cocteau was also impressed by the internationalism of the district. A journalist reported later that when asked to name the great French artists of his time, Cocteau listed 'Picasso, forgetting he was Spanish, Stravinsky, forgetting he was Russian, and Modigliani, forgetting he was Italian'. In Montparnasse, they formed a group, or united front, so much so that their nationalities were irrelevant: 'we fought a lot, we quarrelled a lot, but there was a kind of international patriotism among us too. This patriotism is a privilege of Paris and often threatens to make the city incomprehensible to the outsider.' In the rue Campagne-Première he followed Picasso from studio to studio, fascinated by the artistic rivalry that characterized the district. It was surely the strangest war, he remarked, that took him (and others) from brutal military combat to the artistic spats of Montparnasse, and back again. He relished the provincialism of Montparnasse. 'There are districts in Paris which rise to the surface . . . Once it was Montmartre and in our time . . . Montparnasse had just come up', peopled as it was by artists – Modigliani, Picasso, Apollinaire – all quietly continuing their revolution in the arts.

That spring of 1916 the Rotonde, which had been closed by the police after a drugs raid, had just reopened. The spiritualists and theosophists resumed their sessions. Picasso's old friend from his Montmartre days, Max Jacob, noted approvingly that there were orgies going on everywhere, even in some of the artists' canteens, and secret underground clubs starting up, like the Mon œil (French slang for 'who are you kidding?') in the rue Huyghens, near the Dôme, a black-market venue where people could drink illegally and dance all night. In her artists' canteen Marie Vassilieff resurrected the fancy-dress balls. In rue Montparnasse, Modigliani sat on the steps of Beatrice Hastings' apartment, 'sometimes declaiming Dante, sometimes talking of the slaughterhouse, of the end of civilization, of poetry, anything except painting'. Cocteau noticed him in the Dôme, talking to Picasso, his dealer Léonce Rosenberg

and another (unidentified) associate who had collected Picasso's work before the war. Picasso took them all to Modigliani's studio to see his stone heads and his portraits of women and friends, though Modigliani remained impossible to help. Asked to price a watercolour caryatid, he suggested twenty-five francs. For his portrait drawings he asked five francs, or ten francs and a drink per sitting, refusing to take any more.

Cocteau was struck by Picasso's surreptitious generosity; sometimes he saw him give friends gouaches he knew they could sell. 'He helped them to live. The myth of Picasso's selfishness is completely untrue. He has always helped friends on the quiet without saying a word about it, and anyone who didn't know this couldn't have known him well.' In an upstairs room in the Rotonde, Modigliani made numerous drawings of Cocteau, before borrowing the painter Moïse Kisling's studio to paint his portrait – a broadly cubist depiction of an arch, waspish dandy. Cocteau loved Modigliani's work, his lines like 'the mere ghost of a line', his drawing 'a silent conversation . . . the reflection . . . of a vision as gracious, noble, acute and deadly as the fabulous horn of the unicorn'. In every sense Cocteau felt welcomed by the Montparnasse circle ('perhaps I should say the cube'). To return the favour he introduced Picasso to some of his own set – a world Picasso had no objection to becoming acquainted with. One of them in particular (Eugenia Errázuriz, a wealthy Chilean) took a shine to Picasso, collecting his work and facilitating not only Picasso's introduction into the Parisian *haute monde* but also the development of *Parade*, proving indispensable in smoothing over the inevitable disputes between Diaghilev and others once preparations got under way.

On 6 May Cocteau left Paris, this time for the fields of Flanders. 'Gone to pieces overnight,' he wrote a few days later to his old friend from the Right Bank Valentine Gross. *Parade* now seemed like a dream. On the 15th he wrote again: 'Horribly sick.' By now everyone's morale was flagging, he told her; the *poilus* (French soldiers) hated the Parisians, 'and even spat on the ambulances'. On the 28th he wrote, 'Dune dune dune cave cave cave cano cano canon

[Cocteau's untranslatable onomatopoeia] . . . I am wandering bewildered on a planet of iconoclasts, everyone is destroying, smashing, wasting – sowing bile and death.' At the end of the month he was granted leave to rest in Boulogne. From there he wrote to Étienne de Beaumont that war was nothing but a 'spectacle of destruction – madmen using all their ingenuity to destroy the old fables, but trampling on the new – iconoclastic gorillas [sic] – a death factory'. He returned to Paris, where he resumed his project of attempting to bring together the socialite world of the Right Bank with the bohemian world of the Left – if there was to be no peace after all, perhaps he could effect a kind of reconciliation in the world of the arts. His main task, as he saw it, was to convert Diaghilev to modern painting and Picasso to the 'sumptuous, decorative aesthetic of the ballet'. (At the same time, he had not forgotten his other ambition, to get Picasso to paint his portrait. After much persuasion he sat for Picasso, who produced a delicate, flattering pencil sketch.) Before leaving for Flanders Cocteau had heard the avant-garde composer and one-time pianist in the piano bars of Montmartre Erik Satie play one of his compositions. He now decided Satie should compose the music for Parade. On 10 May he visited first Apollinaire (still in hospital), then Satie, taking the latter a set of notes and sketches so he could begin scoring Parade. He told the musician he wanted the music to convey 'all the involuntary emotion given off by circuses, music halls, carousels, public balls, factories, seaports, movies etc etc'. Then he left again, this time for the Somme, where his ambulance unit was heading to provide medical services, preparing for the major offensive planned for 1 July.

André Breton returned to Paris on leave in late April or early May 1916. While to those who had stayed things seemed to be waking up again, to Breton the city seemed utterly changed; everything seemed to have shut down, except for the surreptitiously burgeoning artistic subculture. In Adrienne Monnier's bookshop in the rue de l'Odéon (La Maison des Amis des Livres, open since the previous November) young poets had begun to gather. On 8 May he received a scrawled note in uneven handwriting from Apollinaire, asking the young

poet to visit him in hospital again. 'Sad and feeble', due to be tre-
panned the next day, he told Breton he had been contacted by a
group of expatriate poets taking refuge from the war in neutral
Switzerland. They were holding regular meetings in a bar at Spiegel-
gasse 1, Zurich, where they were gathering material for a magazine
they planned to publish, to which they were inviting Apollinaire to
contribute. Here, in embryo, were the most significant acknow-
ledged precursors to the surrealists.

They called themselves the Cabaret Voltaire and their mood was
one of incensed retaliation. As Max Ernst insisted some years later,
'Dada was a bomb.' They had no agenda other than to shock; they
were against all forms of civilization, including art. Their group was
formed in Zurich of exiled students whose education, and social and
moral equilibrium, had been abruptly interrupted by the war. They
included Hans Arp (the artist Ernst had seen off on the last train out
of Germany) and Romanian Tristan Tzara, who, before fleeing his
country, had co-edited a student literary review. Another of their
members (Hans Ball) had abandoned his study of philosophy to join
an expressionist theatre group; in Zurich he was attempting to form
an 'international cabaret'. The Cabaret Voltaire combined visceral
anger with wild abandon, and today it may be difficult to imagine
quite how offensive their stance was in the political context of the
time. (Well on into the 1920s, it was still regarded as utterly unaccept-
able to voice any criticism of the loss of so many millions of young
lives in the war – let alone to make a song and dance about it.) Their
aim was to retaliate for the carnage with sessions of wild shouting,
uninhibited dancing and recitals of mad poetry, accompanied by
noisy bell-ringing and drumming. By April 1916 they were calling
their newly created movement Dada ('yes, yes' in Romanian; 'rock-
ing horse' or 'hobby horse' in French; 'baby talk' in German).
Scouring the international art magazines for names of potential sup-
porters, Tristan Tzara had come up with Apollinaire as a potential
contributor to the magazine they were planning to produce, in which
they would announce in print their outrage at the appalling sense-
lessness of the war and its attendant hypocrisies.

By the time he received their invitation news of their activities had reached Apollinaire, who was wary. Despite his own experiences he had voluntarily enlisted in support of France and he remained passionately patriotic. The Dadaists had already shocked the people of Zurich with their disruptive behaviour. Germans assumed they were Communist; everyone else suspected they were German sympathizers. Apollinaire, finding their political anarchy unnerving, was reluctant to establish any connection with them. When he failed to reply, Tzara simply went ahead anyway and published his work.

Now at the Somme, on 8 July Cocteau wrote to Valentine Gross. His few letters to her and others convey his utter horror. The air was filled with fire and men lay burned and slaughtered to death in their thousands. 'We'll all die,' he wrote. 'We're . . . hunting for the dead – horrible deliveries of wretches battered to pulp – blood flows – the very sheds are groaning.' The landscape itself seemed to be collapsing before their eyes, the crops in the fields destroyed by low-flying planes. Bombs dropped from the sky all night, red flashes lighting the ambulance corps tent, which was continually shifted to a new location to collect more of the injured and dump them on filthy bedding. (All of which, of course, was what the Dadaists had set out to expose and publicly deplore.) On the 28th Cocteau was back in Paris on sick leave, suffering dizzy spells, tics and headaches; he was due to return to the Somme on 19 August, but he knew, if he did so, there was little chance he would come back alive. His mother was already pulling strings to have him exempted. Patriotism now seemed to him senseless; all that was left was the patriotism of *art*, which seemed to him an infinitely worthier cause than being returned home a corpse (or being blown to ashes). To those of his own set occupied with sending parcels of blankets to the front or holding benefit concerts for the wounded, his attitude doubtless seemed cowardly, even loathsome. No one, even the horrifically wounded, mentally shattered or tragically bereaved, was permitted to protest or complain.

Breton was among those exposed at close quarters to men

41

suffering from the newly named devastating affliction shell shock. His leave over, he had been transferred from Nantes to the Saint-Dizier neuropsychiatric centre in north-east France, which took in men sent back from the front 'for reasons of mental distress'. He met psychiatrists who lent him published articles which referred to the theories of Jean-Martin Charcot and Freud; this was Breton's first introduction to Freud's work. Though in 1916 Freud's publications were still little known (*The Interpretation of Dreams*, first published in Germany in 1900, appeared in France only in 1926, and his clinical practice was unique), his work was beginning to be noticed in psychiatric circles and was interesting particularly for his two ground-breaking discoveries – that mental illness might be linked to childhood trauma, and that in some cases patients might be responsive to therapeutic treatment. Also of great interest to Breton was Freud's work on sexual inhibition as an aspect of unleashed creativity (a hypothesis later copiously explored by the surrealists). For the young Breton, Freud's ideas chimed with the literature and philosophy of the German Romantics, with their emphasis on personal freedom. At Saint-Dizier his daily work involved interviewing patients, asking routine questions; although under no illusions about the severity of their mental torment and degradation, he found their answers riveting. However, fascinating as he found his patients' observations, the frustrations of trying to communicate with men reduced to mental smithereens succeeded mainly in making Breton bitterly disillusioned with the whole idea of clinical psychiatry.

In the dormitory of the hospital at Nantes, André Breton had been equally inspired by a young man who made no secret of the fact that he was vehemently anti-war. This was new – Jacques Vaché was the first man Breton had met who openly refused to go along with the prevailing spirit of patriotism. Vaché was articulate and gifted, stylish and good-looking, with high cheekbones and almond-shaped eyes; he was a bit of a dandy and his sketched self-portrait shows him dressed in a three-piece suit and flamboyant tie, with artfully floppy hair. His wartime sketches were different – and

unflinching. One shows a soldier decorated with medals, his head turned away from the viewer, pointing a gun at an ordinary soldier about to join the heap of uniformed bodies already piled up on the ground. Consigned to a wartime hospital, Vaché was at his wits' end. While battle raged between Verdun and Rheims, decimating the landscape, causing indescribable carnage, he wrote letters into which he poured his despair, deriding the spirit of bravery and patriotism that was being vaunted across Europe.

Mme Cocteau had pulled her strings. By the end of July Cocteau was back in Paris, determined to put the appalling experience of the Somme behind him by diverting his energies into getting *Parade* on to the stage. After the Somme, Montparnasse must have seemed like paradise. On 12 August, a warm, sunny day, he met Picasso at the Rotonde, bringing his mother's camera. Both he and Picasso were in convivial mood. By one o'clock they had been joined by others, including Marie Vassilieff (she of the artists' canteen), who crossed the boulevard du Montparnasse with them for lunch at the Restaurant Baty, after which they returned to the Rotonde for coffee on the terrace, now joined by Pâquerette, one of couturier Paul Poiret's more unorthodox models. Cocteau had been taking pictures throughout; he now lined everyone up for several photographs before leading them through the streets. Max Jacob devised scenes, like stills for a documentary movie (a group of friends meet in Montparnasse and make their way through the *quartier* . . .), even pulling in extras off the street – the shoeshine boy, a barrow boy selling vegetables. The friends walked slowly down the boulevard du Montparnasse towards the cathedral of Notre-Dame and were joined mid-afternoon by Modigliani. That was the day, Cocteau later dramatically recorded, 'in the middle of the street, between the Rotonde and the Dôme, that I asked Picasso to do *Parade*'. Since he had already asked him, perhaps he asked him again. (Cocteau seemed to specialize in announcing he was doing things for the first time.) In any case, on 24 August Picasso finally gave his agreement, and began work on some ideas for costumes and sets to show Diaghilev. *Parade* was going to be

important – the first production by the Ballets Russes since the start of the war – and the first ever surrealist ballet. Apollinaire agreed to write a programme note.

Picasso immediately took to his first experience of designing for the stage. He enjoyed scaling ideas up for backcloths and fully understood the spirit of *Parade*. When Cocteau and Léonide Massine, Diaghilev's choreographer, were shown the first sketches for the set and costumes they saw 'pure cubism transferred to the theatre'. They decided to introduce some 'superhuman' characters (the managers) to contrast with the cast of acrobats and vaudeville dancers. Picasso created some extraordinary, outsized costumes – a canvas costume for the pantomime horse, and wonderful designs for the managers – cube-shaped versions of Dalek-like outfits (though without the incorporation of the megaphones Cocteau had wanted, since that proved insuperably impractical). Picasso's biographer John Richardson thinks the idea for the managers probably came from a painting Picasso began a year or so earlier, *Seated Man* (1915–16). Initially posed against a backdrop of foliage, with the introduction of a large row of dots like the windows of skyscrapers (which Picasso had seen photographs of) the seated figure had evolved into what Cocteau described as 'a magnificent metaphor of lines, forms and colours', a kind of cubist self-portrait, the artist himself seated within the outer forms. Cocteau considered it Picasso's greatest achievement. Of all those who saw *Seated Man* – a painting Picasso himself considered important; he had himself photographed standing in front of it – Cocteau was the only one who really understood it. Indeed, Cocteau's understanding of Picasso's cubism was unmatchable. 'When you watch him work,' he said, 'you have the impression that like the rest of us he's imprisoned in a very confined space and possesses working tools different from anyone else's. In fact, he's a prisoner between four walls' – compared to everybody else's three. 'What does this prisoner do? He draws on the walls. He carves with his knife. If he has nothing to paint with, he paints with blood and fingernails, then he tries to get out of this prison and starts to attack the walls, which resist, and to

44

bend the bars of his cell.' That year he wrote an 'Ode' to Picasso (published in 1919). It opens with the words *Souvenir de Montparnasse*; the first section is a tribute to *Seated Man*.

In September 1916 Diaghilev returned to Paris and gave the go-ahead for Cocteau's *ballet réaliste*, with Picasso under contract to provide designs for the costumes and sets. Satie's involvement had also been approved. In the evenings Picasso got into the habit of accompanying Satie part of his way home (he walked all the way to Arcueil) in the blackout. On their walks the two of them began to discuss *Parade* between themselves, so without Cocteau, whose idea to incorporate a deluge of mechanical noises to evoke the din of modern life with the sounds of trains, sirens, aeroplanes, revolver shots and typewriters had begun to worry Satie. (He eventually agreed to keep some of Cocteau's ideas for a 'realist' score, but only to placate him.) Both Satie and Picasso felt similarly about some of the visual ideas. Picasso thought Cocteau was going too far with his proposal to have the conjuror mime cutting his own throat to the shrieks of missionaries having their eyes and tongues torn out (it is unclear how Cocteau thought this would be conveyed). After some discussion Cocteau agreed to call the tactlessly named 'Titanic Rag' the 'Steamboat Rag'. It was to be danced by the Little American Girl, a generic type Cocteau found fascinating; he had based the character on the irrepressibly eager character of Pauline in the film series *The Perils of Pauline*, casting Maria Shabelska in the role partly because of her face, which (according to Cocteau) was 'like Buster Brown's dog'. She danced to the accompaniment of typewriters, a Morse code machine tapping out SOS repeatedly and a disembodied voice intoning nonsense: 'Cube tic tic tic tic on the hundredth floor an angel has made its nest at the dentist's tic tic tic *Titanic* toc toc *Titanic* sinks brightly lit beneath the waves . . . ice-cream soda tic tic.' Cocteau's ideas were becoming progressively wilder.

In any case, a sort of agreement was finally reached between the three of them, and by the time rehearsals for *Parade* began in the vast Théâtre du Châtelet, Picasso had regained confidence in it. Apollinaire also attended rehearsals. Massine made a poignant

sketch of the two of them standing side by side, Apollinaire in uniform, head bandaged, looking diminished and frail, Diaghilev towering above him in his distinctive astrakhan-trimmed over-coat. Diaghilev gave his collaborators five months to work together before leaving for Rome (the principal base for the Ballets Russes during the war), where, in February the following year, Picasso would work on his sets and costumes alongside Diaghilev's scene painter and seamstress.

The bitterly cold winter of 1916–17 ended with two parties at the artists' canteen run by Marie Vassilieff, the first to celebrate publi-cation of Apollinaire's *Le Poète assassiné* (*The Poet Assassinated*), a volume of poems he'd written in large part before the war. Tables were decked out in black and red, and excited party-goers pelted the poet with radishes. In the New Year there was a more eventful banquet, this time ostensibly to welcome Georges Braque home. Among the guests was Beatrice Hastings, who arrived with her new lover, sculptor Alfredo Pina, a student of Auguste Rodin, with whom Beatrice had been involved since (some months earlier) disentangling herself from the increasingly dissolute Modigliani. After plenty of alcohol everyone was in high spirits by the time Modigliani (who had been asked to stay away) put in an appear-ance, accompanied by a small crowd of drunken supporters. Pina produced a revolver and aimed. Tiny Marie (so diminutive that everyone remarked on it) launched herself at Modigliani and bun-dled them all out. Someone locked the door after them; Picasso pocketed the key.

In February Picasso (somewhat touchingly) went to say goodbye to Gertrude Stein before leaving for Rome, taking Cocteau with him; they announced their departure, Cocteau noted, 'as if we had become engaged'. They left on the 16th, arriving in Rome three days later, where they were shown around by diplomat friends of Diaghilev. They discovered 'a tiny, dirty little theatre-music hall' with a variety programme and an old orchestra *à tous crever* and the Teatro dei Piccolo, a marionette theatre, both of which seemed to encapsulate exactly what both Cocteau and Picasso had in mind for

Parade. Massine introduced Picasso to the company's scene painter and costume designer; Diaghilev introduced Cocteau and Picasso to his friend the Marchesa Luisa Casati, who dyed her hair the colour of a blood orange and wore fantastic transparent dresses of gold or silver lamé embroidered with diamonds, spike-heeled shoes encrusted with jewels and hats made of leopardskin or peacock's tails. Late at night she exercised her borzois or ocelots in the piazza, naked but for ropes of pearls, a sable wrap and dramatic make-up – she lined her eyes with kohl and used belladonna to dilate her pupils. After this startling encounter Picasso was introduced to the corps de ballet, shortly afterwards falling in love, not (perhaps as predicted, or intended) with the marchesa but with Olga Khokhlova, one of Diaghilev's dancers.

Cocteau generously announced he was willing to assist with the choreography. According to Serge Lifar (Diaghilev's principal dancer and biographer), Cocteau made a significant contribution not only to *Parade* but also to other Ballets Russes productions with his introduction of 'literary flavour and circus-like stylization'. Diaghilev was less convinced; he soon lost patience with Cocteau in person and sent him back to Paris to get on with the (all-important) publicity. Undaunted, Cocteau continued to work on *Parade* there, changing his mind about the setting, which he decided should not be specifically Paris but any city where 'the choreography of perspectives is inspired not by what moves but by immobile objects, around which one moves, especially by the way buildings turn, combine, step, get up again and buckle according to one's walk down a street'. That was ingenious – the buildings themselves were to (appear to) move; an idea inspired, perhaps, by the cinema (where, in 1917, the trick photography that produced absurdly transformed objects still seemed marvellously cutting edge).

In March Diaghilev took Picasso and Massine to Naples for five days, a city Picasso loved. He went there with Diaghilev again in mid-April, to see more of the city. He marvelled at the classical sculpture, particularly at the scale of the statues (one influence on his partial reversion to classicism in his work of this period).

Meanwhile, he continued work on designs for the little vaudeville city-set of *Parade*. He began to look at how other artists had portrayed the city, especially the cubist painters whose pre-war cityscapes had impressed Apollinaire, incorporating also some of the 'skyscraper' elements of *Seated Man*.

In New York in early 1917 Duchamp was rumoured to be working on a cubist piece entitled *Tulip Hysteria Co-ordinating*. He had been appointed head of the hanging committee for the second major exhibition of modern art in New York (after the Armory show of 1913), which was due to open on 10 April and was modelled on the Paris Salon des Indépendants – open to all, with no prizes or jury. With over two thousand works by twelve hundred artists, the exhibition was the biggest ever mounted in America (almost twice the size of the *Armory* show), and included every sort of art, though few exhibits were noticeably avant-garde.

Those anticipating the arrival of *Tulip Hysteria Co-ordinating* were disappointed when no such work arrived. The work Duchamp did (apparently) submit was rejected, but it later became one of the most influential artworks of the twentieth century. A week before the opening, after lunching with friends, he wandered into the showroom of J. L. Mott Iron Works, a manufacturer of plumbing equipment at 188 Fifth Avenue, where he purchased a porcelain urinal. He took it back to his studio, turned it upside down and signed it 'R. MUTT, 1917'. (He changed the spelling, R. Mutt being a character of his own invention – the artist, not the manufacturer.) Two days before the opening the exhibition hall reception took delivery of a heavy object, together with an envelope bearing Mr Mutt's membership and entry fee (six dollars) and the title of the work, *Fountain*. The committee met to discuss the troubling submission. Shortly before the private view on 9 April they concluded that the work, being 'by no definition, a work of art', should be rejected. *Fountain* disappeared from view – and Duchamp took it to Stieglitz's studio and asked him to photograph it.

The story of the bathroom fixture submitted as an artwork was reported in the press, though nobody seemed aware either that

'R. Mutt' was fictitious, or that the work had been submitted by Duchamp – if indeed it had. He told no one he had submitted it, not even his sister Suzanne, to whom he wrote with the news that 'one of my female friends under a masculine pseudonym, Richard Mutt, sent in a porcelain urinal as a sculpture . . . I have handed in my resignation and it will be a bit of gossip of some value in New York.' The gossip reached Paris via the May 1917 number of *The Blind Man* (which ran to two issues, of which this was the second). Apollinaire read the article and was appalled by the committee's philistinism, even though he may not have been aware that it had anything to do with Duchamp.

The point of the submission was its challenge to the committee. The declared intention of the exhibition was that any artist who paid their six dollars was entitled to submit work, thus the rejection of any artwork was an outrage. The work could not, surely, said Duchamp, have been rejected on grounds of indecency, since such fixtures were displayed in plumbers' windows for all to see every day. 'As for plumbing, that is absurd. The only works of art America has given are her plumbing and her bridges.' Nor should it have been rejected on grounds of the identity of the maker. On that point, Duchamp outlined to Suzanne the aesthetic that would underpin his work from now on. 'Whether Mr Mutt with his own hands made the fountain or not has no importance. He CHOSE it. He took an ordinary article of life, placed it so that its useful significance disappeared under the new title and point of view – created a new thought for that object.' In fact, the work may well have been submitted by one of Duchamp's female friends, a painter and poet, as he had written to Suzanne. But that hardly mattered, since by then the work had already been chosen. In a further ironic twist, it has become Duchamp's perhaps best-known work, though it survives, in the surrealist galleries in the Centre Pompidou, only – another twist – in replica.

Back in Paris, the gala performance of *Parade* took place on 18 May at the Théâtre du Châtelet, at 3.30 p.m. because of the blackout, a benefit concert in aid of the Red Cross and other causes. The cheaper seats were reserved for beneficiaries – wounded Allied soldiers.

Apollinaire sat among the smart set with Misia and others (including Renoir and Claude Debussy), his head bandaged in black. By the time the *ballet réaliste* was performed most of Cocteau's sound effects had been radically adjusted, as had the costumes of the three eight-foot-tall managers – a mustachioed French one with a pipe, starched shirtfront and walking stick; an American with a megaphone and papier-mâché skyscraper emerging from his shoulders; and a black minstrel astride the wrinkled-looking canvas horse played by two dancers – grumbling that they could barely move. Apollinaire's programme note made artistic history. It focussed on the show's unique artistic alliance of Satie, Picasso and Massine (he ignored, or forgot, Cocteau, whom he privately considered a charlatan), who between them had created a unique mixed-media event consisting of painting, dance and mime, a combination of decor, costumes and choreography that clearly signalled the future for a more synthetic artform. Apollinaire called it *'une sorte de sur-réalisme'*.

The audience were mystified. The managers, stomping stiffly about the stage, just made them laugh. The Little American Girl (who had to dance a cakewalk, crank up a car, ride a bicycle, box, mimic Charlie Chaplin and fire a pistol) was booed. Maria Shabelska burst into tears in the wings and had to be coaxed back onstage by Massine. From the auditorium came sounds of jeers and catcalls, and women rushed forth, brandishing hairpins. Without Apollinaire's bandaged presence, Cocteau believed, they would have been lynched. The critics were scathing. (Satie replied to one with a series of insulting postcards, was reported to the police and escaped a week's imprisonment only because someone intervened.) Some considered the knockabout, vaudeville spirit of *Parade* shocking in its apparent assumption that the war was over; most others were similarly appalled, but less by the vaudeville mood, unorthodox costumes and startling decor than by the sound of the clacking typewriters (one of the few of Cocteau's sounds of modern life Satie had agreed to retain), unavoidably reminiscent, or so they argued, of the sound of machine-guns. Among the one or two reviewers who appreciated the show, one conceded only that it was a *succès de*

scandale. All they had wanted to do, Cocteau said later in an interview, was to entertain the audience. '*Nous croyions* plaire.' Did that go for Picasso, too? Well, maybe not for Picasso, Cocteau admitted – that was not how Picasso thought.

When he used the word *sur-réaliste* Apollinaire meant that in mixing a variety of elements and media *Parade* had taken elements of the real world and put them together to create a work that extended beyond the limits of realism, achieving a new kind of super-real intensity – comparable with Picasso's constructions, Modigliani's stone heads, Duchamp's ambient nudes, his own poetry. As in '*Lundi rue Christine*', the juxtaposition of fragments of reality felt more real than did the world constructed 'realistically' as mimesis. For the time being, though, *sur-réaliste* remained a made-up word with no precise application or definition. Apollinaire used it again, a month later, in the subtitle of a play of his own after the editor (Pierre Albert-Birot) of a new publication, *Sic*, visited him in hospital to interview him for the magazine. In the interview (which appeared in the October 1916 issue) Apollinaire aired his conviction that new tendencies in the arts would ultimately come together in the art of cinematography, then still in its relative infancy. Albert-Birot asked him to write a play reflecting his conviction that one day both theatre and cinema would be free of obnoxious realism. In response, Apollinaire revived an old idea for a drama to include a pair of inflatable breasts and developed it into a new play he called *The Breasts of Tiresias: A Surrealist Drama*; the action recalled the irreverent absurdities of the avant-garde playwright of the belle époque, Alfred Jarry, and was about androgyny. Its central female character, Thérèse, would rather fight battles than give birth, so she changes sex (becoming Tiresias), grows a beard and unbuttons her blouse to reveal two balloons (one red, one blue), which she bursts with a cigarette lighter. In the end she is reconciled with her husband and they settle down again, having reverted to their original genders, as man and wife. (In this Apollinaire was startlingly ahead of his time – except, perhaps, in the world of vaudeville – though surrealist artists would soon be testing the boundaries of gender identity.)

Apollinaire's play was performed in Montmartre on 24 June 1917 to an audience of 'the artistic *tout*-Montparnasse and the literary *tout*-Montmartre'. Painters in the audience included Braque, Matisse and Modigliani; also present were André Breton and Jacques Vaché (the latter putting in a rare personal appearance, impatiently brandishing a revolver when the performance was late starting). Some of the cubist painters also in the audience (Juan Gris, Moïse Kisling, André Lhote, Jean Metzinger) protested that the play undermined the seriousness of their *recherches plastiques*. Apollinaire replied (to Gris) that he took these things very seriously – including friendship, and he did not expect his friends to desert him the moment he was under attack. Anyway, cubism had nothing to do with it: 'the play is surrealist . . .' There was one performance only. Shortly afterwards, Apollinaire was invited to speak at a benefit event for the war-wounded. Although his lecture covered the latest literary trends, his message was in essence patriotic, which disappointed some, including Breton. In July he drew Breton's attention to another new magazine, this one being produced by the Cabaret Voltaire (or Dadaists) under the title *Dada I*, its first edition just published in Zurich. Apollinaire had received another letter from Tristan Tzara requesting material. This time he stalled them by promising a contribution but sending nothing. He signed off, 'Long live France! Long live the Allies!' and, just to cover himself, 'Long live Romania!' – a nod to Tzara's nationality. Breton took a cursory look at the magazine but saw nothing that particularly interested him – at least, not yet.

While the Dada group remained in Zurich, that autumn in Paris a group of poets with similar fundamentally anti-war convictions began to form around Breton. It had all started one evening in late August when, at one of his Tuesday soirées at Café Flore, Apollinaire introduced him to twenty-year-old Philippe Soupault. Dark, slight, good-looking, Soupault lived with his mother at 250, rue de Rivoli, facing the Jardin des Tuileries. Soupault was the son of a renowned gastroenterologist who had died when Philippe was seven; his uncle by marriage was automobile magnate Louis

Renault; his grandfather and an uncle were lawyers. A gifted poet, he was fey, impulsive, not academic like Breton. He had astounded his family by passing his baccalaureate. Exempted from active service after an experimental typhoid vaccine administered by the army had almost killed him (it killed several of his fellow soldiers), he had spent most of the war in Paris, recovering in hospital; he, too, was vehemently against the war. Breton's impression of Soupault was that he was 'like his poetry, extremely refined, a trifle distant, likeable, and *airy*' (the word was well chosen – in a photograph taken by Man Ray in 1921 Soupault looks elevated, elfin, posing bare-chested, cigarette in his mouth, with a bowler hat and a shiny walking stick under his arm, like a dancer rehearsing with props). In his views, as in his irreverent stylishness, Soupault was another Jacques Vaché – though apparently without Vaché's dark side; Soupault replaced anger with blithe insouciance. He was intrigued by Breton – why was this poet wasting his time studying medicine? Over the following months he and Breton saw each other almost daily; in the evenings they strolled through the streets of Montparnasse or wandered over to Adrienne Monnier's bookshop to talk to other writers. 'We were trying,' Soupault said later, 'to escape what was, for me, a blood-soaked fog.'

In September Breton took up a post at the Val-de-Grâce, this time as a medical intern. Also working in the hospital was another young poet, whom Breton recognized – he had noticed him in La Maison des Amis de Livres. Louis Aragon, aged twenty in 1917, had seen Apollinaire's *Tiresias* and read all the poets Breton admired, including Apollinaire. Aragon, as he was known, was the illegitimate son of a young mother (seventeen when her son was born) who brought him up believing she was his sister. Just before he left for the war she told him that his father was Louis Andrieux, a married politician forty years her senior. Aragon never fully recovered from the shock and continued to introduce his mother as his sister. Born in the *beaux quartiers* of Neuilly, he had grown up in Paris in straitened circumstances, in the *pension de famille* run by his aunt in the avenue Carnot, near l'Étoile. Another gifted poet and original

thinker, romantic, irresistibly seductive (he later briefly became Nancy Cunard's lover), Aragon fascinated Breton. 'No one was ever a more able detector of the unusual in all its forms; no one was ever more inclined toward such intoxicating reveries on a kind of hidden life of the city.' Off duty, the three of them roamed the streets of Paris, or they went to the cinema to see the latest *Fantômas* movie, or Pearl White in *Les Mystères de New York*, or any film starring Musidora.

That summer Modigliani had met a real Musidora – Jeanne Hébuterne, a nineteen-year-old art student at the Académie Colarossi, a girl with long dark hair and huge eyes of piercing pale blue (or green, or brown, depending who was describing them); from their first meeting in July they were inseparable. She struck everyone who met her as a strange, other-worldly creature, silent, inscrutable; an intoxicating muse for Modigliani, she sat for some of his most arresting portraits, nude or clothed, fragile or voluptuous; chameleon-like, she seemed capable of becoming whatever he wanted her to be. She was deeply in love with him; their child (also Jeanne) was born in November the following year. In spring 1918 they were on their way to Cannes with Jeanne's mother, in retreat from the bombing. Since January that year, Paris had been under fire again, the city at its most dangerous since the start of the war, with sudden, shattering explosions coming night after night. By spring Apollinaire was reporting for *L'Europe nouvelle* on the exodus of the painters; those of the avant-garde who had not been called up seemed to be heading for the south of France. Those who remained included Picasso; Apollinaire, back in hospital with a near-fatal congestion of the lungs (after-effects of the poison-gas attack); poets Breton and Soupault, in Paris on leave, 'dragging our soiled uniforms through the railway smoke on the outskirts, forgetting to salute officers, forgetting every kind of deportment, forgetting the hour and ourselves in the bitter cold'; and Cocteau, there for good.

5.

The Dada Manifesto

Breton extends his group. After the Armistice, jubilation; enter poet Paul Éluard and his wife, Gala, who will both, in different ways, exert a significant influence on the development of surrealism. Duchamp returns to Paris on a visit, and travels back to New York with 50cc of Paris air. In January 1920 Modigliani dies, aged thirty-four, marking the end of an era.

Those in the habit of pacing the streets in the small hours at the start of 1918 were already beginning to hear the first strains of jazz drifting up from the odd smoky basement in Montparnasse. Cocteau, hearing it in obscure basement nightclubs, was keen to claim it as Paris's new music. In fact, he had already discovered it the previous summer, at the Casino de Paris; the singer Gaby Deslys had returned from a period in New York, bringing with her the first jazz band the city had ever heard. Cocteau thought the disruptive, underground sounds of jazz signalled the power to effect change. Étienne de Beaumont agreed – he had already hired the entire American army band to play jazz at a private concert in his home. One of Satie's friends, composer Darius Milhaud (one of an avant-garde group, Les Nouveaux Jeunes, later renamed Les Six), was another great admirer – he had first heard the music in jazz cabarets in Harlem. Another friend of Cocteau, writer and diplomat Paul Morand, discovered it the following year. 'In the bars of the post-Armistice period,' he wrote, 'jazz produced such sublime and heartbreaking accents that we all understood that we must have a new form of expressing our own feelings. Sooner or later, I said to myself, we

must respond to this call from the dark, must go and see what was behind that imperious melancholy' (a musical impulse that seemed to signal an appeal from the unconscious, transforming melancholy into marvel – an approximation in music, if you like, of the sur-real).

For Cocteau the sounds of jazz recalled the spirit of raw improvization Apollinaire had identified in painting as *l'esprit nouveau* and called *sur-réalisme* when he wrote about *Parade*. Taking *Parade* as his jumping-off point, Cocteau was writing a series of jottings, published later that year as a seventy-four-page pamphlet of aphorisms, *Le Coq et l'arlequin: Notes autour de la musique* (*Cock and Harlequin: Notes Concerning Music*), exploring the implications of the new music. He also reflected, in passing, on the arts of the circus and the music hall. *Le Coq et l'arlequin* was itself a kind of written jazz, consisting of improvised thoughts, one jamming off another, and including whichever of Cocteau's reflections on life came to mind as he wrote ('An original artist cannot copy. He only has to copy to be original'; 'Debussy played in French, but he pedalled [the piano] in Russian'). Once again, he was castigated: when *Le Coq et l'arlequin* was published it provoked flurries of indignation in both Paris and New York, in journals as different as the conservative *Nouvelle Revue française* and Picabia's avant-garde *391*. Cocteau's aesthetic fluctuated between cubism and vaudeville, sneered one reviewer. But that was nothing to the abuse he would soon be being subjected to by André Breton and his burgeoning group.

On night duty at the Val-de-Grâce, Breton and Aragon carried out their duties; they had both been moved to the *Quatrième Fiévreux* (Fourth Fever ward), for the mentally ill. One day Aragon showed Breton a copy of an issue of *Vers et prose* magazine from January 1914 which included a reprint of the first canto of Lautréamont's *Maldoror*. Now Breton, in his turn, discovered the writer's unrestrained excavations into the depths of the human psyche, the ultimate, so it seemed to them, in freedom of expression. Soupault managed to find them a rare copy of the book, which included all six cantos. After dark, the patients locked in their cells, Breton and

Aragon read *Maldoror* aloud to each other, punctuated by the patients' screams of anguish. Breton managed to get their shifts re-timetabled so that they were both on the night shift; they would lie on the floor wrapped in regulation blankets, reciting passages from the novel. Lautréamont had also written a thirty-page pamphlet, *Poésies*, published in 1870. In the Bibliothèque Nationale Breton tracked down the only existing copy and spent days transcribing it by hand. Aragon later said the impact of the pamphlet on the two of them had been like an earthquake; more so, he thought, than *Maldoror*. If *Maldoror* tested the limits of fantasy, *Poésies* challenged issues of authorship and authority, offering a possible blueprint for real rebellion; it was also to be one of the earliest influences on Breton's *Surrealist Manifesto*. Most astounding to Breton and Aragon was Lautréamont's exhilarating treatment of writers and philosophers whose reputations had seemed inviolable. 'I accept Euripides and Sophocles: but I do not accept Aeschylus.' The author dismissed in one fell swoop the whole notion of an immutable hierarchy. 'Poetry must be made by all. Not one. Poor Hugo! Poor Racine . . . Poor Corneille! . . . Tics, tics, and tics.' The list of 'dismal hacks' to be discarded included 'Sand, Balzac, Alexandre Dumas, Musset, du Terrail, Féval, Flaubert, Baudelaire . . .' – virtually all the modern heavyweights. This echoed the Dadaists' vehement rejection of authority – also fundamental to surrealism, as it came to be defined.

Spurred on initially by his friendship with Vaché, supported by Soupault and Aragon and now by his discovery of *Poésies*, Breton began his impassioned, ongoing argument with the whole notion of establishing individual reputations. 'Personal poetry has had its day of relative juggling tricks and contingent contortions,' Lautréamont had written. Another of his convictions was that poetry was inextricable from philosophy. For Breton this intellectualization of poetry was revelatory and liberating. On the authority of *Poésies*, God was dead, man was all-powerful, individual reputations were suspect, hierarchies despicable, sentimentality useless. The bourgeois search for stability and moral certitude was pointless. 'We say sound things,' he had written, 'when we do not strive to say

extraordinary ones.' After reading the pamphlet Breton took up his own poetry again, abandoning his semi-formal verse (the pretty things he had sent Apollinaire for approval) for new styles of composition, experimenting with sparse verbal collages in which silences – the spaces between words – were as significant as words. In May, Breton and Aragon took the medical examination which would qualify them as auxiliary doctors. Aragon, who passed, was sent straight to the front line, where during the next few weeks he saw some of the heaviest fighting of the war. In a single day he was buried three times by the fallout from grenade explosions, once even declared dead by the military authorities. Breton (having failed the exam) was sent first as an orderly to the instruction centre in Nouailles, then to a regiment in Moret-sur-Loing, near Fontainebleau, where he spent the summer getting to know riverside artists, planning a collaborative volume around the idea of *l'esprit nouveau* (which came to nothing) and generally gathering his forces.

Further respite came in the form of two weddings. Apollinaire had obtained special leave to marry Jacqueline Kolb in Paris on 2 May, in the town hall of the 7th arrondissement (Saint-Germain-des-Près), with a religious ceremony in his parish church of St Thomas Aquinas. Picasso's wedding gift to the couple was a cubist painting, *L'Homme à la guitare*, painted that year. On 12 July Picasso married his Ballets Russes dancer, Olga Khokhlova, in a civil ceremony at the same town hall, followed by a religious ceremony in the Russian Orthodox Church on the rue Daru. Picasso's witnesses were Apollinaire and Max Jacob; Olga's were Valerian Svetlov (ballet critic and friend of Diaghilev), and Cocteau, of whom Olga was extremely fond (she enjoyed his sparkling personality and admired his bourgeois heritage). It was 'a real wedding', Cocteau observed, impressed. 'Lunch at the Meurice. Misia in sky-blue. Olga in white satin-tricotulle. Very Biarritz.' As guests of Picasso's new friend Eugenia Errázuiz, the couple in fact honeymooned in Biarritz, in those days one of France's smartest seaside resorts. Picasso spent his time decorating the walls of Eugenia's rented summer *cabane* with murals and making sketches in his notebooks. Gertrude Stein

identified the period following Italy and *Parade* as Picasso's 'second naturalistic period', during which he was mainly painting beautiful portraits (including of Olga), rather than breaking new ground. Stein thought the works of that summer had 'the serenity of perfect beauty but they have not the beauty of realization. The beauty of realization is a beauty that always takes more time to show itself as beauty than pure beauty does . . . it is only beauty when the things that follow it are created in its image. It is then that it is known as beauty on account of its quality of fecundity, it is the most beautiful beauty, more beautiful than the beauty of serenity. Well.'

That autumn Breton began in earnest the attempt to establish himself in Parisian literary circles. Towards the end of the summer Étienne de Beaumont and his wife had opened their salon in the rue Duroc. One consequence of the war was that (both at the front and in Montparnasse) new meetings took place across classes; the one or two (penniless) artists invited to de Beaumont's soirées would never have been considered suitable guests before the war. As his 'comrade behind the lines', in Paris Cocteau acted as his 'liaison officer'. On 3 September he gave a reading of *Le Cap de Bonne-Espérance* (*The Cape of Good Hope*), a poem (published in 1919) written in homage to Roland Garros, the fighter pilot Cocteau had accompanied on some of his reconnaissance flights. The poem, though long, was a concisely composed reverie on the pilot's aerial view of the world, as quirky, in its way, as *Parade*, ingeniously composed in sparse arrangements of words that give the reader the impression of being in the sky. In advance of its publication Cocteau gave a preview performance of the poem for friends and guests in Valentine Gross's apartment in the Palais Royal. Those invited included Picasso, Misia Sert, Proust and – perhaps via Adrienne Monnier – future 'Pope of Surrealism', André Breton.

This was not, however, the first reading of *Le Cap de Bonne-Espérance*. Cocteau had read his poem a year earlier, in June 1917, in his diplomat friend Paul Morand's apartment, where, according to Morand, the small audience had been spellbound. Not so the group who gathered in Valentine Gross's apartment in September 1918.

Valentine's fiancé, Jean Hugo, afterwards reflected that the event had struck a wrong note from the outset. It was late starting, held up by Proust, who was late. Eventually Cocteau started without him, yelling at him when he finally appeared ('*Va-t-en, Marcel!*' – he was interrupting the reading). Throughout, Breton remained ostentatiously stony-faced and afterwards made no attempt to mingle. He stood still as Cocteau made his way over to him. 'It's very good, isn't it?' said Cocteau. 'But it's not what's needed, it's too sublime and –' (with a glance at Jean Hugo) 'too Victor Hugo.' Breton was dumbfounded; Cocteau, pale with irritation, stood coolly waiting for him to make his way to the door. (When Cocteau gave another reading at the end of the year, in the back room of Adrienne Monnier's bookshop, Breton was there again, this time with Soupault. Adrienne noticed they held themselves straight, 'radiating hostility'.)

Apollinaire continued to communicate with Breton. He asked Breton to help him with a new play he was writing, which Breton did, until 22 September, when he returned to the Val-de-Grâce in preparation for retaking his examinations. Then he broke with his parents, left the family home in Pantin and moved closer to the centre of Montparnasse, taking a tiny room in the in those days notably unprepossessing Hôtel des Grands Hommes, near the place du Panthéon, a building so dilapidated that when Soupault visited he was afraid the floor would collapse. But it was illustriously situated, close to the prestigious Bibliothèque Geneviève. Soon afterwards chance brought about Breton's first meeting with Picasso. Back in Paris in early October Picasso had sent word to Apollinaire – 'My old pard [partner] . . . need to see you, if you have a moment . . . *Je t'embrasse.*' Then the Picassos began to look for a new home, ideally in a *quartier* well away from all Pablo's old haunts, to begin married life. Paul Rosenberg arranged for them to rent an apartment at 23, rue la Boétie, on the Right Bank, in the building next to his own. If Cocteau had crossed the river to revel in the bohemian ambience of the Left Bank, Picasso now migrated to the Right. Apollinaire visited him in the rue la Boétie, shortly afterwards falling ill again. Picasso went to see him in the

boulevard Saint-Germain. In the hallway he passed a young man in a blue soldier's uniform: this was Picasso's first, fleeting encounter with Breton.

All of a sudden, as if out of nowhere, the event everyone had stopped daring to hope for at last took place. On 9 November 1918 the Kaiser announced his abdication. After four years the war was finally over. (The Armistice was announced two days later.) Paris went mad with joy, though the day was tinged with tragedy. That morning Picasso and Max Jacob rushed to Cocteau's mother's apartment, looking for their friend. They had just been to visit Apollinaire, whom they had left with Jacqueline. They called Cocteau's doctor but by the time Cocteau arrived to join them back in the boulevard Saint-Germain it was too late. Cocteau recorded the scene. 'His little room was full of shadows . . . of his wife, of his mother, of ourselves, and of others . . . whom I did not recognize at all. His dead face illuminated the pillow beneath it with a laureate beauty – radiant as if we were looking at the young Virgil. Death, in Dante's gown, was tugging him, like a child, by the hand.' Aged thirty-eight, his lungs already weakened, Apollinaire had succumbed to the influenza epidemic which at the end of the war took another million lives.

De Chirico had contracted it, too. He had been fighting in Ferrara, Italy, when one night in barracks in his sleep he 'heard a loud noise and dreamt that I saw two hens as big as ostriches'. In his delirium he was posted to Reggio Emilia and sent for observation to the hospital, where 'men who looked as though they would collapse at every step were declared fit for active service', then to an old convent converted into a vast hospital for those suffering from influenza, where 'in the night the priest and two nuns would regularly rush up, mumble prayers in Latin and another body would be wrapped in a sheet and removed'. When he recovered he returned to the hotel where he had been living with his mother and his brother. He was painting an interior in his bedroom, the canvas balanced on a chair, when the shouts of an excited crowd reached him from the street below. His brother rushed in with the news that Germany had requested an armistice; the war was over. (De

Chirico was confined to Rome for the next year, working as a clerk in a military record office, until Italy officially exited the war.)

At 11 a.m. on 11 November 1918 all the guns ceased firing. Paris was bathed in sunshine; the streets were heaving with jubilant crowds. Civilians and soldiers streamed out of the Concorde, singing *Madelon! Madelon!* (*La Madelon* was a popular French First World War song) and the songs of the English Tommies, 'It's a Long Way to Tipperary' and 'Home, Sweet Home'. As the correspondent for the London *Times* reported, 'Paris went charmingly off its head.' But peace came at a devastating price. Seven per cent of France's population (1.4 million Frenchmen) had been slaughtered. Tens of thousands of husbands, fathers and sons were never coming home. Food was still rationed. The Rotonde retrieved some of its old clientele but restaurants and cafés were still under curfew; movement remained restricted while the fuel shortage continued. Apollinaire, in the estimation of many the very cornerstone of modern art in Paris, was dead. In Montparnasse the mood soon became subdued. To control the reintegration of thousands of surviving soldiers the government restricted the discharge of many for a further year.

Those not yet demobilized included Breton, and Vaché, who on 14 November wrote to Breton in despair. He was in a state of collapse, drained of ideas; the war had made him senile before his time. Most poignantly: 'How am I supposed to last another few months in uniform? (I have been assured the war is over). I'm at the end of my tether . . .' Twelve days later he wrote to Breton again. He could feel the alcohol meandering through his body, turning him blue. He was done for, apoplectic. But suicide was against the law. Ten days later Breton attended the premiere of *Couleur du temps* (*Colour of the Time*), the play he had been helping Apollinaire to stage. During the interval a young officer and poet made his way hastily along the row of seats, approaching Breton but calling an unfamiliar name. He had mistaken Breton for a comrade believed to be lost in battle. Embarrassed, he rushed away. When they met again the following spring, Breton would remember having briefly seen the man – Paul Éluard – before.

On 6 January 1919 Jacques Vaché was found dead of an opium overdose in a hotel room in Nantes. *L'Express de l'ouest* reported that neither he nor the other young man present was a habitual opium user; Vaché's overdose was attributed to inexperience. Coincidentally, on the day of his death Tristan Tzara wrote again from Zurich, this time to Breton, asking him to contribute to the fourth issue of *Dada*. Breton, shocked and grief-stricken, read *Dada 3* (published in December 1918) and realized what he had been missing. It included Tzara's *Manifeste Dada 1918*, in a sense the precursor to Breton's *Surrealist Manifesto*, though notably different in tone (where Tzara's Dada manifesto was sarcastically mock-didactic, Breton's later surrealist tract was contrastingly nuanced, essentially poetic). In Tzara's call to Dadaist arms he reiterated his fury against slaughter and censorship, which (particularly now, in the wake of Vaché's death) made almost as strong an impression on Breton as had *Maldoror*.

In a tone of pretend-academic solemnity Tzara set out the justifications and principles of the manifesto. 'To launch a manifesto, you must insist on A.B.C., and strike out against 1.2.3. [A white space followed, in parody of Anastasia the censor] . . . sign, shout, swear, arrange the text in the form of absolute, irrefutable evidence, prove your *non-plus-ultra*, and affirm that your new publication resembles life the way the final apparition of a *cocotte* proves the necessity of God . . . DADA – here is a word that leads ideas to the chase . . . Dada signifies nothing. Thus DADA has come into being*) out of a need for independence, for suspicion towards community.' Tzara's manifesto was also vigorously anti-art, like the Futurists' before him (and like Dalí's later writings), arguing that the artist's responsibility was not to paint reproductions or illusions but to develop a language of protest. 'Every pictorial or plastic work is useless . . .' On it went. The text was dotted throughout (as in this extract) with irrelevant punctuation and unnecessary typographical marks, mimicking the appearance of wartime newspapers. Tzara's message – nonsensical but also fundamentally parodic and essentially anarchic – could not have appealed more directly to Breton's state of mind at the time. He was excited by its break with logic, its nerved-up, provocative tone,

and especially by its deeply controversial internationalism at a time when patriotism was still *de rigueur*. The important thing, as he later reflected, was that 'the same currents were forming in two countries that only yesterday had been enemies' – the best justification, in Breton's view, for aligning himself with the Dadaist cause, which, he now decided, was clearly not simply desirable but vital. Dadaism unleashed wild, untrammelled anger, directed at every aspect of the so-called civilized political culture that had resulted in mass human carnage, appalling mental anguish; and the loss of his friend.

Meanwhile, *Parade* had made an impact beyond Paris. News of the sur-realist production had reached Tzara in Zurich, by which time he had been vigorously canvassing for the past year, sending copies of his two reviews, *Dada* and *Dadaphone*, to writers and editors in all the capital cities; he had already contacted all the prominent figures in French artistic circles. Now the names of those associated with *Parade* – Satie, Picasso, Cocteau – began to appear in *Dada*, whereupon one of Apollinaire's more socially influential artist-friends (Francis Picabia) immediately set about poisoning Tzara against Cocteau, who, according to Picabia, was 'on very bad terms with everyone. Erik Satie calls him an idiot and all the others a parasite . . .' The Dadaists went on playing Satie's music at their events but began sending up both Satie and Cocteau in their pamphlets. 'Auric Satie with the Cocteau nut' – one ridiculous squib combined the names of Cocteau, Satie and Auric (one of Les Six) in a pun on 'coconut' and the colloquial expression *à la noix* ('not up to much'). Tzara, whose own *Vingt-cinq Poèmes* (*Twenty-five Poems*) had somehow found its way to Paris (and been reviewed by Aragon), was looking for a French distributor for *Dada*. In the drive to extend his network he wrote to Cocteau and Breton, both of whom responded, separately, by inviting him to Paris. Ignoring Picabia's warning, Tzara also invited Cocteau to contribute to the magazine. He received a friendly reply, and another invitation. Cocteau did not wait for an acceptance before publicizing Tzara's arrival, already scheduled – by Cocteau – for April.

It had already occurred to Breton to try to keep Tzara and his

Dadaist activities to himself. Anyway, as Soupault diplomatically pointed out, too eclectic a band of supporters was surely to be avoided, as it would ruin Dada's reputation for carefully targeted iconoclasm. When he discovered Cocteau was also courting Tzara, Breton was incensed. Within a few months he, too, was warning Tzara to keep away from Cocteau. 'My feeling – altogether disinterested, I assure you – is that he is the most hateful creature around today. Once again, he's done nothing against me and I assure you that hatred is not my strong suit.' Not all that disinterested, then. In fact, Cocteau *had* done nothing against Breton, other than flaunting his social advantage (and perhaps taunting him with Jean Hugo's privileged, socialist heritage), but it was becoming clear even to Cocteau that Breton would have to be dealt with. He wrote to him, offering 'bells, beautiful princesses, celebrations of a friendship that I offer you *by the handful*' – unsurprisingly, to no avail. Breton wanted the Dadaists to himself, since he was already beginning to see how their activities might lend a degree of authority to his own germinating ideas (eventually coalesced into the agenda of surrealism).

Breton, determined that Tzara would arrive in Paris as his guest, impatiently awaited him, meanwhile occupying himself by putting together a magazine of his own. He had appointed the editors – himself, Aragon and Soupault; they just needed a title. After some deliberation (rejected suggestions included Max Jacob's *Ciment armé* ('Reinforced Concrete')) they settled, somewhat contrarily, on *Littérature* ('Literature'), which, though hardly cutting edge, could at least be excused as ironic. The first prospective publisher made off with the funds, which had to be replaced with a substantial portion of Soupault's inheritance; then somehow Cocteau got wind of the magazine's imminent publication. He bypassed Breton and corresponded instead with Aragon, still stationed on the Rhine; their correspondence continued throughout 1919. Cocteau's idea was to contribute *Le Coq et l'arlequin* (presumably in excerpts); Aragon evidently saw no reason why not. He eventually persuaded Breton to include Cocteau's name in the list of contributors to the inaugural

issue, which kept Cocteau at bay while the twenty-four-page maga-
zine was rushed into print, to be distributed by Adrienne Monnier,
with no contribution by Cocteau.

Littérature no. 1 (in some ways the precursor to Breton's later, spe-
cifically surrealist newspaper *La Révolution surréaliste*) (*The Surrealist
Revolution*)) was published in March 1919. Its only obvious competi-
tor, the avant-garde magazine *Nord-Sud* (which Apollinaire had
supported) had been discontinued due to lack of funds, and *Littéra-
ture no. 1* was well received, including by Proust, who took out a
subscription and wrote Soupault a twelve-page letter praising the
editors' boldness. At last, just as he had always intended, Breton and
his team were the hot young men on the scene, invited to all the
literary gatherings. At around the same time, Cocteau's *Le Cap de
Bonne-Espérance* was published as a single work, introducing more
readers to his virtuoso, freewheeling style, his skill in combining
gravity and lightness, dreams and lucidity, and to his uncanny acro-
batic ability to juggle a range of projected selves. Even though this
kind of virtuosity put Breton out of his league, Breton still regarded
Cocteau as a competitor and a threat. He feared his talent, his con-
nections and the force of his personality, all of which made him
furious. At the end of that month Aragon returned to Paris on leave
and he and Breton went for long evening strolls together through
the city streets, deciding during their lengthy discussions to become
'the kind of people one didn't associate with'. Taking their cue from
Dada – and from Lautréamont's *Poésie* – they decided there was little
point in publishing one more novel, one more collection of poems,
by an individual; instead they should be expressing in literature
their outrage at anyone's blithe acceptance of the unacceptable
human condition. A mere poem was inadequate for that purpose;
instead of writing more poems they should be looking for ways of
mounting the 'poem-event'. If a poem was a poster, would the pub-
lic pause to read it? Literature should not be enhancing individual
reputations, it should take the world by force . . . At which point the
stranger who had mistakenly hailed Breton in the theatre reap-
peared, this time on Breton's doorstep.

When Paul Éluard turned up at the Hôtel des Grands Hommes in March 1919, sent by a mutual friend, Breton already knew of him as a poet and had written inviting him to contribute to the next issue of *Littérature*. (As would soon become apparent, the first cluster of surrealists had already begun to form.) Éluard, the author of three books of poetry published at his own expense, fitted naturally into Breton's burgeoning group. Tall, slim, blond, with 'a poet's noble and faraway gaze and an asymmetrical but handsome face', he suffered from mild tuberculosis and a tremor, possibly a symptom of meningitis. Born Eugène Émile Paul Grindel (for his pen name Éluard used his maternal grandmother's name), at twenty-three he was already married with a ten-month-old daughter. After three months at the front he had spent most of the war in military hospitals and had not long been back in Paris, where he was living in the rue Ordener with his parents, baby Cécile and his wife (also tubercular; the couple met in a sanatorium in 1914), twenty-one-year-old Russian émigrée Elena Ivanovna Diakonova, nicknamed Gala.

Éluard had brought some of his unpublished poems to show Breton. Before the jury of three (Breton, Aragon, Soupault) he presented his work, in his affecting, slightly tremulous voice. Éluard was an original and technically sophisticated poet. Breton thought the work promising; he accepted one poem, '*Vache*' ('Cow'), for the third issue of *Littérature*. ('*On ne mène pas la vache/À la verdure rasé et sèche,/À la verdure sans caresses*' ('You would not put your cow/To pasture in grass razed and dry/With no comforting caress'). A poem about the war, '*Perspective*' (in the collection *Mourir de ne pas mourir* (*Dying of Not Dying*)), was more nuanced ('*Ils ont des armes/Ils ont leur cœur, grand cœur,/Et s'alignent avec lenteur/Devant un millier d'arbres verts*' ('They have arms/And their shared heart, their big heart/They slowly line up/Before a thousand green trees'); his love poems read like dances, syncopated, elegant and poised. (Only later, after he met Max Ernst, did he produce more scaring, uncompromising poetry and prose.)

Gala was not present at that first meeting of the group of poets, who immediately absorbed Éluard into their midst. Their shared

views included their intolerance of the repressive older generation, the reprehensible values of the bourgeoisie and the equally despicable behaviour of politicians and the military. Their goal was liberty, the price of which, they considered, had already been more than paid. But how to create an art form truly capable of giving honest expression to their feelings about their slaughtered friends, their own lost – or, at best, compromised – youth? In the cafés they drank grenadine or *café crème*, showing no interest in drugs; they believed paradise should be achievable on earth through free-thinking, not narcotics. They smoked *cigarettes brunes*, a habit they had got into during the war, those with tuberculosis – Éluard and Soupault – smoking the most. Or they went to the cinema to see Musidora in *Les Vampires*, semi-nude in a provocative black garment that hugged her long lithe body like a creeper. Perverse, dangerous, libertine, Musidora was their idol. And they all read *Maldoror*. To them, Lautréamont's novel meant magic and incantation; it seemed to open the door to a possible world of fantasy and dream, and to release them from the expectation, established in childhood, that they would all live obedient, bourgeois lives. Lautréamont taught them, before any of them read Freud, that they were civilization's discontents. Most evenings after dark they wandered the streets together by gaslight, talking about *Maldoror*.

At the Grindel home in the rue Ordener the chants of *Maldoror* could be heard through the walls. Éluard recited it at the top of his voice, and Gala loved it, too. She took it to bed, to read in the afternoons. She was pursuing her own cult of beauty, always characterized for her by the unorthodox or unusual. As a young Russian woman married into a comfortable French family, she had no desire for independence, other than the freedom of spirit she demonstrated in everything she did. If she bought a dress, she re-cut and re-tailored it to make it exclusively her own; everything had to be original. Lautréamont's best-known aphorism – that a young boy's beauty was like the encounter of an umbrella and a sewing machine on a dissecting table (still today, though it predates surrealism, regarded as the quintessential surrealist image) – appealed to her cast of mind.

Uninterested in any formal sense in women's suffrage, she demonstrated an unusual degree of influence within the framework of her marriage. With Éluard she was used to reading and discussing poetry so, initially, she expected to join in conversations with the men. She soon discovered they were less than keen to include her. In fact, they found her disconcerting. (Musidora on screen was one thing . . .) Sometimes she went along anyway and sat listening in silence, when she was not wandering around Paris on her own, buying dresses or searching the brocantes for beautiful junk.

The men seemed to be on the verge of forming their own Parisian version of Dada. Éluard (possibly at Breton's instigation) sent some poems to Tzara in Switzerland. Less confident than Breton in Dada as a movement or philosophy, he was nevertheless willing to go along with it. Breton was still preoccupied with the idea of poetry as advertising (art could be polemic; equally, polemic could be art). That April he wrote to Aragon, now in Alsace, 'For me, poetry, art stop being an end [and] become a means [of advertising].' Breton was writing collage-poems inspired by Apollinaire's *Calligrammes*; in nos. 2 and 3 of *Littérature* (April and May 1919) he reprinted the full text of Lautréamont's *Poésies*. That summer, in a street near the Closerie des Lilas (at least, so the story went) he came upon a stranger he took for a tramp; or, more poetically, 'a poor, abandoned, enlightened man', who had read *Poésies* in *Littérature* and wanted to talk to Breton about it. The man was Modigliani, back in Paris, by now ravaged by tuberculosis, drugs and general deterioration. He had returned on 31 May 1919, alone, leaving Jeanne safely in the south of France, and was borrowing a friend's studio in the rue de la Grande-Chaumière. Friends (Kisling and others) kept an eye on him and brought him coal every week for his stove. Surviving mainly on tinned sardines and wine, he somehow continued to paint.

Breton built his group (soon to become the first definitive surrealist group in Paris) like a rampart, still corresponding with Tzara in Zurich and doggedly avoiding Cocteau. In any case, both Cocteau and Picasso were busy that spring with work on *Tricorne*, Diaghilev's new production for the Ballets Russes. Cocteau had

also been commissioned by *Paris-Midi* to write weekly articles on the Paris scene; between March and August 1919 he published twenty. *Littérature no. 2* included an article by Satie's friend Darius Milhaud (under a pseudonym, Jacaremirim) describing the carnival at Rio de Janeiro as the inspiration for a new kind of music. 'Perhaps I shall write a ballet about the carnival in Rio that will be called "Le Bœuf sur le Toit", from the name of that samba . . . the band was playing tonight as all the Negresses danced and danced in their blue dresses.' Cocteau picked up on the title and began writing the bizarre theatrical show he produced early the following year, which – sure enough – went out under the title *Le Bœuf sur le toit* ('The Bull on the Roof').

Breton was pressing ahead with his literary plans. He had found a new publisher (an old schoolfriend) for *Littérature*, who also published some works by friends of Tzara and an edition of Vaché's *Lettres de guerre* (*Letters from the Front*), introduced by Breton, who selected for the slim pamphlet the most despairing examples of Vaché's correspondence, which make dispiriting, sometimes heart-rending reading. Literature still seemed to Breton inadequate as a vehicle to put into words his outrage at the damage inflicted by the war (not to mention his general rage against the bourgeoisie). He was searching for a new direction, still preoccupied by the ideas and images produced *in extremis* by his shell-shocked patients at Saint-Dizier. In the aftermath of the war years he had been haunted as well by a recurring dream, or hallucination, of his own, a vision which took the form of 'a man cut in two by the window'. Now he had another hallucinatory episode. One night before he fell asleep he seemed to experience (rather than simply hear) a phrase, clearly articulated, apparently unrelated to anything in his daytime experience but nevertheless insistent, and somehow of an organic character – the phrase itself, which seemed to have plastic form, *'was knocking at the window'*. Then a whole series of phrases appeared to him in rapid succession, which made him think perhaps he could 'obtain' from himself what he had collected from his patients – that is, a monologue produced without inhibition or rational intervention, which would as closely as possible resemble

'spoken thought'. Soupault, who shared with Breton a basic familiarity with the work of Freud and other psychiatrists (including Pierre Janet), was also keen to explore the idea of writing an *automatisme psychologique*.

The idea that poetry might flow directly from the unconscious, tapping into untrammelled, uncensored feeling, was exciting to both. In late May or June they tried it out. Throughout the day they made jottings of whatever came into their heads. When they read them out to each other they were struck by how similar their thoughts were and revelled in the absurdity of what they had produced; they found some of it so hilarious they were seized with hysterical laughter. In essence, none of it was especially funny – perhaps the sheer exhilaration of working without any restraint overwhelmed them. The mood of most of what they produced was neither comical, nor indeed especially angry; rather it was a mood of mild wonder. Some lines reflect a kind of wistfulness: *'À quoi bon ces grands enthousiasmes fragile, ces sauts de joie desséchés? Nous ne savons plus rien que les astres morts'* ('What's the good of those great fragile fits of enthusiasm, those jaded jumps for joy? We know nothing any more but the dead stars'). Others verge on the cinematic (or rather, they anticipate the cinema of later years): *'Les couloirs des grands hôtels sont déserts et la fumée des cigars se cache'* ('The corridors of the grand hotels are unfrequented and cigar-smoke keeps itself dark'). The least hopeful phrases seem to betray the underlying sadness of the pair. *'Ma jeunesse en fauteuil à roulettes avec des oiseaux sur le manche de l'avenir'* ('My youth in a bath-chair with birds on the future's handle').

June that year was blisteringly hot – a heat the colour of August, remarked Aragon, arriving back in sweltering Paris. In a café Breton and Soupault showed him the first four chapters of their emerging work. Aragon was riveted. Half a century later he was still calling it 'the moment at the dawn of this century on which the entire history of writing pivots'. They wrote more, until they had a short manuscript, which they called *Les Champs magnétiques* (*The Magnetic Fields*, and set about preparing for publication in September. Here was the first example of automatism, one of the most

crucial early aspects of surrealism. (Picasso, shown the edited manu-script of an 'automatic text' scored over with amendments, said he couldn't see much that was automatic about it.)

In July 1919 there were more ecstatic celebrations when the Peace Treaty was signed at the Palace of Versailles. On the eve of the 14th an estimated one hundred thousand people crowded along the Champs-Élysées. A temporary cenotaph occupied most of the huge vault of the Arc de Triomphe; soldiers with rifles kept vigil. All night long there was dancing in the streets. The Champs-Élysées, someone remarked, looked like a vast ballroom. Gertrude Stein and Alice B. Toklas watched from a friend's hotel room as the Allies processed beneath the Arc de Triomphe. Knowing Paris would later become impossible to cross by car, they had risen at dawn for a last ride in 'Auntie' (the Ford truck they had driven in the latter months of the war, picking up soldiers returning to Paris on foot). 'Everybody was on the streets, men, women, children, soldiers, priests, nuns . . .' They watched as two nuns were helped into the branches of a tree to get a better view. Cocteau reported the event for *Paris-Midi*. 'Here is General Pershing, rigid on his pink horse. His troops halt, mark time, and are off again, like chorus girls. The Marines, entwined in their silver horns, play the latest fox-trot.' Irreverent? Max Jacob thought it was the best of Cocteau's *Paris-Midi* articles. Cocteau's August article for the same publication was entitled 'JAZZ-BAND'. He quoted poet Blaise Cendrars, a friend of Apollinaire, who had lost an arm in the war: '*Mais il y avait encore quelque chose, le saxophone qui pousse un long soupir humain*' ('But there also something else, the saxophone, drawing a long, human sigh'). Jazz, he also wrote, meant '*contacts sauvages. L'art se virilise*' ('wildness, and a new kind of virility' – the potency of chaotic, uncivilized drives, something to which the sur-realist artists soon laid claim). He described an event at the Casino de Paris which indeed sounds wild – the musicians suspended in a kind of cage above the hot hall full of painted girls and American soldiers, everybody's voices drowned out by the noise, out of step, swaying to the rhythm anyhow. From these new tumults, Cocteau insisted, a new order was already breaking free.

Wandering through the passage de l'Opéra, one of the old arcades at the lower edge of Montmartre (now long gone), Aragon discovered a new venue for Breton and his group: Café Certa. The small workman's café had a long bar, barrels for tables, cane chairs, dim lighting, a portable gas heater and a reputation for serving the best port in Paris, as well as cocktails of its own invention. They began to hold their informal meetings there. There was plenty to talk about. The *Nouvelle Revue française* had just reported that, with the war scarcely over, the artists of Paris were apparently listening to 'drivel' from Berlin. Breton responded with a letter of protest and wrote to Tzara in Zurich, asking him to respond, too. Tzara did so, denying any wartime partisanship. 'People these days no longer write with their race, but with their blood (what a platitude!).' In the cause of Dada, he added, he was simply looking for *men* to recruit to his cause (since the war had pulverized a generation of them).

That autumn Marcel Duchamp returned to Paris to help his brother Jacques, who was organizing a memorial exhibition (at the Salon d'Automne, reopening for the first time since the start of the war) in honour of their brother Raymond, who had died in 1918 of complications following typhoid fever. Duchamp had been saddened by Apollinaire's death too, sorry the poet had died without seeing *Apolinère Enameled*, the artist's dedicated and customized readymade. Duchamp dropped in at Café Certa but the Parisian Dada crowd failed to inspire him – unless the only three new works he produced at that time were in fact oblique responses to discussions there. *Tzanck Check* was an outsized cheque, hand-drawn to look printed, and made out to his dentist – a covert reference to the still-unseen Tzara, an outsized (over-inflated) blank cheque? The second work, *L.H.O.O.Q.* (the letters, pronounced in French, sound like *Elle a chaude au cul*, a slang expression for a woman who looks 'hot'), was a postcard reproduction of the *Mona Lisa*, graffitied with a pencilled-in moustache and goatee beard (there had been a revival of interest in da Vinci's works since the reopening of the Louvre). For the third work, Duchamp bottled a piece of Paris to take back

with him to New York. In a pharmacy on the rue Blomet he had bought a large (five-inch-high), sealed glass ampoule, had the pharmacist break the seal, poured out the liquid, re-sealed it and called it *50cc of Paris Air*. The work is one of the more marvellous transformations Duchamp effected by altering the context of a found object, rather than the materials. Suspended on a thin thread, *50cc of Paris Air* becomes a delicate, fragile bauble.

As the year drew to a close, in the rue de la Chaumière Modigliani lay gravely ill. He died on 24 January 1920, of tubercular meningitis, discovered by friends in a state of delirium, Jeanne wrapped helplessly around him. Since the Italian Armistice had only just been signed, his family were unable to leave Italy. His brother sent a telegram: 'cover him with flowers, we will reimburse you'. To the huge crowd of friends, models, waiters and virtually every Italian in Paris who followed the coffin, heaped with flowers, on its way to Père Lachaise cemetery, Modigliani's death seemed like the end of an era. So, as Picasso was heard to comment, he finally got his revenge. 'With Modigliani,' someone else remarked, 'the last Bohemian of his generation . . . Bohemia in the best sense of the word was disappearing. We felt it . . . All were there . . . burying their youth.' Everything was about to change.

6.

Rrose Sélavy

In New York, Duchamp meets Man Ray. Between them they create a
second identity for Duchamp and call her Rrose Sélavy. Dada makes its
presence felt in Paris as the precursor to surrealism in a series of
controversial theatrical events; the first exhibition in Paris by
Max Ernst is proposed.

January 1920 saw the arrival in Paris of the long-awaited Tristan
Tzara, and thus of Dada, surrealism's bad sister (or brother) and
precursor. Breton, Aragon, Éluard and Soupault all gathered in
Apollinaire's old friend Picabia's apartment to meet the maestro of
Dada, where to their astonishment they found a nervous man who
spoke broken, hesitant French. His belongings seemed to consist of
a typewriter. He soon got over his reticence, however. Before the
end of the month he was planning Dada exhibitions, Paul Éluard
had been requisitioned to set up a Dada evening later in the year
and the *Littérature* group was being galvanized into action. Propos-
als included an exhibition of works by Dada member Hans Arp's
friend Max Ernst. By spring Breton was already planning a show of
Ernst's works, which would take place in May 1921.

By spring Dadaist propaganda was already ubiquitously in print;
the seventh issue of *Dada*, retitled *Dadaphone*, included a range of
international contributions. Breton was putting together a dossier
of Dada publications collected from all over Europe. They included
Die Schammade, a Dadaist magazine published in Cologne by Max
Ernst, which had first drawn Breton's attention to the artist. Coc-
teau was already working on his own 'merrily anti-Dada' broadsheet,

Le Coq. He had enlisted the help of his latest flame, dark-haired, sultry seventeen-year-old Raymond Radiguet, who was writing publicity articles on Satie and Les Six for *Spectacle-concert*; Radiguet had also somehow established a rapport with Breton's group of poets, despite not really liking their poetry. The first issue of *Le Coq* was due to appear in May (there would be four issues in total, the latter two called *Le Coq parisien*). This was Cocteau's first project with Radiguet, and together they set out to distinguish themselves from Breton and the Dadaists. 'I am the very model of an anti-Dadaist,' Cocteau was boasting by the end of the year. In February he had produced his ballet *Le Bœuf sur le toit*, amended from its originally intended carnival setting to reflect the more topical theme of Prohibition. The 18th Amendment had come into effect in America on 17 January and Cocteau's ballet was now set in a bar.

Le Bœuf sur le toit was nothing if not another *sorte de sur-réalisme*, surely comparable with *Parade*. The cast (of whom three were played by clowns from the Medrano Circus) moved about in a dreamlike trance, out of step with the music (by Francis Poulenc), the props (bottles, glasses, cigarettes, chalk) piled on their heads. In essence, the show was a farce. A redhead, seduced by a black boxer, walks away on her hands, whereupon a red-faced, gold-toothed bookie punches the boxer. A giant policeman looks in to check the premises for alcohol. Finding 'ONLY MILK DRUNK HERE' (a placard hastily produced by the barman), he performs a little celebratory dance, before being decapitated by a fan operated by the barman. The redhead performs a Salome-style dance. When the policeman, now headless, attempts to stagger to his feet he is dragged offstage by the barman. The end. Surrealist? Yes, in that it was irreverent, irrational and confounded audience expectations. The programme also included an overture and *Cocardes* by Poulenc, a foxtrot by Georges Auric, a musical intermission entitled 'American Bar' and three piano pieces by Satie. The audience completely missed the joke about the American bar – crowding into it in the hope of interval drinks, they found no alcohol, only a jazz-playing trio – but the show was a success and continued to attract

audiences. The *Mercure*'s reviewer (reputedly Paris's toughest) called it 'a choppy, voluptuous fantasy with real charm' – further provocation, if any were needed, for Breton and his friends. The spring issue of *Littérature* included a piece entitled '*23 Manifestes Dada*', to which reactions were generally hostile. In the still all-pervasive climate of fervent patriotism Dadaism was regarded as highly suspect – grist to the Dadaists' mill, since they were hardly courting approval.

A further precursor to surrealist activities, the first Dada event in Paris took place in March at the Palais des Fêtes, an unassuming venue between two cinemas in the rue Saint-Martin, a commercial street of jewellers, watchmakers, wig merchants and cosmetic dealers; these made up a significant portion of the audience, since top of the bill, as announced in *L'Intransigeant*, was a lecture by André Salmon entitled *La Crise du change* ('Exchange Crisis'). As it emerged that the Dadaist agenda had nothing to do with currency exchange, the local businessmen began to file out, leaving only those who had already heard about Dada and come to see Tristan Tzara. Events included the unveiling of a canvas by Picabia which bore simply the acronym L.H.O.O.Q. (after Duchamp's retouched *Mona Lisa*), which – once the audience got the point – provoked jeers. There followed poems by Max Jacob, Blaise Cendrars and Pierre Reverdy, poet and editor of *Nord-Sud* magazine, read by specially appointed professional actors and, somewhat bafflingly, Cocteau, who had presumably invited himself. The final item was delivered by Tzara, his words drowned out by Breton and Aragon, who stood in the wings ringing bells. Tumult ensued, the audience screaming, 'Back to Zurich!' 'To the gallows!'

On Saturday 27 March, at the Théâtre de la Maison de l'œuvre, Paul Éluard made his stage debut – dressed as a woman. He and Gala played two beggarwomen in *S'il vous plaît* (*If You Please*), a play by Breton and Soupault (they had considered and discarded the idea of ending it with a suicide). Gala's lines consisted of, '*Avez-vous quelquefois, monsieur, quand vient le soir,/Pris garde à la pauvresse errant sur le trottoir?*' ('Do you sometimes, sir, when evening comes/To

look out for the poor woman straying on the pavement?'). Her acting skills must have been limited, since she was called for only one performance and consigned to watch subsequent ones from the wings. In the final act, Éluard appeared again. This time, disguised as a village idiot wrapped in a paper bag, he played Pipi in *La Première Aventure céléste de Monsieur Antipyrine* (*The First Celestial Adventure of Mr Benzedrine*) by Tristan Tzara. In this role he had to yell, '*Zoumbai!*' four times before reciting a text written by Tzara: '*Amertume sans église allons allons charbon chameau/synthesise amertume sur l'église isissise les rideaux dodododo*' (untranslatable nonsense, in other words). Two months later on 26 May, the second Dadaist performance took place, this time in a more salubrious venue, the large, plush Salle Gaveau in the rue la Boétie, usually reserved for classical concerts. Breton, in glasses and a stiff collar and sandwiched between two boards bearing a large bull's eye, read from a manifesto: 'Before you can love something, you have to have SEEN and HEARD it for a LONG TIME heap of idiots', signed by Picabia. Was this a swipe at the belief that well-behaved bourgeois children should learn to be seen and not heard?

Performers again included Éluard, who this time had somehow been talked into appearing in a *cylindre de Bristol* (engine cylinder). Soupault, blacked up, held aloft a large balloon bearing the name Cocteau, which he burst with his heel. A cardboard cone bouncing on a sea of balloons was labelled '*sexe of Dada*'. The high point of the evening was – inevitably – another incomprehensible piece by Tzara, *Vaseline symphonique*. The audience, by this time incensed, began chanting *La Madelon*. Some disappeared before the interval. For those who stayed, the ordeal continued. Éluard came on yet again, this time in a blond wig and yellow lace dress, to play the part of the Sewing Machine opposite Soupault, playing the Umbrella, in *Vous m'oublierez* (*You Will Forget Me*), another piece by Breton and Soupault. The reference to Lautréamont's chance meeting of a sewing machine and an umbrella on a dissecting table went straight over the audience's head. More booing and jeering ensued and Soupault was hit in the face by something being hurled through

the air . . . and so it went on. Already, to everyone except Tzara, it was all becoming somewhat trying. 'If one must speak of Dada, then one must speak of Dada,' Éluard was heard to long-sufferingly remark. But for how long? The problem with Dada was that, ultimately, the delivery of utter nonsense was bound to become limiting and expendable. For its spirit to survive, it needed to develop into something with more cultural, intellectual and artistic heft – which was where (as he himself considered) Breton came in.

Almost from the start the Parisian poets of Breton's circle were ambivalent about Dada, partly, perhaps, because it was not their own invention. Breton was already frustrated with its limitations when, that June, while strolling in the Luxembourg Gardens, he met a girl named Simone Kahn. Romantically interesting to him, she also seemed clever, independent and more intellectually sympathetic than any woman he had ever met. At their very first meeting she told him she was anti-Dada, which by now (a mere six months after Tzara's arrival) seemed to him understandable. Simone, whom he would later marry, was influential in Breton's shift of direction away from Dada, though he had not yet formulated anything more substantial to take its place. Invited by the *Nouvelle Revue française* to write a piece, Breton sent an article entitled *'Pour Dada'* ('For/In Support of Dada'). Some began calling him a hypocrite. However, in *'Pour Dada'* he aired his disagreements with hard-liners such as Tzara, revealing his own growing frustrations with the movement and taking the opportunity to clarify his own position and convictions. Breton's sympathies were fundamentally literary and philosophical rather than political; he still wanted, above all, to be taken seriously as an intellectual. 'When will the arbitrary be granted the place it deserves *in the formation of works and ideas?*' he asked his readers – the question that ultimately underpinned the as yet unformulated *Surrealist Manifesto*.

At the same time it was starting to seem as if everyone in the group just wanted to leave Dada's wilder shores. Soupault had married in late 1918, Aragon had successfully resumed his medical studies, and even Éluard and Gala had deserted, albeit temporarily; they

were on their way to Monte Carlo, where they blithely gambled away a small fortune before the Grindel parents called them to order, and after which they continued their travels. In Tunisia, unable to slough off the spirit of Dadaist pointlessness altogether, they bought a chameleon, which back in Paris they managed to palm off on a friend, Jean Paulhan, who collected 'poetic curiosities'.

Even Tzara had followed convention by leaving Paris for the summer. As far as Breton was concerned, Dada's potential in the city now seemed somewhat precarious. One problem was that the French capital was fundamentally unshockable. A *succès de scandale* was still a success, and audiences quickly grew weary of *scandales* that simply repeated themselves. By the same token, an article by Breton in the *Nouvelle Revue française* reminding readers of Dada's status as an intellectual idea was hardly guaranteed to cement the movement's anarchist credentials. No, to make an impact in Paris, Dada itself required some kind of transformation. As Max Ernst later pointed out, the whole point of Dada was that it was meant to be a bomb, not a ripple: 'a "stage", as they call it, in "the history of art" [was] exactly the opposite of what Dada was looking for.' Asked several decades later to write about it, Ernst said, '*(Very sharply)*: I am not a historian!' According to him, the work generated by the Dadist impulse consisted of 'objects, collages, through which we expressed our disgust, our indignation, our revolt' – which is perhaps the best way of putting the distinction between Dada (disgusted, indignant, outraged – like a bomb) and surrealism, which – in theory, at least – was both aesthetically and intellectually more nuanced (searching, exploratory, receptive to the marvellous; improvisational, like the impulses of jazz).

When he returned to Paris in October Breton moved into the Soupaults' apartment on the Île Saint-Louis and began to look around for new ways of earning a living. Tzara appeared to have abandoned him, though Breton knew he was back in town. Apparently deserted by everyone, Breton took on a series of small jobs, including reading to the partially sighted owner of a fashion house who introduced him to the couturier Jacques Doucet, who, having

sold his collection of *ancien régime* art (for 13 million francs), was now collecting modern art, rare books and literary manuscripts. Doucet hired Breton to catalogue his literary acquisitions, including first editions, manuscripts, correspondence and periodicals by those Doucet considered to be at the cutting edge of modernity. The papers included some of Cocteau's, grouped with those of Breton and his *bande*, which merely amused Cocteau. 'The Dadaists know . . . I am at the extreme Right . . . so close to the *extreme* Left, with which I close that circle, that people confuse one of us with the other.' In any case, he added, such comparisons were meaningless. 'Critics always compare, the incomparable is outside their ken.'

Still in New York, Duchamp was being pulled further into the American art scene. Katherine Dreier had decided to establish a museum to house and exhibit modern art and was hoping he would help her. When he visited her to discuss the idea he took along a friend, Man Ray, in those days still a struggling young painter. When they met at Stieglitz's 291 gallery they had struck up an instant rapport; Man Ray had immediately seen the point of Duchamp's readymades and even come up with some of his own. He suggested a name for the new museum, *Société anonyme*; he assumed it meant 'anonymous society'. In fact, the French expression means 'public limited company' or 'corporation', but Dreier liked it as a name, too, so they used it anyway. At 19 East 47th Street they rented a suite and set about creating a substantial venue for the exhibition of contemporary art in New York. Duchamp decorated the rooms and made a banner for the outside of the building, pointing out that, when they judged the works within and if they wanted modern art to come into its own, Americans should be encouraged to refer to their 'far-famed sense of humour' rather than listening to the critics. He and Man Ray had already begun working collaboratively, after Man Ray visited Duchamp's studio one day while he was out of town and found *La Mariée mise à nu par ses célibataires, même* (*The Large Glass* (*The Bride Stripped Bare by Her Bachelors, Even*)), the work Duchamp had begun in Paris but which was still uncompleted, left beside an open window and covered in dust. Man Ray was fascinated by the

coating of dust and the patterns it made on the glass; this time, Duchamp had managed to make art without even being in the room. When he came back the two of them set up a camera and went out for an hour, leaving the lens open, the glass illuminated by a naked bulb overhead. As Man Ray put it, 'While the bride lay on her face decked out in her bridal finery of dust and debris, I exposed her to my sixteen-candle camera.'

Once Man Ray had taken the photograph, Duchamp 'fixed' the dust with varnish until what remained resembled a lunar landscape, then had the glass panel coated with silver at the lower-right section. He spent the next few months crazing the silver surface by scratching it with a razor, which Man Ray thought gave the work the appearance of an aerial view. Duchamp renamed it *Élevage de poussière (Raising Dust)*.

For their next collaborative work, Duchamp helped Man Ray create his first optical machine, *Rotary Glass Panel (Precision Object)*, a motor-driven construction made of three layers of glass propellers mounted on a shaft and driven by an electric motor. Each pair of propellers was painted with parallel lines, creating the illusion of a spiral. When they set it in motion it went so fast that the electric belt connecting the propellers snapped, scattering splinters of glass across the studio. The work was destroyed. However, the process of filming *The Large Glass* and then inventing *Rotary Glass Panel* had triggered something in Duchamp's imagination. Ever intrigued by the problem of creating motion, he had also always been fascinated by the whole notion of motion pictures. As he watched Man Ray with his camera, Duchamp had been reflecting on the whole process of filming and being filmed. When Katherine Dreier bought him a hand-held movie camera (one of the first) he and Man Ray tried using it to make a three-dimensional film in which Baroness von Freytag-Loringhoven shaves her pubic hair. Pleased with the results, Man Ray rented a second movie camera and found a mechanic to help them mount it alongside Duchamp's so as to have two lenses filming in tandem. This, however, was an idea that came to nothing, since when they tried to develop the film the two

reels stuck together and were ruined. But somehow it had all added up to another idea, and Duchamp was soon posing for portrait photographs – in drag.

Rrose Sélavy was the joint invention of Duchamp and Man Ray, and the latter photographed Duchamp as Rrose, sultry in fur collar and low-brimmed art deco-style hat, hands adorned with large rings, then again, more provocatively, in a hat heavy with black feathers, a velvet coat with a frilled collar and two strings of pearls. Rrose was dusky, decadent, a bit sluttish, undeniably seductive and obviously French. Asked how he had chosen the name, Duchamp said 'Rose' was just a corny, popular French girl's name; Sélavy was *c'est la vie* ('that's life'). That winter of 1920 (the year, incidentally, Coco Chanel launched No. 5) Duchamp invented a readymade for Rrose: a bottle of Rigaud perfume, the label amended to read *Belle Haleine – Eau de Voilette*; and another, *FRESH WIDOW COPYRIGHT ROSE SÉLAVY 1920*, which consisted of a miniature French window, all eight panes covered in black leather. How both men felt about photographing her can only be imagined. For the time being, nobody saw the photographs. Also that year Man Ray took some conventional portrait photographs of Duchamp in which his forehead and neck are lit while the lower half of his face is in shadow. He poses without expression; by comparison with Rrose, he looks small-boned, slightly delicate, expressionless. By contrast, the photographs of Rrose are taken full face and are starkly lit, creating the impression that her face has been caked in white powder. Somehow the whole face seems larger, with prominent nose, wide mouth, strong jaw; the expression is haughtily provocative. If the genius of Man Ray was that he seemed capable in photography of creating a complete facial transformation, as far as Duchamp was concerned, the point of Rrose Sélavy was 'not to change my identity, but to have two identities'. (It was, after all, the year American women gained a new social identity, having been given the right to vote; in the UK suffrage was granted in 1918, in France not until 1945).

In December audiences at the Théâtre des Champs-Élysées witnessed the first concerted attack by Breton on Cocteau. On the 21st

the Ballets Russes performed a revival of *Parade*. The cultural climate had changed since the ballet was first performed in 1917; this time, the reception was rapturous. On the first preview night Diaghilev persuaded Picasso and Satie to show the public they had forgotten their differences with Cocteau; the three of them appeared in a box and took a bow together. On the night of the second invited preview there was mayhem when the performance was disrupted by Breton, Tzara and friends. Somehow, they had infiltrated the invited audience and bobbed up and down in their seats, yelling, *'Vive Dada!'* (Long live Dada!). Tzara vented his fury in his high-pitched voice at those who had sent the youth of his generation to their deaths in the war. No one else could see or hear properly, including the critics, who gave up trying to write proper reviews. In one sense the protest backfired, since no sooner was it established than Dada already seemed to be the new *chic*; audiences began to arrive at the theatre with eggs and tomatoes to hurl onstage. Something had to change – surely this same (Dadaist) bomb could not continue to be tediously dropped, again and again. However, Tzara had not lost faith; his ambition now was to convert more celebrated artists to the Dadaist cause. First choice was Picasso, although for the time being his alliance with Diaghilev made him an unlikely prospect. Next was Duchamp, since his reputation in Paris seemed only to have increased with his absence. Tzara approached him via his sister Suzanne, who wrote to him in New York to tell him Tzara was organizing a Dada Salon at the Galerie Montaigne and would Duchamp consider submitting something? He declined. He was working on a new '"assisted" ready-made', or *trompe l'œil* sculpture, a birdcage containing marble 'sugar lumps', two small marble dishes, a thermometer and a piece of cuttlebone entitled *Why Not Sneeze, Rrose Sélavy?*

Max Ernst's Surrealist Collages

Breton's group of Parisian Dadaists daringly exhibit the work of German painter Max Ernst, thereby introducing into the Parisian art scene the first, highly provocative surrealist collages. Cocteau takes over a bar (the Gaya, predecessor to Le Bœuf sur le Toit) and fills it with friends and jazz musicians. In Vienna, Breton visits Sigmund Freud; in Cologne, Paul and Gala Éluard visit Max Ernst. Man Ray arrives in Paris and creates his first Dada object in France.

Breton had been putting all his energies into planning the first exhibition of work by Max Ernst in Paris. With a few months to go before the show, the artist's work began arriving from Germany, one piece at a time. When they unwrapped them, Breton and his group were stunned. Ernst had sent multimedia collages in paint, gouache, pencil and of photographs depicting all kinds of figures and subjects, superimposed on startlingly incongruous grounds. Each work was astonishing. In *The Song of the Flesh, or The Dog Who Shits* (1920) a decapitated dog, eyes in the stump of its neck, a fan in one paw, flies through the air; beneath it a woman's arm emerges from a ball like a maggot from a fruit while two other dogs race across the scene, one jumping through (or encased in) a wide metal band. Ernst's description, etched around the frame, reads, 'The dog who shits the dog with a nice hair-do despite the difficulties of the terrain caused by copious/plentiful snow [cocaine?] the woman with the beautiful chest the song of the flesh/Max Ernst'. In other works, human body parts lie in abandoned landscapes, juxtaposed with outsized vegetation against damaged skies, large lumps of

metal strewn across the scene. Disembowelled, metallic animals stand stiffly about, or seem suspended; birds fly at ground level, fish are propelled through the air; boats move across the sky. There are headless women and an 'upside-down violin' with legs and feet. *Untitled, or Deadly Aeroplane* (1920) is a photocollage of part aircraft, part woman (composed only of two immense arms, her hands posed as if playing a non-existent harp), a massive semi-human construction, free-standing, in the sky above two men carrying a third between them, his arm in a sling. A woman lies on a couch, her chest, one shin, one knee, an arm and her head all padded, the wires affixed to two of the pads leading only to a couple of empty glass vessels. Mysterious shapes have become 'real' simply by virtue of having been photographed. Nothing could have been more conducive to Breton's emerging (soon to be surrealist) agenda.

While Ernst's methods seemed to Breton and friends marvellously compatible with and even to extend the range of Dadaist iconoclasm, Ernst himself was concerned primarily with challenging the limits of painting. If the goals of Dada were to demoralize and destroy, the point of surrealism was not destruction but transformation; within the surrealist agenda, monsters became marvels. Ernst's work was the first manifestation of this. Initially, particularly exciting to Breton and his group was that Ernst's aesthetic explorations had enabled him to find ways of making ordinary objects haunting or shocking. Lifting things out of their habitual contexts enabled him to endow them with new, startling implications, the resulting visions of displacement chiming with their own explorations in poetry. Of the fifty-two works to be exhibited only twelve were purely collages. In others Ernst had superimposed painted or drawn elements on to photographs or parts of photographs. As Aragon pointed out, the important thing was not the method but the result: Ernst had found ways to reveal the hidden functions of images. Enchanted by the poetry of Ernst's work, Aragon saw in it 'strange flowers made out of wheels . . . a master embroiderer becomes a bookmaker; a collection of hats becomes a convoy', as in Ernst's *The Hat Makes the Man* (1920), in which a milliner's window

display seems to have turned into a semi-mechanical structure composed of bright red, blue, orange, green and yellow rods and bolts. Despite the apparent diagrammatic intricacy, the structure is not functional; on close inspection the rods and bolts are not bolted or capable of suspending the hats, which balance on them precariously, subsumed – pointlessly – into the overall structure of black and bright-coloured shapes in pencil, ink and watercolour against a chalk-white ground. In the bottom-right-hand corner Ernst has written, '*!Umpressnerven! (c'est le chapeau qui fait l'homme) (le style c'est le tailleur)*' ('Umbilical nerves! (it's the hat that makes the man) (style is form)'. Into his uncanny landscapes, as Aragon also noted, Ernst seemed to be introducing strange ghosts. As Ernst himself later described it, in his collages he had created 'the chance meeting of two distant realities on an unfamiliar plane, or, to use a shorter term, the culture of systematic displacement and its effects' – both useful working definitions of surrealism.

Tantalizingly, though Breton had been corresponding with Ernst since 1919, still neither he nor any of his group had met him; his avant-garde activities had been keeping him in Cologne. The war had hidden him from view for four years; as he later described the experience, 'Max Ernst died on the 1st of August 1914. He resuscitated the 11th of November 1918.' Ernst said little about his experiences of the war, only that towards the middle of 1917 he had obtained permission to move to the army's maps department, designing and drawing them; his main problem seems to have been isolation. He had lost contact with his good friend Hans Arp and had no idea Arp was involved with Dadaist activities in Zurich, nor even that his friend was still alive. Ernst was still mobilized when in 1918 he married Louise (Lou) Straus, a fellow student from before the war. (Their son Ulrich (Jimmy Ernst) was born in 1920.) Though supported by her father, a wealthy milliner, Lou worked at the Musée Wallraf-Richartz. She was Jewish, Ernst was Catholic; her father remained unpersuaded by his daughter's choice of husband.

Two decades later Ernst assisted his biographer Patrick Waldberg by supplying a few childhood memories that seemed to be

linked to the development of his work; they also bear the imprint of Freud's writings, which by that time Ernst had read. His mother had been kind and pretty, he obligingly recalled, 'white as snow, red as blood, black as the Black Sea', and a good storyteller. His father, who taught at a school for the deaf and dumb, was a dedicated painter. As a child, Ernst had watched him at work on a watercolour, a 'peaceful, yet disquieting, forest scene'. Engrossed in his meticulous work, painting in his book, his father had looked like a monk. 'Absorbed so deeply that he is scarcely there at all, so to speak. Little Max is overwhelmed.' Visiting the actual forest for the first time, aged three, Max experienced conflicting emotions, 'both rapture and oppression', he remembered, the wonderful pleasure of breathing freely in the vast space but also the anguish of being a captive in the prison made by the trees all around him. In one of his strangest childhood memories, the birth of his sister Apollonia (the sixth Ernst child) coincided with the death of his beloved pet parrot, thus provoking 'a sort of delirium of interpretation', as though baby Apollonia had somehow taken for herself 'the vital energy, of his beloved bird'. All his life he remained fascinated by the forms, movement and general uncanniness of birds; they appear throughout his *œuvre*.

Another, more bizarre memory has the child Max seated on a train watching the telegraph wires through the window, transfixed by the way they moved and stopped moving. When the train was in motion, they swung heavily; when it stopped, so did the telegraph wires; their mysterious up-and-down motion mesmerized him. In Ernst's own words, 'in an attempt to penetrate their secret, Max escaped from the house one afternoon', arousing the attention of a group of Kevelaer pilgrims who happened to be passing, stopped in their tracks by the fair-haired, blue-eyed child, barefoot in his nightshirt, brandishing a whip (actually a broomstick with a piece of string). '"*Et Kriskink!*" [the Christ child], they whispered, full of respect. The boy believed them . . .' It was an aura he somehow managed to retain; nobody ever messed with Ernst. In a memory with a quite different texture, on another occasion he lay in bed with

measles, watching in his delirium as from his imitation-mahogany wardrobe emerged 'the rough outlines of organic forms'. All these were, as he put it, 'quite normal hallucinations, quickly swallowed up and quickly forgotten'; he apparently recalled them only almost thirty years later when asked about the sources of his work.

Ernst's own encounter with Dada had come about just after the end of the war. Browsing in a Munich bookshop one day in 1919, he found a mention of Hans Arp in a Dadaist magazine – his first indication that Arp was still alive. At the same time, he turned up an issue of *Valori plastici* which covered contemporary exhibitions in Paris dedicated to de Chirico's work, which Ernst had never seen before. He was struck by the artist's strange landscapes, by the tenuous connections between objects in his work and by the ominous quality of the shadows cast by statues in his nocturnal scenes. For the next six or so years his work remained Ernst's strongest influence. His idea for the collages had come about during the summer of that year, during a trip to the borders of the Rhine. In a strange almost-repetition of his childhood delirium, confined to his lodgings by the rain one day he had amused himself by leafing through an illustrated catalogue of objects for use in demonstrations of every kind – anthropological, microscopic, psychological, mineralogical, palaeontological. It struck him that, seen as a whole, they made a peculiar collection; as he studied the juxtapositions of such arbitrarily related objects the act of looking at them began to seem almost hallucinatory. He cut some of them out and began placing them one against another, then added painted or drawn elements to create scenes the objects now suggested to him – strange skies and deserted landscapes, which in turn began to seem like scenes of unexpressed desire.

In another chance encounter a few months later in 1920, at home in Cologne one day he had answered the door of his studio to Austrian painter and graphic artist Kurt Schwitters, who stood on the doorstep with two suitcases, which he emptied on to Ernst's floor. Out of one fell a cascade of compositions and reliefs made of gold and silver paper, feathers and bits of straw, imprinted with

fragments of all kinds – marvellous collages created in a unique, distinctive style. Ernst was particularly taken with Schwitters' reliefs: rectangular overlapping boards and juxtapositions of pieces of wood in all shapes and sizes, their sources indiscernible, some painted, others ornamented with metallic or other elements and each construction arranged in a definite compositional order. Ernst liked the subtle, edgy cohesion of these unusual *sui generis* works. The other suitcase contained books, drawings, paintings and water-colours. Schwitters told Ernst he was travelling door to door; the point of the two suitcases was that, if the case of collages upset any-one, he could simply open the other one.

In Cologne in April, together with Arp and another friend, Johannes Baargeld, Ernst had mounted an exhibition they called the *Dada Ausstellung, Dada-Vorfrühling*, a show of paintings, sculptures and diverse objects held in the glassed-in courtyard of a café in the centre of the city. At the entrance a young girl dressed for her First Communion recited obscene poems; visitors were directed beyond her to the urinals. At the centre of the courtyard stood an object by Ernst, something like a butcher's block, from which an axe hung by a chain. The public were invited to attempt to destroy the object with the axe. In one corner stood Baargeld's *fluidoskeptrik* (a mean-ingless word), an aquarium with water coloured red to resemble blood. At the bottom could be made out an alarm clock; on the surface floated a woman's (head of) hair. The glass walls were hung with scandalous and sacrilegious collages. The show caused a public outcry; the place was ransacked several times and the works were trampled on before the authorities closed the exhibition. Ernst's next encounter had even more unfortunate consequences. In spring 1921 *The Young King*, a militarist, monarchist play intended to keep alive the wartime spirit of honour and glory, was playing at the Municipal Theatre of Cologne. Though Ernst was not an anarchist, he was acquainted with the local anarchist group, who invited him and Baargeld to join them in storming the theatre. Somehow it was a photograph of Ernst (blond, with a delicate, striking facial bone structure; irresistibly photogenic) that hit the front pages of the

press the next day. He was called a Bolshevik and sent threatening anonymous letters, whereupon his 'disgraced' family threatened to disown him. By the time his work was shown in Paris in May he had already decided that from now on he would avoid political causes.

In Paris, Breton and Simone, Aragon and others spent entire nights in Breton's room in the Hôtel des Écoles, framing Ernst's canvases for the exhibition. The opening was scheduled for 3 May at the Galerie au sans Pareil. Invitations read, *'EXPOSITION DADA MAX ERNST: dessins mecanoplastiques plato-plastiques peinto-peintures anaplastiques anatomiques antizymiques aerographiques antiphonaires arrosables et republicains. ENTRÉE LIBRE SORTIE FACIILE mains dans les poches tableau sous le bras AU-DELÀ DE LA PEINTURE'* (MAX ERNST DADA EXHIBITION (intentionally incomprehensible details of media) FREE ENTRY, EASY EXIT, hands in pockets, picture under arm BEYOND PAINTING.)

Following the scandal of the Cologne exhibition, Ernst's application for a visa was denied; thus the first exhibition of his work in Paris on 2 May 1921 went ahead in his absence. On the opening night visitors were welcomed instead by Breton and his group, in white gloves but no ties, 'uttering bestial cries'. Breton stood 'solemn and priestly' in his pretentious, clear-lensed glasses, sucking on matches. In the cellar Aragon impersonated the kangaroo (as promised in an invitation to *'un petit'*) while Tzara and Soupault played hide-and-seek. From time to time a trap door opened to release 'a diabolical red light and a flood of nonsensical words'. The exhibition went more or less ignored, dismissed by the few notices as yet another Dadaist prank. In the years immediately following the war, any deviation from the rhetoric of honour and glory was still regarded as heresy; the language of war remained prescribed, the glorification of war prevailed. Those who hoped for progress looked to the wonders of science, not to the artistic avant-garde. The war still effectively only just over, the real act of daring was the introduction into the Parisian art scene of the work of a German artist; at that time any German was still indisputably the enemy. (Three years later the Olympic Games were held in Paris.

The forty-four countries invited to participate did not include Germany.) The art press pointedly ignored the introduction of a German artist on to the Parisian scene; reviewers concerned themselves, instead, with Cocteau's avant-garde ballets.

The Eiffel Tower had become a telephone operator – at least, in Cocteau's latest creation. Cocteau was working on a new ballet, *Les Mariés de la Tour Eiffel*, due to open on 21 June. (The first broadcast from the actual Eiffel Tower took place on 22 June.) The work had been commissioned this time not by Diaghilev but by Rolf de Maré, a rich Swedish balletomane visiting Paris that winter who was already making plans to upstage Diaghilev. His ballet, Cocteau explained, was to be a *tragi-comédie*. He had begun meeting friends at the Gaya, a little bar on the rue Duphot, in the 8th arrondissement run by Louis Moysès, a bartender from Charleville whose father owned the place. Cocteau came to hear of it through Satie's friend Milhaud, who knew the regular pianist Jean Wiener; before long, he had more or less taken it over as his new headquarters. Delighted by his new patrons, Moysès decorated the walls with coloured posters bearing their names and word quickly spread that the place had been taken over by Cocteau and his friends, who dined to Wiener's syncopated jazz piano music, which he played with 'ethereal ease', accompanied by black American Vance Lowry on banjo and saxophone.

The mood at the Gaya was upbeat; everybody, said Cocteau, 'was enthusiastic about everybody'. Tzara wandered in one evening and was soon mixing cocktails behind the bar. A rumour was circulating that Cocteau had finally found his true niche – as a nightclub manager – which was neither true nor remotely likely to upset Cocteau, who relished the light-hearted mood at the Gaya; he had begun to fear, or so he said, that with the publication of *Le Coq et l'arlequin* he had started to be taken too seriously. (With the Gaya bar, *'nous étions sauvés!'* ('we were saved!').) The first reading of the new ballet, *Les Mariés de la Tour Eiffel*, took place in the Hugos' apartment (Jean Hugo and Valentine Gross had now married) on 23 February, where the assembled company found the script hilarious.

It concerned the antics of a petit-bourgeois wedding party one 14 July, Bastille Day, in the restaurant of the Eiffel Tower, the controversial construction that fascinated Cocteau; he had written about it before in articles for the *Mercure* and *Le Coq*. Back in the day, the tower had been 'Queen of the Machines' (the extraordinary steel construction had caused huge controversy when erected in 1889) but these days the queen (her first music broadcast scheduled for the following day) was no better than a telegraph operator.

Breton and his group continued their own activities, now extended to include mock-trials of figures they considered treacherous, including Maurice Barrès and Cocteau – which Breton may or may not have known. Barrès was 'brought to trial' by Breton and his group for having abandoned his earlier belief in personal freedom (inspiring a whole generation of young readers with his novels, *Un Homme libre* and *L'Ennemie des lois*) to join forces with superpatriots and right-wing radicals. When Barrès sent word that he was unable to appear in person, a shop dummy stood trial in his place. Dressed in formal evening wear and sporting Barrès' distinctive moustache, it was seated before the jury, who were got up in smocks to simulate judicial attire (red for the prosecution, black for the defence). Tzara gave a long nonsensical testimony followed by a Dada song. Spectators in the courtroom remained mystified or simply bored, until one of Breton's newest recruits (Benjamin Péret) entered as the Unknown Soldier. Dressed in German uniform and gas mask, he 'came onstage, barked a few lines in schoolboy German, and goose-stepped off again', while the hall erupted in protest, some breaking into *La Marseillaise*. Intermittently that spring and summer the group staged other events – irritable gatherings, rained-off walks – none of which did much to improve Breton's mood; by June he was already thinking of writing 'an article bidding farewell to Dada'. Nevertheless, ten days later he was back in Paris, in time to disrupt Cocteau's new ballet.

The gala performance of *Les Mariés de la Tour Eiffel* took place on 18 June. The five ballerinas danced their 'dance of the telegrams' to

a commentary spoken by two voices (one Cocteau's, at some performances) projected through large horns like gramophone (or phonograph) horns.

First Phonograph:	She's the Queen of Paris.
Second Phonograph:	She *was* the Queen of Paris. Now she's a telegraph operator.
First Phonograph:	One must live, as they say.
Second Phonograph:	Don't move. Smile. Look at the lens. Watch the birdie . . .

As the wedding party obediently watched, a bird flew out of the camera and carried off first the bridegroom then the bathing beauty, an ostrich, a huge baby, a lion and, finally, a dove of peace – a succession of marvels in motion. At this point there was mayhem in the auditorium as Breton, Tzara and friends stormed the hall. In fact, they were angry not merely with Cocteau but also with the manager of the theatre. For the past few weeks they had been holding a 'Salon Dada' in a small room above the auditorium which they had renamed the Galerie Montaigne and filled with ready-mades, sculptures and paintings, including works by Ernst, Arp and others. The night before Cocteau's gala, the theatre had been rented by Futurist painters for a *concert bruitiste*. When the Dadaists staged a demonstration the management locked them out of their own exhibition space upstairs. Still furious, on the night of the 18th they again stormed the theatre, jumping up and down throughout the performance, yelling, '*Vive Dada!*' In the event, despite causing chaos on the night, they had little effect on the show's reception. Though the critics were unable to see or hear enough to write proper reviews, *Les Mariés de la Tour Eiffel* was successful, running until 25 June. Picasso attended one of the performances (accompanied, because Olga was pregnant, by Coco Chanel, who, while not oblivious to Picasso's charms, was in love, by then, with Pierre Reverdy). Diaghilev also saw *Les Mariés* . . . and admired the music. Then, on 27 June, Cocteau left for the south of France with Radiguet, who

spent the summer (under Cocteau's direction) writing his first novel, soon to become the next *succès de scandale*.

Paris enjoyed an influx of Americans that summer. With post-war inflation soaring and the value of the American dollar at its height, Americans in Paris were discovering the cafés, the parties, the nightlife – and enjoying the release from Prohibition. They had money to spend and their mood was upbeat. In Montparnasse the sunny terraces of the cafés filled up with animated crowds of visitors. Duchamp, having discovered that temporary repatriation was easier to arrange than renewing his American visa, returned that June. He remarked that strolling through the streets of Paris was like walking through Greenwich Village. He attended various events organized by Breton and friends, though without much enthusiasm. From a distance, he wrote to his friends in New York, 'these things . . . are enhanced with a charm which they don't have in close proximity'. Apollinaire's old friend Francis Picabia had been to the Certa, bringing a picture called *L'Œil cacodylate* (an untranslatable mock-pun) which he asked fifty or so friends to sign. Duchamp added an extended pun on the word *arroser* (to water, sprinkle or spray), which gave him the idea of adding an extra 'r' to Rose's name. From now on she became Rrose Sélavy – though she had still not been spotted in Paris, where, according to Duchamp, there was nothing much happening anyway – until the afternoon of 22 July, when Man Ray arrived from New York.

Like many artists, Man Ray had dreamed of Paris since child-hood. Helped by one of Stieglitz's associates, who advanced him five hundred dollars in exchange for everything he painted during the coming year, and by his sister Dora, who generously gave him five, Man Ray arrived in the city shortly after Duchamp, speaking no French at all. He found the city still on holiday following Bastille Day. He just missed Tristan Tzara, who had temporarily left Paris, vacating a hotel room in Passy. Duchamp reserved the room for Man Ray, then went to meet him at the Gare Saint-Lazare. They left his trunk at the station (told to return for customs clearance a few days later) then stopped off at the hotel, where Man Ray thought

the hotel sign, Hôtel Meublé, seemed very distinguished – despite the prevailing scent of urine and disinfectant in the hotel itself. During the next few days he was surprised to see a number of hotels all displaying the same sign – it meant 'Furnished Rooms'. Then they went to Café Certa, where Man Ray met Breton and others, including Paul and Gala Éluard. Breton seemed to dominate, 'carrying his imposing head like a chip on his shoulder'. Éluard reminded Man Ray of a portrait of Baudelaire he had seen in a book; Gala seemed to speak some English, so he talked mainly to her. Soupault was 'like an impish schoolboy . . . ready for some mischief'. Man Ray was surprised by one thing – that there were no painters in the group. After dinner in a nearby Hindu restaurant with plenty of wine they went up to Montmartre, where there was a fair on. The sounds of trumpets and accordions floated across the hillside from a bandstand strung with tricoloured bunting; couples were waltzing in the lamplight. Soupault embraced a lamp post, then shimmied up it, reciting Dadaist poetry. Back on the ground, he knocked at the door of a concierge's lodge and asked if Philippe Soupault lived there. All along the boulevard an amusement park had been set up, with elaborate merry-go-rounds, miniature railways, steam swings, dodgem cars, booths and sideshows. Here, his new friends 'rushed from one attraction to another like children, enjoying themselves to the utmost, ending up by angling with fishing poles with rings on the ends for bottles of wine, or cheap champagne. I looked on, bewildered by the playfulness and the abandon of all dignity by these people who otherwise took themselves so seriously.'

The *jour de fête* over, Man Ray returned to the station to clear his luggage; it comprised a collection of incongruous marvels (as he himself later claimed, he was actually a pre-surrealist, since he had been making surrealist works before Breton – or anybody – thought to invent it). First his largest case was opened, containing half a dozen canvases. 'Cubist,' pronounced the inspector knowingly, and nodded them through. He then unwrapped a long narrow box beneath glass, containing wire, coloured strips and a zinc

washboard, with a title at the base, *Catherine Barometer*. An interpreter was called. Reluctant to enter into any discussion of what constituted a Dadaist object, Man Ray explained that he 'used it as a guide for my colour combinations. It was passed.' Next came the trunk. Once the inspector had been assured the contents were intended for neither duplication nor commercial exploitation, they in turn were passed. He then picked up a jar of steel bearings in oil with a label which read, '*NEW YORK 1920*'. This Man Ray dealt with by explaining that as an artist he often found himself with very little to eat; with the jar to look at he could pretend there was food in the house. Another object, made of odd pieces of wood and cork, he explained, was a primitive idol made by American Indians. 'Far West, remarked the interpreter, proud of his English.' Man Ray was then dismissed and went to find a taxi. He climbed up beside the cab driver and they rode off to the hotel, the driver keeping up a monologue incomprehensible to Man Ray but for the odd word (such as *Américain*), to which he responded with '*Oui*.' The cab driver sped through the streets 'like a cowboy on a bronco . . . honking his horn at crossings, bawling out pedestrians'. Eventually they reached the hotel and with the help of a porter heaved everything into Man Ray's room.

For the first few weeks he wandered through the streets of Paris, fascinated by the look of the French capital, its boulevards lined with trees, each surrounded by grillework at the base; he felt tall, after moving among the skyscrapers of New York, here, where no buildings were higher than eight floors. He wondered if he should perhaps enrol in a school to learn French. He would probably learn it faster, said Duchamp, by finding himself a French girl. Meanwhile, Duchamp explained, the key to speaking French was not grammar but pronunciation; Man Ray would be understood if he always emphasized the last syllable, which 'worked like magic', at least in the cafés. Duchamp was already planning to return to the States. There was an unoccupied room in his apartment building in the rue de la Condamine (a few paces from the place de Clichy), he told May Ray, who moved into it (a 'maid's room' on the sixth floor)

a month later, when he could no longer afford his Passy hotel room. During his first few weeks in Paris he did no work, the better to concentrate on the challenging process of getting used to everything. He looked for a gallery to represent him, without success. Soupault said he thought he could arrange for him to exhibit in the gallery run by his wife 'Mick' (Suzanne, née Verneuil) in the Librairie Six, but so far nothing had come of that suggestion. Man Ray approached Léonce Rosenberg, but he was still primarily interested in cubism and not particularly taken with anything Man Ray showed him.

Duchamp went out of his way to help him, and finally succeeded in getting him some photographic assignments. Within a few months of his arrival Francis Picabia had engaged him to photograph his art collection, and soon Paul Poiret would provide Man Ray with his introduction into the world of fashion photography. Meanwhile he was entirely dependent on Duchamp. At the Duchamp-Villons' house in Puteaux the two of them worked together on a second short film, which they made with spiral patterns inscribed on circular discs and mounted on a bicycle wheel; as the discs revolved, the spirals seemed to advance or retreat. Other than this, Duchamp seemed to be doing no work either. In fact, during the seven months in Paris that coincided with Man Ray's arrival he produced only one new readymade, *La Bagarre d'Austerlitz* (*The Brawl at Austerlitz*), another miniature French window, this one set into a wall of imitation bricks, the glass panes defaced with white glazier's smears. He could happily have gone on making windows, Duchamp said, each one based on a different idea; they would become his windows 'the way you say, "my etchings"'. But even that seemed too much trouble, so indifferent had he become (at least, so he insisted) to anything to do with the Parisian art scene. To his friends in New York, he wrote that he looked forward to being back. Man Ray, on the other hand, had no desire to leave Paris.

Tzara was on his way to the Tyrol to meet Max Ernst. Granted permission to travel for the first time since the war, Ernst and Lou had arranged to meet Arp and his wife in the village of Tarrenz-bei-Imst for a summer vacation and had taken the

opportunity of sending postcards extending the invitation to all the Paris Dadaists, including the Éluards, who by the end of August were still trying to decide whether or not the weather would be suitable for them. Since part of the plan was to prepare the latest issue of Tzara's *Dada* magazine for publication, Breton and Simone, who married in Paris on 15 September, decided to join the group as part of their honeymoon. Towards the end of September Breton duly arrived, 'like a hair in the soup', insisting on reading aloud passages from the interminable *Maldoror*, a particularly irritating experience for Ernst, since the book was not even in his native language. By this point the magazine was ready for the printer and the others were about to leave – only the Bretons were still there – and Breton decided that, since there was nothing keeping them in the Tyrol, the four of them should go to Vienna, where he planned to realize his long-held ambition of meeting Sigmund Freud – his other honeymoon treat.

Believing that *The Magnetic Fields* (Breton's and Soupault's collection of automatic writings) owed much to the work of Freud, Breton had sent Freud (by now elderly, and suffering from cancer of the jaw) a flatteringly inscribed copy of the book and expected to be appreciatively received. In the first week of October the two couples arrived in Vienna. For the first few days Breton was unable to summon the courage to make his visit. He was finally received by Freud at his home at Berggasse 19 at three o'clock on 10 October. Simone waited in a nearby café. When he emerged, Breton was so disappointed he was unable to speak. Far from being received as Freud's equal in matters of psychiatry, Breton was shown into the waiting room with the patients, and when he did meet Freud the professor had little to say to him. He said he saw Breton as a poet rather than a scientist; in Freud's view, psychiatry was not a form of artistic expression but a means to a therapeutic end. Breton did his best to impress by dropping the names of currently influential psychiatrists, but Freud remained impassive. Back in Paris, Breton got his revenge by publishing an article entitled 'Interview with Doctor Freud', in which he described Freud as 'a little old man with no style

who receives clients in a shabby office worthy of the neighbourhood GP', and who, despite concerted efforts by Breton to engage him in a meaningful conversation, seemed to have little to say beyond generalities.

Having missed Ernst in the Tyrol, the Éluards decided to track him down in Cologne. On 4 November they arrived at his studio at Kaiser-Wilhelm-Ring 14. Among Breton's group, Éluard had been the most enthusiastic admirer of Ernst's collages. On first meeting he was equally impressed by Ernst's athleticism and good looks; he thought Ernst looked more like a tennis player than a painter. As for Ernst's impressions of the Éluards, he saw a man with an aristocratic-looking face and the gaze of someone in a trance, accompanied by a riveting dark-eyed woman. Gala was undeniably striking-looking, with black eyes that arched upwards towards her temples, an imperial nose, a small mouth, lips closed as if she knew how to keep a secret; her pure oval face gave her a mysterious Byzantine look and she was clearly someone used to taking charge. The attraction was instant – between Éluard and Ernst; and between Ernst and Gala.

On the walls of Ernst's bedroom hung two of his most recent works, *Oedipus Rex* (a collage-like depiction of a walnut pierced by an arrow juxtaposed with a bull's eye, a bird's eye and part of a hand emerging through a trap door, the index finger pierced with a steel implement); and *Elephant Celebes*, a painting of a bulbous, monumental figure which Éluard admired so much he bought it on the spot. The figure in the picture has been left stranded in the desert against a stormy sky through which green fish are flying; beside him/it is an apparently unrelated headless woman behind whom stands a tall articulated object similar to ones Ernst had already introduced into his collages. Half cooking pot, half unexploded shell, with the head of a bull, a trunk like a stove pipe, the elephant itself has been described by one critic as 'an armoured, strangely ventilated, cuffed and gauntleted human figure, with a length of thick piping in place of a left arm, a turret for a head, standing either on stumps or with its legs sunk deep into the earth'. The elephant seems both oddly rooted and pointless, the headless woman

incidental, the tall object apparently unconnected to either. Ernst may have been inspired by the German nursery rhyme which begins, 'The elephant from Celebes has sticky, yellow grease on his bottom.' The Éluards loved it; it was the first example they had seen (with *Oedipus Rex*) of Ernst's painting.

Writing about Ernst's work in 1937, Éluard noted that from 1919 onwards Ernst had decided to consign the 'sad monsters' of the war to the past. The 'rational thinking' that had powered the war had caused such disorder and disturbance that he had been determined from then on to explore the imagery of a liberated universe, striving to invigorate the world in the form of a new kind of art. It was not far from the nature of man to that of man's imaginary world. Faced with the poetry of Ernst's painting, Éluard wrote, 'Think flower, fruit and the heart of a tree, since they wear your [human] colours.' From their earliest meeting they unreservedly admired each other's work. Éluard was in the process of putting poems together for a new volume, *Répétitions*, to include the prose poem 'Nul (2)': '*Il pose un oiseau sur la table et ferme les volets. Il se coiffe, ses cheveux dans ses mains sont plus doux qu'un oiseau . . .*' ('He puts a bird on the table and closes the shutters. He combs his hair, his hair in his hands softer than a bird . . .') and now he added a new poem, with which he opened the volume: 'Max Ernst'. Éluard saw Ernst as a fellow poet; more than a decade later he wrote that he still knew of no other poet who penetrated more deeply into the truths of humanity. As an artist, Ernst mingled with what he painted, and showed his viewers, above all, that '*nothing is incomprehensible*'. Ernst, furthermore, turned out to be a stimulating companion, funnier and more charming, the Éluards thought, than most of their friends at home. Before leaving on 10 November they chose eleven of his collages to illustrate *Répétitions*. Both Éluards returned to Paris enthralled.

On 3 December Man Ray's first one-man show in Paris opened, as promised, at Mick Soupault's gallery in the Librairie Six bookshop. On a wet, blustery day visitors arrived to find the space littered with red balloons, popped one by one throughout the

afternoon with lit cigarettes. The exhibition brochure (leaving nothing to chance) featured a map showing the exact location of the bookshop; it also included short statements by Man Ray and others, including Aragon, Éluard, Tzara, Arp and Soupault, whose read, 'Light resembles Man Ray's paintings like a hat to a swallow, a coffee cup to a lace-seller, a letter to the mail.' Man Ray's statement consisted of a Dadaist fish recipe (carve up a *carpe de Seine*) and a mock-survey of how 281 artists had been fed as babies. During the afternoon Man Ray was approached by a 'strange voluble little man in his fifties' who seemed out of place in the predominantly young gathering, with his little white beard, old-fashioned pince-nez, black bowler hat, black overcoat and umbrella; Man Ray thought he looked like an undertaker or a banker. It was Erik Satie, who led Man Ray over to one of his own paintings. When Man Ray mentioned he was cold Satie replied in English, then took him off to a café for a couple of hot grogs. When he said he spoke no French, Satie said that didn't matter. After a couple more drinks they made their way somewhat light-headedly back to the gallery, on the way passing a hardware store, where they picked up a flat iron and, with Satie's help as interpreter, a box of tacks and a tube of glue. Back at the gallery Man Ray glued fourteen tacks to the base of the iron, gave the piece a title – *Le Cadeau* (*The Gift*) – and added it to the exhibition: 'That was my first Dada object in France.' It was also effectively one of the last, since the scene was already being set for the creation of work that would soon be being designated surrealist. Anger would give way to a more playful exploration of the anti-rational, the incongruous; the marvellous; the truly surreal.

8.

The First Rayographs

By the time Le Bœuf sur le Toit has its official opening it is already the hot new night-spot. Man Ray makes photographic portraits of all his friends, revolutionizes fashion photography, and accidentally blurs his negatives, inadvertently creating the first rayograph. Kiki de Montparnasse (his new love interest) hangs out with the Dadaists and the surrealists – and is unable to distinguish between the definitions. Max Ernst illegally crosses the border into France. Breton's group holds séances, receiving messages from the beyond, including (apparently) some from Rrose Sélavy.

On New Year's Day 1922 Breton and Simone moved into a two-roomed studio at 42, rue Fontaine, a few paces from the Moulin Rouge. Cocteau was also relocating; he transferred his social head-quarters from the Gaya bar in the rue Duphot to a place with a discreet black door on the rue Boissy d'Anglas in the 8th arron-dissement. He named his new venue Le Bœuf sur le Toit, after the ballet, and decorated the walls with his own sketches, some large drawings lent by Picasso and Picabia's *L'Œil cacodylate*, with its fifty signatures (including Rrose Sélavy's *'arroser'*). The pianist played an orphéal, an instrument that looks like a harmonium. To the strains of the new jazz music, in Le Bœuf sur le Toit the mood of the 1920s had truly arrived. The club soon became the favourite meeting place for smart café society, 'where high and low, *gens chic and gens louche*, could mingle with the leading lights of the avant-garde'. Celebrities who would patronize it over the following years included Charlie Chaplin, the Prince of Wales, Coco Chanel, Ernest

Hemingway and, from her arrival in Paris in 1925 onwards, Josephine Baker. Within a year or so Jean Hugo was calling the place 'the navel of Paris'. Large, sleek cars slid to the kerb. Up to the intentionally sleazy-looking black door ran lithe, stylish women in shimmering short dresses, their hair styled in the new geometric bobs, fringes and diagonal cuts; as one chauffeur was overheard remarking to another, 'the dirtier the place, the more they love it'.

The official opening of Le Bœuf sur le Toit on 10 January was marred for Cocteau only by the disappearance of Radiguet, who, incidentally, had just emerged from a short fling with Beatrice Hastings. Radiguet put in a brief appearance at the start of the evening, then slipped out with the sculptor Constantin Brâncuşi and Nina Hamnett (another racy female on the fringes of the Montparnasse 'cube'); they arrived at the Dôme at five minutes to two, just in time to buy some cigarettes, before Brâncuşi hit on the marvellous idea of taking a train to Marseilles. Nina, thinking he could not be serious, went home. Brâncuşi and Radiguet headed off and on arrival decided they might as well go to Corsica, where they stayed for two weeks, during which Cocteau remained in a state of dramatic agitation. Regrettably, Radiguet's fling with Beatrice Hastings marks our final glimpse of her. She left Paris for the south of France and lived there and in Switzerland until the early 1930s, when she returned to London, her services as a writer by then long dispensed with by the editor of the *New Age*.

Some might argue (and he himself once pointed out) that surrealism really began when Man Ray arrived in Montparnasse. Riding the Métro one evening, by chance he discovered the district: the cafés were vibrant with people of all nationalities, with many languages being spoken, 'including French as terrible as my own'. Wandering from café to café, he noticed that people of various nationalities had distributed themselves in clusters; one café was patronized mainly by the French, another was more mixed, a third attracted a more boisterous crowd of English and Americans. He preferred the first, where everyone seemed to know one another, changing tables to join other friends as the evening wore

on. Soon afterwards he moved into a small room in the Hôtel des Grandes Écoles in the rue Delambre just around the corner from the Dôme. His visitors included the group, formed around Breton, that Man Ray called the Paris Dadaists, 'overcoming their aversion to what they considered too arty and bohemian a quarter'. (They had begun to wander around Montmartre in search of more ostentatiously working-class places in which to be seen.) When Tzara returned to Paris he took a room in the same hotel and the two of them became friends, ignoring the disagreements and divisions within Breton's group and somehow remaining on good terms with everyone. 'My neutral position,' Man Ray modestly considered, 'was invaluable to all; with my photography and my drawing, I became an official recorder of events and personalities'. Some Thursdays he dined with Satie, the two of them eating lobster in a restaurant in the avenue du Maine.

'Has the so-called modern spirit always existed? . . . is a top hat more or less modern than a locomotive?' On 3 January the arts magazine *Comœdia* announced that the International Congress for the Determination and Defence of *l'esprit nouveau* would take place in late March to debate those two essentially surrealist questions. Also under discussion would be 'artistic groups or schools, such as Impressionism, Symbolism, Unanism, Fauvism, Simultanism, Cubism, Orphism, Futurism, Expressionism, Purism, Dada, etc.', to be explored with a view to helping to 'stem the current confusion' about what actually constituted modern art. The announcement, ostensibly signed by seven members of the organizing committee but in fact only by Breton, was posted by Breton, too; he had come up with the idea and initiated the proceedings; he would also direct the congress. He had an undeclared agenda: to try to consign Dada once and for all to history – and with it the (to him) increasingly irritating Tzara.

In the *Comœdia* of 7 January Breton made a further announcement, warning readers against the activities of 'a publicity-mongering imposter . . . a person known as the promoter of a "movement" that comes from Zurich, whom it is pointless to name more specifically, *and who no longer corresponds to any current reality*'. Tzara, the all too

obvious target, responded in kind; the following day the *Comœdia* printed his response. 'Several days ago I wasn't yet a publicity-mongering imposter, since I was worthy of sitting among this noble conclave . . . I can only remove my top hat and set it on a locomotive . . . an "international" Congress that reprimands someone for being a foreigner has no right to exist.' He had a point. Those who immediately withdrew support for the congress included Satie and Éluard. Others, including Aragon, remained loyal to Breton.

Soupault had decided it was time – for him, at least – to move beyond Dada. *Westwego*, a long poem he began writing in 1917, is a lyrical, dreamlike narrative of a journey which possibly never happened. It takes the poet to London, where in reality he has never been, to 'Whitechapell [*sic*]' and 'Madame Tusseaud [*sic*]', where he sees Nick Carter (a hero in a popular detective fiction series) in his bowler hat. The poet is making a 'strange journey . . . with no luggage' even though he hasn't left Paris. On a carefree perambulation along an avenue, behind every tree a memory reaches out to scratch the surface of his mind. Soupault's poem is wondrous. The mood is ruminative, even joyful: '*le ciel a découvert la terre/et le monde est bleu/parvu qu'il pleuve/et le monde sera content*' ('the sky has discovered the earth/and the world is blue/all the while it rains/and the world will be happy'). The poet walks all night; in the morning, despite not sleeping, his fatigue deserts him. He is the first to bid anyone good morning as he sees mariners coming out to clean the coal, an engineer rolling a cigarette before lighting the steam generator. As readers of *Westwego* we are heading at last not for the Western Front but for an imaginary place in which there is peace, contentment and the poet is at liberty to wander through life in a spirit of dreamy celebration. The endpapers at both front and back are inked with an identical handprint, presumably Soupault's (left) hand. *Westwego* is thus opened and closed by him, bearing his inimitable imprint, since he is alive, happy and free to dream – a felicitous and, in its own way, profoundly provocative alternative to Dada, signalling, in retrospect, the possibility of a definite shift from the anger and indignities of Dada to the exploratory marvels of surrealism.

In March, Éluard and Gala revisited Ernst in Cologne, taking a copy of *Répétitions*, Éluard's newly published book of poems with drawings by Ernst. The opening poem, 'Max Ernst', is tantalizing: *'Dans un coin l'inceste agile/Tourne autour de la virginité d'une petite robe'* ('In a corner nimble incest/Revolves around the virginity of a little dress'). Back in Paris, both Éluards continued to write to Ernst, sending poetry in progress for him to respond and contribute to. That month's issue of *Littérature* appeared with a new format and a bright pink cover featuring a shiny top hat by Man Ray. The title of the magazine had also been revamped. This issue was ambitiously named *'Littérature: New Series'*; the rapid makeover was an attempt to maintain the magazine's credibility as an avant-garde publication. The contents were contrastingly downbeat, including two pieces by Breton, his derogatory interview with novelist André Gide, in which (as Gide muttered to his diary), 'everything that André Breton makes me say . . . is much more like him than me'; and his lamentable, equally grumpy write-up of his visit to Freud. The congress behind him, he set about organizing new sessions of automatic writing, group dream-sharing and a new pastime, Cadavre Exquis, effectively a game of consequences designed to produce a suitably nonsensical narrative in which each person in turn produces a sentence without seeing the preceding sentences.

In his hotel room in the rue Delambre Man Ray was living up to his new, self-appointed role as chronicler of people and events – or, at least, of people. He took portrait photographs of many of the artistic coterie of Montparnasse, including Gertrude Stein, who sat for him in her pavilion at 27, rue de Fleurus, the first of Man Ray's portrait photographs to appear in print. On first meeting her he had mixed feelings. Crossing the courtyard, he rang a bell and was received by 'a small dark woman with long earrings, looking like a gypsy' (his first glimpse of Alice B. Toklas). Gertrude wore a floral blouse and a scarf pinned with a Victorian brooch at the neck; her hair was still, in those days, arranged in a bun at the back of her head. Man Ray wanted a natural look rather than the usual studio finish, an effect he normally achieved both by using coarse-grained

paper and by creating an informal atmosphere, to which end he usually sat about smoking his pipe and playing the session through in his head before appearing behind the camera, a procedure intended to relax the sitter.

In Gertrude Stein's case, something told him a more conventional approach would be required. She arranged herself stiffly and he took the shot, paradoxically managing to record something unusually artful – and subtly revealing – about Gertrude as she sat facing away from the camera with a sceptical frown, her hands formally positioned one over the other. She might almost have been (reluctantly) modelling her blouse. Taking the opportunity to look around the pavilion, Man Ray observed heavy polished Italian and Spanish furniture, porcelain ornaments and, hung between two windows, a black cross. The walls were covered with paintings by Cézanne, Matisse, Braque and Picasso. In another corner hung Picasso's large portrait of Stein – a good likeness, Man Ray thought; it 'looked unfinished but the hands were beautifully painted'. He particularly liked this unfinished quality, which made him want to introduce a more imaginative element into his own portrait photographs, a quality he had so far restricted to 'my freer work which I pursued on the side' and which had attracted attention only from those aware of the latest artistic trends.

Following his own advice, he photographed Picabia in his racy convertible sporting a determined facial expression, one hand gripping the steering wheel, an enormous klaxon looming apparently out of nowhere (but from the unseen dashboard). Then he went up to Montmartre to photograph Braque in his studio. 'Tall, wavy-haired, he moved leisurely, but it was hard to imagine him confined to an easel . . . rather that he had come into his studio for a short while to check the progress of his work . . . developing by itself as a plant grows. Or he might have been a Normandy farmer.' He photographed Braque standing, one hand on his hip, the other holding a cigarette between finger and thumb, in collarless shirt and braces. He stands to one side of a plain, white-painted door; over his right shoulder there is a glimpse of a canvas, possibly a landscape, but the

main focus is Braque and a painted door panel. In his hotel room Man Ray photographed Ezra Pound, who flopped into an armchair, legs outstretched, arms hanging, 'black tie flowing, and his pointed red beard raised aggressively, as if to take possession of the place'. Man Ray knew him by reputation as a kind-hearted and generous man, though arrogant in his literary views; on this occasion he lived up to his reputation by having very little to say and taking no notice at all of Man Ray's work. When Pound returned to view the prints he brought his father, who was travelling around Europe, a remarkably 'pleasant gentleman' who paid particular attention to one of Man Ray's paintings on the wall and said he would like to buy it.

Sylvia Beach (in the process of collecting photographs of writers for the walls of her bookshop, Shakespeare and Company) asked Man Ray if he would photograph James Joyce, since she was about to publish *Ulysses* (1922). Immaculately turned out in dark suit and bow tie, Joyce was between two operations on his eye. He sat patiently until he could no longer bear the glare of the lights, then put his hand over his eyes and turned away, whereupon Man Ray took the shot, which everyone always preferred to the next, more formal one. Joyce took him to a café, where he happily and loudly sang snatches of opera, then on to his favourite Montparnasse restaurant, the expensive Le Petit Trianon, where the wine flowed. While Man Ray talked about photography and painting, Joyce stared blankly through his thick glasses and said very little. Every now and then he'd hum a tune between glasses of wine. Then came Man Ray's first meeting with Cocteau (introduced by Picabia), who said Cocteau was 'someone who knew everybody in Paris, was a social idol, and a poet, although despised by the Dadists'. The session took place at Cocteau's apartment, where Man Ray found him shaved and powdered, in a silk dressing gown. 'He looked quite aristocratic and very engaging. He liked Americans he said, especially their jazz music.' While Man Ray browsed through the apartment looking at all the signed photographs and drawings Cocteau put on a record and wound up his phonograph, filling the air with jazz. When he

saw the photographs he was delighted and sent copies to all his friends. He brought more prospective sitters to meet Man Ray, mostly young musicians – and Raymond Radiguet. As Man Ray said, 'No one paid for the prints but my files became very imposing and my reputation grew.'

Though his exhibition at the Librairie Six had been well attended and reasonably well reviewed, Man Ray had sold nothing. Now that he felt more settled in Paris, he decided to make one more attempt to arouse some interest in his non-photographic work. To the 1921 Salon des Indépendants he submitted two of the pieces he had brought over with him from New York, a painted still life and *Catherine Barometer* (neither had been included in his show the previous December). Visitors found them confusing, critics ignored them and Man Ray decided it was finally time to give up on the idea of being a painter and focus on being a photographer. He told friends he had stopped painting – too messy. Duchamp sent congratulations. Picabia's wife, Gabrielle Buffet, put him in touch with Paul Poiret and Man Ray began on the next phase of his career, which before long would see him take his unprecedented place as surrealist fashion photographer.

When he mounted the marble steps of Poiret's fashion house, Man Ray's idea was to offer to take a portrait photograph of the great couturier. Through the glass doors of the vast vestibule he glimpsed a salon full of mirrors and brocade curtains with beautiful women in exquisite silk and satin gowns watching a model parade in such sumptuous folds of fabric she could barely walk. Saleswomen chatted with clients; the place was buzzing with activity. He followed someone's directions until he found himself in a large salon, similarly richly appointed but empty of people; he noticed contemporary paintings on the wall and, on a pedestal in the centre, Brâncuși's 'magnificent stylized gold bird'. Poiret himself appeared, dapper in cutaway frock coat and striped trousers, and showed Man Ray into an office with bolts of silk and brocade scattered around a desk behind which Poiret seated himself. Hearing that Man Ray had been sent by Mme Picabia, Poiret asked to see

his portfolio, saying he would like some original pictures of models wearing his clothes as if for portraits rather than in the usual fixed poses designed merely to model the garments. This was unprecedented. Poiret was ahead of his time as a couturier; the idea to show models in live situations was both ingenious and a lasting influence on the genre of fashion photography. He mixed socially with the artists whose work he collected and saw himself as an artist. They agreed Man Ray would return in a week. Man Ray said he would need lights.

He arrived laden with his large camera and a dozen glass plates in their holders. Someone went to get the caretaker, who staggered in carrying a seven-foot wrought-iron Venetian stand on top of which was an improvised tin reflector enclosing a large bulb. Placing it in the middle of the room, he left, returning a few minutes later with another. He plugged in a wire, whereupon 'there was a bright little flash for an instant and both lamps were out; the fuse in the house had melted' – a not unusual occurrence. Undeterred, Man Ray decided he would make longer exposures with the limited light of one lamp, introducing one of the wrought-iron stands into the shot as a prop, which would cut off the incongruous reflector at the top; in any case, the wrought iron blended well with the rococo decor. He asked for a blonde model wearing a light-coloured dress, the most feasible combination for a shorter exposure. The fuse was replaced, the lamp was lit, the model posed against the stand, 'very trim and smart, her small blonde head contrasting with the voluminous satin dress built up in complicated folds, one of Poiret's innovations of the period'. Next he asked for a dark-haired model, who appeared in a close-fitting gown of gold-shot brocade gathered in at the ankles in hobble-skirt style. He suggested they adjourn to the salon on the floor above; when she hobbled out with a batch of plate-holders in one hand, holding the folds of the dress in the other, he regretted not having taken the opportunity to photograph her in transit. 'The room upstairs was flooded with sunlight from the windows; I would not need any other light. I had her stand near the Brancusi sculpture, which threw off beams of golden light, blending

with the colours of the dress. This was to be the picture, I decided; I'd combine art and fashion.'

On his way downstairs Man Ray noticed the door to Poiret's office was open, which gave him another idea. What if he posed the model lying down, among the bolts of fabric? This reclining pose was unprecedented in the realms of fashion photography. The office was darker than the upstairs salon, requiring a longer exposure, and lying comfortably among the satins and silks, the model was less likely to move – a plausible argument undermined only when, having taken the photograph, Man Ray accidentally fell on top of the girl. No matter: by that time he had the shot. 'There was colour, line, texture, and above all, sex appeal, which I instinctively felt was what Poiret wanted.' He asked the model to change into a different outfit and she reappeared in a tailored suit and small hat, which had the effect of changing her personality completely. When the session was over he wrapped up his materials and made his way via the tradesmen's exit to the bus stop. Outside, he noticed a young man, smartly dressed in a brown suit, smoking a cigarette. While Man Ray waited for his bus the young man was joined by the model, still in her tailored suit; he kissed her on the cheek. As they left, the model turned, noticed Man Ray, and with a nod of her head the couple were off – cinema in the making, all observed by the path-breaking photographer from New York, who at that moment 'felt like a delivery boy'.

Back in his hotel room that evening he developed the plates and set to work making contact prints in the tiny en suite washroom that served him as a darkroom, his equipment consisting only of his trays, bottles of chemical solution, a graduated glass filter and thermometer and a box of photographic paper. He would lay a glass negative on a sheet of light-sensitive paper, and repeat this to make several exposures, and the prints would be developed by the light of the little red lantern and the bulb that hung from the ceiling. On this occasion an unexposed sheet of photographic paper somehow got into the developing tray along with those already exposed. As he waited for the image to appear he placed a small glass funnel and

thermometer in the tray on the wetted paper. When he turned on the light, 'before my eyes an image began to form, not quite a simple silhouette of the objects as in a straight photograph, but distorted and refracted by the glass more or less in contact with the paper and standing out against a black background, the part directly exposed to the light'. It reminded him of being a small boy, when he had put ferns in a printing frame with proof paper and exposed them to sunlight, obtaining a white negative of the leaves; it was the same principle, this time with a three-dimensional quality and new gradations of tone. He tried the experiment again, with whatever objects he had to hand – his room key, a handkerchief, pencils, a brush, a candle, a piece of twine – and realized he did not even need to put the object in the liquid, just straight on to dry paper, and expose it to the light for a few seconds. In the morning he surveyed his startling and mysterious innovations. He already had a name for them – he had invented the first rayographs.

This was not the first time prints had been made without using a camera but simply by exposing objects to light. Man Ray knew about the work of Christian Schad, who as early as 1918 had made contact prints by laying flat objects directly on to photosensitive paper, creating images he called Schadographs. However, whereas Schad's images were static, Man Ray could make his images (appear to) move by varying the light source and shining it at angles through objects which he moved around above the paper, adding dynamic depth and creating a variety of grey tones. As a result, his rayographed objects looked as if they were moving in fluid and had been captured by the photographer in the process of mutating. At midday Tzara dropped by, immediately spotting the first rayographs Man Ray had pinned to the wall. He was full of enthusiasm – they were 'pure Dada creations', he said, better than Schad's; Schad had himself, according to Tzara, been an early Dadaist. Together they made some more. Tzara dropped matches on to the paper, then bits of broken matchbox, and burned holes in a piece of paper with a cigarette, while Man Ray produced extraordinary results using cones, triangles and wire spirals. Tzara wanted to keep going, trying out

other materials, but Man Ray decided to call a halt. It was his discovery and he was beginning to feel proprietorial; also, he did not want to be influenced by Tzara's ideas.

Shortly afterwards Man Ray returned to Poiret with the fashion prints, slipping one or two rayographs into the portfolio. Poiret thought the plates of the blonde model in the pale dress showed Man Ray 'might have the makings of a fine fashion photographer'. When he got to the rayographs he paused and asked Man Ray what they were; Man Ray described the process of producing them in his darkroom, explaining that he had been trying to work like a painter with pigment, only using light and chemicals. Looking as if he didn't quite get it, Poiret nodded, said it was very interesting and handed back the folder. When Man Ray asked whether it would be possible to advance him some funds to buy materials Poiret said the prints were for fashion magazines: he himself never paid for photographs; photographers considered it a privilege to work for his fashion house. Perhaps Man Ray should take his photographs directly to the magazines. When he said he had no idea how to go about it, Poiret pulled out the two rayographs. He said he 'liked new experiments' and would pay Man Ray for those. He pulled some hundred-franc notes from his pocket and Man Ray gave him all the contact prints.

Tzara was already spreading the word. The editor of an arts magazine turned up at Man Ray's hotel and left with some rayographs for publication. Painters, musicians and writers began arriving, all keen to see others. Cocteau got in touch to ask Man Ray to provide a frontispiece for a deluxe edition of poems he was planning to bring out; 'it had to be a rayograph'. In the April edition of *Feuilles libres* Cocteau published an open letter to Man Ray in which he acknowledged the photographer's importance as an experimental artist; indeed he rated it over and above Ernst's (whose collages he had seen at the exhibition of Ernst's work). He found Ernst's collages enchanting, he wrote, but was Ernst actually doing much more than cutting and pasting? Man Ray, on the other hand, clearly belonged in the illustrious line of photographers of

the past like Daguerre, then Nadar, who had taught painters how to look differently at the human face; like them, Man Ray would also surely influence the painters who were his contemporaries, with the exception perhaps, Cocteau cautiously added, of Picasso and Braque, in his opinion the only two contemporary painters in Raphael's league.

One day, Man Ray answered the door of his hotel room to an imposing woman, her enormous eyes made up in black, so tall in her towering black lace headdress (almost six foot even without), she was forced to stoop as she entered. Introducing herself as the Marchesa Casati (she who had awed Picasso in Rome – had Picasso sent her?), she announced that she wished to be photographed, but in her own habitat. Man Ray asked around and discovered that in the gardens of her Italian villa, where the trees were painted gold, she greeted guests at her elaborate parties dressed in shimmering gowns designed by Ballets Russes scene painter Léon Bakst, some-times with a twelve-feet-long live python as a necklace, and accompanied by a black servant in charge of an exotic animal on a lead. In Paris she lived in a suite of hotel rooms in the place Vendôme; here she received Man Ray in a red silk dressing gown. He noted her startlingly dyed hair, her huge, carefully made up eyes, as she led him through rooms littered with ornaments. Then she posed for him on a table with a large bouquet of artificial flowers made of jade and other precious stones. The usual hitch: he turned on his lights, there was a flash and everything went dark. The por-ter adjusted the burnt-out fuses but Man Ray was reluctant to risk his own lights again. He told the marchesa he would use ordinary lighting but that she would have to keep still and hold the poses as long as she could. 'It was trying work – the lady acted as if I were doing a movie of her.'

When he developed the negatives, they were all blurred. He tele phoned her to explain but she insisted on seeing them. He printed up one or two in which it was just possible to make out a face – one with three pairs of eyes. 'It might have passed for a Surrealist version of the Medusa – she was enchanted . . . said I had portrayed her soul, and

ordered dozens of prints.' Soon the portrait of the marchesa with three sets of staring eyes was being seen all over Paris; and people began arriving at Man Ray's hotel from far and wide, all expecting him to perform similar miracles. He had so much work, he would need to move to a proper studio. All his prospective sitters seemed to arrive with ideas of their own. One of Poiret's major clients, the Comtesse Greffuhle, announced she wished Man Ray to make a spiritualist film based on a scenario by H. G. Wells and starring herself. Étienne de Beaumont came to be photographed, full of startling ideas. Advertisers, fashion editors, interior decorators – all assumed they could put Man Ray into service as a cameraman, which irritated him. In his opinion, his more creative productions should be treated with the same deference as a painting or a drawing.

That summer he moved out of the hotel in the rue Delambre and took a spacious studio at 31 bis, rue Campagne-Première, a large building with decorative exterior stonework, massive rooms and plenty of natural light on the lane running off the boulevard du Montparnasse (opposite Picasso's former apartment building), which housed a number of such studios. His had a mezzanine, on which there was a bedroom and a bathroom, which he converted into a darkroom; he now had space to hire an assistant to make prints while he took photographs. He hung some of his paintings alongside his photographs, 'so that the place would not have a too commercial atmosphere' and began receiving visitors and potential clients. One evening he was sitting in a café near the Gare Montparnasse with Marie Vassilieff. Seated at a nearby table were two girls who caught his eye, both heavily made up and sporting the new short, sleek hairstyle. The darker, prettier of the two waved across to Marie. Suddenly there was a rumpus. The waiter had noticed them and asked them to leave; no Frenchwoman was admitted without a hat. He made an exception for American women, but for Frenchwomen the rule applied – clients (even in 1921) might get the wrong idea.

The pretty girl leapt to her feet, scaled a few tables and gracefully jumped down again. She would never set foot in the place again,

she yelled, she would get everyone she knew to boycott it, and she knew everyone around Montparnasse. Marie invited the young women to join her and Man Ray, who called the waiter back over and ordered more drinks. The indignant girl was Kiki de Montparnasse (presumably allowed to stay now that she was obviously about to calm down). She told Man Ray she was an artist's model; she had worked for artists including Maurice Utrillo and Chaim Soutine. Man Ray took all three women to the Rotonde, where he stood them dinner and large amounts of wine. Then he took Kiki to the cinema. On the way she linked arms with him and asked him to take her to America. He told her he, too, was a painter, but he would surely find her impossible as a model; she would be too distracting. Perhaps he could photograph her first. Back in his studio he took a few shots before giving up. The next morning, he looked at the prints. He was pleased to see they looked like studies for paintings – even like reproductions of academic paintings, which amused him, since before he took up photography he had produced a series of airbrush paintings that had been mistaken for clever photographs. 'In the true Dada spirit I had completed the cycle of confusion. I know this phrase will make scientists smile, thinking I mean the circle of confusion.'

'We hang out with a crowd called Dadaists and some called Surrealists,' Kiki was soon telling her friends, though, 'I don't see much difference between them! There is Tristan Tzara, Breton, Philippe Soupault, Aragon . . . Paul Éluard . . .' – and Man Ray, an American who took great photographs, had an attractive accent and 'a kind of mysterious way with him'. She found a small apartment in a courtyard behind the cafés where some painters she knew worked and lived with their women, which Man Ray found reassuring. In the evenings Kiki lay happily stretched out on the bed while he worked in the dark. Before they went out he did her make-up, painting her eyelids in heavy copper, blue, silver or jade, sometimes adding a veil, or a rose . . . She posed endlessly for him, becoming his most enduring model and muse, as well as a discerning admirer of his work. The photograph she liked best was one of the blurred prints

of Marchesa Casati, taken through a glass bowl filled with water and leaves. She understood that Man Ray still approached his work as a painter as well as a photographer, and was one of the few who considered his paintings as significant as his photographs. She was there when Cocteau came for another portrait photograph, this time wearing black, red and white woollen gloves. Kiki liked him; she found him straightforward and charming and was struck by his 'restless but pleasant' eyes, 'like a pair of diamonds'.

That summer Éluard and Gala left Paris for the Tyrol to take a second holiday with Ernst and his wife, Lou. The Ernsts rented an apartment, while the Éluards took a small house at the side of the lake. Tarrenz-bei-Imst that season was full of visitors, including Tzara, who was staying at the nearby hotel. A few days after their arrival Ernst left his apartment and moved in with the Éluards; it was soon evident to everyone at the hotel that he and Gala had embarked on an affair. Éluard did nothing to stop the liaison. When asked about it he just said, 'I love Max Ernst much more than I love Gala.' This was a complicated *ménage à trois*, with Ernst in love with Gala, Éluard in love with Ernst, and Gala a willing but agitated participant. Was she (as has been suggested) becoming a kind of love token, passed between the two men, the most precious possession of both, in an exchange that was really about the relationship between Éluard and Ernst? Lou (who thought Gala a slithering, snaky, evil creature) and others looked helplessly on. Tzara noted that Gala was becoming increasingly nervous, feverish and irritable as the drama played itself out, like, he said, the scenes of a novel by Dostoevsky. On 30 August the group dispersed. The Ernsts returned to Cologne, the Éluards to Paris, where Ernst had already decided to join them as soon as he could.

On 2 September, travelling under the name Paul Éluard, Max Ernst, having no papers, illegally crossed the border into France. He made for the suburb of Saint-Brice-sous-Forêt, where he joined the Éluards in their rural village eighteen kilometres north of Paris, where Paul's father, Clément Grindel, had settled his son and daughter-in-law in a pavilion set in a small garden. Since both

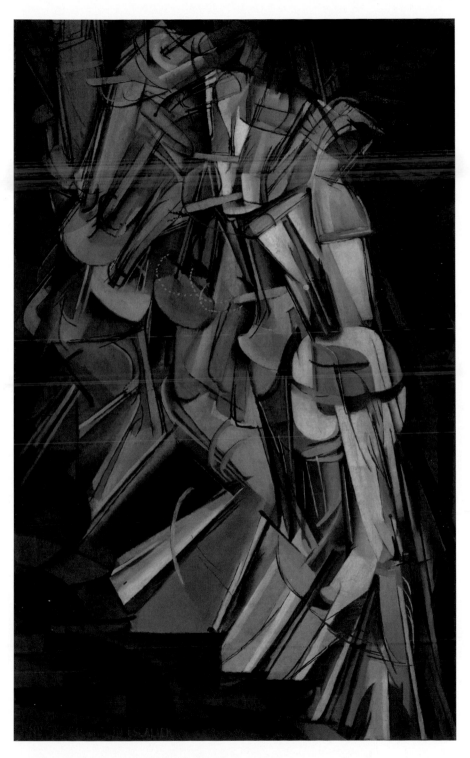

1. Marcel Duchamp: *Nude Descending a Staircase, No. 2*, 1912.

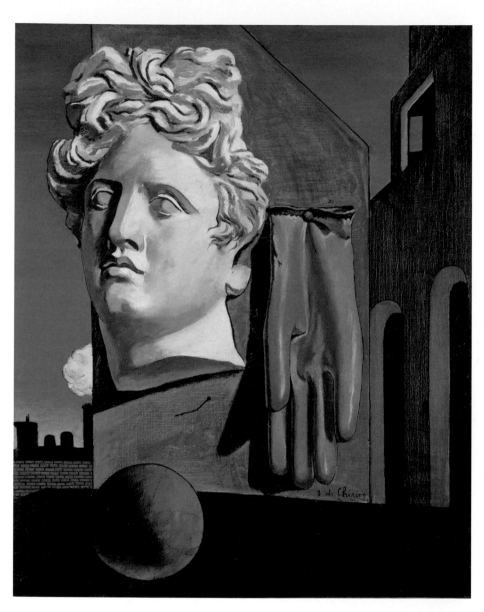

2. Giorgio de Chirico: *The Song of Love*, 1914.

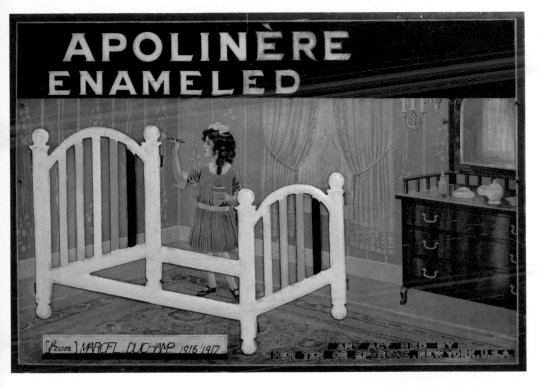

3. Marcel Duchamp: *Apolinère Enameled, c.* 1916–17.

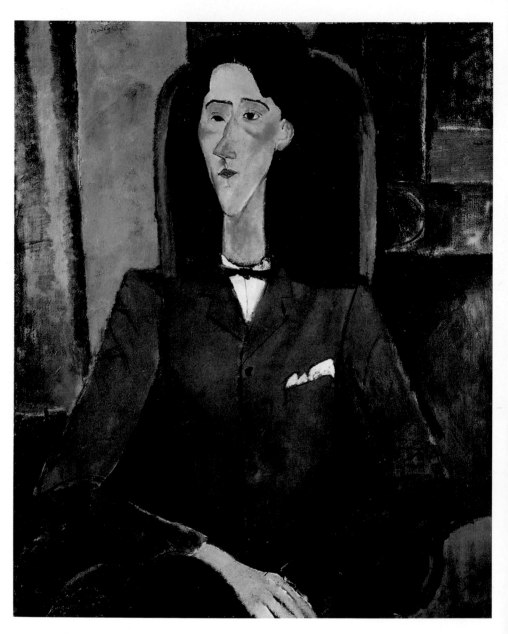

4. Amedeo Modigliani: *Jean Cocteau*, 1917.

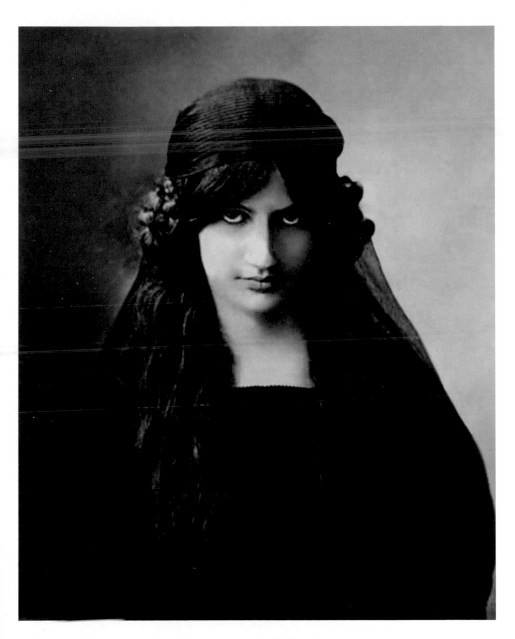

5. *Jeanne Hébuterne*, wife of Amedeo Modigliani, *c.* 1916.

6. Marcel Duchamp: *Belle Haleine – Eau de Voilette* (perfume bottle and box), *c.* 1921.

7. Title page of *Parade,* ballet by Erik Satie, 1917.

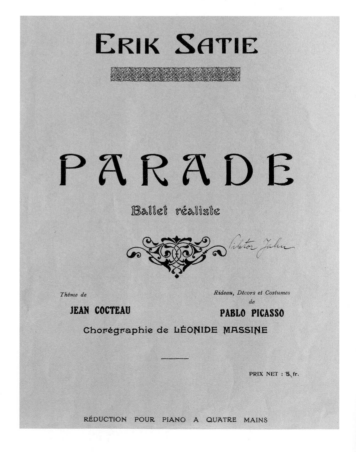

RROSE SÉLAVY

★

Rrose Sélavy trouve qu'un incesticide doit coucher avec sa mère avant de la tuer; les punaises sont de rigueur.

★

Rrose Sélavy et moi esquivons les ecchymoses des Esquimaux aux mots exquis.

★

Question d'hygiène intime :
Faut-il mettre la moelle de l'épée dans le poil de l'aimée ?

8. Aphorisms and puns from 'Rrose Sélavy', published 1939.

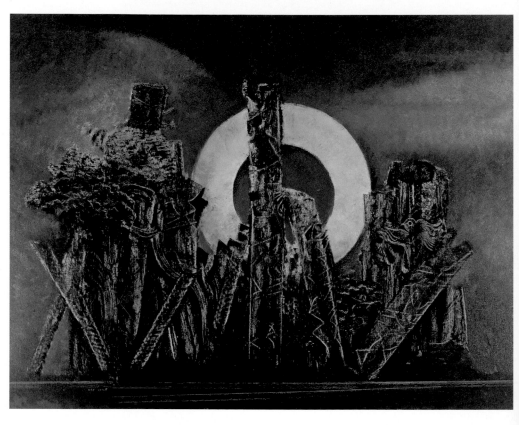

9. Max Ernst: *The Great Forest*, 1927.

suffered from tubercular lungs, the idea had been to house them outside the city; Gala would amuse herself reading and trailing around the salon. For several weeks Ernst remained cloistered in the Grindel household with Gala until a friend (Jean Paulhan, recipient of the chameleon) somehow got him a passport in the name of Jean Paris. With that, Ernst could find employment in Paris. He found a job in a factory in the rue de Bretagne, near the place de la République, and made sure he spoke as little as possible – his fellow workers called him *Le Taciturne*. One day in the boulevard de Strasbourg he came across a group making a film (either *Les Trois Mousquetaires* (*The Three Musketeers*) or a sequel, *Vingt ans après* (*Twenty Years Later*) – afterwards he could not remember which (it must have been the latter since it came out in 1922, *Les Trois Mousquetaires* in 1913)) and briefly became an extra, until he absently removed his wig while still in shot, thus bringing to an abrupt end his brief career in the movies. At the Éluards' home in Saint-Brice he was working on a new painting. Now he had papers he could also risk going out in the evenings, so he went with Éluard to Café Certa or Le Petit Grillon, where they met Breton and friends. Gala was not usually included. Breton tacitly disapproved of the *ménage à trois*; Soupault disliked Gala, thinking she was doing her best to drive Éluard to distraction. Breton and Aragon were keen to help Ernst. They mentioned him to Doucet, who was now being advised on his collection of literary manuscripts by Aragon as well as Breton. Aragon showed him some works by Ernst, including a still life of five vases; Doucet conceded that Ernst probably had a future as an artist. Aragon suggested five hundred francs for the picture of five vases. Doucet said he would give him three hundred if he painted out two of them.

By now, of the three lovers, only Ernst seemed to retain his apparently unshakeable sangfroid. Éluard, helplessly in love with both Gala (still) and Ernst, was finding it increasingly difficult to live with himself. The poetry of *Mourir de ne pas mourir*, particularly, reflected his angst. In '*L'Amoureuse*' ('The Lover'), '*Elle est debout sur mes paupières/Et ses cheveux sont dans les miens,/Elle a la forme de mes*

mains,/Elle a la couleur de mes yeux,/Elle s'engloutit dans mon ombre' ('She stands on my eyelids/And her hair is in mine,/She has the form of my hands,/She has the colour of my eyes/She is drowning in my shadow'). In *'Mascha riait aux anges'* ('Mascha Laughed at the Angels'), *'Un bel oiseau léger plus vif qu'une poussière/Traine sur un miroir un cadavre sans tête'* ('A beautiful, lightweight bird, livelier than dust/Drags a headless corpse across a mirror'). Rather than go home in the evenings, he began to stay out late with Breton and other friends. Aragon took him to champagne bars, trawling for pretty women. In the cafés, spiritualism was enjoying yet another vogue; it interested Breton (whose surrealist agenda would soon encompass the occult, with some startling results), his curiosity not so much about raising the dead as about the language of the unconscious per se. His new recruits to the ever-increasing group included a young poet, Robert Desnos, who was a natural for Breton's *séances sommeils*, displaying a rare talent for falling asleep, heaving hoarse sighs then making startlingly dramatic announcements. From the beyond, Desnos passed on the message that Ernst would live to be fifty-one. (He was out by thirty-four years.) When asked if Ernst was happy among these madmen, the spirits replied, 'Ask the lady in blue' – Gala. Whenever Gala did put in an appearance she exerted an unsettling influence, apparently the cause of continual rifts and ruptures. First Éluard fell out with Tzara, then Breton with Éluard. Ernst remained in the villa Grindel. He had begun the process of scaling up his work, enlarging his collages, transposing small, tinted reproductions into fully modelled large oil paintings and increasingly taking up more of the house.

In the fifth issue of *Littérature: New Series* Breton (by now sole editor of his magazine) published an essay on Duchamp, who was still in New York but in regular correspondence with Man Ray. Duchamp spent most of his time playing chess but he had also bought a dye shop, going into business with a friend – 'he dyes and I keep books – If we are successful, we don't know what we will do.' He need not have worried; they weren't. Before moving to New York the friend had made a living in Paris dyeing rare feathers for

milliners and couturiers but he was no businessman and Duchamp was no book-keeper. After six months the business crashed (taking three thousand francs borrowed from Duchamp's father with it), by which time Duchamp had already begun to consider returning to Paris. Breton may have been aware of that; in his essay he declared that Duchamp was the only living artist truly in touch with intellectual and spiritual forces capable of changing not only art but life itself. When he met Duchamp on his last visit to Paris, he wrote, Breton had been expecting a 'wondrous' intelligence, and he had not been disappointed. Duchamp had presented 'a polished surface that conceals everything going on behind it, and yet a merry eye . . . elegance in its most fatal form'. Breton had seen him toss a coin and say, 'Heads, I leave for America; tails, I stay in Paris.' But his nonchalance was surely deceptive. As evidence of his genius, Breton provided a list of 'strange puns' which Desnos claimed to have received during his séances from none other than Rrose Sélavy, with whom Desnos claimed he was in regular telepathic communication. Duchamp was, in fact, fond of puns, which he produced from time to time; he eventually published a booklet of puns and aphorisms 'by Rrose Sélavy'. When Breton published the ones Desnos had 'received' someone alerted Duchamp, who contacted Breton. 'Got a note from [a friend] this morning, accompanied by 50 of Desnos's rantings. What a telepath!/or rather "psychic" – Why doesn't he ask for Rrose's hand? She'd be thrilled –'

With Man Ray, Breton had clearly managed to be more persuasive. Man Ray's work dominated not only the cover (a pair of disembodied hands in stylized black gloves) but also the contents of the following issue of *Littérature* (no. 6, published on 1 November). The photographer was suffering a serious bout of depression and being looked after by Kiki. On 18 November he managed to rally sufficiently to photograph Marcel Proust on his deathbed, after which he returned to the rue Campagne-Première and retired to bed himself. He recovered, but Kiki was one of his problems. She was beginning to distract him from his work; he was already insisting she stay away from the studio in the afternoons. While he

pretended to be cynical about love and romance, he was troubled by other men's interest in her; as for Kiki, she was perplexed by his friends and their perturbing interest in the irrational. She selected Tzara as her confidant, sending him long confessional letters which he used as material for the novel he was writing, *Faites vos jeux* (*Place Your Bets*).

Somehow, despite all the strains on it, Breton's group maintained its collective identity and the loyalty of its members. Ernst painted a group portrait, *Rendez-vous aux amis* (*All Friends Together*), a strange, somewhat eerie depiction, figures set against a backdrop of mountains but with no apparent natural light, everyone dressed smartly, but somehow incongruously, in suits and ties. The pianist (another of Breton's new recruits) turns his back on the group to play an invisible piano. Éluard and Gala stand separately, one at each side of the group. Breton, the dominant figure, is shown 'running in from stage right, cape over his shoulder, arm raised like a Renaissance Christ figure'. The group includes – most bizarrely – Dostoevsky, Ernst seated on his lap, pulling his beard (a reference to the Dostoevskian scenes in the Tyrol? Or to the dilemma of Dostoevsky's hero in *The Double*?). Art historian John Russell has situated the painting 'midway between visionary landscape and fairground cut-out photograph', calling it a 'marvellous document of its day – proof, also, that for all his experiments with new techniques and new combinations of material, Max Ernst remained in excellent trim as an exponent of "normality" and naturalism in oil painting'. It has also been remarked that the figures in the portrait were all 'more lifelike than they are in reality', which – variously put – would soon became one of the working definitions of surrealism.

On 20 December Cocteau opened his latest show, a revamped production of *Antigone*, in the Théâtre de l'Atelier, up on the hillside of Montmartre, with a score by Arthur Honegger (another of Les Six) and sets by Picasso. Picasso had decided he was no longer interested in working in the theatre but Cocteau had succeeded in changing his mind, perhaps because the manager of the theatre, Charles Dullin, went back to the early days in Montmartre, when Picasso

lived in the Bateau-Lavoir and Dullin had stood at street corners, coins in a hat at his feet, reciting poetry. Cocteau's *Antigone*, written after Sophocles, was a bird's-eye view of the play. His idea had been to view the classic work from a totally new angle, creating a set made of blocks, shadows, angles, unexpected reliefs and generally bringing Sophocles' ancient masterpiece back to life. Even so, said Cocteau, his play was really no more than a modest sketch, a 'pen and ink drawing after a painting by an old master'. At rehearsals he had been fascinated to watch Picasso painting his sets. The back-cloth, 'a sort of laundress blue', had openings at left and right and a hole in the middle so that the voice of the chorus (Cocteau) could be projected through a megaphone (Cocteau positioned on a chair behind the curtain, the megaphone on his lap). Around the hole Cocteau had placed masks of women, boys and old men which he had made himself from Picasso's maquettes. Beneath the masks there was a white panel, left blank for Picasso to paint his interpret-ation of the setting. Picasso arrived and began to pace up and down. He rubbed some red chalk over the panel, creating the illusion of marble. Then with ink from a bottle he made some 'majestic-looking lines'. When he rapidly blackened a few hollow spots, three columns appeared so suddenly, as if magically, that everyone applauded. As they left the theatre, Cocteau asked him if he had planned the appearance of the columns. Picasso said the artist is always unconsciously calculating and he had just sensed it, prob-ably in exactly the same way as had the Greeks.

After much eventful preparation the ballet finally opened. The dancers somehow managed to dance in rough-looking tunics made of heavy Scotch wool designed by Chanel (whose biographer notes that the show achieved more for Chanel than for anyone else, estab-lishing her albeit occasional presence among the artists of the avant-garde). The character of Antigone duly enunciated Cocteau's pseudo-ancient Greek lines through her plaster mask in the manner of the ancient Greeks. On the third night, Cocteau was declaiming the lines of 'the chorus' through the megaphone. 'Creon', went the line, 'attaches the greatest importance to execution of his orders . . .'

Oh no, he doesn't! came a voice from the balcony – Breton, accompanied by friends. Through the megaphone, the chorus called that the performance would not proceed until the hecklers had been removed; they were duly escorted out of the theatre. *Antigone*, despite the undignified interruption, was a huge success, drew enthusiastic audiences and ran for a hundred performances.

At the Éluards' home in Saint-Brice, Ernst was making a small installation set in a black painted frame, *Danseur sous le ciel, or Le Noctambule* (*Dancer beneath the Sky, or Night Bird* (or Sleepwalker)); it has been compared to a puppet theatre. A white figure – a dancer or a sleepwalker – is set against a background that resembles both the folds of a curtain and the trunks of trees in a forest, daubed with constellations of white paint. The figure dances onstage as if about to take a fall, as if the invisible strings of the puppet have suddenly been slackened. Despite the ongoing development of the passionate *ménage à trois*, something had begun to shift. For Éluard and Ernst, further evidence of the uncanny meeting of artistic sensibilities came in the form of the book of poetic prose they wrote together that year, *Les Malheurs des immortels* (*The Misfortunes of the Immortals*), the tone of which was decidedly equivocal, and not without a sense of doom – and nastiness. The opening piece, 'Les Ciseaux de leur père' ('Their Father's Shears') begins, '*Le petit est malade, le petit va mourir*' ('The child is ill, the child is going to die'), and continues: '*Il tient maintenant le monde par un bout et l'oiseau par les plumes que la nuit lui rapporte*' ('A bird is about to fly away and the child hangs on by clinging to its feathers'); '*On lui mettra une grande robe, . . . sur moyen panier, fond d'or . . . Il était bon. Il était doux. Il n'a jamais foutté le vent, ni écrasé la boue sans nécessité. Il ne s'est jamais enfermé dans une inondation. Il va mourir. Ce n'est donc rien du tout d'être petit?*' ('The child has been dressed in a robe and put in an outwardly indifferent casket, lined with gold. He has been good, he has never caused any disturbance. But still he is about to die. So it doesn't mean anything, to be a child?') Another piece, '*Rencontre de deux sourires*' ('Meeting of Two Smiles'), describes the happy realm of hairdressers, where people are fortunate enough to waste no

time getting married, and where (in the prose-poem) in the neck of a violin may be found a phial intended for use in suicide. It is impossible to read these pieces as automatic writing in the style of Breton and Soupault's *The Magnetic Fields*; by contrast with that work, the book Éluard and Ernst wrote in 1922 is indisputably (ingeniously) bitter. Again, 'Rencontre de deux sourires': '*Regardez ces petits serpents canonisés qui, à la veille de leur premier bal, lancent du sperme avec leurs seins . . . Écoutez les soupirs de ces femmes coiffées en papillon*' ('Look at these little canonized serpents who, on the eve of their first ball, spurt semen with their breasts . . . Listen to the sighs of these women, their hair arranged like wings'). That December they contributed two pages of text and illustrations to *Littérature*, the first issue to include Ernst's work since his arrival in Paris and thus a strong announcement of his presence on the Parisian art scene.

The contribution, *En Suivant Votre Cas* ('Following Up Your Case'), consisted of diagrammatic drawings of a nude woman and a clothed man, with the accompanying text (also by Éluard and Ernst) providing precise instructions for the manoeuvre of the woman into different positions: '*Placer la femme à une dizaine de mètres d'un siège sur lequel on vient s'asseoir. Appeler la femme et lui recommander de venir en courant. Elle place, sans s'arrêter, les mains suffisamment en avant sur vos cuisses et saute à califourchon aussi loin que possible . . .*' ('Place the woman about a dozen metres from the chair you have just sat in. Call the woman and command that she comes running. Without stopping, she now puts her hands as far forward as possible on your thighs and jumps astride . . .'). Further instructions commanded that an object should be held above her head, lowered and moved from left to right, always kept just out of reach; she should eventually be given it only as a reward for her effort. The underlying message is as bizarre – and as sinister – as the accompanying drawings. What was this? Ernst's and Éluard's surreal pastiche of a sex manual? Was it overtly misogynist or, by some inverse logic, obliquely feminist in its exposure of male cruelty and female humiliation? What did the title signify, and whose 'case' was being followed up? Or, in keeping with the principles of Dadaism, was the

whole exercise purely, intentionally nonsensical? We might consider surrealism's tendency towards misogyny as beginning here – one (unintended?) consequence of the attempt to depict without censorship chaotic, hitherto unrevealed erotic drives. Whatever *En Suivant Votre Cas* signified, it was clear by now that the collaboration of Ernst and Éluard was intensifying in emotional pitch. In fact, the strain on Éluard was about to become intolerable. Meanwhile, Gala continued her lonely perambulations, prowling the streets, scouring the shops for bric-a-brac and dresses, strung out between the two men like a female Dostoevskian double.

9.

The Female Anatomy Explored

The Ernst/Éluard/Gala love triangle becomes increasingly problematic. In New York, Duchamp brings a piece he has been working on for years (*The Large Glass*) to 'a state of incompletion' before returning to Paris for good. Man Ray creates 'automatic cinema'. Cocteau joins the Ballets Russes in Monte Carlo. Ongoing construction works on the Métro line from Montmartre to Montparnasse offer surreal glimpses of everyday life, as the old arcades are stripped away.

Undisturbed in the Éluards' villa, Ernst continued to produce vast quantities of new work. Gala posed nude by the side of a lake for a piece he called *La Belle Jardinière* (*The Beautiful Gardener*; also the name of a popular Parisian department store), a figure of a graceful woman, the interior of her abdomen entirely exposed (a particularly popular surrealist device in later years). Ernst's painting has since been lost, though two drawings survive. He was working with no constraints, exploring what was then a completely new terrain in painting: experimenting with mixed forms and mixed media, painting the female figure in a variety of poses, postures and guises, opening her up for examination. In some works – such as *Sainte Cécile (Le piano invisible)* (*Saint Cecilia (Invisible Piano)*) and *La Femme équivoque* (*The Equivocal Woman*) or *La Femme qui dort* (*The Teetering Woman*) – the female figure is imprisoned within a construction of metal bands formed like a corset or a piece of machinery. The woman balances, arms outstretched, hair sucked upwards as if by an invisible vacuum, against a contraption made of cylinders and ironwork which may be a device for spreading oil on

water, though two of the cylinders take the form of a man's legs and feet, dressed in trousers and shoes. To her left and in the background are two white cylindrical columns. In the foreground the floor looks like that of an interior, with a skirting board, and on it is a lump of broken concrete (or bread?). The woman, slammed against her contraption, seems to have been pushed up as if through a trapdoor. Behind her is a small expanse of grey sea. Her mouth is open (in shock?) and a piece of curling pipework covers both eyes and appears to have melded with one eye socket. She wears a short, simple skirt like that of an acrobat, perhaps, in rehearsal, and a moulded, plain brown chemise that from her shoulders down might be part of her body, though the armholes and neckline are clearly defined. Is this an act of gymnastic performance, with the contraption as a prop, or has she been tortured by the contraption into motionless submission? She looks asleep – perhaps the whole scene is a dream. Ernst's experiments were not only pictorial; he was also beginning to explore ways of plumbing the depths of the unconscious on canvas.

Ernst continued to use the techniques of collage to juxtapose figures and objects in paint. For his first collages he had used medical illustrations, and he remained interested in the link between medicine and torture, much discussed at the time (possibly another, particularly sinister way of interpreting *En Suivant Votre Cas*). In his paintings he depicted the human form *in extremis*, at the same time continuing to test the boundaries of the medium. His landscapes of 1923 onwards are reminiscent of de Chirico's, some of whose works Éluard already owned. Later that year he and Gala visited the 1923 Rome Biennale, where de Chirico was showing three walls of work. They met him there and purchased various new paintings, including one described by de Chirico as 'a large self-portrait with a background of laurel bushes', establishing the surrealist bias of Éluard's pictorial vision from the outset. In two other major paintings of that year, Ernst made strong, iconoclastic statements. *Of This Men Shall Know Nothing* (now in London's Tate Modern) depicts two cloaked, inhuman figures – or cylindrical pyramids, or unticking metronomes. From the

floor of brown earth protrudes part of a gun, or a musical instrument. A disembodied hand is positioned across the front of the metronome, or heart, of one figure, above which is suspended what appears at first glance to be a nude woman bent double; on closer inspection she has two sets of legs rather than legs and arms. Some think the work may have been inspired by Freud's study of the delusions of a paranoiac (Daniel Paul Schreber) who believed he was a woman, the two pairs of legs inspired by the patient's hermaphrodite desires. Others have offered different interpretations. That same year Freud published the article in which he put forward his theory of the separation of the ego and the id – perhaps Ernst had read it and was attempting to depict that separation in paint. No one knows exactly what his intentions were for this work.

Ernst's figure hangs by her four feet from a yellow crescent moon above which is an orange-brown disc, a sun or just a circle, spliced with blue. Attached to it is a taut, symmetrical network of threads (and a whistle), which seem to culminate somewhere out of sight behind the cloaked, metronomic figures. The woman's (or herm-aphrodite's) hair is visible, her expression hidden. There is, perhaps, nothing new under the sun (or moon); the juxtapositions of figure, natural elements and objects all hung in space against a night sky, brighter towards the base of the painting, are wildly, openly suggestive; irreducible to analysis. Is the figure trapped or liberated? Rising up or parachuting down? In Ernst's work (as in all the surrealists') nothing, any longer, is simply one thing. To the back of the picture Ernst pasted a poem, dedicated to Breton. Roughly paraphrased, he wrote that the moon, like a parachute, prevents the 'little whistle' from falling. Because someone is paying attention to it, it thinks it is rising to the sun. The model is stretched out in a pleasing, dreamlike pose. The hand shields the Earth, which assumes the significance of a sexual organ. The moon quickly passes through its phases. The picture is 'odd in its symmetry', balancing the two sexes. Elucidation, or intentional obfuscation?

The painting includes circles, a crescent moon, a woman with no torso. Something is being reiterated, something to do with the

fact that her legs are spread, but the 'little whistle' is useless and the hand is preventing entry. Men expect women to fly them to the moon, but there are all kinds of obstacles – circles and cycles (of menstruation?), the insertion of foreign bodies (contraceptives?). Woman is strung like a puppet (Ernst often employed strings in his later work) to her own unrelenting cycles, a complex experiential process of which men (at least, in 1923) were expected to know nothing. In the vicinity of the little whistle is a shape that vaguely resembles an egg being propelled in a useless circle like a pinball. The figure is strung up, the whistle (at least for now) futile beneath her, the sun a hot rim above, and she is practically folded in half by such complex mysteries. The surrealist artists, beginning with Ernst, identified in their work the extent of women's captive silence.

Ernst's other obviously provocative painting of that year, *Pietà ou la Révolution la nuit* (*Pietà or Revolution by Night*; also in the Tate Modern) is equally cryptic. Reversing the traditional image of the Virgin cradling the dead body of Christ, Ernst's painting shows a kneeling man dressed in brown, in his arms a motionless, expressionless man dressed in a white smock, red trousers and white (hospital?) boots. Christ as a red-trousered soldier, in a world of men from which no woman, surely, can save him, bringing the wounded, weary or defeated to safety. Ernst was also producing ever larger works – huge canvases such as *Femme, vieillard et fleur* (*Woman, Old Man and Flower*; today at the Museum of Modern Art, New York), in which the female head rests on a metal torso, a landscape visible through her lungs and through the limbs of the principal, wolf-like subject, who holds in his hands a doll-sized woman. With his fearless explorations into the mysteries of the human psyche Ernst was at the same time effecting metamorphoses within the medium of paint itself, testing the relationships between space and form, antiquity and the present, the real and the imaginary, producing collages of paint but never sacrificing his accomplished draughtsmanship; the works are all resonant, beautiful and polished, irrespective of the disruption and distortions that constitute his new subjects.

While Ernst worked on, home alone with Gala, and Éluard paced the streets with Aragon, the rest of Breton's group continued their increasingly fanatical evening trances, sitting for hours in the dark, waiting for signs. They continued despite Breton's growing ambivalence after Robert Desnos somehow managed (in a trance) to lock the others in a room for several hours. Next, they turned their attention to launching a public protest against the naming of new streets, arguing that younger figures should be thus recognized along with the heroes of the past. Since his father was a property developer they enlisted Éluard's help. Some of their demands were put into practice; in the redeveloped suburb of Aubervilliers new streets were named after Lautréamont, the playwright Alfred Jarry, Rimbaud and others. (Breton would perhaps have been gratified to know that the little square at the foot of the rue la Fontaine where he lived with Simone has since been named place André Breton.) At Saint-Brice, Ernst's wife, Lou, paid a sudden visit, arriving from Cologne. If she was hoping for a reconciliation, she was disappointed. At the same time, it was beginning to dawn on Clément Grindel that his son's house guest was in the process of taking over not only his house but Paul's wife. He began to look around for another property for Éluard and Gala in a more remote location, in the hope that a move would jolt Ernst into realizing it was time for him to go. He found one in the forest of Montmorency (at 4, avenue Hennocque) with a large room on the top floor, ideal for conversion into a nursery for his granddaughter, Cécile. He purchased the property in April; the move was planned for the following January.

Raymond Radiguet's novel *Le Diable au corps* was published in March 1923. His story of an illicit affair between a sixteen-year-old boy and the wife of a soldier away at the front was a literary sensation. The publisher, Bernard Grasset, had signed it the previous year on the basis of one meeting with Radiguet, who had arrived at his office 'like a schoolboy at his first interview with the headmaster', accompanied by Cocteau, who read the first few pages aloud. In an unprecedented publishing strategy, Grasset had delayed

publication to launch a publicity campaign based around his dis-
covery of a seventeen-year-old author, the new *gamin* genius.
The idea to promote a book by an unknown author was highly
unusual in 1923 but Grasset's timing was good. Still adjusting to the
tragedy of the lost generation of young men, the reading public was
ready to welcome a bright young person on to the literary scene,
especially as the author of a morally scandalous story. Everyone
rushed to read it, despite (or because of) the rectitude of the critics,
who objected less to the moral turpitude of the story than to Gras-
set's rampant commercialism: 'I don't care whether the author is
seventeen or a hundred and seven. It is a book we have to judge.'
But the story *was* riveting, and not even the most conservative of
the literary establishment could ignore the freshness, economy and
elegance of Radiguet's stylish prose. *Le Diable au corps* was a success
on such a scale that it materially changed Radiguet's life. He moved
into the salubrious Hôtel Foyot and transformed himself from
an awkward young urchin into a model of sartorial elegance who
provided lavish entertainment for his (Cocteau's) circle, at the same
time giving up alcohol, retiring early to bed and getting straight to
work on his second novel, *Le Bal du Comte d'Orgel* (*Count D'Orgel's
Ball*), its central character based on Comte Étienne de Beaumont,
which he completed by the end of the year. Once again, Cocteau's
instincts had been prescient.

By the summer of 1923 Cocteau was writing his own first novel,
Le Grand Écart (*The Big Difference*, or *The Great Divide*), the story of a
sensitive boy moved to tears by everything – cinema, music, serial-
ized fiction . . . In it Cocteau interrogates the impact of difference on
the sensitive youth; his overarching conclusion is that, irrespective
of our (social or other) differences, we are all travelling on the same
train towards a shared destination: death. At the same time he was
writing a new essay on Picasso, who had begun a substantial paint-
ing he would still be working on two years later, *La Danse* (*The Three
Dancers*). As Gertrude Stein would recall, 'It was at this time that
Jean Cocteau who prides himself on being eternally thirty was writ-
ing a little biography of Picasso, and he sent him a telegram asking

him to tell him the date of his birth. And yours, telegraphed back Picasso.' As Stein also noted, Picasso, having 'emptied himself of Italy', was seeking new directions in his work. During 1923 he made copious drawings, 'his pleasure in drawing was enormous, he almost repeated the fecundity and happiness of his first rose period, everything was in rose. That ended in 1923.' Inspired by the classicism of Italy, he also began to introduce experimental nuances into his figure paintings. As Cocteau put it, Picasso was not a literary painter; influences passed through his work like ghosts. If anything, he thought Picasso's gifts included a kind of clairvoyance – though not the kind practised by Breton and his group. In Cocteau's judgement, Picasso's real breakthrough in the early 1920s was his work in the theatre, especially at a time when scene painting was regarded as essentially decorative. With *La Danse* he was transposing some of the elements of theatrical set design on to a painted canvas – an entirely new experiment. The figures in the painting are not only clearly dancers, they are also obviously onstage.

In July Duchamp returned to Paris, where he moved into a tiny unheated room at 37, rue Froidevaux, near Montparnasse Cemetery, just around the corner from Picasso's former studio in the rue Victor-Schœlcher. Before leaving New York, he had brought *The Large Glass* to 'a state of incompletion'. He signed it, inscribed the back, '*LA MARIÉE MISE À NU PAR/SES CÉLIBATAIRES, MÊME*/Marcel Duchamp/1915–1923/*inachévé*', (THE BRIDE STRIPPED BARE BY HER BACHELORS, EVEN/Marcel Duchamp/1915–1923/ unfinished) and sold it to his wealthy collector friends the Arensbergs, who sold it on to Katherine Dreier. Though the work still had missing portions (which meant the 'electrical stripping' of the bride could not take place), Duchamp was bored with it. Or perhaps (as he reflected, though only decades later), 'subconsciously I never intended to finish it because the word "finish" implies an acceptance of traditional methods and all that paraphernalia that accompanies them'. An alternative explanation (offered just before his death) was that his intention was to make a work of art rather than simply a form of self-expression, even 'to get away from myself, though I

knew perfectly well that I was using myself. Call it a little game between "I" and "me".' Before he left New York he found a way of announcing his own disappearance with *Wanted/$2,000 Reward*, a spoof poster offering a reward for the arrest of a new alias, 'George W. Welch . . . alias . . . etcetery, etcetery. Operated Bucket Shop in New York under name HOOKE, LYON and CINQUER . . . Known under name RROSE SÉLAVY.' The poster bore two photographs of Duchamp (full face and profile) and detailed the distinguishing marks of George W. Welch, alias Bull, alias Pickens, alias Rrose Sélavy. 'Height about 5 feet 9 inches. Weight about 180 pounds. Complexion medium, eyes same.' Then he spent four months in Brussels before returning to France for good (he visited America only three times during the next twenty years). In Paris he accepted an invitation to serve on the jury of the 1923 Salon d'Automne; otherwise, he avoided the art scene and even the café gatherings, keeping his distance from both Café Certa and Le Bœuf sur le Toit, between which two venues Tzara apparently continued to divide his time, and his loyalties.

Tzara's Dadaist activities rattled on (as if needed until surrealism was invented to replace them). His latest event, *Soirée du cœur à barbe* (*The Bearded Heart Soirée*), was about to open at the Théâtre Michel, the programme to include music, poetry, a performance of his own play *Le Cœur à gaz* (*Heart of Gas*), a defamatory proclamation by writer Pierre de Massot and three short films, including one by Man Ray, asked to supply his at twenty-four hours' notice. To make *Le Retour à la raison* (*The Return to Reason*) he cut twenty metres of celluloid into manageable lengths, spread them across his work table and 'seasoned' some with salt, pepper and nails. He also included composites of stills (both photographs and rayographs) – a torso striped with light, a revolving egg box. After modifying each piece, he fixed the image, as in a rayograph, then developed it. The following day, with no facilities for cutting and splicing, he simply glued the whole chain together to form a reel. The running time was just under two minutes; there was no narrative, and no scenario: 'It was automatic cinema.' On the opening night in July 1924

the theatre was packed, with an audience who by now was looking forward to the latest disruptive novelty. Initially the indignation was all in the wings, where the performers were already in a state of high dudgeon, following the discovery that Éluard's poems had somehow appeared without his permission on the programme alongside Cocteau's.

The first part of the programme seemed tame by Dadaist standards; the audience listened quietly to performances of music by Stravinsky, Auric, Milhaud and Satie, politely applauding. Afterwards there were poems, read by an actor. Then Pierre de Massot came on and began his outrageous mock-proclamation, so pointedly and nastily ironic it horrified even Breton. 'André Gide, dead on the field of honour. Picasso, dead on the field of honour. Francis Picabia, dead . . .' At that point Breton picked up the gist and leapt on to the stage, ostensibly to defend Picasso; he hit de Massot so hard with a walking stick that he fractured his arm. Tzara rushed onstage, too, then called the police, who marched Breton and others out. The lights went down and the audience, apparently unperturbed, settled down again to watch the films. The programme concluded with Tzara's *Le Cœur à gaz*, a Dadaist farce in which professional actors played the parts of 'Mouth' (later, surely, inspiring Samuel Beckett), 'Eyebrow', 'Ear', 'Neck', 'Eye' and 'Nose', in stiff, tubular cubist costumes designed by Sonia Delaunay. Éluard sat loudly heckling throughout the performance until Tzara called for order, whereupon chaos ensued. Éluard climbed onstage and hit Tzara in the face. One of Breton's new recruits was thrown by stagehands into the orchestra pit. Aragon, 'splendid and diabolical in his dinner jacket and black shirt', rushed onstage, too, in an attempt to rescue Éluard, who had already been badly beaten, and frogmarched him back to his seat. The footlights were smashed, the theatre substantially damaged. Outside on the street, the riot continued. Afterwards Tzara brought a suit against Éluard, who counter-sued. The case eventually petered out, but the infighting continued. As for Picasso, he told Satie the evening had been delightful, he had enjoyed it immensely.

That summer Breton visited Picasso in Antibes, hoping to persuade him to paint his portrait for the frontispiece of his latest book of poems. Anything would do, he said, as long as it would pass for a portrait of him, even if it had no eyes, nose, mouth or ears. Picasso eventually agreed to a drypoint sketch; several months later, after two attempts, he finally produced an engraving they both liked. Seizing an opportunity, during the sittings Breton brought up a subject he had raised before, the suggestion that Picasso might sell *Les Demoiselles d'Avignon* to Doucet. Having raised this with Picasso, in November Breton wrote to Doucet, reminding him that the painting was 'the centre of all the conflicts that Picasso had given rise to and that will last for ever . . . a work that to my mind transcends painting; it is the theatre of everything that has happened in the last fifty years'. When Doucet saw *La Danse* in Picasso's studio he said he would gladly purchase that, but Picasso refused. Possibly because Doucet had promised that, following his death, his entire collection would go to the Louvre, Picasso eventually agreed to sell *Les Demoiselles d'Avignon* and it was purchased by Doucet for three hundred francs. (Henri-Pierre Roché, writer, collector and inveterate networker among the Parisian avant-garde, and future author of *Jules et Jim* (1953) afterwards estimated its value at between two hundred and three hundred thousand francs; Doucet's collection did not go to the Louvre.) Breton's book of poems, *Earthlights*, duly appeared on 15 November, with its etching by Picasso. Alongside poems composed in traditional layouts it included dream narratives, automatic prose and calligrammes. The final poem, entitled '*À Rrose Sélavy*' ('To Rrose Sélavy'), consisted of a one-line alexandrine: 'I've left behind my tricks, my pretty tricks of snow' (or cocaine).

By autumn 1923 Duchamp had moved from his freezing room in the aptly named rue Froidevaux (the painter Gwen John, who once lived there, nicknamed it 'cold veal street') to the Hôtel Istria at 29, rue Campagne-Première, where Man Ray now also took a room, on the same floor. Man Ray told people he would be in his hotel room at no. 29 when not working in his separate studio at no. 31 bis;

Duchamp said he would be in his room all the time, since he never did any work. He had taken up with a woman called Mary Reynolds, a friend of the American art collector and socialite Peggy Guggenheim, according to whom Mary was the only person in bohemian Paris with any money. Duchamp's arrangement with Mary was kept discreet – at least, in theory. Though Duchamp disliked being seen with her in public, they met regularly at the Rotonde, taking care to arrive separately. As for Man Ray, he and Kiki – by now the subject of some of his most well-known works – still seemed to be together, despite their chronically strained relations. Kiki liked the Hôtel Istria, as it was heated and there was a bathroom, a rare luxury in Paris in those days; she spent long, languid hours luxuriating in the bath. She had also taken up painting and was producing figures and landscapes. In her country scenes the cows' horns twisted the wrong way; when she had trouble drawing a dog she pasted on cut-outs over the top – a novel take on collage, which she said she had never heard of. But she was not without technical facility; her drawings, especially the ones of herself as a young girl, are indisputably expressive.

In the evenings she still patronized the bars of Montparnasse, especially Le Jockey, a nightclub that had opened in November 1923 at the corner of the boulevard du Montparnasse and the rue Campagne-Première. The former jockey who owned it painted the outside with huge murals of cowboys astride their horses and Indians in feathered headdresses. Inside there were colourful posters, a wooden bar, and the tables were pushed against the walls in the evenings to make a miniature dance floor. A pianist was hired, and Kiki sang Burgundian peasant songs in her distinctive gravelly voice. When the theatres turned out, Le Jockey filled up with Parisians, Americans and Russians, singers and dancers, painters and models, actors and film stars '. . . and what pretty women, what gowns!' The film stars Kiki saw in Le Jockey may have inspired her attempt to make a career in the movies. In French cinema the vogue was for languid blondes – definitely not her style – so towards the end of 1923 she decided to try her luck in America and headed

for Paramount Studios in Astoria, Queens. Something went wrong; as one newspaper reported it, she had been 'hoping to do grotesque slapstick' but became instead 'one of the best laugh-getters in the Quarter'. (Perhaps something was lost in translation and she had been hoping to do *comédies*.) Her own version of events was more prosaic. She had been queuing for her audition when she realized she had forgotten her comb; by dashing back to get it she had missed her audition altogether. Whatever had happened, it seems to have left her unfazed: 'Oh, well, maybe I'm better off the way it was! It's much nicer to go to the movies than to make them.' She returned to Montparnasse, where she mounted a solo exhibition of her pictures, which sold better than Man Ray's paintings ever had.

Man Ray, in the meantime, had been teaching Brâncuşi photography, since the sculptor remained unconvinced that anyone else who had made the attempt (even Alfred Stieglitz) understood how to photograph his work. Man Ray took him to buy a camera and a tripod, and Brâncusi built a darkroom in one corner of his otherwise completely white studio. Sometime later he showed Man Ray his photographs, which were 'out of focus, over or under-exposed, scratched and spotty', but Brâncuşi was delighted with the results, saying that this was exactly how his work should be reproduced. He had photographed one of his golden bird sculptures 'with the sunrays striking it so that a sort of aurora radiated from it, giving the work an explosive character'. When he saw it, Man Ray began to think that perhaps Brâncuşi was right. But then he looked again at his sculptures . . . no, Brâncuşi was fundamentally a sculptor.

In September Radiguet had fallen ill. Warning signs had been appearing since the spring, when, in a small, pink-velvet-lined anteroom in the Hugos' apartment, the assembled company had received an ominous message from beyond (passed on by Jean Hugo): 'malaise increases with genius'. Cocteau asked for a name. No, came the reply, 'because I am death'. On 30 April the 'spirit' had tapped out, *'Je veux sa jeunesse'* ('I want his youth'), whereupon the séances were brought to a halt. In December, threatened also with the prospect of military service, he had resumed his old habits of heavy drinking,

drugs, insomnia and promiscuity, roaming like a vagrant 'from hotel to hotel, from crime scene to crime scene' until he collapsed with exhaustion. Cocteau's doctor diagnosed influenza. Chanel – who, as Diaghilev's great friend, seems to have kept an eye on Cocteau and his activities – was not so sure. She sent for her own doctor, who told them Radiguet was suffering from typhoid. On the 11th Radiguet told Cocteau, 'Tomorrow I'll be dead.' And he was. Cocteau was too terrified to spend the night with the dying boy, nor could he bear to view the body or attend the funeral, arranged by Chanel, who designed the entire event in white – the altar, the flowers, the coffin, two great horses that pulled the hearse through the streets to the funeral, then on to Père Lachaise. Chanel and Misia Sert took care of the funeral costs; others dealt with Radiguet's unpaid hotel bills and the vast debt he had run up at Le Bœuf sur le Toit. The procession and the funeral were both crowded with friends, including the group of black musicians from the Bœuf, who all sat together in one pew. Cocteau fled, broken down by shock and grief; it would take him several years to recover. Those whose favourite pastime was insulting Cocteau now referred to him as *'le veuf sur le toit'* ('the widower on the roof').

In the New Year he went with the Ballets Russes to Monte Carlo, where the company was due to appear at a festival of music at the casino. Most of the company was now stateless, unable since the Revolution to return to Russia. Their subdued mood suited Cocteau, who began taking opium to dull his grief. Diaghilev had appointed two new dancers, a Russian, Serge Lifar, and an Anglo-Irishman, Patrick Kay (aka Anton Dolin, or 'Antoine Doline' when in France). Rallying slightly, Cocteau began to devise a ballet around Dolin, as well as thinking out a new idea for Étienne de Beaumont, who, discovering that Diaghilev had fallen out with Massine, had decided to 'refloat' the choreographer by producing a series of dances, to be performed the following year, under the title *Les Soirées de Paris* (named after Apollinaire's pre-war magazine). Cocteau was planning to contribute to the series with his own (marvellous, even surrealist) adaptation of *Romeo and Juliet*, and had

already cast himself as Mercutio. His idea for the adaptation was partly inspired by an act he remembered seeing at a street fair four years earlier. 'Miss Aerogyne, the Flying Woman' had 'flown', in tinsel bodice and white tights, against a dense black background, strapped by a rhinestone-studded belt and harness to a peg that moved along invisible rails, the whole paraphernalia hidden from the audience by dazzling lights so that they saw only the Flying Woman (a subject favoured by Ernst, too – Freud had linked birds, and flight, with the desire to escape from emotional turmoil or trauma). Cocteau, who had always been fascinated by aerial views, was planning a similar set for *Romeo and Juliet*, using a black cloth with coloured decorations. The actors would be dressed in black tights and dresses, the men's doublets and hose painted with 'embroidery' that would be picked out by the lighting. Red lights framing the stage would direct the eyes of the audience, as the speaker of the first-act prologue came 'flying' on to the set, like Miss Aerogyne. All this gave Cocteau plenty to think about before returning to Paris.

Some who came to the Closerie des Lilas wore the ribbons of the Croix de Guerre in their lapels, 'or the yellow and green of the Medaille Militaire, with lost limbs, artificial eyes, reconstructed faces', as Hemingway would recall. In January 1924 (with his wife, Hadley, and baby son) Hemingway was about to move into an apartment at 113, rue Notre-Dame-des-Champs. 'In those days we did not trust anyone who had not been in the war, but we did not completely trust anyone.' In the Rotonde and the Dôme the mood was similar, though the clientele was still mainly artists and models. Duchamp usually turned up at the Dôme at around midnight for scrambled eggs before returning to his room at the Istria at about four in the morning to spend the rest of the night playing chess. He was still keeping Mary Reynolds at a distance; they took separate taxis even to visit friends. Mary had confided in Henri-Pierre Roché that 'Marcel goes straight for beauty', which apparently more or less ruled her out as a public consort. Duchamp was protecting his independence, his solitude, his calm nights

working out chess moves, for him in itself a form of artistry, and his amorous nights with other women. As for Rrose Sélavy, she also continued to keep a low profile. That year Pierre de Massot published *The Wonderful Book: Reflections on Rrose Sélavy*, the first edition of which bore on the title page the words of Gertrude Stein, who had said, 'I was looking to see if I could make Marcel out of it but I can't' – hardly surprisingly, since the book consisted merely of an introduction by 'A woman of no importance', followed by twelve blank pages, each headed with the names of the months of the year.

In his role as Doucet's assistant, Breton had introduced Doucet to Duchamp, from whom the couturier/collector commissioned a new optical machine. A piece more visually sophisticated than the *Rotary Glass Panel* he had earlier made with Man Ray, *Rotary Demisphere (Precision Optics)*, was a white wooden globe, halved and painted with back concentric circles, with a small electric motor which appeared to make the circles move backwards and forwards in space (now in the surrealist galleries of the Centre Pompidou, Paris). Mounted on a flat base covered with black velvet, the contraption sat beneath a glass dome secured by a copper disc which bore the inscription, '*Rrose Sélavy et moi esquivons les ecchymoses des esquimaux aux mots exquis*' ('Rrose Sélavy and I avoid the bruises of the Eskimos with their exquisite words'). This, Duchamp presented to Doucet as a gift, pointing out that it was not to be regarded as a means of exchange. He also told Doucet that all exhibitions of painting or sculpture made him ill; furthermore, he would be unhappy if anyone regarded *Rotary Demisphere* as anything other than optics. (Perhaps he had heard the story of Ernst's five vases.)

Surrealism was by now creeping as if by stealth into the artistic culture of Montparnasse, in the form of a series of marvellous explorations and encounters. Aragon was writing *Le Paysan de Paris* (*Paris Peasant*; first published in 1924 in instalments in the *Revue Européenne*). When, at Breton's request, he read unpublished portions to a group Breton gathered in his studio, the work astounded and shocked the assembled company with its overtly surrealist inventions and evocations: 'I have never in my life unleashed such

consternation.' Reporting on the progress of the construction of the new Métro line from Montmartre to Montparnasse, *L'Intransigeant* had just announced the latest development: 'the Boulevard Haussmann has reached the Rue Laffitte'. Whole areas of the district of Montmartre were in the process of being carved up. In *Le Paysan de Paris* Aragon wrote about the projected demolition of two of the old arcades, including the passage de l'Opéra, which meant the closure of Café Certa, along with that of a number of small shops. The owners, put out of business, were destitute. In *Le Paysan de Paris* the Métro line is a 'giant rodent', devouring whole blocks of houses and gashing open the undergrowth of the two arcades about to be destroyed. What seemed invisible to the developers (and the press) was the inner life of Paris and its people, their mysteries rising from the ruins as the narrator, a modern *flâneur*, strolls through the arcades uncovering the marvels of hidden lives, about to be destroyed. The passage de l'Opéra had become 'a big glass coffin' bearing the visible remains of Montmartre's community of small businesses and livelihoods – death itself rendered meaningless.

Among the debris, the arcades had become alleys where prostitutes gathered; as the lights of small businesses went out, the girls came in to ply their trade. In his philosophical writings, Hegel had described the assimilation of the objective life of the world as the human being gradually determines his own identity in relation to external existence. Aragon's narrator, on the other hand, watches lives come into being only to die. 'On stage, young ladies,' directs Aragon's narrator, 'on stage, and start stripping.' The arcades had become nothing but 'a little palace for [Death's] flirtations'. Here was death, approaching in a taffeta dress on teetering high heels, about to perform her fatal dance – prefiguring, perhaps, surrealist artists' emerging fascination with mannequins, dolls and female glamour (all rendered uncanny or macabre).

'All the world's subterfuges, all the artful expedients which enlarge the powers of my senses, astronomical telescopes and lenses of all kinds, drugs like fresh meadow-flowers, alcohols and their power hammers, surrealisms, all reveal to me your presence

everywhere. Death, as round as my eye, I had forgotten you. I was strolling about oblivious of the fact that I had to return home, to you.' In writing his account, Aragon was also inventing a new narrative form capable of evoking the process of disintegration and the layering of unseen experience. The work is a vivid, lyrical reflection, the narrator meandering through a world viewed as if under water or through a prism (perhaps inspiring Nathalie Sarraute's work of 1950s surrealism, *Tropismes*). A place where people's working lives could be axed at random with no thought for the consequences was presented as wondrous, bewildering, fantastical; Aragon was uncovering 'whole fauna of human fantasies, their marine vegetation, [which] drifts and luxuriates in the dimly lit zones of human activity'. In the process of exploring these things the narrator was also forced to look within. Like Ernst's painting, Aragon's writing unfurled, *en passant*, the impulses of the creator along with all he wished to expose and explore – another tenet of surrealism as it was now emerging.

On 21 February 1924 Étienne de Beaumont had written to Picasso with details of *Les Soirées de Paris*, the theatrical series he was planning. The shows were to be 'part ballet, part mime, part *poses plastiques*, part sculpture, part drawing' because, Beaumont explained, his point of departure had always been Picasso's drawings. He invited Picasso to participate in the first of them, a production of *Mercure*, and asked him to submit a series of drawings. 'What I want from you are TAB-LEAUX VIVANTS (short theatrical scenes, or tableaux).' He proposed figures from mythology and suggested Picasso begin with Mercury, as opposed to Jupiter or Saturn, but really, 'do what you want . . . you will certainly find a way to adapt the admirable nudes in your incomparable drawings to music-hall requirements'. Satie, appointed composer, got together with Picasso to consider de Beaumont's instructions, which somehow put them both in mind of one of Cocteau's favourite fancy-dress-party outfits, a Mercury outfit with winged helmet, winged shoes and silver tights . . . perfect. But given the squabbles that had surrounded *Parade*, they decided there was probably no need this time to involve Cocteau in their plans. Anyway,

Cocteau was still busy with *Romeo and Juliet*, which he had now cast (mainly) with opium addicts and, to play Juliet, a leading man so lacking in feminine charm that gossips had already renamed the show *Roméo et Jules*.

Café Certa survived for a short while longer before demolition work was extended to the passage de l'Opéra. Meanwhile, at the lavishly refurbished L'Empire (the Empire Theatre, rebuilt on the site of the original café-concert), Yvette Guilbert made her re-entry on to the Parisian stage. The new vogue in the music halls was for simulations of the old caf'-conc' days, which Paul Poiret had been instrumental in reviving. Thus, while in one area of Paris tradition was being wiped out, in another the belle époque rose – as it were – from the dead. (By the time Dalí wrote about it half a decade later, the (phallic) forms of art nouveau seemed – to him, at least – replete with the shock of the new.) At the age of fifty-nine, having travelled the world singing the songs of the *ancien régime*, Guilbert had come full circle, appearing in Paris once more in her legendary green gown and long black gloves. The new bill incorporated musical elephants, acrobats, black jazz musicians and cowboy stunt men. 'Triumphal!' agreed the critics. In Montparnasse, the barman of Le Jockey moved to the Dingo bar, in the rue Delambre (where Hemingway first met F. Scott Fitzgerald), where he was surprised not only by the internationalism of the clientele but also by the ferociousness of the women, capable of such energetic late-night arguments that he got into the habit, as the night wore on, of removing all sharp objects from the bar. Americans in Paris continued to enjoy the city's nightlife, unconstrained by the 18th Amendment. An anti-Prohibition wine parade was scheduled to run from Montparnasse to Montmartre, but it had hardly got off the ground when someone decided to go for a quick drink before rejoining the march, whereupon the rest of the marchers broke away and followed suit. End of march. Éluard wrote a poem, *'Sans Rancune'* ('Without Rancour'), which began, *'Larmes des yeux, les malheurs des malheureux,/Malheurs sans intérêt et larmes sans couleurs./Il ne demande rien, il n'est pas insensible,/Il est triste en prison et triste s'il*

est libre' ('Tears in their eyes, the misfortunes of the unhappy/ Misfortunes without interest, colourless tears/He asks for nothing, he is not impervious/He is sad in prison, and sad when he is released').

One Monday evening in March he got up from the café table to buy a box of matches, walked out of the café and disappeared.

10.

The Surrealist Manifesto

Cocteau's *Le Train bleu* (*The Blue Train*), the first 'beach ballet', is performed
by the Ballets Russes, with sets by Picasso and costumes by Chanel.
Cocteau experiences a surrealist episode (in the lift going up to Picasso's
apartment). Breton's group become fully established surrealists by
publishing a surrealist newspaper with illustrations by Ernst, Picasso and
de Chirico (still protesting he is not a surrealist). Man Ray and Duchamp
appear in Man Ray's new film, playing chess together on a rooftop.

Nobody knew where Éluard had gone. Gala and Ernst were left
alone together in Eaubonne, the Grindels' new property in the
forest of Montmorency. Ernst was making birds. That year he made
a small installation, *Cage et oiseaux* (*Cage and Birds*, 1924), consisting
of a black lacquered frame with a touch of scarlet at each top cor-
ner. The frame is stringed like an instrument but it also resembles
a theatre set, since the strings make a curtain, parted – as it
were – just far enough to reveal a little box painted with two caged
birds mounted on a wooden panel set behind the curtain. The
whole piece has a delicate beauty as well as an obvious theatricality,
and a toy-like quality, almost as if it were made for a child. In
another 1924 piece, *In Praise of Folly*, painted on a panel, two birds,
one large, one small, are behind bars. They have no wings, feathers
or even beaks; the eye of the larger one is a red-ringed blue circle.
The paint is thick impasto, dragged horizontally and vertically
across the board in orange, yellow, black and red, as if the birds are
hemmed in by the paint itself. (The technique of dragging impasto
anticipates new discoveries Ernst would make the following year

when he began scratching the paint into place.) The atmosphere of both pieces is arresting: in the first, the birds are at play; in the second, they are trapped. For Ernst, birds increasingly became an emblem of surrealism, charged with Freudian associations – bird as phallic symbol, bird as entry into the realms of spiritual power and as a sign of spiritual longing for change.

Shortly after Éluard vanished, Breton, Aragon and two other friends gathered to read his poems, perhaps as a kind of talisman, before setting off on an expedition. For their *voyage magique* they went to Sologne, in central France, setting both of the *Vampire* films and of the enchanted walk taken by the narrator of Alain-Fournier's *Le Grand Meaulnes*. Breton and friends walked to Blois, a destination picked at random, then south-east to the village of Cour-Cheverny, arriving back where they started on 14 May, having covered some three hundred and eighty kilometres. The idea had been to wander into the unknown, with the aim of investigating the effects on the mind of sustained disorientation – perhaps a kind of cross-country version of Aragon's urban wandering among the arcades, both lived metaphors for the explorations being embarked on into the unknown territory of the psyche. In the two school exercise books he took with him Breton wrote five hundred jottings, two of which he developed into a single text, *Poisson soluble* (*Soluble Fish*), which would be published in October that year, alongside the as yet unwritten *Surrealist Manifesto*. Aragon published his own imaginative record of the trip, *Une Vague de rêves* (*A Wave of Dreams*), shortly after their return, explicitly announcing in it that their trip had been surreal: 'There's a surreal light: the one which falls on a counter of salmon-coloured stockings, as cities start to glow.'

They were all unaware that just before they left for their walk, Éluard's father had received a telegram from his son, sent from Nice and dated 24 March.

Dear Father, I've had enough. I'm going travelling. Take back the business you've set up for me. But I'm taking the money I've got, namely 17,000 F. Don't call the cops, state or private. I'll see to the first one I spot.

And that won't do your reputation any good. Here's what to say: tell
everyone the same thing; I had a haemorrhage when I got to Paris, that
now I'm in hospital and then say I've gone to a clinic in Switzerland.
Take great care of Gala and Cécile.

Somehow, within three days, Breton's wife, Simone, was in pos-
session of the facts, including the precise sum of money Éluard had
picked up from the bank before, rather than taking it home, as
arranged, absconding with it. Still no one knew where he was, or
why he had left, or anything about his intentions. Shortly after-
wards Gala ran into Breton in the street, after which Simone had a
new story to spread. 'Gala's left with 400 Fr, the little girl, and an
impossible situation on account of Max Ernst. Her parents-in-law
will only look after her if he leaves. And he's all she's got. André saw
her today, calm. She's looking for work.'

Now Gala showed her mettle. Mme Grindel wanted to forgive
her son and beg him to come home. M. Grindel would not hear of
it. He wanted his money back; he also wanted Ernst out of his
house. By the end of May the new rumour was that Éluard had
gone to Tahiti and was asking Gala to join him there, then in Singa-
pore. In fact, setting sail from Marseilles on 15 April, after six weeks
at sea he had disembarked in French Polynesia, where he settled
down to wait for Gala. She decided she would not only pay her own
passage but also reimburse the money Éluard had taken from his
father. By now both Ernst and Gala presumably knew where Éluard
was, since they were both in touch with him by telegram. He urged
Gala to sell their art collection and join him as soon as she could.
She should visit an art dealer in Berlin who knew about tribal
masks; he sent her a procuration authorizing her to sell their Afri-
can objects, as well as various books and paintings. 'You alone are
precious,' he told her. 'I love only you, I have never loved anyone
but you. I can love nothing else.'

Back in Paris, Cocteau had once again joined forces with Diaghi-
lev. They were preparing the Ballets Russes' next show, *Les Biches*
(*The Young Ones*), a piece of 'lifestyle modernism' with music by

Poulenc and sets and costumes by Marie Laurencin. The ballet tinkered with elements of transgression, androgyny and homosexuality; in its 'open exploration of [so-called] sexual perversity' *Les Biches* went further than any work Diaghilev ever produced. But it did so with such lightness, the tone set by Laurencin's airy pastel-coloured sets, that audiences found it entirely acceptable, recognizing none of the overt provocation they had been faced with in *Le Sacre du printemps* or, in 1912, *L'Après-midi d'un faune* (*The Afternoon of a Faun*). Meanwhile, continually dogged by financial worries, Diaghilev was dependent on sponsors and dealing increasingly with competitors, of which Rolf de Maré's Ballets Suédois company was merely one.

On 16 June *Mercure*, Étienne de Beaumont's first production, opened at the Théâtre la Cigale in Montmartre, described as *poses plastiques* in three scenes. Sets were by Picasso, who had produced drawings for thirteen successive tableaux, most of them less than a minute long; Satie provided suitable *musique d'ameublement*. Satie had scored the work as if for a film rather than the theatre, the music to fit the choreography rather than the other way around, providing a sonic backdrop to Picasso's poses. He also, mischievously, took some liberties with the music to send up the actions of the title character, Mercure, played by Cocteau. The score included the kind of syncopation and jerky rhythms that normally accompanied slapstick, so that exits looked like pratfalls; it also referenced American musical idioms to pastiche the jazz Cocteau loved. The sets and set pieces were no less provocative. In a memorable sixth tableau – a bathing scene featuring the Three Graces, played by men in drag – the Graces enter from the waist up through a large hole in part of the backcloth, designed to represent a bathtub. In the following scenes, Mercure breaks in and steals the girls' pearls and the Graces are turned into basketwork puppets. The final tableau is a party thrown by Bacchus, danced to the music of Vincent Youmans' popular song 'Tea for Two'; in it Satie and Picasso had managed to include gentle send-ups of Diaghilev, Poiret and even de Beaumont. The show ended with dancers in multicoloured tights – a dig at the surrealists, or perhaps the Futurists (Gino

Severini, leading member of the movement, regularly in Paris from November 1906 onwards, had a reputation for wearing brightly coloured odd socks, one raspberry red, one green). Whatever the intended references, they were lost on the audience. Nevertheless, the show provided yet another opportunity for Breton and friends to cause disruption – this time, carelessly implicating Picasso. Increasingly establishing an ever more nuanced surrealist agenda, exploring the mysteries and marvels of the mind, in their public activities Breton's group were still, even now, taking their cue from the antics of the Dadaists.

On the first night the Breton *bande* announced its presence. Though their real target was the extravagantly bourgeois Étienne de Beaumont, as instructed by Breton, Aragon and others rose up and began yelling, 'Bravo, Picasso, down with Satie!', at the box where Picasso and Olga were seated. The police were called; Aragon jumped onstage and continued his onslaught . . . the usual antics, relatively meaningless by this time, especially since Aragon in fact admired the show. He reviewed it in the June issue of *Le Journal littéraire*: '*Mercure* caught me unawares. Nothing stronger has ever been brought to the stage . . . It is also the revelation of an entirely new style for Picasso, one that owes nothing to either cubism or realism, and which transcends cubism just as cubism transcended realism.' This may have been tactical, since Breton had realized all too late that Picasso and Satie had been working in collaboration. In a hasty, sycophantic letter to the *Paris-Journal* printed on 20 June he attempted to repair any damage. Beneath an announcement for the show, '*Les Soirées de Paris, Création de* Mercure *d'Erik Satie et Picasso*', appeared a chaotic-looking illustration (lots of naked breasts, figures bursting through holes, a pantomime horse), beneath which was a report of the violent incidents that had interrupted the performance. *Paris-Journal*, ran the announcement, had received from various friends and collaborators (actually, Breton) the following communication, which was quoted verbatim. 'It is . . . our duty to put on record our deep and wholehearted admiration for Picasso . . . Once again, in *Mercure*, he has shown a full

measure of his daring and his genius, and has met with a total lack of understanding. This event . . . proves that Picasso . . . is today the eternal personification of youth and the absolute master of the situation.' As Satie remarked, the letter seemed *'assez curieux et un peu "con"'* ('rather odd, and a bit silly'). As for Picasso, to whom it was really addressed, he seems to have been duly placated or perhaps he was just (by now) indifferent.

Also on 20 June Diaghilev opened his own quintessentially modern ballet, *Le Train bleu*, again written by Cocteau, at the Théâtre des Champs-Élysées. The score was by Milhaud; Chanel, still keen to be associated with the artistic avant-garde, designed the bulky knitted *sportifs* costumes, which had had to be remade when they proved impossible to dance in; Picasso provided a backcloth scaled up from his painting *Deux Femmes courant sur la plage* (*Two Women Running on the Beach, or The Race*), of two chunky female figures running with abandon along the seashore. This was hugely admired; Picasso signed the corner for Diaghilev, who used it as the company's official curtain for many years. The ballet, despite its flimsy plot (Diaghilev called it an *operette dansée*), became 'the first of the beach ballets', hugely appealing to the It crowd, since *le train bleu* was the popular name for the *wagon-lit* painted in eye-catching blue that took stylish young Parisians to the Côte d'Azur – though, as Cocteau took pains to explain, the ballet does not actually feature a blue train; since this is the modern age of speed, the train has already reached its destination and the passengers have already disembarked. Instead they are seen 'on a beach which does not exist, in front of a casino which exists still less. Overhead passes an aeroplane which you do not see. And the plot represents nothing.'

The methods of production were as (intentionally) misleading as the story. Danced by the Ballets Russes, it had nothing to do with Russian ballet. It was invented for Anton Dolin, a classical dancer who does no classical dancing. The scenery was painted by a sculptor and the costumes were by 'a great arbiter of fashion who has never made a costume' (actually she had, for Cocteau's *Antigone* – but never mind). Nevertheless, art as advertisement had arrived.

Soon anyone who was anyone was taking the blue train to Deauville to practise the newly fashionable balletic exercises on the beach. The public showed far more enthusiasm for *Le Train bleu* than did its creators. It was Picasso's last collaboration with the Ballets Russes; he was becoming disillusioned with the high-class world of princesses and bourgeois who could not, as Stravinsky himself put it, distinguish between Emmanuel Chabrier's *Une Éducation manquée* (a light opera set in the eighteenth century, composed in 1878–9) and Stravinsky's *Le Sacre du printemps*. As for Cocteau, despite the popular success of *Le Train bleu*, he now thought it 'silly, slight, and without novelty'. He spent the summer smoking opium and drawing his own face in the mirror.

In reality, Cocteau was (temporarily) burnt out. He said he had played Mercure in a state of such exhaustion that he had welcomed the opportunity to die, if only publicly onstage for ten performances. He was tired out by grief, opium and the gruelling attempt to distract himself from both. *Mercure* had been 'a blinding nightmare'. In the dressing room, waiting to be called onstage, he had wept with exhaustion and had to be pushed from the wings by his fellow actors, 'like a dumb animal'. He had carried on, hoping death would take him, feeling as if he had been turned into an insect. 'Had I been cut in two like a wasp, I would have gone on living, moving my painted ruff and my legs.' But he was tough, he had to be – so much so that Breton and his *bande* appeared to have had no impact on him at all. Perhaps they hadn't. Asked how he felt about them, Cocteau responded that such things were only to be expected since they were, after all, one big, happy family. Nevertheless, his addiction was taking its toll. Before leaving to spend summer in the south of France he accepted an invitation from Picasso to lunch at his home in the rue la Boétie. Going up in the antique, hand-operated lift, he experienced a vivid hallucination. He imagined he was growing larger, alongside 'something terrible – I don't know what'. A voice called to him, 'My name is on the plate!' He came to with a jolt and read the words on the metal door plate: *Ascenseurs Heurtebise*. For the next few months he felt possessed by

an evil angel, the Angel Heurtebise, who seemed to take up residence in his body, torturing him until, eventually, he exorcized the angel in a poem describing his own torture and rape; he later claimed the poem was as important a turning point in his artistic development as *Les Demoiselles d'Avignon* had been in Picasso's. During lunch with Picasso and Olga he told them about his extraordinary experience in the lift. But 'everything is a miracle', said Picasso. 'It's a miracle not to melt in the bathtub like a lump of sugar.'

The final issue of *Littérature* (no. 13, June 1924) included a photograph by Man Ray which remains one of his best-known works, *Le Violon d'Ingres*, a view of Kiki's back bearing the two curlicue 'f' holes of a violin or violoncello, perhaps inspired, since Man Ray was familiar with the artist's work, by Ingres' *La Baigneuse, dite Baigneuse Valpinçon* (*The Valpinçon Bather*), in which the figure is similarly posed, and/or a nod to Ingres' habit of insisting that visitors to his studio attend to his (inferior) violin playing rather than his paintings – or perhaps simply Man Ray's modern take on the old symbol of woman as a musical instrument. Also that year Man Ray photographed Gala, her two staring eyes reminiscent of the six staring eyes of the photograph of the Marchesa Casati, though not this time the result of distortion in the development process. Gala gazes straight into the camera lens as if in a state of shock, mouth closed, hair untidy, the white collar of her blouse standing up so stiffly it almost appears to be holding her in place.

On 7 July the Éluards' art collection went on sale at the Hôtel Drouot auction house, including works by Picasso, de Chirico, Braque, Gris, Derain and Picabia, and one by Marie Laurencin, and three oil paintings added by Ernst. Also included were African masks, a Peruvian terra cotta piece, a Persian helmet and several *antiquités kitsch*. As soon as the sale was over Gala reimbursed her father-in-law his seventeen hundred francs, settled her other debts, put her daughter in the care of Mme Grindel and bought a ticket for her voyage to join Éluard. Meanwhile, Ernst had been asking Robert Desnos (who was now receiving messages that Éluard was at sea) for advice about obtaining a false passport. He needed to go to

Germany to sell some of the works he had painted in Paris to a buyer in Düsseldorf, since he needed to raise enough to fund a trip to Indochina. Ernst was going too.

Ten days later Gala and Ernst boarded the SS *Paul Lecat* in Marseilles, bound for Singapore. On 12 August Éluard sent a telegram to his father from the Hotel Casino, Saigon. 'Gala here looking forward to coming home and to properties you were not the reason reply by telegram have always loved you.' He signed it Grindel; there was no mention of Ernst. One of the real mysteries of the surrealist years is the story of Éluard's visit to Saigon, and this telegram is one of the few pieces of evidence. What was he doing there for three months? Probably not a lot, other than running away from an unbearable situation at home. Ernst, after he arrived with Gala, painted Éluard as an Indochinese wearing a saucer-shaped hat and eating a plate of noodles with outsized chopsticks. If Éluard produced any art during his time in the east, it does not survive. Before she left France, Gala had been asked by M. Grindel to tell Paul he was prepared to forgive his son's behaviour; Grindel made no mention of Ernst either. The three of them now faced the problem of how to finance their return. For the time being, they were grounded together in the Hotel Casino while they tackled the problem, but from this point on it seems to have become tacitly (or overtly) clear that the days of the *ménage à trois* were numbered. Éluard and Gala returned to Paris as a couple; Ernst stayed behind in Saigon for a few weeks, perhaps waiting for them to send funds to cover his return home. On 28 August Éluard sent a telegram to his parents. 'We should have left by now. Life very expensive. Send quickly a cheque for at least ten thousand with instructions to the *Banque Indochine*.'

Late that August or in early September Éluard and Gala left Saigon and boarded a connecting steamer from Saigon to Singapore. What Ernst did in Saigon for the next few weeks is another mystery. According to those who asked him about it later, he went on one or two traditional excursions in Indochina, possibly visiting the river landscape of Angkor Wat and perhaps also the Khmer ruins. In the

fragments which he later provided for his biographer, Ernst covered this period more or less cryptically. 'Max Ernst travels around, visits Khmer ruins, explores Moi country, takes against the monsoon rains in the jungle.' (The jungle may have influenced his later paintings of forest landscapes – looming, mysterious forms, some of the central works of surrealism – though not necessarily; there were other influences, including his childhood experiences.) When he returned to Paris he rented a room in Montmartre, high up on the hill in the rue Tourlaque. Now barely able to scrape a living, he went on painting in solitude. Éluard supported him by buying his work.

On 1 October Éluard walked round to Breton's apartment with a hand-written note inviting him to meet him at Café Cyrano, another of the group's regular haunts. At first Breton was pleased Éluard was back; then he realized he was angry with him. On the 3rd Simone Breton began a letter to her cousin. 'First: Éluard is back. No comment.' His return seemed to throw everyone into a state of emotional confusion. Simone told her cousin she would never forgive Gala – not for her lies so much as for the underhand method of her departure. What they really could not forgive was Gala's exasperating silence; she was a sorceress, someone grumbled, who cast her spells to cause disruption within the group – which hardly seems to have been her intention.

One who welcomed Éluard's return was Aragon, who enthusiastically passed on the great news. He had in September published the last of his four instalments of *Le Paysan de Paris*, in which he turned up further marvels among the subterranean world of the arcades of Montmartre, including the Librairie Eugène Ray, one of the four or five places in Paris where it was possible to leaf through books and magazines without buying them, and where he found young people engrossed in their reading. He discovered concierges crouched in their basement lairs, holed up for years, 'ineluctably moulded to the shape of this absurd place', watching skirts and trouser legs make their way upstairs. In the window of the old stamp dealer's (now empty) there were two notices pasted up: 'Closed on account of owner's sickness' and, beneath it, 'Closed on

account of owner's death.' The defunct champagne merchant's in the Galerie du Baromètre (supplier of wines 'By Appointment to *Son altesse Royale Monseigneur le Duc d'Orléans*') had been bought out four years earlier for two hundred thousand francs, of which the sum of eighty thousand francs remained unpaid.

The impact of these findings on the narrator of *Le Paysan de Paris* is chronically stunning; he is forced to pause in his monologue to deal with his reactions, which become increasingly visceral in this narrative of gathering emotional momentum. The collapse of the author's authority as he falls prey to the effects of what he is describing heightens the piece's impact as a quintessentially surrealist encounter with reality. 'A screw thread behind my forehead is unwinding blindly to readjust the focus: the smallest object I look at appears to be of enormous proportions, a water jug and an inkwell remind me of Notre Dame and the Morgue.' Words themselves seem to be unravelling fast. The narrator (as reliable witness or ultimate authority) seems to be spiralling out of control. Sustained contemplation of such moral devastation becomes almost hallucinatory. Disintegrating himself, along with the places and things he is looking at, Aragon's narrator views them through a kind of prism of surrealism. Everything seems to be unravelling before his eyes, until it is unclear whether he is seeing things or merely conjuring them in his memory. He reflects on hairdressers' salons, those female-only domains into which he has often looked and seen 'heads of hair uncoiling in their grottoes', here described as if hair had its own sinister inclinations, separately from its place on the female head (again, here, anticipating the surrealists' later preoccupation with mannequins, bald or bewigged). Were there, the narrator ponders, any hairdressers who worked only with brunettes, or only with blondes? 'My palette of blondnesses would include the elegance of motorcars, the scent of *sainfoin*, the silence of mornings, the perplexities of waiting . . . How blond is the sound of the rain, how blond the song of mirrors! From the perfume of gloves to the cry of the owl, from the beating of the murderer's heart to the flowerflames of the laburnum.' The old public baths had taken on the look

of some sinister laboratory . . . So it goes on . . . until he reaches the about-to-be-demolished Café Certa, the old headquarters of his group, with its coat-and-hat stand, its barrels for tables, its sofa upholstered in imitation leather, its rows of seats lined up against the wall, its moveable gas radiator, potted plants, bottle racks – all waiting for the bulldozer. 'Beautiful, good, right, true, real . . . so many other abstract words are crumbling into dust . . .'

Breton, too, in his way, was in the business of juggling and spinning words. By the time he published the *Surrealist Manifesto* in late October (he had been writing it since the spring) the word 'surrealist' had already entered the vernacular. Breton had used it in his article '*À Dada*', in which he both referred back to Apollinaire's coinage (in his 1917 preface to *Parade*) and extended its meaning to encompass the realm of the unconscious. It had also been used by Aragon more than once in the pages of *Le Paysan de Paris*, by Kiki de Montparnasse to describe Man Ray's social set, and by others. Breton had now not only redefined Apollinaire's usage of the word but also implicitly claimed the word as his own (he used it again in an article of 1924, '*Entrée des médiums*' ('The Mediums Enter')). Others, including devotees of Apollinaire (nothing to do with Breton's group), objected to his use of the word they considered their exclusive inheritance. He, however, was ready to claim the definition of surrealism, with emphases on automatism, marvellous chance encounters and the significance of the unconscious. Four days before the publication of the manifesto, on Friday, 10 October 1924, the grandly named Bureau Central de Recherches Surréalistes (Bureau for Surrealist Research) opened in premises at 15, rue de Grenelle, where, in an empty room a female shop-window dummy hung from the ceiling for anyone to examine at his or her leisure. Aragon reported that 'worried men come there every day [to look at it], bearers of weighty secrets'.

Ostensibly consolidating what for Breton constituted surrealism, in its wide-ranging, free-associative exploration of what surrealism is, the *Surrealist Manifesto* stretched the definition in various new, inventive directions which ran counter to its mock-authoritative,

pseudo-scientific tone. Adrienne Monnier once remarked that she had always assumed the manifesto was satirical. Whether or not that was true (Breton was not known for being much of a satirist), it was impassioned, declamatory and didactic; it was also poetic, reminiscent in tone of Aragon's *Le Paysan de Paris*, especially in the opening lines, in which Breton explores the troubling relationship between man and inanimate objects – a connection enduringly central to surrealist art.

Breton also addressed in the manifesto an issue he felt very passionate about – the notion that the working life destroyed a man's right to freedom. By imposing 'the laws of an arbitrary utility', employment subdued the natural freedom of the imagination; it was an example of the way the social order was based on a kind of rational thinking that took no account of the actual reality of human experience. 'We are still living under the reign of logic,' Breton wrote; but that was surely about to change. He attributed to Freud the uncovering of the imagination; his explorations into the mental world had plumbed the depths of 'that dark night' of sleep and dream. 'Had I lived in 1820,' Breton wrote – like the German Romantics – 'I would have revelled in the enormous metaphors.' Now there was no need for empty metaphors, since Freud had uncovered the dark side of human nature (already depicted in the writings of Lautréamont and the art of Moreau) in all of us. With the discoveries of surrealism, metaphor was metamorphosed into everyday lived experience as acted out in the here and now by Breton and his friends and associates. He himself, Breton went on, lived in a marvellous castle with his friends: Aragon, Soupault, 'Paul Éluard, our great Éluard, who [at the time of writing] has not yet come home'; and 'Marcel Duchamp whom we had not hitherto known. Picasso goes hunting in the neighbourhood. The spirit of demoralization has elected domicile in the castle . . . but the doors are always open.' The implication was that life could become marvellous, a castle in the air made manifest, since freedom was a club anyone could join. The fundamental message of the manifesto was that surrealism 'asserts our complete *non-conformism*'.

Breton made other, subsidiary claims. After Apollinaire died, the manifesto continues, he and Soupault had 'baptized the new mode of pure expression which we had at our disposal . . . SURREALISM'. He supplies a lengthy spoof dictionary definition. 'SURREALISM, *n*. Psychic automatism in its pure state, by which one proposes to express – verbally, by means of the written word, or in any other manner – the actual functioning of thought . . . ENCYCLOPÆ-DIA. *Philosophy*.' Surrealism, the definition continues, is based on the reality of previously neglected associations, on the omnipotence of dreams, on the disinterested play of thoughts. Surrealism alone, of all 'psychic mechanisms', can solve 'all the principal problems of life', especially for those who recognize the significance of dreams, for whom waking experience will be intensified. 'I believe in the future resolution of these two states, dream and reality, which are seemingly so contradictory, into a kind of absolute reality, a *surreality*.' Lapsing into the idiom of the *séances sommeils*, Breton alludes to the 'secrets of the magical surrealist art': 'Surrealism will usher you into death, which is a secret society. It will glove your hand.' And in what is surely a moving allusion to the losses of the war, '"You are no longer trembling, carcass." This summer the roses are blue; the wood is of glass, the earth, draped in its verdant cloak, makes as little impression on me as a ghost. It is living and ceasing to live which are the imaginary solutions. Existence is elsewhere.' It was time to choose how – even whether – to live.

Breton's manifesto, despite its veneer of objectivity, was thus fundamentally a poetic, even Romantic call to arms (or rather, permanent disarmament) which took its cue from Lautréamont as much as from Freud or Marx. The surrealist castle – even the manifesto itself – is at one level a marvellous fantasy, just a precursor to the fabulous images of surrealism in writing, painting and other art forms. The manifesto was merely a start, and Breton was still looking for converts to join him in the 'castle'. Picasso, for one, continued to refuse to align himself with the surrealists, denying any definitively surrealist elements in his work until the summer of 1933. Although during the year following the appearance of the

manifesto he introduced surrealist elements into *La Danse* (the theatrical painting he had begun in 1923), he did so for reasons of his own, which had yet to emerge. Not until 1933, when she looked at Picasso's drawings of that year, did Gertrude Stein come up with her own inimitable definition of surrealism, in which she implicitly acknowledged Breton's Romanticism: 'The Surrealists still see things as everyone sees them, they complicate them in a different way but the vision is that of everyone else, in short the complication is the complication of the twentieth century but the vision is that of the nineteenth century.' Even then she continued to distinguish Picasso from the surrealists. 'Picasso only sees something else, another reality. Complications are always easy but another vision than that of all the world is very rare . . . Picasso saw something else, not another complication but another thing.' As for Duchamp, it more or less went without saying that his inclusion in the surrealist castle was nothing to do with him.

For the time being, both the *Surrealist Manifesto* and to some extent the Bureau Central de Recherches Surréalistes (the latter less than Breton had hoped) attracted a degree of interest in the activities of Breton's group (of which the core still consisted of Breton, Aragon, Soupault, Éluard – and trance masters such as Desnos) and new recruits to what was by now a formal organization. These included painters André Masson and Joan Miró, who by 1924 were working in adjoining studios in an alley adjoining the rue Blomet. Breton approved of both Masson (yet another admirer of Lautréamont, and with the added credential of an interesting history of nervous breakdowns) and Miró, whose work Breton preferred to that of Masson. On 21 October visitors to the Bureau Central de Recherches Surréalistes included Max Ernst, who turned up within hours of his return to Paris to offer his services. Another visitor was de Chirico, in the city again that November. He and Breton met on a number of occasions, one evening in a café in the place Pigalle, de Chirico usefully identifying its ghosts. He also witnessed some of Desnos's recitations, until he began to find the surrealist group activities unintentionally comic; he also found Breton's interminable readings

from Lautréamont less and less endurable. When Breton took him to meet Doucet, de Chirico treated the couturier/collector with hauteur. At the end of the month the artist left Paris and headed back to Rome – but this was far from the last of his (reluctant) involvement with, or appropriation by, the surrealists.

By the close of the year Breton was fully occupied with preparations to publish the new magazine he had begun working on, *La Révolution surréaliste,* with illustrations (reproductions of paintings and photographs) by both Picasso and Man Ray; the latter, though unwilling to become a bona fide member of the surrealist group, was happy to publish his work in the magazine. Strictly speaking, he told Breton, he was a pre-surrealist, having invented surrealist photography before Breton had even thought of it. He also warned Breton that he, for one, would be unable to give up work, since he had to earn a living. In January 1924 his work had appeared in French *Vogue,* retrospectively covering an exhibition of contemporary art, including Man Ray's, in the 1923 Salon d'Automne. *Vogue* published his portraits of Kiki de Montparnasse and Duchamp, both painted to look like photographs, and after this he received commissions for fashion images from both *Vogue* and *Vanity Fair.* After the editor of British *Vogue,* Dorothy Todd, sat for her portrait, he received a steady flow of commissions for fashion and portrait photographs for *Vogue* on both sides of the Atlantic, all of which, being Man Ray, he effortlessly and uncontroversially combined with his rising reputation as the central photographic chronicler of surrealism.

La Révolution surréaliste was a substantial undertaking. Unlike the early Dadaist magazines, the publication that first appeared on 1 December 1924 (it ran for twelve issues, until December 1927) was produced as a conventional newspaper and contained a large amount of text. There was nothing amateur or ad hoc about its production; on the contrary, it gave the appearance of providing serious coverage of a range of events and opinions. Its strongly surrealist mood and flavour and the general tone of uncanny iconoclasm were most strikingly established by the images which

were set within or alongside columns of conventional-looking type. Included in the first issue was a full-page advertisement for the Bureau Central de Recherches Surréalistes, illustrated with a drawing of a fish, with the words '*Nous sommes à la veille d'une RÉVO-LUTION. Vous pouvez y prendre part*' ('We are on the eve of a REVOLUTION. You may come and take part'). The columns of text included reports of dreams by Breton and de Chirico; *textes surréalistes* by various lesser-known recruits; an unsigned poem entitled 'Paul Éluard'; and a photograph of a woman's breasts, double exposed so that there were four.

A reproduction of one of Picasso's constructions, a guitar folded open to reveal another guitar, looked more surrealist than cubist among the columns of surrealist text. Poet Pierre Reverdy also contributed a piece. In place of the usual column of births, marriages and deaths there was a column simply headed 'Suicides'. A column of 'Press Extracts' included quotations which contained references to surrealism. '*Le surréalisme . . . c'est la foutaise*' ('Surrealism . . . is bullshit'; Francis Carco, in *Le Journal littéraire*); '*Voici le surréalisme et tout le monde cherche à en faire partie*' ('Now that Surrealism is here, everyone wants to join in'; Tzara, in *Les Nouvelles Littéraires*). A tiny sketch by Ernst showed a man fallen to the ground being attacked by a flock of birds; also included was *Catherine Barometer*, with which he had baffled the customs officer on arrival in Paris). Here, in newspaper format, was surrealism laid out for all to see, ingeniously presented and selected, succinctly and brilliantly illustrated, at first glance entirely intelligible; on greater scrutiny, progressively irrational.

In December 1924 Man Ray was approached by Rolf de Maré to make a film called *Entr'acte*, to be shown (as had been the custom in the early days of cinema) in the intermission of a new ballet with music by Satie and sets by Picabia; the film was to be directed by René Clair. The title of the ballet was *Relâche*, the word normally posted on kiosks or the doors of a closed theatre to mean 'no performance', or 'closed'. Soon posters appeared all over Paris, advertising the 'no-performance'. In the run-up to the show

members of the company and their wives moved into the Hôtel Istria, at the corner of the rue Campagne-Première, where anyone glancing in at the windows got a glimpse of women in their underwear bent over tables, cutting out cloth for their dresses for the opening night. Word spread; *le tout Paris* was soon fighting for tickets. Life imitated art – the date of the premiere, set for 17 November, was postponed until 27 November, then put back a further two days; meanwhile, the Théâtre des Champs-Élysées, where the show was to take place, was still in (actual) *relâche*. On 29 November audiences arrived to find the doors locked and a notice pasted up which read '*Relâche*'. They waited in vain until 11 p.m. for the show to open; the choreographer, who was also playing two of the parts, a corpse and a ballerina, had a high fever and was unable to perform. After a hurried dress rehearsal on 4 December, the first performance took place on the 7th of that month.

Relâche was quintessentially surrealist. At curtain up a movie screen was lowered into place on to which were projected images of Satie and Picabia leaping around in slow motion on the roof of the theatre the audience were sitting in, apparently admiring a huge field gun. After some deliberation they fired it – at the audience, who were then almost blinded by lights the size of car headlamps being shone into the auditorium from the stage. Onstage, a fireman continually poured water from one bucket into another while a ballerina danced, but only when the music stopped; when it started up again she stood still. The audience was shocked by the gun and did not much like the car headlights, but they loved *Entr'acte*, which took up twenty-two minutes of the thirty-minute show. Now, still on screen, a dancer in white tights and a tutu appeared, filmed from below through a pane of glass, followed by random glimpses of traffic at night. Cut to Man Ray and Duchamp seated on a ledge above the rooftops of Paris playing chess, until their game is brought to an abrupt end when a powerful jet of water hits the board. Various apparently unrelated shots followed (the dancer again, now with a beard; a shooting-gallery sequence), until the finale – a funeral-procession set piece which has gone down in

surrealist history. In a jerky sequence, mourners in a dishevelled-looking line meander untidily through the streets of Paris, the men in top hats, the women in hobble skirts, following a hearse pulled by a camel. As the hearse gathers speed the mourners take long, leaping strides to keep up, breaking into a run as it leaves the road, hurtles on to the track of a roller coaster, and finally comes to a halt in an open field, whereupon the casket falls to the ground. The corpse leaps up and taps the mourners on the shoulder, and they all disappear.

Timeless in its wondrous, comically absurd effects, *Relâche* remains one of surrealist art's finest – and weirdest – achievements. On the evening of the final run in 1924 audiences were treated to an additional *divertissement*, *Ciné-Sketch* performed live by Duchamp and a young Swedish model. Miming the exaggerated, sputtering gestures of the early movies, they enacted an absurd farce featuring a thief, a wife, her lover, *his* wife, a policeman, a maid, a ballerina and – apparently unrelated – Adam and Eve as they appear in Lucas Cranach the Elder's celebrated painting of 1526. The young Swedish model was a sylph-like and mock-bashful nude; Duchamp played Adam bearded and nude but for a rose in place of Cranach's fig leaf. The audience loved it, the show got a rousing ovation; Satie and Picabia took their curtain calls in a Citroën 5VC.

New Surrealist Perspectives

With the surrealists, Montparnasse gets its second wind as the artistic quarter of Paris. Cocteau is confined to an opium clinic. Picasso paints two of his few works of the 1920s to be designated surrealist. Paris is alight with the art deco exhibition, at which Man Ray's photographs render the fashion mannequins surreal. Breton's group of surrealists meets Joan Miró, and Breton begins writing his book on surrealist painting. Max Ernst invents frottage and *grattage*, the basis of some of his key surrealist paintings. Josephine Baker takes Paris by storm. The first surrealist exhibition in Paris opens, then the first surrealist gallery.

In the rue Mouffetard, the narrow lane leading down from the place du Panthéon, things were livening up. The bars and *bals musettes* were all packed late into the night with people dancing the foxtrot, the Black Bottom and a new dance, the java, which involved a lot of stamping. Women arrived alone and danced the night away with unknown partners – no need to ask their name. New places had opened, including the particularly licentious Jungle, on the boulevard Montparnasse. By spring all the hotels were booked up for the summer by American visitors settling down in the district for a couple of weeks as if into a summer resort. That summer of 1925 they included Cole Porter, who became one of Diaghilev's new sponsors. As life on the Left Bank increased in vivacity, up in Montmartre things were disappearing. At the end of January the passage de l'Opéra was demolished, and Breton's group decamped from Café Certa to the bars of Montparnasse and Saint-Germain, where, in Les Deux Magots, they had their own table facing the door, the

better to insult any incomer to whom they took instant exception. As someone remarked, Montparnasse was (once again) coming up. 'With the surrealists the *quartier* got its second wind.'

Man Ray, continuing his contribution to the developing array of surrealist artworks, took his camera to the boulevard Edgar-Quinet one midnight and set up his apparatus in the street, leaving the shutter open. He called the resulting image his first 'lumino-graph' – discs of white light floating free against an indistinct black ground. A reproduction of *Boulevard Edgard-Quinet à minuit* (*Boule-vard Edgard-Quinet at Midnight*) appeared (thus misspelt) in the second issue of *La Révolution surréaliste* (published on 15 January 1925), which also featured a new enquiry, '*Qu'est-ce que le surréal-isme?*' ('What is Surrealism?') and replies to an earlier questionnaire headed '*Le suicide est-il une solution?*' ('Is Suicide a Solution?'). Other illustrations demonstrated some of the major concerns of the emerging surrealist agenda: a photograph of a man manacled, visible through the bars of a cattle truck; a photograph by Man Ray of an over-exposed female nude; and some anonymous photo-collages -- one of a man playing an accordion in front of free-standing advertising hoardings against a background seascape; another of a box, the lid removed and cast to one side, the front of the box open to reveal the head of a female mannequin and two disembodied hands and arms. Wax or wooden figures and dislocated heads and body parts, particularly, were becoming synonymous with surreal-ism in these still-transitional postwar years when some shop windows featured stylish female mannequins showcasing the latest, streamlined fashions and others displayed their ranges of prosthetic limbs.

Also included were some small sketches by Ernst. That January he experienced a visitation, or hallucination, which he later added to his fragments of biography. 'January 1925. I see myself lying in bed, and standing at my feet a tall slender woman dressed in a very red gown. The gown is transparent, the woman also. I am ravished by the surprising elegance of her bone structure. I am tempted to pay her a compliment.' (There may be remnants of that dream in

his later, celebrated work of 1939, *La Toilette de la mariée* (*The Robing of the Bride*), in which a nude female figure bursts forth from the red feathers or entrails of an outer skin.) In 1925 he and Éluard were working on a book of poems and drawings which they published anonymously on 1 April in a limited edition of fifteen copies. *Au Défaut du silence* (*For Want of Silence*) consisted of eighteen poems (of which fourteen were only one verse long) with twenty pen-and-ink drawings. For the few who received or obtained copies, here, apparently, was evidence of the Ernst/Éluard/Gala *ménage à trois* laid bare. The twelve issues of *La Révolution surréaliste* detailed with journalistic precision the development of surrealism as it happened; nevertheless, by the time he had produced two issues, Breton himself was characteristically disillusioned, with the newspaper as with everything else in his life. His ennui was catching, as was his restless search for some elusive meaning beneath the surface of everyday life. He and his group spent their days trawling the flea markets, or patronizing small, sleazy backstreet cinemas.

Meanwhile, in an attempt to introduce a new aura of authority among members, he had engaged Antonin Artaud, who on Breton's behalf (before Breton sacked him) produced a new declaration of the group's philosophy ('Declaration of 27 January 1925') intended to realize an 'indispensable objectification of ideas'. In Breton's own words, 'SURREALISM is not a poetic form. It is a cry of the mind.' The rallying cries continued to go more or less unheard. The Bureau Central de Recherches Surréalistes was proving a disappointment; Breton called his group together and reprimanded everyone for laziness. He was particularly irritated by his own ineffectiveness, since the arrival at the bureau some weeks earlier, on 24 December, of a seductive young woman wearing a pair of long, sky-blue gloves. Aragon had noticed the gloves and suggested she leave one behind as a calling card. She could do better than that, she said, she owned a glove cast in bronze which she would bring instead – so they called her 'the lady of the glove' (the glove being an example of Freud's infinite list of receptacles symbolic of female physicality; Cocteau loved gloves; de Chirico had been the first to paint them suggestively,

if cryptically – red gloves juxtaposed with a child's green ball in *The Song of Love*, his metaphysical work of 1914).

Her name (when Breton met her) was Lise Meyer. He was fascinated by this twenty-six-year-old daughter of a renowned physician and (on her mother's side) heir to the Dreyfus banking dynasty; impressed by her glamorous paraphernalia and eye-catching jewellery. As one commentator noted, among their myriad contradictions, the surrealists managed to be both trenchantly anti-establishment and sartorially dapper. Suspicious of money, refusing to work for a living, they loved ostentation and the parties of the wealthy; with holes in their shoes they had been seen decked out in spats, monocle and cane; morally self-righteous, they believed in passionate love, and were perpetually in pursuit of *l'amour fou*. With her languor, wealth and 'voice of a heliotrope', Lise had no trouble snaring Breton, despite the fact that one of her close friends was Cocteau (who had supplied the description of her voice). To Breton she stood for idealized love. When she was absent he pined for her; when she turned up at his apartment in the rue Fontaine they spent their evenings at the Luna Park near Porte Maillot, or one of the other carnivals in the outskirts of Paris, visiting the funfair. Breton's wife, Simone, was subjected to a running commentary on the progress of the affair. In the daytime he distracted himself with his new work in progress, a thirty-page introduction to *Un Discours sur le peu de réalité* (*A Discourse on the Paucity of Reality*; published the following February in *Commerce*). The discourse itself remained unwritten.

Aragon, back in Paris, was writing up his notes on a second major surrealist perambulation. After their expedition to Sologne he, Breton and others had made another journey, this time an impromptu nocturnal expedition into the forest-like gardens of the Buttes-Chaumont, a location with a reputation for mystery and enchantment, once notorious for its so-called suicide bridge (since destroyed for living up to its name). In *Le Sentiment de la nature aux Buttes-Chaumont* (*A Feeling for Nature at the Buttes-Chaumont*; published the following year in instalments in the *Revue européenne*)

Aragon described the 'ranks of great dusky plants that look like nomadic encampments in the heart of cities', the atmosphere of enchanted forests. As a metaphor for the unconscious, on their walk the place had 'stirred a mirage in us . . . Our black mood evaporated in the light of a huge, naive hope' – a version of surrealism clearly rooted in the art of German Romanticism, in which the desire for the liberty of body and mind was reflected in the contemplation of nature. At night the gardens seemed to exude sexual desire: 'in the hollow of black foliage, figures could be just glimpsed coupled together . . . O couples! a great bird is suddenly silhouetted against your silence.' Desire evoked melancholia ('In search of pleasure . . . the whole of human despair is there') and disorder, the suspension of logic to which all surrealist thinking aspired. The extraordinary thing, Aragon reflected, was surely not the chaotic nature of the unconscious but the expectation of order; the freedom of the unconscious, on the contrary, was all about the disorderly loss of self. 'My life? It no longer belongs to me.' In the disordered texture of the erotic, who was to say what was real and what imaginary? 'Love is a state of confusion between the real and the marvellous.' (Cocteau, in all his work, had been saying much the same.) Aragon would soon have an opportunity to put his reflections into practice. Later that year he met Anglo-American heiress Nancy Cunard, a striking new arrival on the nightclub scene of Montparnasse. By this time Breton had closed the Bureau Central de Recherches Surréalistes. He had hired Antonin Artaud (a dastardly, powerful-looking figure, if ever there was one) in the hope that Artaud would succeed where he (Breton) had failed in imposing some discipline on the group: 'From today onward, the logbook is once more to be kept *strictly* up to date.' But Artaud was soon experiencing the same problem as Breton – it seemed impossible to extract from anyone the degree of commitment Breton expected. Breton vented his frustration by sacking various colleagues (among them Aragon) and becoming furious with others, including Pierre Naville, whom he had appointed editor of *La Révolution surréaliste* and who had enraged Breton by printing his own opinion that 'as

everyone now knows, there is no such thing as *Surrealist painting*' – just at the point when Breton was beginning to turn his attention to the painters of his acquaintance (Ernst, Picasso and the two rue Blomet neighbours Miró and Masson) as potential new spokesmen for surrealism.

Breton's array of surrealist painters did not include de Chirico, whose recent work (being shown that April at Léonce Rosenberg's gallery) Breton regarded as retrograde. True, de Chirico's work had changed. In place of his earlier depictions of deserted piazzas and railway stations littered with strange objects, he was now painting in the style of a kind of Italian classicism. He had published a book on Gustave Courbet in which he argued that Courbet's metaphysical vision was compatible with realism; and he was producing copies of his own work for clients who asked for paintings dated earlier – a shocking development, in the opinion of Breton, who had visited his studio one day and caught him doing it. His new work seemed to consist of pictures of semi-human figures with transparent bodies (buildings or archaeological remains visible inside), horses by the seashore and segments of broken classical columns. His brother Alberto Savinio (the eccentric pianist) helpfully explained that de Chirico's source was a book, *Travels in Greece*, by Pausanias, dating from the first century AD. Irritated by what he saw as de Chirico's dereliction of surrealist duty, Breton and his group (who were nothing but 'hooligans' and 'petty delinquents', according to de Chirico) continued to attack him. The painter now decided he had never been truly convinced by them in any case. He had visited Breton's studio twice, on the first occasion enduring Breton's tedious readings from Lautréamont, on the second watching as the assembled company lapsed into a (he thought, probably simulated) trance. He had his own theory about Breton's reactions to his recent work. When he returned to Italy during the war he had left behind in his studio some paintings which his landlord had sold in lieu of unpaid rent, some of them to Breton. Had he died in the war, de Chirico thought, Breton could have capitalized on his acquisitions; as it was, the new work superseded the old, rendering

it less valuable. Despite this bizarre combination of venom and conspiracy theory, Breton continued to reproduce de Chirico's early work in *La Révolution surréaliste* – his work appeared, either with or without his permission, in virtually every issue.

The self-appointed role of spokesman for de Chirico now fell to Cocteau, who unlike Breton made no distinction between the painter's earlier and later work. For Cocteau there was nothing retrograde about the new 'huge figures in a white mist beside the sea, their egg-shaped heads wrapped in quantities of gossamer threads, their open chests displaying a monumental heart'. He identified de Chirico's puns and riddles and his depictions of the 'petrified imagination', and drew attention to his experiments with form, perspective and subject matter. 'A rubber glove hanging beside a plaster head, a deserted street, an egg placed in a destructive solitude, lighting that belongs to an eclipse and an outbreak of plague: it is normal for all this to lead our painter to the drama of Aeschylus or Sophocles and conjure up these tragic actions side by side, with their chests opening on the tangled constructions of insects.' In 1925 Cocteau, inspired still himself by the Greeks, was working on a new translation of *Orpheus* (to be performed the following year), with Death as an elegant woman in surgical rubber gloves which enable her to pass through mirrors, 'the doors by which death comes and goes'. In de Chirico's work Cocteau identified themes of death, crime scenes, trains and journeys into the unconscious, all of which were beginning to preoccupy him, too. In *Le Mystère Laïc* (*The Mystery Layman*), his reflections on de Chirico, published in 1928, he identified a connection between the artist and Freud. 'It is through the things which Freud regards as childish that an artist tells his own story without opening his mouth, dominates art and endures.' Although in de Chirico's opinion not even Cocteau understood his work, he did acknowledge Cocteau as the 'only intellectual who supported me at that time with a certain warmth'.

By mid-March Cocteau was confined to a spa at 15, rue Chateaubriand, struggling to deal with his opium addiction. (Coco Chanel

paid, and resisted his continual appeals to get him out of there so emphatically that in the lobby where he made his telephone calls she could be heard – '*non!*' – on the other end of the line.) For the past few months he had been smoking opium every day. 'Radiguet's death literally killed me,' he told friends. 'I did *Roméo* as though in a dream, and every day has deepened the hole into which I have been sinking.' His 'cure' marked a new phase of visceral anguish, consisting of 'showers, electric baths, nerves on edge, jerking legs that want to walk on the ceiling and stretch out across the street . . . like having a Chinese tree pulled out of you'. His most loyal visitor and correspondent was Picasso's old friend from their Montmartre days, Max Jacob.

In his agony Cocteau was writing a poem triggered by his hallucinatory experience in the lift up to Picasso's apartment. He had written about the angel figure who had appeared to him before, in *Le Cap de Bonne-Espérance*, in which Garros's plane personifies the Annunciation and shells are angels spitting deadly gas; and from the Somme, when, on 28 July 1916, after shelling had lit up the sky for three days, he wrote to Valentine Hugo, 'I have seen my angel again, with her *new* little wings.' In Cocteau's love poems, Raymond Radiguet had appeared as the angel who merges with the poet. Now, once again an angel was dwelling within him. He called the new work *L'Ange Heurtebise* ('The Angel Heurtebise') after the name he had seen on the brass door plate in Picasso's lift. In his opiate state the writing of the poem felt like giving birth to a monster. When one suicidal night he finally expelled it, he considered it the only completely successful poem he had ever written and vowed that even on pain of death he would refuse to change a single syllable. Perhaps the sheer sensation of ascending, as he rose in the lift to meet Picasso the previous summer, had triggered all the deeply felt sensations that contributed to this eventual catharsis. *L'Ange Heurtebise* was published later that year, in the May–June issue of *Les Feuilles libres*; at the end of April, the clinic had been condemned for demolition, bringing to an abrupt end Cocteau's harrowing cure.

Picasso, presumably oblivious to the dramatic turn of events

apparently prompted by the name plate on his lift, had resumed work on a painting that was later identified as one of his few major surrealist works, triggered by the death on 1 March of an old friend from his early days in Montmartre, Spanish painter Ramon Pichot. Begun in 1923 as a balletic variant of the Three Graces, in 1925 Picasso transformed the painting, which now hangs in London's Tate Modern, into the work now known as *La Danse*, a title Picasso himself disliked; he said it should be called *The Death of Pichot*. That spring he reworked it from a classically influenced depiction of the Three Graces into a more obviously modern, multicoloured, essentially theatrical work in which all three figures are jagged in form, with elongated arms and legs; one is dancing with thoroughly modern abandon. The most substantial changes were to the body and face of the figure on the left; its face became mask-like, with huge black eyes and open, red-painted mouth, and the figure potentially menacing – had Ramon Pichot admired *Les Demoiselles d'Avignon*? She appears to have a shadow, which picks out and exaggerates the form of her left breast, arm and hand. The shadowy hand loosely clasps or brushes the right hand of the middle figure. The figure on the right has gained what look like sunglasses and her body seems split in two, half brown, half white. Her (or his) brown right hand clasps the right hand of the dancer on the left. The white left hand, raised, takes the middle figure's raised left hand as if leading her, but the middle figure is apparently crucified by her more traditional dancer's pose, her body in the form of the cross. The figure on the left is clearly a jazz dancer; by the time Picasso completed the painting in 1925 she was probably doing the Charleston, a new dance in 1923, when he started the painting (her left foot is raised in a Charleston step). Now Picasso also added the shadow of Pichot, which appears in profile as a blackened silhouette merging with the right-hand dancer, a haunting figure, less like a shadow or reflection than a surreal negative superimposed on the scene. A surreptitious, painted rayograph? Another strange ghost? When asked for his explanation as to what the painting was about, Picasso replied, 'blood and guts'.

From 28 April to October 1925 the city was diverted by the Exposition Internationale des Arts Décoratifs et Industriels Modernes (International Exhibition of Decorative and Industrial Modern Art). The art deco exhibition (as it was commonly called) dominated Paris, spread across dozens of pavilions stretching from the place des Invalides on the Left Bank to the Champs-Élysées on the Right, lining both banks of the Seine between the Pont Alexandre III and the Pont de l'Alma, the riverbanks sparkling with electric lights, enhanced with glass fountains by Lalique. Four thousand visitors arrived for the inauguration, followed daily by thousands more, in Paris to see the new, essentially decorative style of streamlined modernism showcased: sleek machinery, cars and women's clothing, stylized fountains, minimalist architecture (Le Corbusier was a strong influence) and jewellery and *objets d'art* dominated stylistically by African, Aztec and other ethnic influences – in sum, the fashionable products of France's fast-expanding luxury market. Visitors also had the opportunity to attend performances by both the Ballets Russes and the Ballets Suédois; and a hundred exhibitions were being held at galleries throughout the city, including Cocteau's show of (mainly) drawings and stage designs at the Galerie Briant-Robert on the rue d'Argenteuil. In Corbusier's *Esprit Nouveau* pavilion visitors saw his *Plan Voisin* for Paris, named after aviator Gabriel Voisin and consisting of a series of two-hundred-metre-tall skyscrapers and rectangular apartments. Though it was never built, Le Corbusier's architectural vision represented the height of modernism, consistent, as composer George Antheil later observed, with Brâncuşi's sculptures, Modigliani's 'marvellous elliptical heads', de Chirico's 'painted rooms full of Roman ruins with egg-heads', black music and surrealist paintings – although, in 1925, the heyday of surrealist painting was still to come.

Man Ray was commissioned by *Vogue* to photograph the couture pavilions, where dresses were being shown on seven- or eight-foot-high mannequins so stylish they were like sculptures. The most striking were Madeleine Vionnet's, which outshone even Poiret's, whose lavish models posing on sumptuous barges decorated to

simulate a theatre, a nightclub or a modern home now seemed retrospective, compared with the more streamlined mannequins of other designers, with their bobbed hair, boyish figures and clad in less ostentatiously luxurious fabrics. In her boutique on the Pont Alexandre III Sonia Delaunay was showing her *Robes-Poèmes*, dresses and coats that looked like cubist canvases, the material densely embroidered with squares and triangles of bright colour, with accessories including a car, its exterior painted to match the garments. The art deco exhibition coincided with *la vogue nègre*, the craze for decorative objects derived from ethnic art which burst upon the scene that year, transforming all aspects of daily life. Decorators and ceramicists, jewellers and cabinet-makers, silversmiths and bookbinders, silk weavers, poster makers and glassblowers – all 'went black'. Even the Siegel & Stockman manufactured mannequins created by André Vigneau for department-store windows were lacquered black. The dummies had become works of art in their own right, as *Vogue*'s reviewer announced on 1 August: 'The art of the mannequin, which did not previously exist, has now been perfected.' Aragon disagreed; writing in *La Révolution surréaliste* on 15 July, he had dismissed the art deco exhibition in its entirety as *'une vaste rigolade'* ('a huge joke'). Nevertheless, with the arrival of Vionnet's mannequins and Man Ray's fashion photography, surrealism had surreptitiously entered the realms of the fashionable – even though it would be another four or five years (and take the arrival on the scene of Salvador Dalí) before surrealism and fashion became fully synonymous.

When he finished *La Danse* Picasso showed it to Breton, perhaps because he knew Breton was writing a study of painters. Breton was also planning the first ever surrealist exhibition, to take place at the end of the year. Picasso had no intention of lending *La Danse*, so Breton immediately arranged to have the painting photographed by Man Ray for reproduction in the next issue of *La Révolution surréaliste*. Having photographed Picasso's work, Man Ray, as was his habit, made a portrait photograph of the artist, which he thought 'showed the intense, intransigent look of the man, his black eyes sizing one

up'. Then the Picassos left for Juan-les-Pins on the Côte d'Azur, closely followed by Breton, who was still determined to persuade Picasso to lend his painting to the exhibition. Other visitors to Juan-les-Pins included one of the two rue Blomet painters, André Masson. Picasso had no particular desire to befriend him; he accused Masson of talking up cubism, the better to talk it down. Masson was also the first artist since the end of the war to have been signed by Kahn-weiler, Picasso's pre-war dealer, which was also unlikely to recommend him to Picasso. Anyway, everyone in Montparnasse knew Masson was rowdy and chaotic, with a drink problem. Of the two rue Blomet artists, Picasso preferred fellow Spaniard Miró, whose second one-man show in Paris had just opened.

Breton also admired Miró; he was planning to reproduce his work in *La Révolution surréaliste*, together with Picasso's. Though regarded to this day as one of the foremost artists of surrealism, Miró was at no point fully integrated into Breton's group. (In the rue Blomet, a lesser-known, more randomly assembled and haphazard group had formed around him and Masson, a kind of sub-branch of surrealism.) In any case, Miró was private by nature, living quietly with his wife in the suburbs of Paris; outside his studio he never really took part in the artistic life of the capital. Nevertheless, the principles of surrealism seemed to be already embedded in his work. Since his first solo exhibition in 1918, at the Dalmau Gallery in Barcelona, he had been concerned with what he called the calligraphy of the image – painted 'leaf by leaf, twig by twig, blade of grass by blade of grass, tile by tile'. His distinctive style of draughtsmanship seemed to release objects, even scenes, from any visible attachment to the picture plane so that they appeared to be suspended in space. Some saw his simply depicted objects (a tractor, a ploughed field, a house, a bird) as signs. But there was no logical system of meaning in Miró's early work.

When he first rented his studio at 45, rue Blomet back in spring 1921 Miró had met some of Breton's surrealist group, but his work was influenced as much by his rural Spanish roots as by any of the painters he met in Paris. In June 1924 he and Picasso had attended

the Ballets Russes performance of *Mercure* together, and Miró saw Picasso's curtain, on which the starry sky is depicted by the word *étoile*. In Miró's *Painting (The Birth of the World)* of 1925 a triangular black flag floats free while a stick figure with a white oval in place of a head reaches for a yellow-stringed red balloon. Space is pure colour, a dog barks at the moon; a ladder stretches upwards, leaning against nothing. As Picasso's friend the writer Michel Leiris put it in 1926, in Miró's work, 'the void fixed a new starting point: once the details of the world had been thought away, they were, one by one, to be brought back into being'. As Leiris also noted, space itself thus becomes a significant element of the painting. 'Miró . . . never saw the void as an ending: it was a state from which to depart as well as towards which to move. In every case, however, the void remains . . . The void is a new force.' In the July 1925 issue of *La Révolution surréaliste* Breton duly reproduced both Miró's *The Hunter (Catalan Landscape)* and Picasso's *La Danse*.

Also in July 1925 Breton and friends staged another surrealist revolt, this time storming a banquet given by the *Mercure* newspaper at the Closerie des Lilas. They arrived early, in time to slip under each place setting a copy of an open letter published that day (the 2nd), signed by twenty-eight surrealists – their reply to a recent interview given by the French ambassador and published in *Comœdia* which had infuriated them with its patriotism. 'We take this opportunity,' the letter announced, 'to dissociate ourselves publicly from all that is French, in words and actions.' By the time the banquet began Breton and others were already calling across to one another and creating a general rumpus. When a guest was overheard advising against marrying a German, Breton stood up and accused her of insulting his friend, Max Ernst. Soupault swung from the chandelier, knocking plates and glasses to the floor. Aragon screamed obscenities. Leiris leaned out of the window and yelled, 'Down with France!' to a rapidly gathering crowd, drawn by the noise. More than any previous demonstration, this one set the press and the Parisian literati against the surrealists, which, as far as Breton was concerned, was an achievement. He had already

begun to consider establishing more formal political allegiances, notably with France's Communist group, and would have done so had he not felt unable to reconcile any idea of formal allegiance with his ideal of personal freedom – a conflict that continued to exercise him. Breton's two most influential surrealist statements had yet to appear; they would take the form not of any manifesto or political allegiance but of a poetic novel and a long, perspicacious essay about painting.

The 15 July issue of *La Révolution surréaliste* was something of a landmark publication, in that it brought together the works of Miró, Masson, Ernst and Picasso under the magazine's surrealist umbrella. It also marked the first reproduction of Picasso's *Les Demoiselles d'Avignon*, which took up two-thirds of a page, in a two-page section headed *Rêves* ('Dreams'), beneath the text of Michel Leiris's description of a dream: *'Je suis mort. Je vois le ciel poudroyer comme le cône d'air traversé, dans une salle de spectacle, par les rayons d'un projecteur . . . André Masson et moi évoluons dans l'air comme des gymnasiarques'* ('I am dead. I see the sky turned to dust like a flying cone of air produced in a theatre by the rays of a projector . . . André Masson and I are manoeuvred into the air like gymnasts'). Also included were Man Ray's photograph of a bright disc (the moon?) suspended in a dark, cloudy sky above a passing ship and Ernst's collage/painting of 1923, *Two Children Pursued by a Nightingale*, the components of which – eye, nose, bird's head, fleeing woman, man carrying a child across a roof – had been provoked by the memory of a childhood hallucination during a bout of measles. The issue also featured the first part of Breton's long essay *Le Surréalisme et la peinture (Surrealism and Painting)*, published in instalments over the next two years (and by Gallimard as a short book in 1928).

With this instalment Breton for the first time introduced painters firmly on to the surrealist agenda. He began by acknowledging the significance of cubism, as established by Picasso and Braque, before introducing some of the artistic ideas to have emerged since. In successive instalments he explored the works of Ernst, Derain, Man Ray, Masson, early de Chirico and Picasso; for publication as a

book, he added sections on Miró, Yves Tanguy and Hans Arp. As in the *Surrealist Manifesto*, Breton's quasi-discursive language was essentially poetic. 'The eye exists in a savage state,' the first instalment began. 'The Marvels of the earth . . . the Marvels of the sea . . . have as their sole witness the wild eye that traces all its colours back to the rainbow.' Nevertheless, art had habitually been judged against the standards of the 'very narrow concept of imitation', a habit (Breton argued) which still prevailed. The problem with this way of assessing art was that the critics looked for comparisons to the external world, whereas 'for a total revision of real values, the plastic work of art will either refer to a *purely internal model* or will cease to exist'. The new challenge was to determine what could be understood by 'internal model'. The path to understanding was mysterious but it was already being explored, Breton claimed, by Picasso, who for the last fifteen years (since he painted *Les Demoiselles d'Avignon*) had been 'advancing deep into unknown territory, bearing rays of light in each hand'.

By 1927 Breton would be establishing Ernst at the centre of his agenda for surrealist painting. For now, however, he continued to map out the surrealist ground. In 1925 Ernst was still, in any case, at the start of his career as an artist, and his prospects were bleak. At the beginning of the year a private dealer had offered him a contract but six months later the man had disappeared, leaving Ernst once again with little likelihood of finding opportunities to show or sell his work. That summer he took a short holiday in Pornic, a small seaside town in Brittany. Kept indoors by the rain one afternoon, he found himself contemplating the floorboards, which put him in mind of the time in his childhood when he had been riveted by the look of the simulated mahogany panel at the foot of his bed. In Pornic, he wanted to understand what had so preoccupied him. Taking some sheets of paper, he began to make drawings by placing them on the floor and rubbing the surface with sticks of black lead. When he looked at the drawings he seemed to see images essentially unconnected to the forms he had traced. Letting his mind continue to wander, he found he was seeing all sorts of

things – leaves and their veins, the ragged edges of linen, the brush strokes of a modern painting, the unwound thread of a spool. If he kept on looking he saw 'human heads, animals, a battle that ended with a kiss . . . rocks, the sea and the rain, earthquakes . . . the conjugal diamonds, the cuckoo . . . the feast of death, the wheel of light . . .' – a spool of unconscious associations seemed to be unravelling before his eyes. He thought of Botticelli, who, disliking landscape painting, had once remarked that 'by throwing a sponge soaked with different colours against a wall one makes a spot in which may be seen a beautiful landscape'. Then of Leonardo, who argued with Botticelli that in such a mark might be seen 'human heads, various animals, a battle, some rocks, the sea, clouds, groves, and a thousand other things'. (Virginia Woolf's short story 'A Mark on the Wall' explores the same idea.) The painter's imagination informed the image. Then, by mixing memory and technique, he might draw on or have recourse to such visual impressions to compose his own battles, animals or men, landscapes, monsters or devils.

Thinking of Leonardo, Ernst realized he could develop the rubbing technique – frottage – he had hit on. With the rubbings as the bases of his drawings, he added further marks, all the time trying to work without conscious intervention, letting the images themselves determine where he went next and becoming interested not only in what he produced but in the way he was working, fascinated that 'by widening in this way the active part of the mind's hallucinatory faculties I came to attend as spectator at the birth of all my works'. Working in this way he collected thirty-four images that resembled a combination of natural history, botanical-style drawings and illustrations of mythological tales. (The following year he published them as a book under the title *Histoire naturelle* (*Natural History*), all the drawings developed into beautifully executed images.

This process of layering and uncovering fascinated him. Over the next few years he adapted it for painting in oils, applying several coats of ground to a canvas, placing bits of wood, string or

textured glass beneath it, painting over them with a palette knife then scraping off the raised portions with a bricklayer's trowel smeared with darker colours, producing transparent lines revealing underlying areas of colour. He called the new process *grattage* (scraping), and thus effectively dispensed with conventional aspects of painting, letting go of modelling or any overall design and making few conventional spatial indications. Exactly as with the frottages, he followed the direction the work took him in, without conscious intervention, adding further marks to the images that emerged. From this point on his work was dominated by surface texture, often delicately coloured, in pale earth and pastel colours, the figures scratched out of the impasto surfaces like forms emerging from the void.

From the scumbled surfaces emerged the birds, female figures and forests of Ernst's imagination, recurring motifs in some of his most impactful and lyrical works. *100,000 Doves*, one of the first, most lyrical *grattages*, is like an encrusted wall formed of lines, whorls and circles, the bird motifs fossilized or stretched out of an impasto surface in pinkish earth colours and black and blue. In other *grattages*, birds seem basted on to the surface, formed of a combination of fossil-like whorls and lines, and thick vertical lines of paint. In some works he combined *grattage* and conventional painting, as in *Hands on the Birds*, of birds on a wire, two realized in *grattage* and a third, painted black and red, being plucked from the wire by a human hand. At the bottom right Ernst has painted something skewered by a black steel pin – a piece of yellow fabric or parchment? A letter? These three birds, one executed quite differently from the other two, are about to be forcibly separated.

The female figures Ernst created in *grattage* emerge from surfaces resembling brickwork or concrete with bodies but no facial features. The female body in surrealist art became a figure that could be seen through, taken apart and reassembled like a mannequin, the hair unfurling or standing on end; women in paint became more like dolls, as if the effort of understanding displayed, for example, in Ernst's earlier work, *Of This Men Shall Know Nothing*,

had given way to a simpler, more organic form of experimentation. In his *grattages* Ernst's female figures seem to be being formed from the artist's materials – but only partially, as if the effort to create them has become more tentative. For these Ernst tended to use delicate pastel tones, and his female figures typically stand out from the often indeterminate ground. They are usually dressed, yet not quite human – more like petrified statues, as in *Eve, The Only One Left to Us*, a column-like back view of a woman with roughly bobbed hair the texture of matted string or rope and streaked with green, the vertebrae of her neck clearly visible, her shoulders strong and muscular. The background is (approximately) two-thirds sky, or abstract ground; one-third resembles a tree bark, or roughly striated concrete pillar. Barely noticeable to the right of the figure is a shape that at first glance looks like a shadow, but it does not echo Eve's form; it has its own form, resembling an upturned (grave-digger's?) spade. Like the blackened profile of Ramon Pichot which hovers in Picasso's *La Danse*, it is not a reflection, rather a strange, surreal addition to the picture, floating at the surface of the work. When Breton caught up with Ernst's work and began to write about it, he found most significant of all Ernst's discovery of ways to make art unrestrained by the intervention of rational thinking – his (paradoxical) awareness of the part played by the untapped arena of the unconscious. In Breton's terms, Ernst had discovered a way of painting automatically.

'At any season, and all year long, in the evening the view of the city from the bridges was always exquisitely pictorial,' wrote Janet Flanner, correspondent for the *New Yorker*, when she arrived in Paris in 1925. 'One's eyes became the eyes of a painter.' She admired the appearance of the Louvre as if in chiaroscuro, with the luminous lemon sunset to the west, the great pale stone silhouette of Notre-Dame to the east: 'The Pont Neuf still looked as we had known it on the canvases of Sisley and Pissarro.' At the same time, it was a pivotal year, one of vital contrasts in the arts. Flanner also noticed the surrealists, positioned at their table by the door in Les Deux Magots. Hemingway, now living in the rue

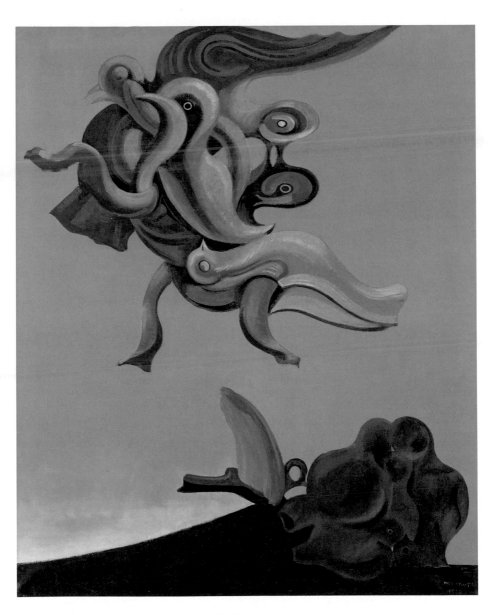

10. Max Ernst: *Monument to the Birds*, 1927.

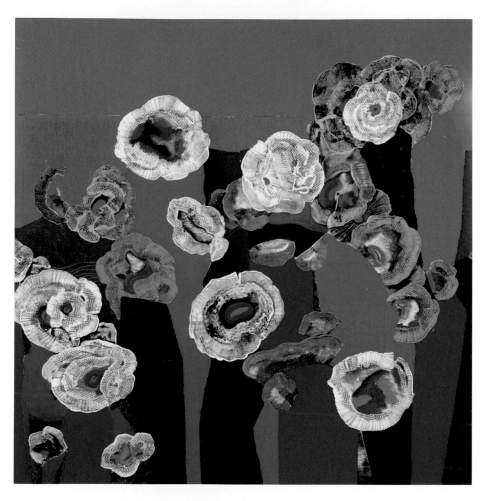

11. Max Ernst: *Flowers and Shells*, 1929.

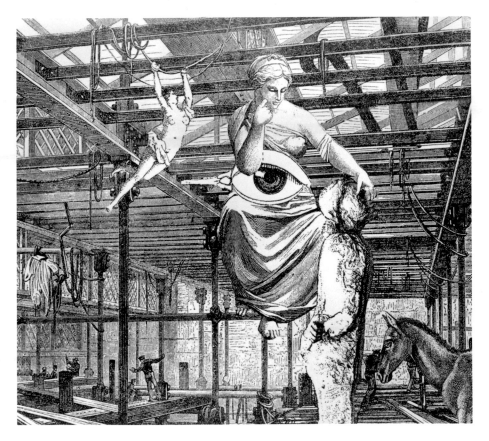

12. Max Ernst: illustration from *La Femme 100 têtes*, 1929.

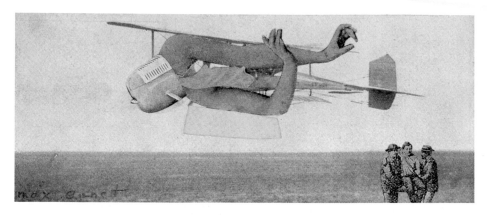

13. Max Ernst: untitled photographic collage, 1920.

14. Marcel
Duchamp and
Man Ray playing
chess in *Entr'Acte*
(1924), 1968.

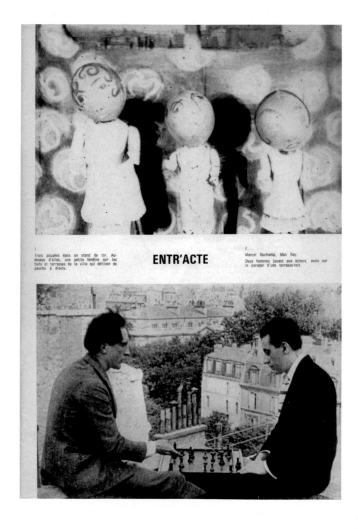

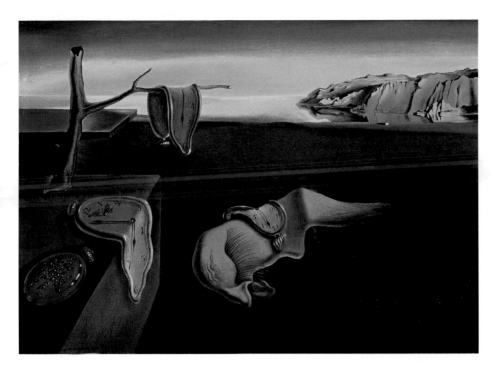

15. Salvador Dalí: *The Persistence of Memory*, 1931.

16. Salvador Dalí: *Surrealist Object Functioning Symbolically* (1931/73).

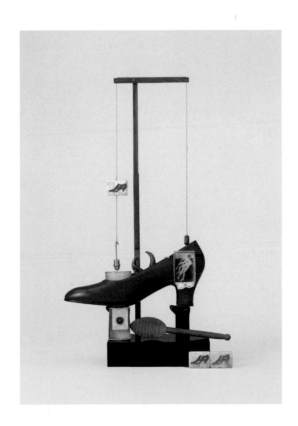

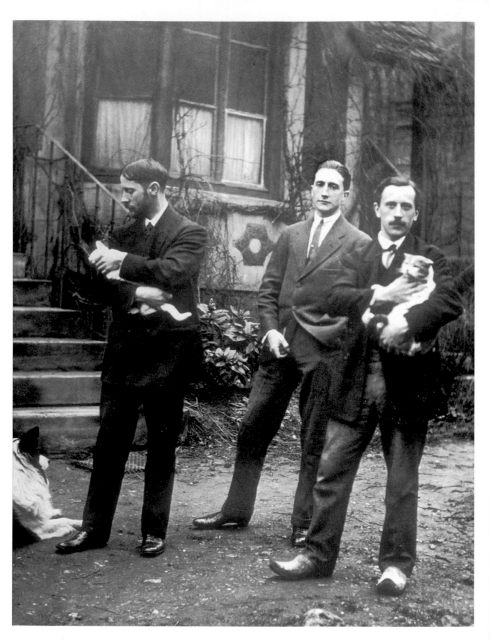

17. Marcel Duchamp with his brothers, Jacques Villon (*left*) and Raymond Duchamp Villon (*right*) in Puteaux, 1913.

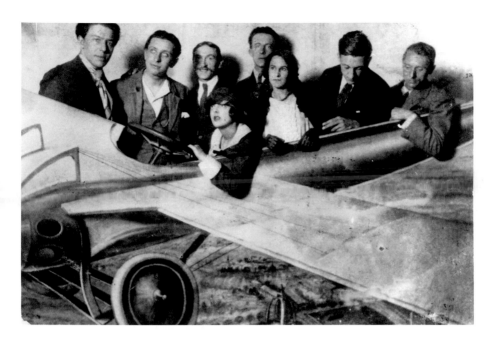

18. The surrealist group in a plane in an amusement park.

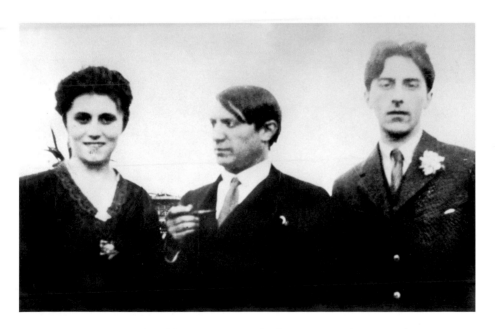

19. Jean Cocteau and Pablo Picasso with the Russian dancer Olga Khokhlova, 1917.

20. Salvador Dalí and Gala.

Notre-Dame-des-Champs, was writing *The Sun Also Rises* (published the following year, to huge acclaim). F. Scott Fitzgerald was in Paris with Zelda that summer, 'the summer of a thousand parties and no work'; it was the year he first met Hemingway in the Dingo bar, and published *The Great Gatsby*, his ingenious inversion of the American dream in which the millionaire's tragedy is juxtaposed with that of the manager of a garage, their respective stories unfolding beneath the surreal gaze of a pair of gigantic spectacles on an advertisement hoarding.

News of the art deco exhibition had reached New York, where everyone was talking about 'The French Exhibition' (as it was called there). Man Ray was now commissioned to provide fashion shots for American *Vogue*. For American readers he showcased André Vigneau, his mannequins made of wax painted silver, gold and Egyptian red. Some bald, some with their hair dressed to resemble bathing caps, these surreal presences were posed in graceful, natural stances that highlighted their material strangeness, standing out starkly against the slender, svelte creations of Pierre Lanvin, the Callot sisters, the House of Worth and Jeanne Paquin, with their off-the-shoulder dresses and gowns with deep 'V's cut down the back. With his photographs of Vigneau's uncanny mannequins, 'gazing blankly and disquietingly into nowhere', Man Ray was rocketed into the stratosphere of fashion photography, earning five hundred dollars or more for a single spread, at a time when it was possible to live well in Paris on a hundred dollars a month. In his studio in the rue Campagne-Première he was working with Duchamp on a new film, *Anémic Cinéma*, based around a seven-minute animation of nine punning phrases by Rrose Sélavy cut and pasted one character at a time in a spiral pattern on round black discs glued to phonograph records. With the help of cinematographer Marc Allégret they shot the slowly revolving discs, alternating them with shots of Duchamp's earlier *Discs Bearing Spirals*, ten abstract designs which when turned appeared to be advancing and receding. The film can be seen today at the Pompidou Centre, where it is described thus:

Anaemic Cinema presents images of rotating discs on which abstract motifs alternate with spiral texts. A succession of static shots of an apparatus contrived by M. Duchamp, it seems to parody the silent film's alternation of image and intertitle. Optical effects generating depth are commented on, as it were, by coiling words that return the viewer to flatness. The slow rotation of the discs produces an effect of swelling out and shrinking in on which the punning and suggestive texts confer erotic connotations.

In 1925 it was shown in a private screening room in Paris, while elsewhere *le tout Paris* gathered for another stunning new spectacle, when Josephine Baker made her entrance in the French capital.

On 22 September the producer of the forthcoming show at the Théâtre des Champs-Élysées was on the platform of the Gare St-Lazare, where he watched the arrival of Josephine and her troupe. 'Out spilled a little world, rocking, boisterous, multicoloured, carrying bizarre musical instruments, all talking loudly, some roaring with laughter. Red, green, yellow shirts, strawberry denims, dresses in polka dots and checks. Incredible hats – derbies – cream-coloured, orange and poppy, surmounted thirty ebony faces, wild and joyous eyes.' *La Revue nègre* had arrived. Baker had already made her debut two years earlier, in New York, in an unpromisingly named Broadway musical (*Shuffle Along*); in Paris she became a star. Janet Flanner told her *New Yorker* readers, 'She made her entry entirely nude except for a pink flamingo feather between her limbs; she was being carried upside down and doing the splits on the shoulder of a black giant. Mid-stage he paused, and . . . swung her in a slow cartwheel to the stage floor, where she stood . . . in an instant of complete silence. She was an unforgettable female ebony statue. A scream of salutation spread through the theatre.' Within half an hour the news had spread to every café on the Champs-Élysées. Everyone went to *La Revue nègre*. Parisian audiences adored Baker. As one reviewer put it, she was 'like a revolution or a tidal wave'. Right and Left Bank audiences alike poured into her shows. From the Théâtre des Champs-Élysées she moved to the Folies Bergère and from there to the Casino de

Paris. Though few of her songs were indebted to jazz, somehow jazz became associated with Josephine Baker. The 'new' music (which Cocteau had heard before the war) was now being played in *boîtes de nuit* the length and breadth of Montparnasse and Saint-Germain-des-Près. The basement bars and little clubs where jazz had been playing for the past few years – Le Grand Duc, and Le Bal Nègre on the rue Blomet – were packed with new enthusiasts, including Picasso and Michel Leiris.

At the end of September Picasso moved into his new apartments, on two floors of 23, rue la Boétie – one floor for him, the other for Olga. He removed (or left wide open) all the doors of the fifth floor and turned it into an enormous studio filled with stacks of paintings, wrapped packages, buckets full of moulds for his statues, piles of books and reams of paper, all covered with a thick layer of dust. The south-facing window looked out over the rooftops of Paris, the Eiffel Tower mistily silhouetted. On her separate floor below Olga maintained her own, more bourgeois lifestyle; as the photographer Brassaï remarked when he visited, even the walls, hung with Picasso's cubist paintings, looked as if they had nothing to do with Picasso. Though the couple's bedroom was in Olga's apartment, there was also a bedroom on the fifth floor, where visitors were admitted by invitation only. In the evenings, Picasso and Leiris took to the clubs and bars.

At midnight on 13 November Miró's dealer, Pierre Loeb, mounted the first exhibition designated surrealist at the Galerie Pierre which he had recently opened at 13, rue Bonaparte, where small, avant-garde galleries proliferated, and still do, in the vicinity of the École des Beaux Arts. The modest exhibition, lasting only eleven days, included works by Man Ray, Ernst, Arp, Miró, Masson, early paintings by de Chirico, and three works by Picasso which had nothing to do with surrealism. Breton's ambition for the first surrealist exhibition was confused, since he aimed both to establish a wider presence for it and to present the show as another of the surrealist group's revolutionary events; in the latter ambition he was disappointed. Although the opening attracted more visitors than

could be squeezed into the gallery, it held none of the attractions of Tzara's earlier Dada events. Nor did the inclusion of Picasso's works succeed in recruiting the artist to the surrealist cause, as Breton continued to hope. By this time Picasso was keen to positively dissociate himself from the surrealists, and he stayed away from the opening. His three works were not even lent by him but by Doucet. The fact that they were in no sense surrealist did not stop Breton from reproducing one (*Head of a Woman*, 1924) in the catalogue.

In the event, the surrealist mood of the exhibition was most firmly established by two works by Miró, *Harlequin's Carnival*, in which unattached shapes (resembling a bird, a cat, a die, a disgruntled face, a ladder) float free, even bounce, around a space that resembles a room; and *Photo: This is the Colour of My Dreams*, an enigmatic work consisting only of the word 'photo' elegantly scrolled at the top left, and at the bottom right a blue cloud, or ink spot, the words, *'ceci est le couleur de mes rêves'* ('this the colour of my dreams') scrawled beneath. There is no photographic image – unless the smudge of colour becomes in some way (within the terms of the work) the negative or shadow of the word. (Given that the light falls diagonally, perhaps the suggestion is that the word 'photo' is the source of light which renders the colour blue. More likely, the juxtaposition of word and image is simply intentionally illogical.) On 10 March Breton went one step further and opened his own surrealist gallery, the Galerie Surréaliste, in premises at 16, rue Jacques-Callot, the road that gives on to the rue de Seine, also within the vicinity of the small galleries. On 26 March 1926 the Galerie Surréaliste celebrated its inauguration with a show of works by Man Ray. *Paintings by Man Ray and Objects from the Islands* was largely a retrospective, including paintings, airbrush works and constructed objects from Man Ray's New York days, some dating from before the war. To accompany the show he added *Revolving Doors*, a multicoloured collage series of 1916–17 in a ten-sheet, stencilled edition – which attracted almost no interest at all. The Galerie Surréaliste had some significant competition. Also on 10 March, the nearby Galerie Van Leer opened an exhibition of works by artists

including Miró and Ernst, among them recent frottage and *grattage* works. The introduction to the catalogue took the form of Éluard's poem 'Max Ernst'.

Michel Leiris had reviewed Miró's work for the spring/summer 1926 issue of the *Little Review*, calling it visual poetry. Leiris's own interest at the time was in primitive art and magic practices, which he identified in both Miró's and Picasso's work of 1926. In Miró's, Leiris wrote, 'the bird is represented by a feather, the swift arrow of his flight or the mark of his talons'. In former times, he wrote, tribesmen buried nail parings and hair to ward off sorcery, since even those particles contained their vital spirit, whereas today man retains the mere traces of that holistic unity. We think we can make sense of the world by being rational but what is actually required is 'a new fetishism', demanding nothing less than 'the perfect adhesion to the heart of any sort of object, free of symbol, but reflecting in the tiniest cell the infinite harmony of the universe'. Inspired by Leiris, in spring 1926 Picasso was making fetishes of his own; he put together a series of two large and ten smaller ones, constructed of rags, nails and other found materials, or pieces of junk. Taking a bath one day he spotted a cleaning cloth on the floor. In his studio he cut a round hole in it and hammered it on to a canvas from the back so that the nails jutted through, then he added a column of a newspaper cutting, string and cord. When Gertrude Stein saw this 'picture made of a rag cut by a string' she thought it his most interesting work for months; since the height of his cubist phase he seemed to have lost the joy of experimenting; now here was something truly new. 'This picture was beautiful, this picture was sad and it was the only one.'

There was certainly something poignant about the piece, strung up and pierced with nails, points facing towards the viewer, then almost cancelled out by the two horizontal strings that extend beyond it on both sides. Picasso called it *Guitar*. The following summer, Breton reproduced a similar piece in the 15 June issue of *La Révolution surréaliste* (where it appeared untitled), a piece of torn rag bordered with studs and pierced with large nails which

somehow has a quality of utter pathos. So, though he continued to resist Breton's attempt to recruit him to the group, Picasso had now produced, in spirit if not in name, two essentially surrealist works – *Guitar*, and *La Danse*, the first of his paintings to be specifically referred to as surrealist. When asked to explain its surrealist implications Picasso simply pointed to the shadow of his old friend Ramon Pichot, whose family lived in the whitewashed, sea-bleached coastal village of Cadaqués, which was about to release its second remarkably talented painter into the artistic mecca of Paris.

Surrealists Divide

Salvador Dalí makes his first appearance in Paris and visits Picasso. For *Romeo and Juliet*, the Ballets Russes finally acquires some surrealist artists (costumes by Miró; backcloths by Miró and Ernst). Breton's core surrealists, for whom the ballet and the bourgeoisie remain inextricable, shower protest leaflets down into the auditorium. Cocteau reviews the hottest new performer on the Parisian scene, American transvestite artiste Barbette. Breton meets a strange, apparently rootless woman – a marvellous chance encounter and the inspiration for *Nadja*, the definitive surrealist novel.

In April 1926 Salvador Dalí made his first, brief visit to Paris, eager to explore the galleries of contemporary art, and to meet Picasso. He travelled with his sister and aunt (who was also his stepmother; she married his father after Dalí's mother's death). Twenty-two-year-old Dalí was still a student at the San Fernando Royal Academy of Fine Arts in Madrid, a progressive institution where recent visiting lecturers had included Breton and Aragon (in 1922 and 1925 respectively), though the academy was more advanced intellectually than artistically; when Dalí saw some cubist pictures in one of the arts magazine and showed them to his tutors, they were wary. In Spain at that time, Toulouse-Lautrec and Van Gogh still seemed avant-garde.

As a student Dalí cut a striking figure. At the academy his closest friends were poet Federico García Lorca, with whom he was – reluctantly – intimately entangled, and future *cinéaste* Luis Buñuel (who had made his first visit to Paris in 1925). Socially shy and

awkward, with an embarrassingly loud, deep voice, Dalí had attempted to blend in by wearing an expensive suit, blue silk shirt and sapphire cufflinks. He treated his hair with brilliantine and varnish so that it no longer looked like hair and went *tock* when he tapped it with a comb, realizing only too late that he had merely succeeded in standing out even more. He had already read Freud (*The Interpretation of Dreams* was translated into Spanish in 1922); Dalí considered his work 'one of the capital discoveries in my life'. He had been 'seized with a real vice of self-interpretation', which he never shook off.

At the age of twelve, he had spent the summer with the family of Picasso's friend Ramon Pichot, who, like the Dalís, had a summer house in Cadaqués, the coastal resort near the Dalí family home in Figueres. At the time Pichot was still living and working in Montmartre (where he had got to know Picasso) but his brother Pepito, at home that summer, spent time with the young Dalí, recognizing his talent for drawing and persuading him to take classes at the local municipal drawing school. Pichot's paintings, hung on the walls of the family home, provided Dalí with his first opportunity to see original canvases at close hand. He responded to the eroticism of Pichot's early works (influenced by Toulouse-Lautrec), and particularly admired those done in the pointillist style; he was fascinated by the difference between the canvases seen close up, where they seemed casually painted, and from a distance, which effected an 'incomprehensible miracle of vision . . . this musically coloured medley became organized, transformed into pure reality'. In Cadaqués, Pepito allocated an outhouse for Dalí to use as a studio. There, on a wormy old wooden door Dalí painted a still life of cherries, incorporating actual cherry stalks and small worms. 'That shows genius,' said Pepito.

By the time he visited Paris in 1926 Dalí's work had been exhibited, that January, in an exhibition at the Permanent Salon of the Madrid Fine Arts Circle, receiving positive notices in the Spanish press, though Dalí was being hailed, as yet, for his classical rather than for any avant-garde attributes. The reviewer for the daily

Heraldo de Madrid praised his originality and his draughtsmanship. 'A youthful and wide-ranging curiosity has led him to pose and resolve – with extraordinary graphic sense – the pictorial problems that even now preoccupy various centres of modern art. He possesses the temperament of a draughtsman in the widest and noblest sense of the word. In line he finds so many possibilities of expression . . . *Girl in the Window* . . . might be a debutant Mantegna.' He had also shown *Venus and a Sailor*, a painting unmistakably influenced by Picasso's cubist works, which Dalí had seen in reproduction and in exhibitions in Spain.

The previous year he had also shown two works at the Dalmau gallery in Barcelona, *Figure at a Window* and *Seated Girl Seen from the Back* (both 1925). Those works were painted in the colours more typical of his early works: pastel pinks, yellows and pale earth colours; in them, the figures are positioned oddly in relation to their surroundings; the paintings reveal his fascination with the backs of female figures. Picasso had visited the Barcelona exhibition, and seen *Seated Girl Seen from the Back*. In it the female figure, positioned strangely close to the viewer, seems so intensely real, her flesh, hair and drapery so vividly evoked, that the landscape in the distance looks contrastingly unreal, as if the girl might at any moment get up or turn around, leaving the picture-book scene behind. Picasso found the work so striking that he mentioned it to Paul Rosenberg, who wrote to Dalí, inviting him to send him some photographs, but somehow Dalí had never got around to replying. That summer Miró (tipped off by Picasso?) took Pierre Loeb to visit Dalí in Figueres. Loeb thought Dalí's work was still a little confused and lacking in personality but encouraged him to stay in touch. Miró said Dalí should go to Paris, though he warned him it was not an easy city for any artist.

When he went to Paris Dalí took a picture with a similar theme to show Picasso. Introduced by a friend who knew both Picasso and Lorca, Dalí made his way to the rue la Boétie, 'as deeply moved and as full of respect as though I were having an audience with the Pope'. He told Picasso he had come to see him first, even before

visiting the Louvre. 'Quite right,' replied Picasso. They unpacked Dalí's painting, and Picasso studied it for at least fifteen minutes, without comment. Then they went up to Picasso's studio. Dalí stood nervously while Picasso silently pulled out one painting after another, moving canvases across the room and placing them on his easel for Dalí to study. He clearly took Dalí seriously. Picasso generally took an interest in younger painters, but if it was unusual for him to demonstrate quite this degree of support, perhaps he had already spotted that here was an obvious recruit for the surrealist group, and one who might eventually sidetrack Breton from his fixation on Picasso. Or perhaps the point of Dalí was that he (like Miró) was a talented Spaniard . . . or maybe Picasso was just willing to support the Pichots' promising young protégé. 'At each new canvas he cast me a glance filled with vivacity and an intelligence so violent that it made me tremble. I left without in turn having made the slightest comment.' They parted on the landing with a nod of mutual understanding. Then Dalí returned, via Brussels, to Spain, where the influence of his meeting with Picasso was immediately reflected in his work. His next painting of a female figure was far removed from the earlier, wistful or mysterious figures at the window. In *Figure on the Rocks*, painted that year, the girl appears as a chunky, foreshortened figure splayed out on her back across the rocks at the seashore. In *Still Life by Moonlight* (also 1926) Dalí included objects Picasso typically used in his cubist works – a bottle, a guitar. That painting also fleetingly introduced the first of Dalí's 'soft' forms – the elongated guitar neck, two flopping fish – which would reappear in his work of three or four years later. He stayed in Spain for the next three years, before returning to Paris in January 1929, when he would make a more resounding impact on the art scene, in more ways than one.

Dalí had left Paris by the time the Ballets Russes performed Boris Kochno's new adaptation of *Romeo and Juliet*, which premiered on 28 April 1926 with significant new elements – costumes by Miró, and backcloths by Miró and Ernst. The choice of artists was a late decision. Diaghilev had already decided the show would go ahead

without sets, since it seemed impossible to recruit a suitable art-
ist. He had dismissed composer Constant Lambert's two (unlikely)
ideas: first, Augustus John (too dull, said Diaghilev), then Christo-
pher Wood (friend of St Ives painter Ben Nicholson), who left in
despair two weeks before the opening night, unable to cope with
Diaghilev's 'ridiculous and useless changes. He has driven me mad.'
In that case, said Diaghilev, since the ballet itself was intended to
play as a mere sketch, or 'a rehearsal as it says in the programme',
there would be no scenery at all. Fine. Then just before the com-
pany left for Monte Carlo (where the show was due to open on 4
May, before moving to Paris on 18th), Diaghilev, always interested
in contemporary art, sent two of his dancers, Kochno and Serge
Lifar, to the Galerie Van Leer to see the exhibition of works by
Ernst and Miró. (Diaghilev called it the 'Surrealist exhibition' but
the show they saw was not the one at the Galerie Surréaliste.) As he
saw them off to Monte Carlo, Diaghilev asked them what they
thought of the surrealists. Lifar said he disliked both Ernst's and
Miró's work and found surrealism incomprehensible, but perhaps
Diaghilev should visit the exhibition and see for himself. A few
days later, just two or three days before the opening night, Diaghi-
lev arrived in Monte Carlo, accompanied (or closely followed) by
Miró and Ernst.

In Lifar's opinion, both painters' designs were 'wholly inappro-
priate and unconnected to the ballet', but Diaghilev loved them. He
was interested in the emergence of surrealism and keen to associ-
ate with painters belonging to the latest artistic movement. He
bought works by both artists and in Monte Carlo stayed up most
nights talking about art with Ernst, sometimes until five in the
morning. No reliable record survives of which paintings were used
in the sets of *Romeo and Juliet*, nor of whether they were the paint-
ings brought over from Paris or ones painted at the last minute in
Monte Carlo. Records do show that Diaghilev commissioned two
sets of decorations, one for each act, making Miró largely respon-
sible for Act I, Ernst for Act II; and that Ernst's works (enlarged in
each case on to scenic canvas by the company's scene painter) were

all simple compositions related to the series of drawings Ernst called *Histoire naturelle*, depictions of the sun floating between the horizontals of earth and sky.

Though most of the company agreed with Lifar, Diaghilev was very happy with the designs and took enormous trouble to make sure they were properly lit. At one lighting rehearsal he asked his lighting director, Serge Grigoriev, did he not think the first-act drop especially lovely? Grigoriev said he could see only 'a huge plain pale-blue expanse of canvas in the centre of which was painted a large disc resembling a gramophone record, of which three-quarters were distinct and the remainder lost in a haze'. Yes, well, that was because he had not the faintest idea about modern art, replied Diaghilev. Critic Henry Malherbe, who later noted that the audience seemed more interested in the surrealist decor than in the ballet, gave (unreliable) descriptions of the cloths – one 'made of parallel lines, circles, and a few clumsy, coloured commas', which could have been by either Ernst or Miró; another, by Ernst, divided into equal segments of grey-beige, and acid yellow – which is roughly correct, though the beige was more like blue. Miró's back-cloth for scene one certainly depicted a dark night, two surreally formed clouds and what appears to be a shooting star.

In Diaghilev's view the sparse, almost abstract designs beautifully enhanced the spirit of the production, which told the unorthodox story of *Romeo and Juliet* in rehearsal. At curtain up, dancers in ordinary rehearsal clothes (including the two principal dancers) were shown practising their steps while in another corner of the stage another couple of dancers rehearsed the play. The action was nothing if not economical. 'The ball at the Capulet mansion, the love duo between Romeo and Juliet, the tomb, and the rehearsal is over. Romeo puts on his street clothes and carries the resuscitated Juliet off the stage.' But anyone anticipating a happy collaboration of the surrealists with the Ballets Russes was about to be proved over-optimistic. On 18 May the audience took their seats at the Théâtre Sarah-Bernhardt. The lights went down, the conductor raised his baton; the dancing was about to begin when (as

reported in the *Dancing Times*) 'some thirty or forty young men surged up the central gangway blowing whistles as loudly as possible, whilst confederates posted all over the house howled and shrieked at the top of their voices'.

From a box on the uppermost balcony, showers of printed leaflets rained down on the heads of those below. Far from recognizing a way to resolve their differences with Diaghilev, the surrealists were launching their most sustained protest yet. For fully ten minutes pandemonium reigned. Though the music could not be heard, the orchestra valiantly continued, as did the dancers, forced to stop dancing only by the arrival of the police. By this time theatre audiences were used to the surrealists' riots. Those more interested in the ballet than the riot pitched in with the attempt to eject Breton, Aragon and friends. The composer Sergei Prokofiev, seated in the balcony, watched patrons in evening tails deliver blows and punches to the demonstrators, one of whom was seated on the ground nursing a crack on the cheekbone when a lady ostentatiously *décolletée* advanced on him and hit him several times with her programme. The protesters were dragged away by police, already notably the worse for wear. The audience returned to its seats, Diaghilev gave a sign; and the performance recommenced.

The *Romeo and Juliet* protest differed from any of the surrealists' previous ones in that this time Breton's fury was specifically about what he saw as the disloyalty of his new recruits. He was incensed with Ernst and Miró for getting mixed up with Diaghilev, who represented the main thing Breton loathed – the (in his opinion) unscrupulous pandering to the bourgeoisie to the end of financial gain, which also, at least partly, explained his loathing of Cocteau. As far as Breton was concerned, Diaghilev was motivated purely by money – though nothing, in fact, could have been farther from the truth: Diaghilev constantly struggled to keep his company afloat and was more or less perpetually penniless. Nevertheless, as he afterwards put it to Éluard, Breton was convinced that any participation in a ballet could succeed only in stifling his two new surrealists. Oddly, Picasso's involvement with the Ballets Russes

never seemed to cause Breton a problem – perhaps because Picasso was his own man, and not actually (despite all Breton's attempts) a member of the surrealist group.

The leaflets the surrealists had hurled down into the auditorium were headed 'Protest' and supplied a fulsome outline of their position. 'It is inadmissible that ideas should be at the behest of money. Not a year goes by but that someone whom one thought to be unshakeable submits to forces to which he was opposed until then.' Such people, the text continued, rendered themselves unimportant, since the ideals of surrealism would survive without them. Thus, whatever they might think, by deserting the surrealist cause, painters Max Ernst and Joan Miró need not think they were undermining it. Nevertheless, they (and everyone) should realize the surrealist ideal was utterly incompatible with such enterprises as the Ballets Russes, whose goal had always been to dampen down the dreams and rebellions of the hungry in the interests of providing entertainment for the international aristocracy. In fact, what Breton really feared (despite the blustering text of the 'Protest') was that Ernst and Miró ran the risk of jeopardizing both Breton's current intentions – to (at some stage) recommend himself to the Communist Party; and to outline a programme for surrealist art. The diatribe continued: 'It may have seemed to Ernst and Miró that their collaboration with M de Diaghilev, legitimized by the example of Picasso, would not have serious consequences.' Far from it, their actions had forced the surrealists to denounce their attitude, which 'arms the worst partisans with questionable ethics'.

The text of the 'Protest' seems to have meant little to Ernst or Miró, who from now on merely distanced themselves from any further association with the surrealist group (though Ernst had already become a member and did not formally resign for another decade). Diaghilev, on the other hand, was hurt and disappointed. Far from having won the affection and support of the surrealists (his intention), he seemed to have succeeded only in igniting their fury. In some ways the whole event was something of a damp squib, since though the scandalous first night certainly attracted audiences

throughout the run, on the whole reviews of the ballet were dis-
appointing. Furthermore, after all that, the sets were not even a
success. 'It is all so colourless,' one critic complained. 'Once the rule
of the Ballets Russes used to be wealth of colour, richesse, harmony
and *volupté*. Today it appears to be strictly black and white and sharp
angles with grace entirely banished.'

As for the slight on Picasso (blamed in the leaflet for setting Ernst
and Miró a bad example), he did not even dignify it with a response.
From 15 June he was exhibiting some fifty-eight paintings at Paul
Rosenberg's, his first show since 1924. Works included a large rag
guitar sewn by Picasso himself, and some smaller pieces made
from strips of tulle from Olga's tutus entangled with the skeletons
of guitars made of sticks and string, buttons and lead shot. These
and other constructions, built of string, leaves, ropes, nails, news-
paper, carried no particular message or statement; one step away
from found objects, they were suggestive, open to interpretation,
some of them even pretty, despite the fact that to some they
appeared to be Picasso's way of masking darker thoughts. Cocteau
thought they were shamanistic attempts on the medium of paint-
ing itself: 'those canvases [that Picasso] sticks with crucified shirts
and bits of string', he remarked to Max Jacob, 'are an attempt to
assassinate painting' – broadly consistent, in other words, with
the surrealist agenda. Paul Rosenberg purchased all the works in
the show except *La Danse*, which Picasso kept back for himself. The
work notably absent from the show was the simple 'fetish' Ger-
trude Stein had admired, reproduced that summer in *La Révolution
surréaliste*.

The timing of Picasso's exhibition coincided with that of another
show, at Léonce Rosenberg's, of de Chirico's recent work, which pro-
voked a new attack by Breton and his group. This time, according to
de Chirico, the surrealists launched 'a large-scale boycott of my new
output'. The Galerie Surréaliste was showing *Objets sauvages*, an
exhibition of African and Indonesian carvings and artefacts, and
other surrealist objects. After seeing de Chirico's show, Breton and
his group added to their own exhibition a small display of the early

'metaphysical' paintings in Breton's possession. They then produced a catalogue with an 'utterly silly' preface by Aragon which, in de Chirico's opinion, was positively libellous. He saw the surrealist exhibition as an attempt to parody the work he was showing at Rosenberg's. To ridicule his paintings of horses by the seashore, they mounted a display of toy rubber horses on a mound of sand, a few stones ranged around them and a scrap of blue paper for the sea. In mockery of some of the works de Chirico was calling 'furniture in the open' they showed furniture from a doll's house. The feud with de Chirico continued despite the fact that, somewhat bafflingly, Breton continued to reproduce his early work in the pages of *La Révolution surréaliste*. In succeeding years, the surrealists (hysterical with envy, in de Chirico's view) went so far as to organize boycotts of his work in Belgium, the Netherlands, Switzerland, Britain and the United States. While they went on behaving like 'eunuchs and old maids', Cocteau persisted in his support of the artist.

Also on 15 June Cocteau's adaptation of *Orphée* (his revamp of the Orpheus myth, featuring Death in rubber gloves) opened at the Théâtre des Arts, starring Paris's most popular transvestite performer, Barbette (real name, Vander Clyde), fabulously adorned in feathers and sequins, in Cocteau's opinion the modern-day encapsulation of the Greek notion of metamorphosis. He had watched Barbette dress (and undress) and been transfixed by the process of transformation as his entire physiognomy changed from that of a man to that of a woman, then back into that of a man as he left the stage. According to Cocteau, the idea to adapt *Orpheus* had been inspired by Picasso's remark (following the apparently unforgettable hallucinatory episode in the lift) that it is marvellous that we do not melt in the bath; Barbette fitted the role of Orpheus not only because he signified metamorphosis but also because he reminded Cocteau of a screen actor. Present-day audiences, Cocteau thought, watched the movies the way people used to look at sculpture, seeing 'shadowy volumes . . . all that abstract humanity, that silent inhumanity', and Barbette, as he moved on stage, captivating audiences who watched the show 'as if it were happening in the streets

of a dream', had taken on 'the solitude of Oedipus', reminding Cocteau also (as if all of the above were not enough) of 'the loneliness of one of Chirico's eggs in the foreground of a city on the day of an eclipse'.

In early July Cocteau left Paris for Villefranche, where his summer visitors included Man Ray and Kiki de Montparnasse. Picasso and Olga spent the summer in Juan-les-Pins. On their way back, Picasso narrowly missed causing a drastic rift with Cocteau when he and Olga stopped off to visit a friend in Céret, where they happened to run into the editor of the Catalan-language newspaper *La Publicitat*, who somehow coerced Picasso into giving an interview (Picasso almost never gave interviews). Asked for his opinion of Cocteau, he uncharacteristically answered without giving the question much thought, possibly even intending a compliment. 'Cocteau is a *machine à penser*. His drawings are ever so graceful, his writings journalistic . . . If we could market his talent, we would be able to spend the rest of our lives buying Cocteau potions from a drugstore without ever depleting his stock of talent.' Though Picasso was not, after all, quoted in *La Publicitat*, somehow his words (if indeed they were his) found their way into the pages of *L'Intransigeant*, whereupon he received a frantic cable from Cocteau in Villefranche. Since these were clearly not Picasso's own views, Cocteau cabled, he was begging him to retract them. Picasso did nothing, whereupon Cocteau wrote to *L'Intransigeant* himself, since he could not possibly allow the journalist's error to go uncorrected. Two days later he wrote again to Picasso. 'You, who never talk about people . . . have talked about who else but me?' – a fair point. 'Without Maman and the Church, I would have thrown myself out of the window.' Back in Paris, the situation was fortuitously rectified, by Maman herself (and Olga). As Gertrude Stein inimitably summarized the story:

> The Picassos went to the theatre and there in front of them seated was Jean Cocteau's mother. At the first intermission they went up to her, and surrounded by all their mutual friends she said, my dear,

you cannot imagine the relief to me and to Jean to know that it was not you that gave out that vile interview, do tell me that it was not. And as Picasso's wife said, I as a mother could not let a mother suffer and I said of course it was not Picasso and Picasso said yes yes of course it was not, and so the public retraction was given.

Ernst seemed characteristically unruffled by his brief, eventful encounter with the Ballets Russes, though there is more fluidity of movement in his work of that year, perhaps obliquely influenced by his experience of designing sets. In the spring the Galerie Van Leer had mounted his first substantial exhibition (of forty-eight works) since arriving in Paris. Alongside his *grattages* he was developing a new style characterized by melded forms mostly depicted in motion or flight, his figures becoming more subtly performative. In paintings such as *The Kiss*, *After Us*, *Motherhood* and *One Night of Love* Ernst seems to be looking both backward to Leonardo da Vinci (*The Virgin and Child with Saint Anne*) and forward to Francis Bacon, the figures metamorphosed into stretched, extended forms with exaggerated gestures, moving into new, 'impossible' areas of space. His birds seem to be in the process of metamorphosis, a number of works with the same title, *Monument to the Birds*, depicting fused and dismembered figures, part bird, part human, the forms so pared down they seem embryonic, as if Ernst has begun to tease out connections between elemental, bird-like and human forms.

While Ernst's imagination continued to soar, Breton was becoming increasingly depressed and lonely, wandering around the flea market at Clignancourt in search of unusual objects, or pacing the streets around the Gare du Nord. He missed Aragon, who was fully preoccupied with a new development in his romantic life. That summer he had met Nancy Cunard, who seems to have arrived at an opportune moment, bringing to an end his previous obsession with an American woman who, in addition to being married, had turned out to be not only partly lesbian but also having an affair behind his back with one of his friends. The daughter of English shipping magnate Sir Bache Cunard and his American socialite

wife, Lady Emerald, Nancy was irrepressibly sociable and out-going. She found Aragon very shy but thought him 'beautiful as a young god'. In 1926 she was thirty, the author of three volumes of poetry, a friend of Ezra Pound and William Carlos Williams and a *habituée* of Cocteau's nightclub, Le Bœuf sur le Toit – not exactly, perhaps, a predictable companion for the reserved and retiring Aragon, but he was captivated.

For the past three years since leaving his family home, Aragon had led a rootless existence in hotels and borrowed studios. Now he moved in, all expenses paid, with Nancy, and the pair of them rushed about between her various homes in Paris, London, New York, Normandy and the Périgord. Still nevertheless prey to des-pair, he sought intermittent refuge in his latest (angry, anarchist) work in progress, *La Défense de l'infini* (*The Defence of Infinity*). It had not gone down well with Breton, who considered it reasonably surrealist but lacking in communist credentials – increasingly a preoccupation with Breton, who later that year began expelling all members of the surrealist group he considered insufficiently com-munist (starting with Soupault) and introducing into his café meetings more overtly political agendas. In fact, Aragon joined the French Communist Party in December of that year and remained an ardently committed communist, but that summer he had little to do either with Breton's group or the Communist Party; he spent most of it away from Paris, travelling with Nancy.

On Monday, 4 October, Breton's romantic fortunes took a new turn when he experienced a completely new, marvellous chance encounter of his own; more extraordinary to him by far than even his infatuation with Lise, this new encounter seemed to promise exactly the collision of the sexual, the imaginary and the uncanny he seemed to have been waiting for. Browsing through the stall outside the Humanité bookshop, he noticed a woman with pier-cing eyes who seemed to have wandered straight out of his fantasies into the rue La Fayette – though 'she scarcely seemed to touch the ground as she walked'. She said her name was Nadja, Russian for 'the beginning of hope' – but only the beginning. When later he

transcribed the narrative of their meetings into fiction Breton scarcely deviated from real events; Nadja was the embodiment of a walking, talking surrealist idea; their relationship played itself out like a waking dream.

From the start he was captivated by her strange elusiveness. When he asked her what she was doing in Paris she told him she hardly knew, just that in the evenings at about seven she liked to be underground, so she went down into the Métro and sat watching people as they made their way home from work. He arranged to meet her again the next day and found her already waiting for him, more stylishly dressed this time in black and red, with a pretty hat, silk stockings and smarter shoes. He had brought some of his books to show her; she found them puzzling but did her best to engage with his book of critical essays, *Les Pas perdus* – 'Lost Steps? But there's no such thing!' She read it until she got to the line '*Chasse de leur acier la martre et l'hermine*' ('Spoils of their blades, marten fur and ermine'), which frightened her. 'Oh! That must be death!' She commented on the difference between the colours of the books' covers. Then it was her turn to initiate the conversation. 'Close your eyes and say something. Anything, a number, a name . . . Two, two what? Two women. What do they look like? Wearing black. Where are they?'

The third time he met her she looked the same as she had at their first meeting and her attitude appeared somehow to have subtly changed; she seemed even a little suspicious of him: 'For instance, she looks into my hat.' When Breton offered to accompany her home, she gave the cab driver the address of the Théâtre des Arts, saying it was just a few yards from where she lived. In the cab she stared at Breton in silence for a long time, then began blinking as if she could hardly believe her eyes, before telling the driver to take them instead to the place Dauphine, where they found somewhere to have dinner. When they were harassed by a drunk, she hardly noticed. As their desserts arrived she announced she was certain there was an underground tunnel beneath their feet. Outside in the square she seemed to see a crowd: 'And the dead, the dead!' They

passed a window shrouded in darkness. In a moment, she announced, it would light up and turn red. It did – a light went on behind red curtains. On they wandered, Nadja apparently looking for something. When they strayed into the courtyard of a police station she began to panic. 'It's not here . . . Listen, tell me why you have to go to prison?' She made her way over to a railing and held on tight, more or less ignoring Breton's questions, until he eventually persuaded her, still in a state of agitation, to follow him. When he tried to calm her down by reciting a poem by Baudelaire, Breton's voice sent her into a panic, 'her fear aggravated by her memory of the kiss we exchanged a little while before'. On it went, everything becoming increasingly bizarre as they made their way towards the river. Leaning over a wall, she gazed into the Seine.

'That hand, that hand on the Seine, why is that hand flaming over the water?' Standing in front of a fountain, she remarked that the water was sending up their thoughts: 'that broken spurt again, that fall'. To Breton this seemed an uncanny coincidence; he had seen just such an image in an edition of Berkeley's *Dialogues* . . . But Nadja was not listening; she told him she was now thinking about her little daughter, who was nothing like other children, who take out their dolls' eyes to see what's behind. 'One thing, that's all,' she then abruptly announced. 'I suddenly felt I was going to hurt you.' Turning to face him, 'It's over.' It was not, though, until they had taken a train out to the banlieues and spent the night in a hotel, whereupon Breton realized that the spell (for him) was broken. Desire had been tantalizing; consummation brought everything back to the level of the mundane, despite the intrinsic fascination of a woman who was evidently 'so pure, so free of any earthly tie, and cares so little, but so marvellously, for life'.

Having decided their relationship was over, Breton ran into her again, as if they were destined to keep meeting. But as more of her life began to emerge she became increasingly disconcerting. She had run up debts, she told him; she had a gentleman friend who had hit her; she had assisted someone else in trafficking drugs. He gave her his telephone number and she later called him at home. Asked by

whoever answered where she could be reached, she replied, 'I cannot be reached.' She sent Breton a telegram asking him to meet her. As they walked along the rue de Seine she seemed distressed, telling him to 'follow a line slowly traced across the sky by a hand'. To help him understand how she lived she supplied another image: 'it's like the morning when she bathes and her body withdraws while she stares at the surface of the bath water'. She sang and danced as she walked beneath an arcade of the Palais Royal. She conversed with a woman who appeared before a strange closed door and gave her a card. (Éluard was sent to the address on the card; he found no one there, only a cryptic message pinned the wrong way up – Mme Aubry-Abrivard would be home very late but would certainly return.)

Nadja's remarks became ever more cryptic. 'Time is a tease. Time is a tease – because everything has to happen in its own time.' And so the mysterious liaison carried on. On the way to the hotel in Saint-Germain, 'suddenly, as I am kissing her, she screams. "There" (pointing to the top of the window), "someone's there. I just saw a head upside down – very clearly."' For four months the meetings continued. She produced ingenious drawings (a bag, a mask, a heart, a broken line, a star) and interpreted them for him. He took her for 'a free genius', she took him for 'a god, she thinks of me as the sun'. She had puzzled him from the start, but for a while it had been exhilarating; now she was simply confounding. Perhaps life did need to be 'deciphered like a cryptogram', he reflected; but who was she, anyway? 'Who is the real Nadja . . . I mean, is the real Nadja always this inspired and inspiring creature who enjoyed being nowhere but in the streets?'

It occurred to him that perhaps she was an artist. Several times she attempted Breton's portrait, drawing him with his hair standing on end. In his apartment he showed her his collection of ethnic statues and paintings. She seemed to understand them all, especially Ernst's *Of This Men Shall Know Nothing*, her interpretation of which was uncannily consistent with the poem the artist had written on the back of the canvas. Breton invited Ernst to draw Nadja's portrait, but he declined. After seeing Breton's collection of ethnic artefacts Nadja

had her hair arranged by a hairdresser in five strands like a star across her forehead. She said she was a butterfly, whose body was a Mazda lightbulb (a familiar image, emitting rays of bright light, on advertisement hoardings) towards which a charmed snake was rising. Eventually Breton admitted defeat. 'For some time, I had stopped understanding Nadja. Actually, perhaps we have never understood one another.'

She, too, it appeared, was growing bored, unable to live up to his exacting view of the world; he noticed she made no distinction between her more mundane remarks and those that seemed to him profound. Though the concept of Nadja as a live surrealist artefact is certainly comprehensible, Breton's misogyny (symptomatic of the times?) is surely breathtaking. As was shortly to emerge, Nadja was vulnerable and mad, perhaps driven crazy by poverty, abuse or drugs, or all three. What surprised him was that she seemed to want to persist in playing the game he had created once he had lost interest in it. As an experiment, Nadja had been riveting; meanwhile, Breton faced the problem of how to shake her off. But he already knew he could make use of the experience: he wrote his novel *Nadja* the following year. It remains perhaps the best-known surrealist novel, a revealing insight into both what Breton intended for surrealism and into the nature of his own desires. The novel opens with the words, 'Who am I?'

He swiftly diverted his attention from his living mannequin to attempt more serious politicking. The front cover of the 1 December 1926 issue of *La Révolution surréaliste* for the first time overtly signalled Breton's engagement with communism per se. A face and head, with a collage (objects, bodies, faces) for hair bore the caption, '*Ce qui manque à tous ces messieurs c'est la dialectique*' ('What all these gentlemen lack is the dialectic'), attributed to Engels. Breton outlined his view of the communist position in the article '*Légitime Défense*' ('Self-defence'), though he signed off admitting that, despite his intellectual engagement, he still felt unable to align himself with any ideal other than that of personal freedom. The issue included some particularly bleak reportage, anonymous articles

with titles such as '*Suicide inattendu, une idylle qui finit mal*' ('Unexpected Suicide, an Idyll that Ended Badly') and '*Une Tragédie dans une maison des fous*' ('Tragedy in an Asylum'), the latter revealing that, due to a recent shortage of space, two extremely dangerous madmen had been placed in the same cell, where, howling like wild beasts, they had torn each other to pieces. A third piece on the same theme, headed '*Suicide sauvage d'une mère et ses deux enfants*' ('Savage Suicide of a Mother and Her Two Children'), was signed by Paul Éluard and Benjamin Péret. Illustrations included reproductions of two of Ernst's most shocking works, *The Beautiful Season*, which depicted a goat, its outer form intact, burnt or electrocuted from within (a pastiche of Holman Hunt's *The Scapegoat*?); and *The Virgin Spanking the Infant Jesus in Front of Witnesses*, a pseudo-religious portrait of the virgin and child (recalling the sacred images of Mantegna or Botticelli) so sacrilegious that when it was seen in Germany Ernst was not only formally excommunicated before the congregation in the cathedral of Cologne but also, when his father saw the picture, banished from his family. Man Ray's signed contributions to the issue consisted of an indecipherable image (a rayograph?), of a shape resembling cloud, skin or shell with a slit or blemish across the centre; and an assemblage entitled *Sculpture*, pieces of wormy wood stacked in such a way as to (faintly) resemble a rough appropriation of an ethnic statue or totem.

Man Ray had been wandering the streets of Paris taking photographs – of the rue de la Paix in the rain, a sunlit cobbled courtyard seen from the gloom of a driveway, the old Bal Bullier dance hall on the avenue de l'Observatoire. He was collecting shots for a film sponsored by a patron of the arts in New York who had offered him three thousand dollars to make an avant-garde movie, to be shown in December 1926. *Emak Bakia* was a ciné-collage incorporating rayographs, street-scene montages and some additional, realistic sequences. There was no script and no discernible narrative; it was composed solely of motifs, created by repeated patterns of dazzling light against dark grounds. Man Ray called it a 'ciné-poem', since he said it had been composed, like a poem, as 'a whole that still remained

a fragment'. The final shot was of Kiki de Montparnasse's face. She appears with closed eyes but there are eyes painted on her eyelids so that, as she shuts her eyes, she seems to open them. In addition to its striking finale the film included other startling sequences, among them a scene shot by Man Ray with a juddering hand-held camera from an open-top car speeding along a country road in which his female companion is sent flying into the air above a herd of sheep. In another scene an actor pulls out torn shirt collars from a suitcase and they flap upwards like a flock of fluttering doves. More women, more duplicated eyes, more bird-like women, and now – why not? – bird-like shirt collars. Surrealist art continued to throw up ways of staging marvellous new encounters, between birds, women, objects, and women-as-objects.

Surrealists Explore l'amour fou

Picasso meets Marie-Thérèse Walter. Duchamp is (briefly) married,
astonishing all his friends. With the publication of the first instalment
of *Le Surréalisme et la peinture*, Breton positions Max Ernst at the centre
of surrealism. Paul and Gala Éluard separate. The grand opening of
La Coupole attracts the *fashionata* of the Right Bank. Ernst meets
seventeen-year-old Marie-Berthe Aurenche and paints surrealist flowers.

Picasso and Michel Leiris had been cruising the *grands boulevards* 'in
search of *l'amour fou*'. On the evening of 8 January 1927 Picasso thus
encountered blue-eyed, blonde, buxom seventeen-year-old Marie-
Thérèse Walter – in every way a contrast to Olga, his dark, disciplined
dancer wife. Marie-Thérèse came with the added attraction of a touch
of scandal, being the illegitimate daughter of Leon Volroff, who
fathered four children with Marie-Thérèse's mother after she divorced
her husband. Marie-Thérèse had been shopping for a *col Claudine* and
matching cuffs (mock-demure 'Peter Pan' accessories adopted in the
wake of the success of Colette's novel of 1900, *Claudine à l'école*, a fash-
ion which seemed to be having a comeback) when Picasso stopped
her in the street and told her she had an interesting face. She had no
idea who he was. When he took her to a bookshop and showed her a
book about his work (in Chinese or Japanese, she thought), she was
none the wiser. A few days later she visited his studio, where he sat
closely observing her before asking her to come back the following
day. From then on, she was his lover, model and muse.

Marie-Thérèse ushered in a new phase of Picasso's work. His por-
traits of her are playful, sensuous and flooded with colour, especially

vibrant reds and yellows. He drew and painted her voluptuously asleep, sprawled naked in a patterned armchair, her beads flung over her shoulders, not quite like Chanel's. In both *Marie-Thérèse endormie dans un fauteuil à motifs* (*Marie-Thérèse Asleep in a Patterned Armchair*) and *Femme endormie* (*Woman Asleep*), she seems to be playfully stretched widthways, like the reflections in a hall of mirrors. In other, even more experimental works the large-nosed, moon-shaped profile which was only partly hers (it had appeared in Picasso's work before) now gained Olga's black hair and startled eyes as Picasso mingled Olga's features with those of Marie-Thérèse. Painting her, he joyfully remodelled the female form. She spent many hours upstairs in Picasso's studio, Olga apparently oblivious downstairs, while he made luscious, sensual, endlessly inventive portraits of his new model or transformed her on canvas into a guitar or the shadowy silhouette of a dove. Their relationship was like the flight of a bird, he once said. Outside the studio Marie-Thérèse was energetic and sporty, enjoying boating, swimming, kayaking and skating; Picasso went with her and watched her as she sailed around the rink. In Montmartre they went to the amusement parks and the circus, sometimes accompanied by Picasso and Olga's now six-year-old son Paolo, who apparently said nothing to his mother. When Marie-Thérèse said she had been deprived of her own childhood Picasso took her shopping for toys. That spring he rented an apartment for her near the Gare St-Lazare, where she lived, while keeping up the pretence that she had a job in Paris. None of Picasso's friends, except possibly Leiris and Tzara, was allowed to meet her.

In February Duchamp returned to Paris and took a two-room apartment on the seventh floor of 11, rue Larrey, not far from the place de Clichy. He returned from New York a bachelor, apparently content to resume his affair with Mary Reynolds and 'an ever-changing supply of *demi-mondaines*', until Picabia's wife, Germaine, introduced him to Lydie Sarazin-Levassor, the curvy daughter of an automobile magnate, son of the co-founder of Panhard cars. M. Sarazin-Levassor was keen to divorce his wife and marry his mistress but his wife had made him promise to do nothing until

their then twenty-four-year-old daughter was safely off their hands. Duchamp made a diary note of his first meeting with her – 'desastrous' [*sic*] – but he was keeping an open mind. After two or three meetings he was invited to the family's country house at Étretat, where he proposed to her. He kept his apartment on while looking for a marital home, and when no financial assistance seemed to be forthcoming from the bride's family the couple moved into the rue Larrey together. The wedding was set for 8 June.

· The marriage of Lydie and Duchamp astonished all his friends. In New York word reached Alfred Stieglitz, who passed on the news in amazement. 'Duchamp married!!! . . . At any rate it's a woman he married.' If, as has been speculated, Duchamp married in the hope of money, he was disappointed. When the marriage contract was presented for signature it emerged that Lydie would receive a mere two thousand five hundred francs a month (a singularly modest sum for the daughter of a successful businessman), which astounded even her. Nevertheless, she enjoyed her white wedding, with bridesmaids, a modishly short dress and high heels and a veil that swathed her head like a bandage, trailing yards of white tulle, in the fashion of the day. Man Ray filmed the couple as they left the Protestant Temple d'Étoile (Lydie's family were Protestants). After their gastronomic honeymoon (sampling restaurants throughout Paris, this being Lydie's particular passion) they returned to the rue Larrey, where she was amazed to discover that Duchamp had absolutely no possessions other than an old trunk containing some photographs of his work. To friends in New York the artist reported that it had all been 'a charming experience so far, and I hope that will continue. My life hasn't changed in any way.' He realized he would need to make money but was clear in his own mind that, though Lydie was 'really very nice', he had no intention of supporting them both. When in mid-July he received a commission to design a spiral staircase he rented a hotel room to work on the drawings and was soon passing more of his days there alone. When he did return to the rue Larrey and Lydie, he seemed to spend most of his time smoking his pipe and staring into space.

The ensuing events might almost have been directed by Fran-
çois Truffaut or Jean Renoir. That summer Duchamp and Lydie
set off in her little Citroën for the south of France (Lydie was at
the wheel; Duchamp could not drive), to Moulins, where they were
staying in a house built by her father. Friends also on holiday in the
region, including Man Ray and Kiki de Montparnasse, kept Lydie
company while Duchamp went off to Nice to play in a chess tour-
nament, which, according to Man Ray, irritated Lydie so much she
got up in the middle of the night and glued his pieces to the board.
At the beginning of September Duchamp was off again, this time
to play chess in Chamonix. Lydie drove over to collect him at the
end of the tournament (he came seventh), a journey hampered by
the Citroën's unreliable engine and dodgy suspension. Back in
Paris they returned to an apartment Duchamp had rented for them
at 34, rue Boussingault, near the Parc Montsouris (the rent to be
paid by Lydie, the furniture to be supplied from her parents' house),
but when the day came for the move, the furniture still unpacked,
they spent the night in the rue Larrey, where Lydie made another
disappointing discovery. While she had been moving her belong-
ings into the rue Boussingault, Duchamp had taken the opportunity
to tidy up the rue Larrey apartment, reinstating it as his bachelor
pad. The next day, he left to play chess with Man Ray. He never
returned to the rue Boussingault and Lydie hardly saw him again
until late October, when he asked her to join him in the rue Larrey
for a talk. Explaining he could no longer bear the responsibility of
marriage, he asked her for a divorce, which was granted on 25 Janu-
ary 1928, whereupon Duchamp happily regained his freedom. To
Lydie (who eventually remarried) the entire episode apparently
remained forever bewildering.

Aragon's love affair with Nancy Cunard had also hit a rocky
patch. On holiday with her in Normandy he had been dashing off
ten pages a day of his inflammatory work *Traité du style* (*A Treatise
on Style*; 'I shit on the entire French army . . .') while Nancy reso-
lutely continued to try to enjoy herself. By the time they returned
to Paris he had been driven to distraction by her volatile moods and

drinking sessions. He sought solace with an old friend (Simone Breton's married cousin Denise), only to discover that Denise was already having an affair. In his despair, Aragon hit on the solution of destroying one of his other works in progress, a novel he had been working on in private for four years, *La Défense de l'infini*, of which he had already written fifteen hundred pages. He had read a passage or two to the surrealist group, who had responded with contempt. Now he removed the central section (a free-standing, more or less pornographic piece later published as a work of short fiction, *Le Con d'Irène* (*Irene's Cunt*), and started a bonfire with the rest. All but a few pages of his magnum opus, those snatched from the flames by Nancy, were destroyed. The romance with Nancy survived (and/or was temporarily enlivened by) this moment of high drama and they returned to Normandy, where Nancy wanted to buy a country house, before leaving together the following year to travel through Italy.

Breton had spent the summer on a retreat of his own, in a medieval *manoir* in Varengeville-sur-Mer, where he had been struggling with the difficulties of transposing his relationship with Nadja into fiction. On 21 March she had been found in the hallway of her hotel 'screaming in terror at visual and olfactory hallucinations', removed from the premises and incarcerated. Breton was surprised but consoled himself with the thought that, for Nadja, there was probably not much difference between the inside of a mental institution and the world outside. The tragic outcome did however unleash his long-pent-up fury with the psychiatric profession and the way the mentally ill were treated (recorded, notably, by Virginia Woolf in *Mrs Dalloway* (1925), which depicts the treatment of a shell-shocked soldier by bullying (fictional) psychiatrists Bradshaw and Holmes). Despite the advances in psychiatric literature published by Freud and others such as Charcot and Pierre Janet, the mentally ill, once incarcerated, were restrained, put on peculiar diets and sometimes locked up for years. Nadja's incarceration vividly brought back to Breton his wartime experiences of psychiatric units, 'the sound of a key turning in a lock, or the wretched view of the garden, the cheek

of the people who question you when you want to be left alone'. Conversations came back to him (' "You're being persecuted, aren't you?" – "No, Monsieur." – "He's lying . . ." . . . "You hear voices, do you?" – "No, Monsieur." – "You see, he has auditory hallucinations" '), which he eventually included in his novel. In 1927 the arena of psychiatry was still something of a hit-and-miss affair. Yvette Guilbert had once been invited to a psychiatric hospital, where she was introduced to musicians, opera singers and other professionals; it had taken a while for it to dawn on her that she was lunching with the inmates. As a young woman Jane Avril (one-time star of the Moulin Rouge and immortalized by Toulouse-Lautrec) had had a similar experience; as a patient she had been encouraged to behave like a madwoman when the psychiatrists did their rounds, to help them justify their theories.

As Breton saw it, 'all confinements are arbitrary. I still cannot see why a human being should be deprived of freedom. They shut up [the Marquis de] Sade, they shut up Nietzsche; they shut up Baudelaire.' And they shut up Nadja, whom Breton apparently never visited, though Éluard and Aragon went to see her. Perhaps, Breton reflected, he should not, after all, have encouraged her to abandon what he called 'the jail . . . of logic'; he simply had not realized she could lose, or might already have lost, the instinct for self-preservation he and his friends took for granted. (Nadja remained in the institution, the Perray-Vaucluse, for fourteen months, after which she was transferred to a hospital near her native Lille, where, having provided the material for his truly marvellous chance encounter, in February 1927 she was thus conveniently removed from Breton's life.) For some months he found it impossible to write the book – until the end of August, when his unproductive labours suddenly turned a corner. In just two weeks he produced the bulk of the novel; by the close of the month he was ready to return to Paris, with only the concluding section still to write. (He published the first part that autumn in *Commerce*, and a further fragment the following March, in *La Révolution surréaliste*, illustrated by one of de Chirico's deserted landscapes featuring arches, cloisters and a fountain.)

The development of his other work in progress, *Le Surréalisme et la peinture*, was evidently proving less problematic. With the instalment published in *La Révolution surréaliste* on 1 October 1927 Breton effectively placed Ernst at the centre of the surrealist endeavour. With his collages, Breton claimed, Ernst had broken new ground, reassembling 'the unrestorable fragments of the labyrinth'. In Ernst's radical juxtapositions images yielded up new meanings, relinquishing all stale associations and any inference that the meaning of an image is intrinsic. Breton compared Ernst's collages with Man Ray's photography: Ernst's images assumed new kinds of existence just as did 'a lamp, a bird or an arm' photographed by Man Ray; how amazed Man Ray's beautiful models would be if Breton were to tell them that 'they are participating for exactly the same reason as a quartz gun, a bunch of keys, hoar-frost or fern!' With Ernst's arrival, the artistic mood had irrevocably changed; he looked at the world as if through a window and noticed 'a man with an open umbrella walking along a roof' or, like Hieronymus Bosch, saw a headdress in a windmill. Furthermore, as Breton also pointed out, both Ernst and Man Ray were working directly from nature since, after all, nature herself was constantly cutting up and reassembling. 'Nature rends things asunder . . . the sparrow-hawk rends the sparrow, the fig devours the donkey and the tapeworm eats man away!' Nature, like the artist, ceaselessly transforms her materials, a phenomenon we miss only if we are not looking. If we chose to look, we would see nature's collages continually before us.

Perhaps most pertinently of all from Breton's point of view, Ernst had acknowledged in his work a deep connection between painting and the unconscious. In the same issue of the magazine Breton printed transcriptions of Ernst's two earlier hypnotic experiences – of the girl who appeared before him in a semi-transparent red dress and the mesmerizing experience of staring at the wood panels in his room that had led to his discovery of *grattage*. By this time Ernst had developed the connection still further: his work of 1927 included powerfully evoked forest landscapes set against nocturnal grounds that look as if they are made of steel or verdigris, with great

corrugated, metallic-looking structures in place of trees, in which appear huge, bright white or yellow circles that may be suns, moons or just painted rings; he was experimenting with perspective as if to push at the limits of space itself. His figures by now were stretched, fluid, biomorphic, metamorphic, moving towards monumentality in paintings such as *One Night of Love*, in which he seemed to be inventing a new pictorial language of desire. The forest pictures began to include figures with flying hair, holes for eyes; dark, brownish, loosely ape-like forms unleashed against pale grounds. Breton saw such works as harking backwards to Bosch, the Symbolist poets and the German Romantic tradition and moving forwards in the sense that Ernst was not copying but finding equivalents in paint for strong, barely expressible emotion – things as yet unsaid, even unsayable. Breton concluded his piece by reminding readers of Edgar Allan Poe's observation that the artist sees beauty in deformity – or, more precisely, that the pure imagination selects for examination elements, whether beautiful or ugly, which have never before been combined. Breton also quoted Poe's remark that if we wish to identify the traces of those with lasting influence we should read not the biographies of so-called great men but the memories of those left to die in prison or wandering the wings of our asylums. With such insights, especially as visualized by Ernst, Breton insisted, the texture of the world itself seemed freshly made. 'An inexorable rain, gentle and certain as the twilight, began to fall.'

By the time Breton's piece appeared in October Ernst had undergone a major metamorphosis in his personal life. That autumn in a gallery he met blonde, blue-eyed, twenty-year-old, convent-educated Marie-Berthe Aurenche, with whom he embarked on an exhilarating courtship. When her parents found out, they called the police – not only was their daughter below the age of consent, she was also, or so her mother claimed, a member of the royal family of France. She and Marie-Berthe's father (Director of Records at the Chamber of Commerce) forbade the union – none of which made the slightest impact on Ernst, who eloped with Marie-Berthe

to the Île de Noirmoutier, where the couple were married. When they returned Ernst rented a house for them in Meudon, the quiet village just outside Paris where Rodin had lived and worked. Even among Ernst's friends, not everyone approved. Those he fell out with during this period included (temporarily) Éluard, who called Marie-Berthe a liar for some remark she made about Gala, whereupon Ernst punched him in the eye. Éluard was already suffering, since the death of his father on 3 May, which although it had left him rich (he inherited the colossal sum of over a million francs, the equivalent today of several hundred million), had also left him shocked and depressed. For a while he confined himself to the house, giving Gala the opportunity to amuse herself, in Paris and elsewhere. He wrote to her, as ever, declaring his undying love: *'Je t'adore à l'égal de la lumière que tu es, de la lumière absente. Tout le reste n'est pas que passe-temps. Vous êtes ma grande Realité, mon Éternité'* ('You are the light of my light, wherever you are. Nothing else has meaning. You are my great Reality, my Eternity'). But it was time to let her go. The impact of his father's death had made him tired and sad; he was disillusioned with everyone. Eventually he also grew tired of trying to keep Gala when she clearly wanted to be independent. 'Enjoy your freedom,' he told her. Thus encouraged, Gala prepared herself for new adventures.

Breton met his own blonde that November, the mistress of a potential sponsor for *La Révolution surréaliste*. (Were all these women really blonde, or had they all just 'gone blonde'?) 'Blonde, sensually beautiful, with . . . a slightly haunted shadow behind blue eyes', Suzanne Muzard was soon dashing off to the Midi with Breton, who sent regular updates to his long-suffering wife Simone, reassuring her that Suzanne was everything he had hoped for; and by the way, could Simone please get in touch with Gallimard to ask where his proofs of *Le Surréalisme et la peinture* (due to appear in spring 1928) had got to? For the next few months he divided his time between Suzanne (who wanted him to marry her) and Simone (who had no desire to divorce him). The experience was fruitful in one sense, since Suzanne gave him the idea for the third and final

section of *Nadja*. He had been planning a final meditation on Nadja's 'jolts and shocks' of beauty. Instead he added a brief, more general reflection, a 'manifesto on the intrusion of marvellous chance and "jolting" beauty in human life'. With Nadja he had learned that desire disappears on possession, but that was not how he concluded his book. The final words of *Nadja* now read, 'Beauty will be CONVULSIVE or will not be at all,' long regarded as Breton's definitive encapsulation of surrealism, though it raises an interesting question – at what point in Breton's thinking had desire become synonymous with beauty? Unless he was still thinking of Poe's definition of beauty, deformed (and reformed) within the artist's imagination. In Poe's sense, Nadja's beauty becomes complex and multifaceted, an endlessly changeable (convulsive), moving collage; and her life, as she wanders the wings of her asylum, as valuable and meaningful as any obviously meaningful life – at least, to the observer.

The problem of the surrealists' misogyny has been noted by commentators including Angela Carter, who was vehement in her view that the surrealists hated women. But it should be remembered that though the 1920s seems in retrospect to be the decade of liberation for women (short skirts, late nights, blatant promiscuity), the Married Women's Property Act was introduced only in 1928; women did not easily find employment (except in wartime); and most apparently liberated women were in fact enjoying someone else's money. We know about the exceptions (Chanel was in a league of her own); the literature of the time should suffice as a window on so-called independent women's lives as they were actually lived (novels by men as well as women, that is, by F. Scott Fitzgerald and Hemingway as well as by Jean Rhys; and, for a consummately subtle example of the impact of deft misogyny, try Michael Arlen's *The Green Hat*). The surrealists' art took the female figure apart, inspected her – as it were – through a microscope; sifted through the parts of a woman with a metaphorical scalpel. The artists were baffled by women and wanted in their work to dissect and inspect the female – which does not quite excuse Breton

for his treatment of Nadja (who was not posing but all too poign-
antly real).

The opening of La Coupole on 20 December 1927 identified Mont-
parnasse not only as the hub of daytime café life but also as the
fashionably arty locus of Parisian nightlife. The former owner of the
Dôme had acquired a huge venue a few yards away on the boule-
vard du Montparnasse, and the glamorous new restaurant/bar
became overnight the place everybody went to be seen. According
to legend, the two thousand guests who attended the launch party
included film-makers, actresses, journalists, writers and artists
including Cocteau, Man Ray (with Kiki de Montparnasse, and other
adoring women) and Hemingway, well known by this time as the
author of *A Farewell to Arms* and also surrounded by fashionable
women. Before midnight (so the story went) one thousand five
hundred bottles of Cordon Rouge had somehow disappeared and
someone was sent urgently in a taxi to the Mumm depot for more.
La Coupole immediately eclipsed the Rotonde and the Dôme as the
most popular venue in Montparnasse. With its eye-catching geomet-
ric glass-and-steel art deco electric light-shade at the entrance and
fashionable murals depicting dancing couples decorating every pil-
lar, it was filled every night with joyous party-goers, the women
sparkling in short sequinned flapper dresses and costume jewellery,
the men in natty suits and highly polished shoes. Lined up outside
along the kerb, even the cars were two-toned. Everyone came to La
Coupole; *le tout Paris* crossed over from the Right Bank for their
demis bien tirés, their *whiskys réconfortants*; and to overhear all the
latest Left Bank gossip. The chef, dressed as the gatekeeper in *A
Thousand and One Nights*, served exotic curries. La Coupole quickly
became the symbol of 'the new Montparnasse'. At the same time, a
few streets away in the rue de la Gaîté, Yvette Guilbert, now well
over sixty, sang retro songs lit up in crimson and yellow lights against
a gold curtain to packed houses in the Bobino Music Hall, just as she
had in the 1890s. Nostalgia was enjoying a comeback.

At the start of 1928 the art market in Paris rocketed, then plum-
meted. 'Painters and Painting go up and down like Wall Street

Stock,' Duchamp grumbled to Alfred Stieglitz. Invited back to New York to manage a gallery, Duchamp had been on the point of accepting before remembering he was quite happy in Paris, enjoying his bachelor life in the rue Larrey. Why move? Man Ray told him he could earn ten thousand dollars a year if he would only return to painting; Duchamp said he had accomplished all he wished to in paint and saw no point in repeating himself. On 11 February Breton's *Le Surréalisme et la peinture* appeared in book form, with an additional section on Miró. He made up for having so far overlooked Miró by designating him the painter who best exemplified automatism in painting, perhaps even 'the very reason why he could perhaps pass for the most "surrealist" of us all'. In his work there was 'a pitchfork in every star'. Perhaps he had seen one of Miró's most striking pieces of 1928, *Portrait d'une danseuse* (now in the Surrealist Galleries of the Pompidou Centre), a delicate, minimalist construction made of cork, feather and metal on painted paper. Balanced on a cork pierced through with a ball bearing on a long spike, the feather drops from the steel ball like a dancer after a leap. No one else, Breton wrote, had 'the same ability to bring together the incompatible, and to disrupt calmly what we do not dare even hope to see disrupted'.

By spring the Galerie Surréaliste permanently housed work by artists including Arp, Braque, de Chirico, Ernst, Masson, Miró, Picasso and Man Ray – a significant line-up. The March issue of *La Révolution surréaliste* included advertisements for the forthcoming publication of *Nadja* and of publications by Freud (*Three Essays on the Theory of Sexuality, The Interpretation of Dreams, Leonardo da Vinci and a Memory of His Childhood, My Life and Psychoanalysis*) and yet another hatchet job on de Chirico. This time the attack was personal – compared to the youthful painter of mystery, melancholy and dream, de Chirico had become merely an unsavoury old copyist. From now on, the artist viewed Breton (not the author of the attack) with pure, unmitigated hatred – though Breton continued to reproduce de Chirico's early work in the newspaper. Also that year Cocteau published *Le Mystére Laïc*, his book of jottings

with five lithographs by de Chirico; improvised reflections included one of his most celebrated remarks: 'Victor Hugo was a madman who thought he was Victor Hugo.' The book also contained Cocteau's further reflections on de Chirico, among them the insight that, despite their air of solemnity, his 'paintings borrow nothing from dreams. His paintings seem rather as though they are sleeping and dreaming of nothing.' Cocteau compared them instead with photography and film and remarked that the works look as if they have been made into statues. And he compared de Chirico's work with Picasso's, coming up with a subtle distinction. One day, he predicted, 'our age will be called the age of mystery. People paint mystery as they used to paint the circus. Chirico is a painter of mystery. Picasso is a mysterious painter.'

As it headed towards closure, the tone of *Le Révolution surréaliste* became ever darker. In that same March issue Breton and Aragon celebrated the centenary of Freud's great revelation of 1878 that hysteria was the expression not of sickness but of passion. Six large photographs of a hysteric (spanning a page and a half) accompanied the article, which was printed entirely in capitals. They announced that, following centuries of misappropriation, in which hysteria had been successively regarded as divine, infernal, mythical, erotic, lyrical, social, *savant* and irreducible to definition, they were here sharing their own conclusion: 'L'HYSTÉRIE N'EST PAS UN PHENOMÈNE PATHOLOGIQUE' ('HYSTERIA IS NOT A PATHOLOGICAL PHENOMENON'). In the same issue there also appeared the findings of a two-part seminar held by Breton on sexuality; in it he posed the question, could a man love two women at the same time? Man Ray supplied his answer: yes, but in that case, he would need more than two.

The publication of *Nadja* on 25 May made little impact for the first few months; it was only towards the end of the year that the book began to get good reviews. That was not right either, as far as Breton was concerned, for if surrealism was gaining acceptance, what had happened to its agenda of rebellion? To Éluard he complained that there seemed to be fewer and fewer conversations

worth having. 'Endless games. The phonograph. What's the use of it all.' He could no longer count on Aragon's friendship either, since Aragon's private life had taken a dramatic downturn that summer. During their travels he and Nancy had visited the Hotel Luna in Venice, where the band consisted of four black musicians playing jazz improvisations and swing melodies. Nancy adored the music, which she thought better than anything she had heard in Paris. The musicians also appealed to her, particularly striking-looking Henry Crowder, in the city with the band for the season. No sooner had they struck up a conversation than she was immediately swept away. Within three years, with Henry's help she had set up a publishing house, and in 1931 published *Negro*, an extraordinary 460-page album of profoundly significant writings on the African-American experience, incorporating pieces on music, education and law, poetry and accounts of racial injustice; it also included Lincoln's 'Proclamation of the Emancipation of the Slaves' as well as writings by some of the first influential female poets and abolitionists. (By contrast, Josephine Baker got a single mention, as one who had 'obtained a success in a special art. The taste of the times for exotic song and dance has brought to her artistic recognition but no social admittance in America'.) Meanwhile, at the end of the Hotel Luna's 1928 summer season Henry accompanied Nancy back to Paris, where he resumed his former existence playing in small bars in Montmartre and Montparnasse. For a while the three of them hung out together, *'en groupe'*, as Aragon drily put it. Sometime later, probably in mid-September, Aragon took an overdose of sleeping pills and lay down in a hotel room to die . . . except that someone found him in time and took him to hospital, where he recovered.

In October he reappeared in Paris, where he and Breton attempted to revive their spirits by writing a theatrical sketch together, *Le Trésor des Jésuites* (*The Treasure of the Jesuits*); although based on the true story of an unsolved murder, it was primarily a tribute to Musidora, the wild silent-movie star of their youth. They interspersed the drama with references to current events, yet it was

seeped in nostalgia, and reviewers dismissed it as fatally dated. Musidora was fifty by now, remarked one (actually, not quite forty); the authors were clearly just trying to relive their youth. All they had achieved was 'a poor pastiche of Surrealism, with its stereotyped insistence on seedy hotels and café tables and "mysteries" as flabby and middle-aged as Musidora herself had become'.

As if to confound everyone (including Breton) yet again, Ernst's large exhibition of December 1928 at the Galerie Georges Bernheim included fresh new work in pale colours incorporating shells, feathers, crystals, jellyfish, reeds and jewels. *Snow Flowers* (1927) was among the first of these works in an entirely original style. The catalogue included an introductory text by René Crevel: 'All his friends are metamorphosed into flowers. All the flowers are metamorphosed into birds, all the birds into mountains, all the mountains into stars. Each star becomes a house, each house a town.' *'L'entrée des fleurs*; *comment ne suis-je pas cette charmante fleur?'* ('Entry of the Flowers; why aren't I this Charming Flower?' was the title of one of the paintings). The preface broadened out this wholly novel question: why are we not flowers? Such an enquiry seems almost to supersede surrealism, referring forward to questions such as that posed a decade later by Virginia Woolf in *The Waves*: '"like" and "like" and "like" – but what is the thing that is beneath the semblance of the thing.' In Ernst's shell paintings, shells are encrusted as though washed up from the depths of the sea. In his flower pictures, the flowers seem suspended completely from the picture space, signifying nothing; in a world – as it were – of their own. Ernst continued to develop this idea; his *Shell Flowers* of 1929 are more like jewels. (Dalí pastiched them in a work of the same year, *The Accommodations of Desire*, which features shells containing miniature lions' heads, human skulls and ants).

In Montparnasse by the end of the year most of Breton's friends had been lured by the glamour of La Coupole, a milieu Breton loathed – he found it too smart, too fashionably arty, nothing to do with mystery or chance. In the final issue of *La Révolution surréaliste* (which eventually appeared in December 1929) he planned to

publish his readers' responses to a questionnaire on love. '*Quelle sorte d'éspoir mettez-vous dans l'amour?*' ('What sort of hope do you place in love?) he had asked. '*Comment envisagez-vous le passage de* l'idée d'amour *au* fait d'aimer?' ('How do you picture the passage from the *idea of love* to the *reality of loving?*') Did anybody still care?

14.

The Impact of Salvador Dalí

Accompanied this time by film-maker Luis Buñuel, Salvador Dalí
arrives in Paris to stay. He is already (through Spanish art magazines)
well versed in surrealism, and particularly tantalized by rotting
donkeys, shop-window (and real) mannequins . . . and Gala Éluard.
Breton's surrealist group meets René Magritte. Diaghilev dies in Venice.
Dalí and Buñuel make a film, *Un Chien Andalou*, which – somewhat
surprisingly – proves a hit with the surrealists.

In April 1929 Salvador Dalí returned to Paris, this time with future
film-maker Luis Buñuel, the two of them planning to make a film
devoid of any rational element whatsoever. Buñuel's first idea had
been to film the story of a newspaper which became animated, the
film composed of shots of bounding news items, comic strips and
other scraps of print, until at the end the paper would be thrown on
to the pavement, swept into the gutter by a waiter. Dalí thought it
was a terrible idea. Anyway, they were about to create something
of an altogether different order. Buñuel (who had first visited in
1925) loved Paris – the cafés, the accordion music, the kissing
couples in the streets, the fancy-dress balls . . . One evening, on his
way to the Closerie des Lilas dressed as a nun, he and a friend (dressed
as a monk) were stopped by two policemen. He had expected to be
cautioned, even thrown in gaol, but no . . . 'Good evening, Sister.
Can we help you?'

Dalí and Buñuel were taken about by Miró (with whose work
Dalí was already familiar). The three years since Dalí's previous
visit to Paris had done nothing to reduce his awkwardness; he was

still very shy and had developed a new habit of bursting into uncontrollable, hysterical laughter in the company of strangers. Miró told him not to talk so much, advised some form of physical training and introduced him to a friend of René Magritte, Belgian dealer Camille Goemans, who was planning to open a gallery in the city. Goemans promised Dalí an exhibition later that year. After a visit to the brothels (where Dalí found the decor more appealing than the girls), Miró took them to the cafés, where they met Breton, Aragon and the other surrealists.

Dalí was by now well acquainted with surrealism, through Spanish art magazines as well as through exhibitions in Spain, but he did not yet see himself as a surrealist artist. At first, he was keen to distinguish himself from them, working out a position of his own in articles he was already publishing in *L'Amic de les arts*. He was still grappling with the issues that had preoccupied him since meeting Lorca, poet and 'swarthy gypsy with black hair and a child's heart', who had spent the summer of 1927 with Dalí in Cadaqués, where he had succeeded in releasing (or increasing) Dalí's 'perversions' (Dalí's word). For Dalí the summer of intimacy had provoked a fascination with scatology and putrefaction, topics he went on to explore in detail in his articles and in early paintings. Now, he had succeeded in extricating himself from the relationship, having found their intimacy too perplexing. The tipping point had come in September 1928 with the publication of Lorca's book of poems *Gypsy Ballad Book*, which Dalí found unforgivably retrograde. Lorca's work was so conventional, it was not even poetic, Dalí told him. 'You speak of a rider and you suppose that he goes on top of a horse . . . You have to leave things *free* of the conventional ideas to which intelligence has sought to subordinate them.' To Lorca he recommended surrealism as 'the one means of Escape' and told him he should be concentrating on the escape from rational thinking, not the events of the previous summer. (Lorca, devastated, left Spain for New York, where, dazzled by the ambience of the city, he spent the next three months writing his first plays.)

Thus liberated, Dalí pursued with vigour his own researches into

the subject of putrefaction. For Dalí, decay was the thing. His own bodily functions fascinated him; these, together with those of other organisms, constituted the main focus of his art between 1927 and 1929. The sight of anything disintegrating intrigued him, as did what he called 'small things' – ants, single hairs – and the sheer, uncanny notion that everything naturally ended in decay, in the process undergoing fascinating visual and textural transformations. Everything he looked at – his body, the world around him, even religious art – seemed to offer up its own dark side: the strange spectacle of decomposition and its metamorphoses. Development of the intriguing large, fluid, 'soft' forms which had first emerged in his Picasso-inspired work of 1926 remained on hold while he painted these intricate figures and objects, truncated body parts and decomposing animals, perhaps most starkly conveyed in two works of 1927, *Honey is Sweeter than Blood* and *Apparatus and Hand*. In the latter a kite-like apparatus, part geometric, part human (very like the structure in Ernst's *Elephant Celebes*), is surrounded by smaller forms apparently stranded in mid-air, including a torso, random female figures, a pair of free-standing breasts and a partially decayed headless donkey. Etched in ghostly wisps of white where the head should be is a bird with the skeleton of a fish. Through the top of the whole bizarre construction appears a flayed hand, vivid with blue veins, apparently in the process of electrocution.

Dalí continued painting in this style, referencing Ernst once again in *The Spectral Cow* (1928), reminiscent of the German artist's *The Beautiful Season*. Where in Ernst's painting the interior of the goat is revealed, Dalí goes one step further. *The Spectral Cow* depicts a flayed animal surrounded by the decaying bodies of other indeterminate creatures rotted to almost nothing, the head of a robust-looking worm the only live creature shooting up from inside it. To the right of the scene a disembodied form (which again resembles the apparatus in *Apparatus and Hand*) floats free. The apparatus has no rational identity or purpose. The real subject of *The Spectral Cow* seems to be nature herself – the earth is dark brown, the sea blue, the background earth-pink turning to

brownish-yellow and suspended above the whole scene is a clearly delineated, milky full moon.

All things rotting fascinated Dalí and he wrote about decomposing donkeys, disintegrating cows, putrefied giraffes; he was unprepared to exclude even the saints from his examinations. (In 2016 the Museum of Contemporary Arts in Malaga showed a stuffed donkey perched like a seated human at the top of an immense pile of books on every subject.) For Dalí the point of art was revelation, not obfuscation or concealment, the latter having been perpetrated, in his view, by the ancient religious artists, since where there was no decay there was no truth and thus no true spiritualism; if these painters' work was art, then contemporary artists, he thought, needed to practise what he began calling 'anti-art'. In one of his earliest published articles, 'Description of the Figure of Saint Sebastian' (1927), he reimagined the head of Saint Sebastian split into halves, one made of something like a jellyfish. In another article, 'Putrefaction', he wrote that on the 'other side of Saint Sebastian's magnifying glass' was putrefaction; by looking at the figure of the saint from behind, he claimed, he had gradually discovered 'the whole world of the putrefieds'. He saw no virtue, in any case, in reverence for the art of the past, pointing out that even the Parthenon had not actually been built as a ruin; in its own day it had been as new as a 1928 automobile. (In 2017 Damien Hirst inverted that observation with *Treasures from the Wreck of the Unbelievable*, displayed at Venice's Palazzo Grassi across five thousand square metres of pavilion space, the result of a spoof excavation by a freed slave, the immense, apparently sea-drenched treasures in fact created by Hirst between 2007 and 2017.) According to Dalí, if photography had been invented then, photographs of the newly constructed Parthenon would mean more to us today than our obsession with its 'miserable ruins'. The mechanized world of the present was surely 'perfect and pure as a flower'; there were countless examples of such beauty in everyday life – white wash basins and refrigerators, the telephone, the phonograph . . . works of art should surely be treated like those objects: all, though beautiful in their own way, replaced when they wore out, like old shoes.

For Dalí, in the modern world the art of photography took the place of the religious art of the past, since in revealing the world precisely, in all its physicality, the camera rendered things truly spiritual. He was equally fascinated by the art of cinematography. 'In the cinema, a tree, a street, a game of rugby, are transubstantiated in a disturbing manner', that is, unembellished and unaltered by the eye of the maker, since the 'anti-artistic' film-maker is anonymous, invisible behind the camera, shooting the world as it really is, composed, in the here and now, of a coffee shop, a simple room, 'a kiss inside a taxi'. He himself, he considered, looked at the world not merely as a photographer but as a film-maker, as through a precision lens or a magnifying glass, to uncover and bring into focus figures and things in motion; he claimed he had once (by using binoculars?) discerned 'on the deck of a white packet boat, a girl with no breasts teaching sailors to dance the *black bottom*'. In an article of December 1927, 'To Luis Buñuel, Film-maker', he warned, '*Careful! A lot of birds are coming forth!*' (echoing the photographer's warning in Cocteau's *Les Mariés de la Tour Eiffel*).

In early 1928 he had set out his own position as an artist in an article immodestly entitled 'The New Limits of Painting'. In it he distinguished between the 'art of conception' (early de Chirico and the cubist painters) and 'the art of perception' (Vermeer and the Impressionists, painters who looked without theorizing and painted what they saw). In another piece of 1928, 'Joan Miró', he had specifically pinpointed photography and the cinema as forerunners of surrealism, arguing that 'nothing could be more favourable to the osmosis between reality and surreality than photography'. Increasingly, then, he was beginning to identify with surrealism; and by 1929 he remained unconvinced by only one element of the surrealists' agenda – their interest in automatism, which he was unable to reconcile with his own emphasis on viewing the world objectively, as through a lens. (In Dalí's terms, automatism presumably counted as art, rather than anti-art.) In an article of February 1929 he wrote of documentary cinema that it was 'the most complete, scrupulous and exciting cataloguing ever to be imagined', identifying it as the

supreme form of 'anti-art'. As for Ernst and Magritte before him, for Dalí the very business of cataloguing was inventive, involving 'the capturing of an UNKNOWN REALITY. Nothing will prove Surrealism right as much as photography, with the unusual faculties of the Zeiss lens!' He read Breton's *Nadja* and completely understood it, as Breton had intended it, as a kind of documentary. By the time he arrived in Paris in April 1929 Dalí was an enthusiastic advocate of surrealism.

In the streets of Paris, he was tantalized by the shop windows, with their displays of shoes and mannequins, those sur-real objects already rendered uncanny by Man Ray, Vionnet and Vigneau. Dalí described them: 'quiescent in the electric splendour of shop windows, with their neutral mechanical sensualities and disturbing articulations'. Just as bizarre, to his eye, were the live mannequins, in those days employed in department stores to model the outfits on sale, 'sweetly stupid . . . walk[ing] with the alternating rhythm and opposing movement of hips and shoulders, clasping unto their arteries the new, reinvented physiologies of their costumes' (life imitating art). Of the painters he now met in Paris, those he most admired were Miró, with his free-floating objects and calligraphy, and Ernst, then still painting horses, their manes flying, galloping through the sky, and works such as *Inside Sight: The Egg*, in which the mother as well as the baby birds are visible through the eggshell – forms within unhatched forms. Ernst was also just completing his first collage-novel, *The Hundred Headless Woman* (1929), composed of some hundred and fifty separate *papiers collés* lifted straight from other illustrated publications, the images spliced scene by scene, as in the cinema. (An enormous pair of naked legs bursts through a box while two diminutive, fully clothed men look on. Against a minuscule city backdrop an outsized hand holding a dial or measure is set against the gigantic geometric rays of the sun.) Since the invention of frottage and *grattage* Ernst had continued to explore the interaction of internal and external experience, though this is not to be confused with painting pictures of dreams. As he himself put it, 'If the Surrealists are called painters of

a continually fluctuating dream-reality, this should not be understood to mean that they copy their dreams on canvas.'

Others involved in surrealist activity by that spring included Belgian artist René Magritte, in Paris since 1927, who was already being championed by Breton as the only painter in the Belgian group of surrealists (the others being philosophers and poets). While still in Belgium, Magritte's first professional commission had been with film-maker Paul Nougé, with whom he designed a catalogue for a Brussels furrier, advertising luxury fur coats. Their spreads had depicted headless, legless women; a woman stepping through a free-standing door unattached to a wall; women with dissolving bodies, eyes closed or otherwise obscured; the head of a woman partially obscured by a cut-out of a car. Nougé's captions were correspondingly surrealist. 'Dressed thus, she requires no explanation': 'Not in the eyes, not in the hands, it is in the folds of the coat that she hides her secrets and yours.' Magritte's paintings of 1927 were similarly, if more brutally, unsettling. In *Girl Eating a Bird (Pleasure)* a girl eats a bird with macabre relish, blood dripping from her lips; in *A Murderous Sky* dead, still-bleeding birds are strewn across a pile of rubble. As Magritte himself put it, his interest, like Dalí's, was in showing a thing becoming '*gradually* something else, an object *merging into* an object other than itself'.

Through Goemans Magritte had met Miró, Ernst and others. Though Magritte never lived in the city (he and his wife, Georgette, lived in the suburb of Le Perreux-sur-Marne), by 1929 he had established strong connections in Paris, notably with Aragon and Breton. His work became increasingly identifiable as surrealist. During those early years there he produced *Man with a Newspaper* (1928, now in the Tate Modern), a work in four frames in which the man with the newspaper appears only in the first; and *The Reckless Sleeper*, in which the sleeper lies in an alcove suspended in the sky above a stone or tablet in which are set apparently unrelated objects – bird, hat, mirror, ribbon, candle, apple; he may be dreaming of them, or they may be simply, arbitrarily, there. Another work of 1927, *The Key of Dreams*, consists of four pictures each accompanied by a caption, but the captions are unrelated to the images – except for one (which,

though it matches its image, is written in a different language from the rest). As in Miró's work, there is no easy correlation between word and image; the word does not explain the image, it merely unsettles the relationship between word and thing. Magritte's connection with the Paris surrealist group deepened that spring of 1929, but though his work seemed (and still seems) unquestionably surrealist in style, he was never particularly close to any of the surrealist group. Even so, during his less than three years in (or near) Paris, he produced a hundred and seventy new works, among them major surrealist paintings, including *The Treachery of Images* (1929), his painting of a pipe which famously bears the caption, *'Ceci n'est pas une pipe'* – 'This is not a pipe'. (It is a painting.) With the arrival of first Magritte and now Dalí, surrealist painting in Paris was rapidly moving in new directions. Breton was preparing the December 1929 issue of *La Révolution surréaliste*, in which he planned to reproduce works by both artists. He was, however, running short of funds, and with no new support forthcoming.

By the summer Dalí and Buñuel were ready to show *Un Chien Andalou* to a small group of friends at the Studio des Ursulines cinema. The animated-newspaper idea had been abandoned, its place taken by a startling cinematic collage of images allegedly taken from Buñuel's and Dalí's dreams. Made with financial backing from Buñuel's father, the twenty-four-minute silent film began with the close-up of a razor blade slicing into an eyeball (Dalí's dream of his mother), followed by a succession of apparently random actions – a man riding a bicycle with no hands on the handlebars, a couple viewed from above, kissing in the street beside an enormous glossy car . . . until the final shot, of a couple buried up to their chests in sand, 'blinded, in rags, being eaten alive by the sun and swarms of insects'. Dalí's major contribution (according to Buñuel) had been the idea for the shot of two dead donkeys splayed out beneath the lids of two grand pianos, their decaying heads lolling across the keyboards. In Dalí's opinion, with the opening shot they had made artistic history, ruining ten years of 'pseudo-intellectual' post-war avant-guardism: 'That foul thing which is figuratively called abstract

art fell at our feet, wounded to the death, never to rise again, after having seen "a girl's eye cut by a razor blade . . ." ' In fact, the eyeball was a cow's – which hardly diminished the impact.

Un Chien Andalou impressed everyone who saw it. Buñuel knew about the surrealists' reputation for storming events and had prepared himself for one of their protests, but Breton and his group all loved the film. Breton immediately began attempting to persuade Buñuel to publish the full screenplay as an exclusive in the forthcoming issue of *La Révolution surréaliste*. (He succeeded, despite competition.) Breton's mood had, in any case, improved, perhaps as a result of his latest romantic conquest – Cocteau's friends Jean and Valentine Hugo were on the point of separating because of her affair with Breton, an unexpected turn of events which, if nothing else, had apparently resolved the Simone/Suzanne dilemma, at least for the time being. Cocteau's friend the Vicomte Charles de Noailles, who had recently begun to provide backing for avant-garde films, had been in the audience at the Studio des Ursulines. He was so impressed by the film that on 1 July (three months before the commercial opening at Studio 28 scheduled for 1 October) he arranged a private showing in his fabulously ostentatious home.

Cocteau also admired the film. In the midst of preparing his next book, *Opium*, for publication he amended his observation that he had so far seen only three great films (Buster Keaton's *Sherlock Holmes Junior*, Chaplin's *Gold Rush* and Eisenstein's *Battleship Potemkin*). 'I add: Buñuel's *Un Chien Andalou*. There it is, the style of the soul. Hollywood was becoming a luxury garage and its films were more and more beautiful types of motor-cars. With *Un Chien Andalou* we are back on our bicycles. Go forward and fall, bicycle, bull-ring horse, flea-ridden donkeys.' The film showed the flow of 'blood from the soul's body', seldom if ever portrayed.

> It is this inexpressible thing, this phantom of the awakening of condemned men, that the screen shows us like objects on a table. Only Buñuel can bring his characters to those moments of paroxysm in suffering when it becomes natural and as though fated to see a man

in a frock coat ploughing up a Louis XVI bedroom. If Buñuel fasci-
nates Eisenstein this must be through Freud. The complex of hands
and doors . . .

To accompany their showing, on 3 July the Vicomte and
Vicomtesse de Noailles gave a spectacular party in their great mir-
rored ballroom with its frescoed ceiling and an up-to-the-minute
projection room, equipped for sound, the workings concealed
behind rococo panelling. Guests included Cocteau, the Beaumonts,
the Jean Hugos (evidently presenting a united front for the occa-
sion) and assorted members of the *gratin*. The more Marxist-inclined
surrealists were scathing about the de Noailles' ostentation but had
no problem enjoying their hospitality. Picasso attended the party,
then seemed to go into retreat. From now on, he occasionally
appeared with Olga, but they seemed to have more or less given up
on social engagements. Picasso had come to the end of his *époque
des duchesses*. He retreated to work on new sculptures and to spend
time, still secretly, with Marie-Thérèse. Though he had missed the
preview of *Un Chien Andalou*, he saw the film later that year. He said
he admired it because it was so Spanish.

For the time being Picasso still resolutely dissociated himself
from surrealism, though he was concerned to establish his own pos-
ition vis-à-vis Breton's. A short time later he told his dealer Daniel
Kahnweiler that of course the word 'surrealist' had been his own
invention, taken up and published by Apollinaire, and that it meant
'something more real than reality'. Putting aside the question of
who first thought of it, Picasso's interpretation (echoing Apollin-
aire's) was thus closer to Dalí's than to Breton's, and Picasso (like
Dalí) never agreed with Breton about the relevance of either Freud
or Marx. To another friend (writer André Warnod) Picasso said
more or less the same thing. 'Resemblance is what I am after, a
resemblance deeper and more real than the real, that is what consti-
tutes the sur-real.' In February that year Michel Leiris had published
an article in *Documents* in which he, on the other hand, argued that
Picasso's work was too 'down to earth' to be surrealist. It 'never

emanates from the foggy world of dreams, nor does it lend itself to symbolic exploitation – in other words, it is in no sense surrealist'. Even so, Picasso continued to watch carefully as surrealism evolved from its origins in poetry that appealed (he said) to 'pale young girls rather than girls in good health on the grounds that moonlight is more poetic than sunlight etc. . . . Dada followed a better route', into works on canvas by Ernst, Miró, Magritte and now Dalí. Within three or four years Picasso was telling friends, 'the Surrealists . . . were right. Reality is more than the thing itself. I always look for its super-reality.' His own fully surrealist phase was still to come – in the mid-1930s, after he met Dora Maar. In the meantime, once Miró, Magritte and Dalí had begun to move centre stage it was clear the artistic tide in Paris had already turned.

Dalí remained in Paris for the preview of *Un Chien Andalou* but not for the party or the commercial opening in October. In June he returned to Cadaqués to spend the summer with his family. The evening before he left the city, Goemans took him to the Bal Tabarin. They had just sat down when a man came in with a woman in a black-spangled dress. 'That's Paul Éluard, the Surrealist poet' (with a friend, not Gala), said Goemans, and called them over. Before leaving, Éluard promised to visit Dalí in Spain.

Dalí thus once again just missed the new season's show by the Ballets Russes – in the event, the company's last production. *Le Bal* opened in June at the Théâtre Sarah-Bernhardt, a tale of love and magic which unfolds during a masked ball, with sets and costumes this time by de Chirico, who (though he had designed sets for the Ballets Suédois in 1924 and for a production of his brother's in Italy in 1925) was working for the first time with Diaghilev. The script was an adaptation by Boris Kochno of the original story, set in the Romantic period, which Kochno described as a poetic episode with a mysterious, unearthly character which he thought few people understood. Though de Chirico's sets were hardly typical of the period, Kochno was satisfied that they reflected the spirit of the piece, the sets successfully accentuating the ballet's ghostly elements. For the costumes de Chirico had used motifs adapted from

classical architecture – scrolls, triumphal arches, Ionic capitals – and marbled not only the walls of the ballroom but also the fabric of the costumes, giving the dancers the appearance of animated statues. His designs proved hugely popular. On the last night of the production he was called to the stage – 'Scirio! Scirio!' – to take his bow with the composer and principal dancers. Cocteau, in the audience, found himself moved, after always associating de Chirico with the 'eloquent silence' of his canvases, to see him 'emerging suddenly from the deathly silence of private views into a din of applause, like the bull from the darkness of the *toril*' (bull pen).

Le Bal was successful in all its venues – Paris, Monte Carlo, Berlin and London, where the final performance took place at the Royal Opera House on 29 July. By 19 August the great maestro of the Ballets Russes was dead. Diaghilev, who had always feared death by water, was taken ill on the Lido, in the last stages of diabetes, having neglected his health for many months. The local Venetian doctor was no help – he thought Diaghilev might be suffering from rheumatism, typhus, influenza, septicaemia . . . At the Grand Hotel des Bains, he took to his bed. On the night of 18–19 August his great friend Misia Sert was summoned to his side. Discovering he could not pay for further medical assistance, she rushed off to pawn her diamond necklace until the arrival of Chanel, his other devoted friend, who took care of all the arrangements, including his funeral. 'In the grey hour, three gondolas moved away from the hotel' . . . 'That floating bed of honour, a Venetian convoy, carried the magician's remains to the funeral isle of San Michele.' It was followed by a gondola containing Kochno and Lifar, Misia and Chanel, all dressed in white, the only four mourners at the cemetery. Following a brief service in the Russian Orthodox church, Diaghilev was buried in the Greek section of San Michele. He died penniless, having always invested everything he earned straight into his next production. And so, as Janet Flanner informed readers of the *New Yorker*, 'the Ballet that altered stage decors in England, France, and America, and left a rich heritage of color and form to a generation that originally wished for neither' came to an end.

By the time Dalí arrived at Cadaqués, the whitewashed coastal village of his childhood and adolescence, he had already received a telegram from Goemans offering three thousand francs for all the paintings he could paint that summer, to be exhibited in Paris in November. The cable was followed by Goemans himself, who expressed particular enthusiasm for the painting Dalí was working on, *The Lugubrious Game*, a scene depicting open spaces, ornate statuary and a male figure with excrement running down his legs. A few days later Magritte and his wife arrived, followed by Buñuel. Éluard and Gala were on their way. 'Thus, within four days I was surrounded for the first time by surrealists', all attracted there (he assumed – probably rightly) by his extraordinary personality. Even in his native surroundings Dalí was assailed, as in Paris, by fits of shyness and nervous giggles. In the midst of serious discussion, he would dissolve into peals of laughter. Don't ask Dalí, someone would say, we'll be in for another ten minutes of it. He was already 'writhing with laughter' one morning when a car stopped in front of his house and Éluard and Gala stepped out. They arranged to meet him for drinks at five o'clock.

The whole assemblage of surrealists went with him to join the Éluards. Over a drink beneath the plane trees, Dalí's 'case' was explained to Éluard (his paintings were good, but potentially offensive), then Gala and Dalí went for a walk, after which they arranged to meet again for a swim the following morning. At eleven o' clock Dalí looked out of the window and saw Gala already there; he instantly recognized her bare back and ran out to meet her. Gala was in holiday mood, enjoying the beach and the sunshine, and now here, to add to her delight, was the black-haired, olive-skinned slender young boy, whose father, like Éluard's, was rich, and whose art, like Éluard's, was original, sensuous and excitingly progressive. Éluard it was who sent Gala to question Dalí more closely, wary of the scatological aspect of his painting. She was to ask him whether that element was a vital component of his art, or merely incidental.

The following day Dalí went over to the Hotel Miramar to meet Gala. She talked to him about *The Lugubrious Game* and told him she

recognized that his work was important but that, if the scatological aspect reflected his personal taste, he should know they had nothing in common; and if he saw his art as a means of proselytism and propaganda, that was almost as bad, since he ran the risk of undermining it by reducing it to the level of a psychopathological document. Dalí set her mind at rest; scatology was merely a terrorizing influence, he told her, on a par with blood, or his phobia for grasshoppers, which had horrified him since childhood, when he had once picked up a small fish whose head reminded him of one. The start of his relationship with Gala was thus marked, as he noted in his memoirs, by 'a permanent character of diseased abnormality' (as any element of sexual deviance was classified, before Freud's writings gained wider credence) and by his irrepressible sense of humour. Dalí and Gala spent hours alone together, walking, swimming, day-dreaming in silence and amusing themselves by pushing granite blocks over the edge of a cliff, before Dalí experienced an overwhelming desire to push Gala over, too, at which point they decided they had better stop. Gala was hooked. She told Dalí she had already realized they would never part. Now she just had to decide what to do about Éluard. By 26 September Dalí's father had changed his will, leaving all his property to his daughter (Dalí's sister, Ana Maria), almost certainly his reaction to his son's outrageous dalliance with Gala, a shameless, married woman. Gala left for Paris with her daughter Cécile, taking with her, at Éluard's request, the controversial painting *The Lugubrious Game*.

The Long Lens of Surrealism

With Miró, Magritte and now Dalí on the fringes of Breton's group, surrealist art seems to be being consolidated . . . although Breton offends Magritte, who returns to Belgium. Dalí exhibits with the Parisian surrealist artists. At the showing of a second film by Buñuel and Dalí, *L'Âge d'or*, protestors storm the cinema. Breton falls out with Dalí, who visits New York with Gala. The long lens of surrealism is briefly trained on the Parisian Surrealist Exhibition of 1938, where Rrose Sélavy makes her debut (as a scantily clad mannequin in male clothing). With the infiltration of surrealism into popular culture, the surrealists announce their conviction (formalized some years later by Duchamp) that the viewer (still waiting, maybe, at the foot of the staircase) is required to complete a work of art.

Dalí followed Gala, arriving in time for his first solo exhibition in Paris, due to open at Goemans' new gallery on 20 November 1929 (and ending on 5 December), where a mixed exhibition of work by surrealist painters (Arp, de Chirico, Dalí, Ernst, Magritte, Miró and Picasso) was also planned, for December. Two of Dalí's works were sold before the opening of his show, one to the Vicomte de Noailles, who had snapped up *The Lugubrious Game*, the other, *Accommodations of Desire*, to Breton. All boded well for Dalí, as for others (the Galerie Van Leer was also due to show works by Ernst and Man Ray in December). Then, suddenly, everything changed. The opening of the Galerie Goemans coincided precisely with the overnight collapse of the New York stock market, which triggered a worldwide depression. 'The Wall Street crash has had its effect here,'

Janet Flanner informed her readers, 'at the Ritz bar the pretty ladies are having to pay for their cocktails themselves . . . In the rue la Boétie a thrifty young Frenchwoman, who . . . bought herself a majority of stock in the art gallery where she works, finds that all the 49 blue Dufys are still hanging on the wall' . . . and unlikely to move. 'In real-estate circles certain advertisements have been illuminating: For Sale, Cheap, Nice Old Chateau, 1 Hr frm Paris; Original Boiseries, 6 New Baths; Owner Forced Return New York Wednesday; Must Have IMMEDIATE CASH; Will Sacrifice.' Goemans was forced to close his gallery after only three exhibitions, abandoning artists including Magritte, who had signed a contract with him only a month earlier. Dalí's exhibition nevertheless went ahead. Just before the opening he ran into Éluard, who said Gala was surprised Dalí had not yet been to see her. He headed straight to the florist's and would have arrived on her doorstep bearing a hundred red roses had he not noticed just in time they were priced by the stem. On 18 November he and Gala disappeared on a lovers' voyage, missing the opening of his show.

On 14 December Breton held a gathering in his apartment, to which Magritte and his wife, Georgette, were invited. Noticing Georgette was wearing a cross and chain, Breton asked her to remove it. Deeply offended, she explained it was a family heirloom, and the couple made their exit. The rupture was permanent; in the New Year they returned to Belgium, Magritte having both lost his dealer and severed his connection with the surrealist group in Paris. On the 29th the final issue of *La Révolution surréaliste* duly appeared, including examples of work by both Dalí and Magritte, the entire script of *Le Chien Andalou* and Breton's *Second Surrealist Manifesto*, a brief diatribe in which he insisted that, despite all the wrongdoing and monstrous failures of history, '*L'homme . . . est encore libre de* croire *à sa liberté. Il est son maître*' ('Man is free to *believe* in his liberty. He is his own master'). A column by Breton and Éluard entitled 'Notes on Poetry' included the observation that '*La poésie* est *une pipe*' ('Poetry *is* a pipe') – the assertion being a simile, or perhaps just nonsense. The paper also included an unsigned,

oddly haunting photograph of an overturned car, apparently undamaged, abandoned beside a deserted building at the corner of a street, like a kicked-aside shoe – or a Nice Old Chateau.

Dalí and Gala did not return to Paris until the following spring, after spending a few months in the south of France. On the way back, they stopped off in Barcelona, where on 22 March 1930 Dalí gave a lecture, 'The Moral Position of Surrealism', for the edification of the coming generation of Spanish artists. Surrealism, he told his student audience, revealed that, although people appeared to behave in accordance with accepted moral and rational conventions, in fact all human action reflected the workings of the unconscious. Being in love is really just the return of the repressed; real moral goodness consists in being honest about our desires (the example Breton had tried to set with Nadja), which provokes crises of consciousness positively encouraged by surrealism, within the terms of which the Marquis de Sade displays 'the purity of a diamond'. Having thus enlightened the youth of Barcelona, they headed for Cadaqués, where at the Hôtel Miramar, under orders from Dalí's father, Dalí and Gala were refused entry. They put up instead at a guest house, where Dalí kept up his correspondence with friends in Paris, including the Vicomte de Noailles (characteristically unaffected by the stock-market crash), who, in view of the imminent closure of the Galerie Goemans, offered to help Dalí promote his work. (He also assisted with the purchase of a fisherman's cottage in Cadaqués, which Dalí thought he might as well mention, since de Noailles was apparently willing to help him with no disadvantage to himself.) It was then that the couple returned to Paris.

Between 28 March and 12 April 1930 Aragon organized an exhibition of collages in which Dalí's work appeared along with that of others such as Duchamp, Ernst, Miró, Magritte, Man Ray and Picasso. Dalí showed *The First Days of Spring* (1929), a harshly lit intentionally indistinguishable mix of oil and collage on board, composed of images including a black-and-white photograph of Dalí as a child propped on what could be a moving walkway on which a fish which seems to have combusted into flame, straw, and

a strange blue claw with numbers inscribed on it appear. Other similarly indecipherable elements include pictures of a glass box of coloured squares (or sweets?), a female face cut out of a greetings card and an insect attached to the mouth of Dalí's disembodied head beneath which kneels a limp, suited figure. Also pasted or painted on are various images of individual men, seated or kneeling; one astride another. Beside the figure of Dalí sits a half-clothed androgynous figure with a flayed head from which arises a flock of birds, powered by streaks of multicoloured flame – or perhaps simply paint. Dalí's father appears in the work at least twice; two tiny figures in the distance are almost certainly the child Dalí and his father, who is also shown in conversation with Dalí's sister, Ana Maria. It may be that all the men are Dalí's father; perhaps the work is a pasted and painted scene of childhood confusion.

Although by now Dalí seemed to have been naturally absorbed within the surrealist group, his work was distinguishable from theirs in the sense that in the Spanish painter's the unconscious is baldly brought into play and employed more or less strategically. Unlike Aragon (in *Le Paysan de Paris*), for example, in Dalí's work the implied presence of the artist never seems to be at the mercy of the work; unlike Ernst, Dalí never seems to be dealing with episodes from his internal world that strike him or the viewer as haunting or disturbing. Unlike the other surrealists, Dalí could always explain the role of his unconscious. Perhaps the difference was merely a question of attitude. 'The only difference between myself and a madman,' as he once succinctly put it, 'is that I am not mad.' Another other major way in which Dalí distinguished himself from the other surrealists was, of course, that Dalí's work in no sense reflected the impact of the war.

That same year saw the appearance of *The Persistence of Memory*, perhaps one of his best-known works. One evening, home alone with a migraine while Gala was out with friends, he found himself mesmerized by the remains of a Camembert left on the table. Fascinated by the softness of the cheese, he had gone into his studio, where the painting he was working on, a sparse, twilight view of

Port Lligat, stood on his easel. To the unfinished landscape he added huge watches, soft as melting cheese, draping them across the desert-like scene. They hang from the few remaining branches of a truncated tree (perhaps struck by lightning), drooping from a wall or a box and slung across the sleeping or embryonic form of a strange, shapeless creature apparently subdued or asleep. The figure looks as if it has made it almost to the shore, but time has come ashore with him/it; the clock face may be blue, white or even obscured by ants or cockroaches; in whatever form it is read, time dominates the scene – ubiquitous, universal, rendering us as malleable as cheese – or paint. Dalí subsequently decided that the picture represented 'the horrible traumatization of birth by which we are expunged from paradise', adding, 'Someday somebody will have to wind up my limp watches so they can tell the time of absolute memory, the only true and prophetic time.' Breton, for one, accepted Dalí's bursts of self-analysis, whether serious or jesting, and did not seem to acknowledge or even notice any distinction between Dalí and the other surrealists – at least, not for the time being. Planning publication of his *Second Surrealist Manifesto* as a separate pamphlet, he asked Dalí for a frontispiece; when the pamphlet was published he gave him an inscribed copy: 'To Salvador Dalí, whose name is, in my eyes, synonymous with revelation in its most dazzling and invariably quite stunning sense . . . with affection, my trust and my absolutely infinite hopes.'

Breton had evidently forgiven Ernst for his involvement with the Ballets Russes. That summer, in the space of a few weeks (during August and September), he and Éluard wrote a book together, working separately, then pasting their contributions together in a seamless collage. Dalí drew the frontispiece for *The Immaculate Conception*, a poetic work of virtuoso philosophical thinking that provocatively undermines the Christian notion of the virgin birth, bringing its subject, instead, into a secular world in a succession of ingeniously lyrical pieces. '*Un matin, il est là . . . La rue salue de toutes ses roues . . . Il écoute la musique qui reluit sur ses chaussures*' ('One morning he is there . . . The street says hello with all its wheels . . .

He listens to the music that shines on his shoes'). The final section consists of a list of commandments. *'Vole le sens au son, il y a des tambours voilés jusque dans les robes claires'* ('Rob the meaning from sound; there are muffled drums in among the pale dresses'), *'Ne tue jamais un oiseau de nuit'* ('Never kill a night-bird'). The book took its place in the surrealist *œuvre* as a piece of adapted automatism (synonymous, perhaps, with Duchamp's adapted readymades).

Buñuel was also working with Ernst, whose film-starry looks had earned him a cameo appearance and voiceover in Buñuel's second film, *L'Âge d'or*, to be shown that autumn, a work even more obviously provocative than *Un Chien Andalou*. Opening on a scene of two scorpions fighting, its characters included priests, politicians and a Christ figure; the film as a whole was wildly anti-Christian, also taking thinly veiled pot-shots at both fascism and anti-Semitism. A stuffed giraffe fell from a window into the sea, to the surging music of the death scene in *Tristan und Isolde*. The action culminated in a night of depravity in a castle. Even before the film opened Buñuel was prepared for opposition and attacks. Included in the programme was a manifesto written and illustrated by Aragon, Breton, Dalí, Éluard, Tzara und others and with drawings by Dalí, Ernst, Miró and Man Ray, defending *L'Âge d'or* against detractors, arguing for 'LOVE' as the solution to all ills, 'the very cornerstone of . . . violent liberation'.

Following an initial private screening by the Vicomte de Noailles in the Cinema du Panthéon, the premiere took place in Studio 28, a small, private cinema, with an accompanying exhibition of works by artists including Arp, Dalí, Ernst, Miró and Man Ray. From 28 October to 3 December the film was shown without incident. Then, that final night, the tables were turned on the surrealists. At the point in the film when someone sets a reliquary on the ground, the auditorium erupted. This time the cry was from Christians and patriots. 'This will teach you there are some Christians left in France!' The protestors, members of the League of Patriots and the Anti-Semitic League, threw purple ink at the screen, smashed furniture and slashed the paintings hanging in the lobby. At that point

they left the cinema and the performance resumed. On the 10th *L'Âge d'or* was banned by the local police department, supported by the Board of Censors (who had previously authorized it).

Dalí had been putting together a selection of his previously published articles, which appeared that year under the title 'The Invisible Woman'. It included 'The Rotting Donkey', the piece in which he had for the first time expressed the startling view that there was nothing as dreamlike as art nouveau, composed as it was of obviously phallic forms, especially in the decorative ironwork at the entrance to every Métro station, for him 'a true realization of solidified desires'. Two years later he was still obsessed with art nouveau. To the newly inaugurated surrealist journal *Minotaure* he contributed an article, 'The Terrible and Edifying Beauty of Art Nouveau Architecture' (1933), accompanied by a photographic spread of four indisputably phallic-looking bits of art nouveau ironwork with suitably provocative captions – 'EAT ME!'; 'ME TOO'. For the past year he had also been working to define the 'surrealist object', having assembled a collection of found objects which at first glance appeared to be beautiful but quirky, and on closer inspection revealing the scatalogical and fetishistic elements that were becoming Dalí's trademarks.

The most striking of these was *Surrealist Object Functioning Symbolically* (1931), the centrepiece of which is Gala's red shoe, in which he placed a portion of soft paste the colour of excrement and a small glass of warm milk. Suspended above the actual shoe is a sugar lump and a small drawing of a shoe, which may be lowered so that both sugar lump and drawing dissolve. Also included are another sugar lump glued with a small swatch of pubic hair, an erotic photograph, a box of spare sugar lumps and a specially designed spoon for stirring lead pellets into the shoe. As Dalí explained in his article 'Surrealist Objects' (1931), the point of such objects is that they lend themselves to 'a minimum of mechanical functioning', being 'based on phantasms and representations likely to be provoked by the realization of unconscious acts'. His claim for the surrealist object was that it comprised not only freedom from censorship but

also the provision of 'a new and absolutely unknown series of perversions'. He went on to itemize six categories of surrealist object, including 'wrapped objects', 'objects-mouldings' and 'transubstantiated objects', examples of the latter being the 'soft watch'.

Next, he began working out a blueprint for a fully orchestrated surrealist experiment, with the aim of producing a collaboratively made surrealist object. The first phase would disclose items including one or two headless dummies and an unidentifiable shape wrapped as a parcel and tied with string . . . and so on, through to the last phase, during which the viewer would fuse with the object, by now rendered (apparently) edible. This promised to be a long-term project but, in the event, the idea never came to fruition, since – perhaps predictably – it took Breton only another two years to become disenchanted with Dalí. 'My painting never really convinced Breton,' Dalí said later. 'My works were stronger than his theories.' Breton was as floored by Dalí's fascination with art nouveau as by his refusal to countenance Marxism, dismissed out of hand by Dalí as 'a cancer on the body poetic'. As far as Dalí was concerned, their rift was caused entirely by Breton. Three years later, Dalí 'stood trial' before Breton and was formally dismissed from the surrealist group. They parted company in 1933, ironically the year Dalí was commissioned to illustrate the forthcoming edition of the astonishingly indestructible *Maldoror* (1934). Dalí soon found new supporters. In 1933 the Vicomte de Noailles introduced him to Alfred Barr, director of the Museum of Modern Art in New York, who invited him to America, and to Julien Levy (later the surrealists' principal dealer in New York), who acquired *The Persistence of Memory*, which he took straight back with him to New York for inclusion in a group exhibition, *Surrealism: Paintings, Drawings and Photographs*, alongside works by Picasso, Duchamp, Man Ray and Ernst. That August Duchamp visited Dalí in Cadaqués, where Dalí urged him to persuade Man Ray to join them in Spain, since Dalí wanted him to photograph Gaudí's architecture to accompany 'The Terrifying, Edible Beauty of Spanish "Art Nouveau" ' in *Minotaure*. Significant new friendships were already being forged. (The

friendship of Duchamp and Dalí, on the face of it two very different artists, lasted through the succeeding decades, as Duchamp's conceptualism and Dalí's surrealism entered and remained in the artistic vernacular, in the present day often perceived as more or less intertwined.)

By 1930 surrealism had thus already transformed the culture of Paris, making its irrevocable impact on the art world. Breton and Aragon both eventually joined the Communist Party; Cocteau, with investments from the Vicomte de Noailles, was about to make his debut in the role that brought him his widest and most lasting audience, as a film-maker, beginning with *The Blood of a Poet*. Duchamp resisted Katherine Dreier's attempts to persuade him back to New York to manage her Société Anonyme; he was now competing in international chess tournaments against some of the world's top players and spent most of his time playing chess – he was no longer living an artist's life, he told her; he had given up all that years ago. By 1930 Apollinaire, Modigliani, Radiguet and now Diaghilev were all dead. The memoirs of Kiki de Montparnasse had just appeared in print (in 1929), with her own illustrations and an admiring preface by Ernest Hemingway. In her chapter 'Montparnasse, 1929' she noted that the *quartier* had remained essentially unchanged. Though the old *crêmeries* (small, cheap restaurants which once upon a time provided milk, and coal) were gone, there were still parties, dance halls and movie evenings at the 4 Colonnes, rue de la Gaîté or Bobino's. Her own life had been transformed since her arrival before the war. In summer 1929 her relationship with Man Ray had finally come to an end, when he answered the door of his studio one July day to find Lee Miller, unannounced, on his doorstep. Thus began the next (three-year) period of Man Ray's romantic and professional life, as with him Lee Miller made her transition from model to photographer (prior to taking her place, in later years, within the next phase of surrealism).

In June 1930 Janet Flanner informed readers of the *New Yorker* that the Ballets Russes had been replaced as darling of the *gratin* by the transvestite artiste Barbette. Still performing on the high wire,

he was now playing circus venues, accompanied by the music of *Scheherazade* – the first time it had been heard in the circus ring – dressed in gauzy white skirts and 'fifty pounds of white ostrich plumes'. Before and after the show the crème de la crème crowded into his dressing room. The popularity of Paris's fancy-dress balls showed no sign of abating. 'The June season of 1930 will be remembered as the greatest fancy-dress-ball season of all years.' In preparation for one of the largest, Chanel was being kept busy, 'cutting and fitting gowns for young men about town who appeared as some of the best-known women in Paris'. Josephine Baker was the star of the Casino. Dalí went to see her and felt as if he was watching a movie. 'The rhythm of Josephine Baker in slow motion coincides with the purest and slowest growth of a flower produced by the cinematographic accelerated motion.' Flanner rated the show 'one of the best in years . . . as full of staircases as a Freudian dream'.

Dalí and Gala finally made their first visit to New York in November 1934, in time for his first solo exhibition in that city, a show of twenty-two works, at Julien Levy's gallery. Dalí published his own accompanying pamphlet, entitled 'New York Salutes Me'. Though the reviewer for *Time* magazine preferred Dalí's 'miniaturist' to his larger works, he had no reservations about Dalí's place in the art world of New York: 'Craftsman, man of art and magician of the paintbrush, Dalí deserves to be placed among the greats.' After a stay of two months, to mark his departure on 18 January he was given a *bal onirique* at the Coq Rouge, where the decor featured a bathtub and the carcass of an ox with a record-player in its stomach. Dalí and Gala arrived in fancy-dress, Dalí dressed as a shop window with a display of bras, Gala as a *cadavre exquis*, in a dress made of red cellophane. Instead of a hat she wore a celluloid baby and some lobsters – always for Dalí a key surrealist image, since, he claimed, he had seen the fishermen of Cadaqués hang lobsters from the altarpieces of their churches, where watching their death throes had helped the men focus on the Passion of the Mass.

Throughout the 1930s, while the Depression devastated America, in Paris the art world survived the initial catastrophic collapse of the market to witness its gradual revival. During the years of the Depression surrealism found a new niche, becoming suddenly, ubiquitously, fashionable, during which time Dalí produced some of his most lastingly popular inventions, including *Lobster Telephone* (1936), commissioned by English surrealist poet and collector Edward James following publication of a piece by Dalí in *American Weekly* in 1935. Invited by the magazine to provide his impressions of New York in a series of drawings, he duly supplied a response: 'I do not understand why, when I ask for a grilled lobster in a restaurant, I am never served a cooked telephone.' His words appeared beneath the caption: 'NEW YORK DREAM – MAN FINDS LOBSTER IN PLACE OF PHONE'.

In Paris, surrealism survived – even flourished. In 1938 Breton and Éluard organized the definitive surrealist exhibition at the Galerie Beaux-Arts in the rue du Faubourg-Saint-Honoré, where on the opening night of 17 January three thousand of the Parisian elite gathered, expecting to be shocked. The first exhibit, in the outer courtyard, was Dalí's *Rainy Taxi*, or *Mannequin Rotting in a Taxi-cab*, an actual car, with a male chauffeur (with a shark's head) at the wheel. Seated in the back was a shop-window dummy in evening dress with touselled hair, lettuce and chicory growing around her, live snails crawling across her body. Entering the exhibition, visitors found the interior walls of the gallery draped in coal sacks, making it so dark they could hardly see; they were issued with torches to explore the 'street of sixteen mannequin-ladies of the night', where sixteen provocatively dressed street walkers (more shop-window mannequins) included Rrose Sélavy, finally making her debut, dressed from the waist up in male clothing (and otherwise nude). In the half-light visitors peered into rooms at shop-dummy prostitutes that looked startlingly real. One, by André Masson, stood naked, with a bird cage on her head. The claustrophobic atmosphere was intensified by the odour of brewing coffee and a recording of the screams of incarcerated mental patients,

German marching music, the burning of coals, and a performance in the central 'grotto', *L'Acte manqué*, by Hélène Vanel, dancing half naked with a live rooster. *Jamais*, by Oscar Dominguez, was a phonograph with a mannequin's legs emerging from the horn; Breton's *Coffre d'objets* (*Object Chest*) was a mannequin with legs, hands, and a torso of drawers. Duchamp, de Chirico, Ernst, Miró, Masson and Man Ray all contributed works.

Also during the 1930s Dalí painted some of his most celebrated works, including *The Persistence of Memory – Mountain Lake* (1934, now at the Tate Modern); *Sleep* (1937, in a private collection) and *The Metamorphosis of Narcissus* (1938, at the Tate). In collaboration with Elsa Schiaparelli, who opened her boutique in the place Vendôme in 1935, in the second half of the decade Dalí again explored the for him provocative power of nostalgia. Along with her famous lobster dress and shoe-shaped shoulder pads, Schiaparelli brought back 'surreal' hair (the chignon) from the belle époque to replace the sharp lines of the 1920s bobs. The 1930s also saw the emergence of surrealist household objects: Dalí's *Lobster Telephone* (1936) was followed by his *Mae West's Lips* sofa (in five versions, 1936–7); as well as Méret Oppenheim's furred cup and saucer (*Objet*, 1936), allegedly created in response to a chance remark by Picasso, after he and Dora Maar ran into (twenty-three-year-old) Oppenheim in Café Flore. Oppenheim was wearing a brass cuff covered with ocelot fur (one of her designs for Schiaparelli); Picasso remarked that all sorts of things could be covered with fur. Even, parried Oppenheim, this plate and cup. When her tea cooled she asked for a little more fur to keep it warm. Afterwards she bought a department-store cup and saucer, covered it in fur and named it *Objet*, a work Breton found enchanting – he called it *Déjeuner en fourrure*. It may have been that implicit association of surrealism with earlier daring breakthroughs (notably, of course, Manet's *Le Déjeuner sur l'herbe*, painted half a century earlier) that occasioned Gertrude Stein's remark: "The surrealists still see things as every one sees them, they complicate them in a different way but the vision is that of every-one else.' As Dalí was in the process of pointing out, surrealist art captured the

impulses of the past and swept them into the net of the present. By the 1930s Gertrude Stein's observation had become not only a compliment but in a sense the whole point, and perhaps the reason for the enduring popular appeal of surrealism – though, as the Surrealist Exhibition of 1938 revealed, Breton and his fellow artists had no intention of ignoring its dark side.

As far as Dalí was concerned, surrealism explored and celebrated not only the surfaces but the depths of ordinary life – our dreams, our repressions, our desires, our inevitable decay – and painting was merely one means of expressing the whole field of human experience. Why not sit on Mae West's lips, or hold a conversation with a lobster clamped to the ear? As Cocteau had said of de Chirico, the artist makes his presence felt with an artichoke in a city reserved for statues. As Cocteau also noted, Dalí had somehow, by now, moved centre stage without any particular by-your-leave, arriving, apparently effortlessly, complete with his own artistic *raison d'être*. 'One has only to look at a painting by Dalí to be sure that he possesses an inevitable point of view on all things, that he inhabits a world which he dominates . . . He would be incapable of undertaking the slightest exchange with the outside.' Yet his viewers seemed to have no difficulty assimilating his works; his popularity was immediate, and enduring. With the infiltration of surrealism into the prevailing popular culture, nothing was the exclusive reserve of anyone any more. As Duchamp put it some years later (making, for better or worse, a substantial impact on course of artistic history), only when set before the viewer does the artist's work finally assume its status as a work of art.

The early surrealists worked without censorship or restraint to create works which, reaching beyond the medium of painting, undeniably made an impact on the art world. Today such gestures are ubiquitous. A cow in formaldehyde? An unmade bed? A staircase leading nowhere? The works of Damien Hirst, Tracy Emin, Rachel Whiteread and others would surely have been unthinkable before surrealism. (Dalí himself first had the idea of filling a structure full of concrete to make – or reveal – a work of art, carried out

by Whiteread with *House* in 1993.) In the 1990s Alexander McQueen's breakthrough collections overtly incorporated surrealist imagery and ideas, dramatized in his shows. For *The Birds* he sent a sinister flock of feathered and winged models down the catwalk; *Bellmer la Poupée* was influenced by German surrealist artist Hans Bellmer's 1934 series of photographs of articulated dolls (*'Poupée: variations sur le montage d'une mineure articulée'*; 'Doll: variations on the apparatus of an articulated female minor'). In 2001 at *Voss* McQueen's audience faced an enormous glass box constructed to resemble a padded cell (white tiles, surveillance-mirrored walls), the lights going up to reveal the models incarcerated within; *Sarabande* (2007) was inspired by Diaghilev's friend Marchesa Luisa Casati.

The surrealists (as did the Dadaists before them, whose nihilist aim was purely and simply to shock) explicitly set out to jar the relationship between artist and viewer, and the expectations of the viewer on entering a gallery space – so used are we today to this challenge that the surrealist art which occupies several galleries of the Whitney Museum is, though exciting, hardly shocking (indeed, to some, perhaps barely noticeable). The contemplation of an immense overflowing ashtray full of gigantic cigarette butts made of canvas, urethane foam, wire, wood, Latex and Formica, one butt (as it were) casually stubbed out on the other side of the room (Claes Oldenburg's *Giant Fagends*, a clever pop art gimmick in 1967) still looks provocative now, but contemporary viewers are hardly likely to scream in indignation that such inflated realism cannot possibly be art, as did the viewers of early surrealist works. The surrealists of the 1910s and 1920s (Marcel Duchamp, Man Ray, Max Ernst and, from 1929 onwards, Salvador Dalí) were all, in a sense, conceptualists long before conceptualism was invented – though it might also be said that even the most blatantly conceptual works of their day (Duchamp's *Bicycle Wheel*, Dalí's later *Lobster Telephone*) encompassed the artist's pictorial sense of rhythm, balance and understanding of light and space, suggesting a concern with execution abandoned by the conceptualists of the 1960s and 1970s (or so they claimed). How surprised Duchamp and Dalí would have been to see their works decorously

presented in 2017, hung like serious art and presented like museum pieces – or perhaps, and more likely, they would just have been amused. What is art? What are the materials of art? What is the relationship between artist and viewer? The surrealists explored all those questions. Contemporary artists whose works overtly reference those of the early surrealists – Deborah Stevenson, Jaz Henry, Tommy Ingberg, Loreen Hinz, to name but a few (all shown at London's Saatchi gallery) use paint, mixed media, photography, photomontage and now digital collage to explore aspects of the unconscious. For Philippa Perry's television programme for BBC 4, shown in 2017, she set up her own Bureau of Surrealist Research on the streets of Paris, read the *Surrealist Manifesto* and gave a screening for students of *Un Chien Andalou*. A hundred years after the surrealists made their first revolutionary experiments, the questions of how to depict the unconscious in art and how to find new ways of engaging the viewer are being explored by artists in lively and provocative encounters the world over. The nature of the cutting edge goes on changing, as surrealist art continues to evolve.

Acknowledgements

Warm thanks to my literary agents Cara Jones of Rogers, Coleridge and White, London, and Melanie Jackson of Melanie Jackson Agency, New York; also to my editors Juliet Annan of Fig Tree Penguin, London, and Ginny Smith of Penguin Press, New York, and to copy-editor Sarah Day. I benefited greatly from visits to museums and galleries including the Centre Pompidou and the Orangerie in Paris, the Tate Modern, the Royal Academy of Arts and the Saatchi Gallery in London and the Whitney Museum in New York. In researching the pictures, I was grateful for the assistance of John Moelwyn-Hughes and Siân Phillips of Bridgeman Art Library and of Elizabeth Walley of DACS. Steve Ward has generously supported and encouraged me throughout. My post as Royal Literary Fund Fellow at the University of Sussex contributed substantially to the completion of the research.

Notes

Introduction: Nude Descending a Staircase

p. 1 'This final version . . .': It wasn't; *Nude Descending a Staircase, No. 3* (watercolour over a photographic base) followed, in 1916: Anne D'Harnoncourt and Kynaston L. McShine (eds.), *Duchamp*, p. 256

p. 1 'only a rough sketch . . .': ibid., p. 256

p. 2 'a repetition of schematic lines . . .': Calvin Tomkins, *Duchamp: A Biography*, p. 73

p. 2 'the anatomical nude . . .': D'Harnoncourt and McShine (eds.), *Duchamp*, p. 256

p. 2 '*vilains*' (stunning): Guillaume Apollinaire in *L'Intransigeant*, 19 March 1910, in Guillaume Apollinaire, *Marcel Duchamp, 1910–1918*, p. 11

p. 4 'we are still living under . . .': André Breton, *Manifesto of Surrealism*, in Alex Danchev (ed.), *100 Artists' Manifestos. From the Futurists to the Stuckists*, p. 243

1. *Café Life, Performances and Fancy-dress Balls*

p. 8 ' "This is the first time . . .': Jean Cocteau, *Professional Secrets: An Auto-biography of Jean Cocteau*, p. 54

p. 8 'We could hear nothing . . .': Gertrude Stein, *Autobiography of Alice B. Toklas*, p. 150

p. 8 'Montparnasse knew nothing of . . .': Cocteau, *Professional Secrets*, p. 54

p. 9 'Much laughter, much applause . . .': Beatrice Hastings in *The New Age*, no. 1132, vol. XV, no. 2., Thursday, 28 May 1914, p. 91

p. 9 'quick and fireworky . . .': ibid.

p. 9 'the street I used to take . . .': Beatrice Hastings in *The New Age*, no. 1133, vol. XV, no. 3., Thursday, 21 May 1914, p. 68

p. 10 'like a seigneur . . .': Olivier Renault, *Montparnasse: Les Lieux de légende*, p. 31

p. 10 'trees that have leaves . . .': Beatrice Hastings in *The New Age*, no. 1135, vol. XV, no. 6, 11 June 1914, p. 139

p. 10 'the bad *garçon* . . .': ibid. no. 1134, vol. XV, no. 5, 4 June 1914, p. 115

p. 10 'genius of evil': Rémi Fournier Lanzoni, *French Cinema from Its Beginnings to the Present*, p. 43

p. 10 'You mustn't go to sleep . . .': Beatrice Hastings in *The New Age*, no. 6, 11 June 1914, p. 138

p. 10 'Ah!' . . .: ibid.

p. 10 'That is where *la belle Américaine* . . .': ibid.

p. 11 'This woman's name is . . .': Comte de Lautréamont, *Maldoror*, in *Maldoror and The Complete Works*, p. 33

p. 11 'The wind groans . . .': ibid., p. 34

p. 11 'arrive': Beatrice Hastings in *The New Age*, no. 1138, vol. XV, no. 9, 2 July 1914, p. 210

p. 12 '*Superbe!*' '*Magnifique!*' . . .: ibid.

p. 12 'tawdry finery': Guillaume Apollinaire, 'Picasso, Painter and Draftsman', in Leroy C. Breunig (ed.), *Apollinaire on Art: Essays and Reviews, 1902–1918*, p. 13

p. 12 'the presence of real . . .': ibid.

p. 12 '*ces traces d'êtres*': Guillaume Apollinaire, 'Marcel Duchamp', in *Les Peintres cubistes*, pp. 100–103 (p. 102)

p. 13 'golden section': see Jean Suquet, Preface to Guillaume Apollinaire, *Marcel Duchamp, 1910–1918*, p. 7; see also Guillaume Apollinaire, *Les Peintres cubistes*, pp. 44–5

p. 13 'lost interest in groups': Calvin Tomkins, *Duchamp: A Biography*, p. 80

p. 14 '*ambiance*': Giorgio de Chirico, *The Memoirs of Giorgio de Chirico*, p. 65

p. 14 'metaphysical': ibid., p. 68

p. 14 'exceedingly solitary . . .': ibid., p. 67

p. 14 'a kind of atmosphere of terror . . .': ibid.

p. 15 'nefarious': ibid., p. 68

p. 15 'real objects to the light . . .': Guillaume Apollinaire, 'Pablo Picasso', in Breunig (ed.), *Apollinaire on Art*, p. 279

p. 15 'real or in *trompe-l'œil*': ibid., p. 279

p. 15 '*La mère de la concierge* . . ./The concierge's mother . . .': Guillaume Apollinaire, *Zone: Selected Poems*, pp. 164–5

p. 16 '*Écoutez-moi* . . ./Listen to me . . .': ibid., pp. 128–9

p. 16 '*J'allume au feu* . . ./I light my cigarette . . .': ibid., pp. 130–31

p. 16 'nothing is more reminiscent of . . .': Francis Steegmuller, *Apollinaire: Poet among the Painters*, p. 211

p. 16 ' "evil women" of history and mythology': Mark Polizzotti, *Revolution of the Mind: The Life of André Breton* (2nd edn), p. 18

2. What is Art?

p. 17 'dead skins' 'came to life': Jean Cocteau, *Professional Secrets: An Autobiography of Jean Cocteau*, p. 22

p. 17 'very urgently about the fourth . . .': for more on the fourth dimension (or golden section), see Jean Suquet, Preface to Guillaume Apollinaire, *Marcel Duchamp, 1910–1918*, p. 7; see also Guillaume Apollinaire, *Les Peintres cubistes*, pp. 44–5

p. 17 'Can one make works of "art"?': Calvin Tomkins, *Duchamp: A Biography*, p. 127

p. 17 'a first gesture . . .': ibid., p. 128

p. 17 'tapped the mainspring . . .': ibid., p. 128

p. 19 'Your chance is not the same . . .': ibid., p. 131

p. 20 'something to have in my room . . .': ibid.

p. 21 'an awkward and very gifted painter . . .': Guillaume Apollinaire, 'The Opening' (16 November), in Leroy C. Breunig (ed.), *Apollinaire on Art: Essays and Reviews, 1902–1918*, p. 327

p. 22 '*Montparnasse*, a weekly gazette . . .': Apollinaire, 'Montparnasse', in ibid., p. 410

p. 22 'defined as a language of dreams': Apollinaire, 'New Painters', in ibid., p. 422

p. 23 'university for bathing beauties': ibid., p. 437

p. 23 'take a good look at . . .': Apollinaire, 'Neurosis and Modern Art', in ibid., p. 437

p. 23 'To Berlin! . . .': Francis Carco, *From Montmartre to the Latin Quarter*, p. 266

3. Anticipation in Paris, Readymades in New York

p. 25 'We did this': John Richardson, *A Life of Picasso*, vol. II: 1907–1917: *The Painter of Modern Life*, p. 345

p. 25 'could not leave her room . . .': Gertrude Stein, *The Autobiography of Alice B. Toklas*, p. 162

p. 25 'Paris was pale . . .': ibid., p. 164

p. 27 'an especial kind of seriousness': Beatrice Hastings in *The New Age*, no. 1144, vol. XV, no. 15, 13 August 1914, p. 350

p. 27 'Crackle, tac, tac, borrrrorr!': ibid., no. 1149, vol. XV, no. 20, 17 September 1914, p. 478

p. 27 'We are all waiting . . .': ibid., p. 479

p. 27 'Some news is expected . . .': Beatrice Hastings in *The New Age*, no. 1153, vol. XV, no. 24, 15 October 1914, p. 576

p. 28 'a circus on the move': Richardson, *A Life of Picasso*, vol. II, p. 383

p. 28 'all I can say is . . .': Beatrice Hastings in *The New Age*, no. 1160, vol. XVI, no. 5, 3 December 1914, p. 123

p. 28 'No really!': ibid., no. 1161, vol. XVI, no. 6, 10 December 1914, p. 145

p. 30 'Do not expect any thoughts . . .': ibid., no. 1178, vol. XVI, no. 23, 8 April 1915, p. 611

p. 30 'I am in a horrid state . . .': ibid., no. 1179, vol. XVI, no. 24, 15 April 1914, p. 639

p. 30 'all aeroplanes with their sound . . .': ibid., no. 1187, vol. XVII, no. 6, 10 June 1915, p. 131

p. 30 'partner': the term of affection Picasso had hitherto reserved for Braque

p. 30 'willingly live in New York': Calvin Tomkins, *Duchamp: A Biography*, p. 137

p. 30 *'I do not go to New York I leave Paris'*: ibid., p. 139

p. 31 'The *Rochambeau* . . . slipped out . . .': ibid.

p. 31 'it was a joke in Paris . . .': Stein, *The Autobiography of Alice B. Toklas*, p. 146

p. 31 'New York itself . . .': Tomkins, *Duchamp*, p. 149

p. 31 'I bought this bottle rack . . .': ibid., p. 154 (author's approximation of C.T.'s translation)

p. 32 'de Marcel Duchamp': ibid., p. 155

p. 32 'poet's sense of paradox . . .': Richardson, *A Life of Picasso*, vol. II, p. 384

4. *Parade: Une sorte de sur-réalisme*

p. 34 'in whom gallantry is . . .': Francis Steegmuller, *Cocteau: A Biography*, p. 142

p. 34 'a mountain of old lace': ibid., p. 125

p. 34 'the canopy of our own . . .': ibid.

p. 35 'a pale blue uniform . . .': Jean Cocteau, *My Contemporaries*, ed. Margaret Crosland, p. 41

p. 35 '"assisted" or "rectified" readymade': Calvin Tomkins, *Duchamp: A Biography*, p. 174

p. 35 'Little American Girl': Jean Cocteau, *Œuvres complètes*, vol. VII, p. 303

p. 36 'a rag-and-bone man of genius': Cocteau, *My Contemporaries*, p. 76

p. 36 'He uses everything that's old . . .': ibid.

p. 36 'The Rotonde was our mall . . . far shore': Frederick Brown, *An Impersonation of Angels: A Biography of Jean Cocteau*, p. 139

p. 37 'If I had looked back . . .': Steegmuller, *Cocteau*, p. 149

p. 37 'Picasso, forgetting he was Spanish . . .': Cocteau, *My Contemporaries*, p. 75; see also Jean Cocteau, *Professional Secrets: An Autobiography of Jean Cocteau*, pp. 70–71

p. 37 'we fought a lot . . .': Cocteau, *My Contemporaries*, p. 75

p. 37 'There are districts . . .': Jean Cocteau, *Modigliani*, pp. 5–6

p. 37 'sometimes declaiming Dante . . .': Carol Mann, *Modigliani*, p. 128

p. 38 'He helped them to live . . .': Cocteau, *My Contemporaries*, p. 79

p. 38 'the mere ghost of a line . . . the unicorn': ibid., p. 72

p. 38 'perhaps I should say the cube': John Richardson, *A Life of Picasso*, vol. II: *1907–1917: The Painter of Modern Life*, p. 388

p. 38 'Gone to pieces overnight': Steegmuller, *Cocteau*, p. 151

p. 38 'Horribly sick': ibid.

p. 38 'and even spat on the ambulances': ibid.

p. 38 'Dune dune dune . . .': ibid., p. 152

p. 39 'spectacle of destruction': ibid., p. 153

p. 39 'sumptuous, decorative aesthetic . . .': ibid., pp. 138–9

p. 39 'all the involuntary emotion given off by circuses . . .': Richardson, *A Life of Picasso*, vol. II, p. 389

p. 40 'Sad and feeble': Mark Polizzotti, *Revolution of the Mind: The Life of André Breton* (2nd edn), p. 41

p. 40 'Dada was a bomb': René Passeron, *Max Ernst*, p. 8

p. 40 'international cabaret': Ruth Brandon, *Surreal Lives: The Surrealists 1917–1945*, p. 102

p. 40 'yes, yes . . .': ibid.

p. 41 'We'll all die': Steegmuller, *Cocteau*, p. 157

p. 41 'We're . . . hunting for the dead . . .': ibid.

p. 42 'for reasons of mental distress': Polizzotti, *Revolution of the Mind* (2nd edn), p. 46

p. 42 'in the middle of the street . . .': Cocteau, *Modigliani*, p. 32

p. 44 'pure cubism transferred to the theatre': Margaret Crosland, *Jean Cocteau*, p. 46

p. 44 'superhuman': ibid.

p. 44 'a magnificent metaphor . . .': Richardson, vol. II, p. 416

p. 44 'When you watch him work . . . bars of his cell': Cocteau, *My Contemporaries*, p. 75

p. 45 '*Souvenir de Montparnasse*': Jean Cocteau, *L'Ode à Picasso: Poème 1917*, in Jean Cocteau, *Entre Picasso et Radiguet*, p. 134 (unpaginated page in publication)

p. 45 'realist' (*Parade* was subtitled *Ballet réaliste*): Steegmuller, *Cocteau*, p. 162

p. 45 'Little American Girl': Jean Cocteau, *Œuvres complètes*, vol. VII, p. 303

p. 45 'like Buster Brown's dog': John Richardson, *A Life of Picasso*, vol. III: *The Triumphant Years, 1917–1932*, p. 16

p. 45 'Cube tic tic tic tic . . .': Steegmuller, *Cocteau*, p. 166

p. 46 'as if we had become engaged': Cocteau, *Professional Secrets*, p. 78

p. 46 'a tiny, dirty little theatre-music hall': Richardson, *A Life of Picasso*, vol. III, p. 9

p. 47 'literary flavour and circus-like stylization': ibid., p. 17

p. 47 'the choreography of perspectives . . .': ibid., p. 24

p. 48 'skyscraper': Richardson, *A Life of Picasso*, vol. II, p. 414

p. 48 'by no definition, a work of art': Tomkins, *Duchamp*, p. 179

p. 48 'one of my female friends . . .': ibid., p. 181

p. 49 'As for plumbing . . .': ibid., p. 182

p. 49 'Whether Mr Mutt . . .': ibid.

p. 50 *'une sorte de sur-réalisme'*: Guillaume Apollinaire, *'Parade et l'esprit nouveau'*, in Cocteau, *Entre Picasso et Radiguet*, pp. 69–71

p. 51 *'Nous croyions* plaire': Jean Cocteau, *Jean Cocteau par Jean Cocteau*, p. 73

p. 52 'the artistic *tout*-Montparnasse . . .': Polizzotti, *Revolution of the Mind* (2nd edn), p. 54

p. 52 *'recherches plastiques'*: Richardson, *A Life of Picasso*, vol. II, p. 426

p. 52 'the play is surrealist': ibid., p. 427

p. 52 'Long live France! . . . Romania!': Polizzotti, *Revolution of the Mind* (1st edn), p. 47

p. 53 'like his poetry . . .': ibid. (2nd edn), p. 58

p. 53 'We were trying . . . blood-soaked fog': ibid. (2nd edn), p. 60

p. 54 'No one was ever a more able . . .': ibid. (1st edn), pp. 68–9

p. 54 'dragging our soiled uniforms . . .': Brown, *An Impersonation of Angels*, p. 176

5. The Dada Manifesto

p. 55 Les Nouveaux Jeunes: (named Les Six after the 'Russian Five'. The six composers were: Georges Auric, Louis Durey, Arthur Honneger, Darius Milhaud, Francis Poulenc, Germaine Tailleferre), Francis Steegmuller, *Cocteau: A Biography*, p. 238

p. 55 Les Six: ibid.

p. 55 'In the bars of . . .': Paul Morand, *'Magie Noire'*, in Edmonde Charles-Roux, *The World of Coco Chanel: Friends, Fashion, Fame*, p. 223

p. 55 'jazz produced such sublime . . .': ibid.

p. 56 'An original artist cannot . . .': Jean Cocteau, *Entre Picasso et Radiguet*, p. 57

p. 56 'Debussy played in French . . .': ibid., p. 58

p. 57 'I accept Euripides . . .': Comte de Lautréamont, *Poésies*, in *Maldoror and The Complete Works*, p. 223

p. 57 'Poetry must be made by all . . .': ibid., p. 244

p. 57 'dismal hacks . . . Baudelaire . . .': ibid., p. 231

p. 57 'Personal poetry has had its day . . .': ibid., p. 232

pp. 57–8 'We say sound things . . . extraordinary ones': ibid., p. 250

p. 58 'a real wedding': John Richardson, *A Life of Picasso*, vol. III: *The Triumphant Years, 1917–1932*, p. 86

p. 58 'Lunch at the Meurice . . .': ibid., p. 85

p. 59 'second naturalistic period': Gertrude Stein, 'Picasso' (1938), in Gertrude Stein, *Picasso: The Complete Writings*, p. 70

p. 59 'the serenity of perfect beauty . . .': ibid., p. 71

p. 59 'comrade behind the lines . . . liaison officer': Ornella Volta, *Satie Seen through His Letters*, p. 157

p. 59 'Pope of Surrealism': Mark Polizzotti, *Revolution of the Mind: The Life of André Breton* (2nd edn), p. 182

p. 60 'Va-t-en, Marcel! . . . too Victor Hugo': Richardson, *A Life of Picasso*, vol. III, p. 102

p. 60 'radiating hostility': Adrienne Monnier, *The Very Rich Hours of Adrienne Monnier*, p. 456

p. 60 'My old pard . . .': Richardson, *A Life of Picasso*, vol. III, p. 96

p. 61 'His little room . . .': Jean Cocteau, *Professional Secrets: An Autobiography of Jean Cocteau*, p. 73

p. 61 'heard a loud noise . . . sheet and removed': Giorgio de Chirico, *The Memoirs of Giorgio de Chirico*, p. 85

p. 62 'Paris went charmingly off its head': Alistair Horne, *Seven Ages of Paris*, p. 365

p. 62 'How am I supposed to last . . .': Jacques Vaché, *Lettres de guerre* (14.11.18), p. 25

p. 63 'To launch a manifesto . . . towards community': André Breton, *Dossier Dada*, p. 33

p. 63 'Every pictorial or plastic work . . .': ibid.

p. 64 'the same currents . . .': Polizzotti, *Revolution of the Mind* (2nd edn), p. 82

p. 64 'on very bad terms with everyone . . .': Volta, *Satie Seen through His Letters*, p. 174

p. 64 'Auric Satie with . . .': ibid., p. 175

p. 64 *à la noix*: ibid.

p. 65 'My feeling – altogether disinterested . . .': Polizzotti, *Revolution of the Mind* (2nd edn), p. 84

p. 65 'bells, beautiful princesses . . .': ibid.

p. 66 'the kind of people . . .': ibid., p. 86

p. 66 'poem-event': ibid., p. 87

p. 67 'a poet's noble and faraway gaze . . .': ibid., p. 91

p. 67 'On na mène pas la vache . . .': Dominique Bona, *Gala: La Muse redoutable*, p. 119

p. 67 'Ils ont des armes . . .': Paul Éluard, 'Perspective', *Mourir de ne pas mourir*, in Paul Éluard, *Capitale de la douleur*, p. 73

p. 69 'For me, poetry, art stop being . . .': Polizzotti, *Revolution of the Mind* (2nd edn), p. 87

p. 69 'a poor, abandoned, enlightened man': Polizzotti, *Revolution of the Mind* (1st edn), p. 98

p. 70 'Perhaps I shall write a ballet . . .': Steegmuller, *Cocteau*, p. 239

p. 70 'a man cut in two . . . *knocking at the window*': Polizzotti, *Revolution of the Mind* (2nd edn), p. 93

p. 71 *'spoken thought'*: ibid., p. 94

p. 71 'À quoi bon ces grands enthousiasmes . . .': André Breton and Philippe Soupault, *Les Champs magnétiques*, p. 27

p. 71 'Les couloirs des grands hôtels . . .': ibid., p. 87

p. 71 'Ma jeunesse en fauteuil à roulettes . . .': ibid, p. 81 n.

p. 71 'the moment at the dawn of . . .': Polizzotti, *Revolution of the Mind* (2nd edn), p. 99

p. 72 'Auntie': Gertrude Stein, *The Autobiography of Alice B. Toklas*, pp. 207–8

p. 72 'Everybody was on the streets . . .': ibid., p. 208

p. 72 'Here is General Pershing . . .': Steegmuller, *Cocteau*, p. 237

p. 72 'JAZZ-BAND': 4 August 1919, in Cocteau, *Entre Picasso et Radiguet*, pp. 99–102

p. 72 'Mais il y avait encore quelque chose . . .': ibid., p. 99

p. 72 'contacts sauvages . . .': ibid., p. 101

p. 73 'drivel': Polizzotti, *Revolution of the Mind* (2nd edn), p. 102

p. 73 'People these days no longer . . .': ibid.

p. 74 'cover him with flowers . . .': Francis Carco and Jean-Paul Crespelle, *From Montmartre to the Latin Quarter*, p. 293

p. 74 'With Modigliani . . . burying their youth': ibid., p. 296

6. *Rrose Sélavy*

p. 75 'merrily anti-Dada': Francis Steegmuller, *Cocteau: A Biography*, p. 247

p. 76 'I am the very model of . . .': ibid., p. 257

p. 76 'ONLY MILK DRUNK HERE': Jean Cocteau, *Le Bœuf sur le toit*, *Œuvres complètes*, vol. VII, pp. 305–12 (p. 311)

p. 77 'a choppy, voluptuous fantasy . . .': Steegmuller, *Cocteau*, p. 243

p. 77 'Back to Zurich . . .': Frederick Brown, *An Impersonation of Angels: A Biography of Jean Cocteau*, p. 181

p. 77 'Avez-vous quelque fois . . .': Dominique Bona, *Gala: La Muse redoutable*, p. 138

p. 78 'Zoumbai!': ibid.

p. 78 'Amertume sans église allons . . .': ibid.

p. 78 'Before you can love something . . .': Mark Polizzotti, *Revolution of the Mind: The Life of André Breton* (2nd edn), p. 123

p. 79 'If one must speak of Dada . . .': ibid., p. 124

p. 79 'When will the arbitrary be granted . . .': ibid., p. 126

p. 80 'poetic curiosities': Bona, *Gala*, p. 143

p. 80 'a "stage", as they call it . . .': 'A Game of Boules with Patrick Waldberg' (interviewing Max Ernst), in René Passeron, *Max Ernst*, p. 8

p. 80 '(Very sharply) . . . our revolt': ibid.

p. 81 'The Dadaists know . . . outside their ken': Steegmuller, *Cocteau*, p. 257

p. 81 'far-famed sense of humour': Calvin Tomkins, *Duchamp: A Biography*, p. 223

p. 82 'While the bride lay . . .': Neil Baldwin, *Man Ray: American Artist*, p. 71

p. 83 'Rose': Duchamp originally spelled Rose's name as here; later he changed the spelling to Rrose.

p. 83 'c'est la vie': Tomkins, *Duchamp*, p. 228

p. 83 'not to change my identity . . .': ibid.

p. 84 'Vive Dada!': John Richardson, *A Life of Picasso*, vol. III: *The Triumphant Years, 1917–1932*, p. 169

p. 84 '"assisted" readymade': Tomkins, *Duchamp*, p. 174

7. Max Ernst's Surrealist Collages

p. 85 'The dog who shits . . .': Edward Quinn, *Max Ernst*, pp. 68–9

p. 86 'upside-down violin' (*Violon renversé*, 1921): ibid., p. 74

p. 86 'strange flowers made out of wheels . . .': Patrick Waldberg, *Max Ernst*, p. 142

p. 87 '*Umpressnerven!* . . .': Quinn, *Max Ernst*, p. 61

p. 87 'the chance meeting of two distant realities . . .': ibid., p. 166 (quoting Max Ernst, in *Beyond Painting*)

p. 87 'Max Ernst died on the 1st of August . . .': Max Ernst, *Beyond Painting*, p. 29

p. 88 'white as snow, red as blood . . .': Quinn, *Max Ernst*, p. 24 (quoting 'Notes for a Biography, by Max Ernst')

p. 88 'peaceful, yet disquieting . . . delirium of interpretation': ibid., pp. 26–7

p. 88 'the vital energy, of his beloved bird': ibid.

p. 88 'in an attempt to penetrate their secret . . .': ibid., p. 25

p. 88 ' "*Et Kriskink!* . . .': ibid.

p. 89 'the rough outlines of organic forms . . . forgotten': ibid., p. 28

p. 91 'disgraced': ibid., p. 62

p. 91 'EXPOSITION DADA . . .': André Breton, *Dossier Dada*, p. 77

p. 91 'solemn and priestly': Mark Polizzotti, *Revolution of the Mind: The Life of André Breton* (2nd edn), p. 139

p. 91 'a diabolical red light . . .': ibid.

p. 92 '*tragi-comédie*': Francis Steegmuller, *Cocteau: A Biography*, p. 265

p. 92 'ethereal ease': ibid., p. 264

p. 92 'was enthusiastic about everybody': ibid.

p. 92 '*nous etions sauvés!*': ibid., p. 265

p. 93 'Queen of the Machines': ibid., p. 266

p. 93 'brought to trial': Polizzotti, *Revolution of the Mind* (2nd edn), p. 141

p. 93 'came onstage, barked a few lines . . .': ibid., p. 142

p. 93 'an article bidding farewell to Dada': ibid., p. 143

p. 93 'dance of the telegrams': Steegmuller, *Cocteau*, p. 266

p. 94 'She's the Queen of Paris . . . Watch the birdie . . .': ibid., p. 267

p. 94 'Salon Dada': ibid., p. 273

p. 94 *'concert bruitiste'*: ibid.

p. 94 *'Vive Dada!'*: ibid.

p. 95 'these things . . .': Calvin Tomkins, *Duchamp: A Biography*, pp. 233–4

p. 96 'carrying his imposing head like . . .': Man Ray, *Self-portrait*, p. 108

p. 96 'like an impish schoolboy . . .': ibid.

p. 96 'rushed from one attraction to another . . .': ibid., p. 109

p. 96 'Cubist: ibid., p. 110

p. 97 'used it as a guide for my colour . . .': ibid.

p. 97 'Far West, remarked the interpreter . . . *Américain . . . Oui*': ibid.

p. 97 'like a cowboy on a bronco . . .': ibid.

p. 97 'worked like magic': ibid., p. 111

p. 98 'the way you say, "my etchings" ': Tomkins, *Duchamp*, p. 236

p. 99 'like a hair in the soup': Polizzotti, *Revolution of the Mind* (2nd edn), p. 145

p. 100 a little old man . . .': ibid., p. 146 (date of 'Interview with Doctor Freud' not supplied in source)

p. 100 : a mysterious Byzantine look: (approximate translation of) Waldberg, *Max Ernst*, p. 173

p. 100 'an armoured, strangely ventilated . . .': John Russell, *Max Ernst: Life and Work*, p. 64

p. 101 'The elephant from Celebes . . .': Roland Penrose, *Max Ernst's Celebes*, p. 19

p. 101 'sad monsters': Paul Éluard, *'Au-delà de la Peinture'*, in Max Ernst and Paul Éluard, *Max Ernst peintures pour Paul Éluard*, p. 34

p. 101 'Think flower, fruit . . .': ibid.

p. 101 *'Il pose un oiseau . . .'*: Paul Éluard, *'Nul (2)'*, *Répétitions*, in Paul Éluard, *Capitale de la douleur*, p. 26

p. 101 *'nothing is incomprehensible'*: Paul Éluard, *'Au-delà de la Peinture'*, in Ernst and Éluard, *Max Ernst peintures pour Paul Éluard*, p. 36

p. 102 'Light resembles Man Ray's paintings . . .': Neil Baldwin, *Man Ray: American Artist*, p. 89

p. 102 *carpe de Seine*: ibid.

p. 102 'strange voluble little man . . .: Man Ray, *Self-portrait*, p. 115

p. 102 'That was my first Dada object in France': ibid.

8. The First Rayographs

p. 103 'where high and low . . .': John Richardson, *A Life of Picasso*, vol. III: *The Triumphant Years, 1917–1932*, p. 209

p. 104 'the navel of Paris': ibid.

p. 104 'the dirtier the place . . .': Billy Kluver and Julie Martin, *Kiki's Paris: Artists and Lovers 1900–1930*, p. 126

p. 104 'cube': John Richardson, *A Life of Picasso*, vol. II: *1907–1917: The Painter of Modern Life*, p. 388

p. 104 'including French as terrible . . .': Man Ray, *Self-portrait*, p. 117

p. 105 'overcoming their aversion . . .': ibid., p. 118

p. 105 'My neutral position . . . personalities': ibid.

p. 105 'Has the so-called modern spirit . . .': Mark Polizzotti, *Revolution of the Mind: The Life of André Breton* (2nd edn), p. 153

p. 105 'artistic groups or schools . . . current confusion': ibid.

p. 105 'a publicity-mongering imposter . . .': ibid., p. 154

p. 106 'Several days ago I wasn't . . .': ibid.

p. 106 'Whitechapell': Philippe Soupault, *Westwego*, p. 2

p. 106 'Madame Tusseaud': ibid., p. 5

p. 106 'strange journey . . .': ibid., p. 7

p. 106 '*le ciel a découvert* . . .': ibid., p. 11

p. 107 '*Dans un coin l'inceste agile* . . .': Paul Éluard, 'Max Ernst', *Répétitions*, in Paul Éluard, *Capitale de la douleur*, p. 9

p. 107 'everything that André Breton makes me say . . .': Polizzotti, *Revolution of the Mind* (2nd edn), p. 157

p. 107 'a small dark woman . . .': Man Ray, *Self-portrait*, p. 179

p. 108 'looked unfinished but . . .': ibid., p. 181

p. 108 'my freer work . . .': ibid.

p. 108 'Tall, wavy-haired . . .': ibid., p. 217

p. 109 'black tie flowing . . .': ibid., p. 185

p. 109 'pleasant gentleman': ibid., p. 186

p. 109 'someone who knew everybody . . .': ibid., p. 118

p. 109 'He looked quite aristocratic . . .': ibid.

p. 110 'No one paid for the prints . . .': ibid.

p. 110 'magnificent stylized gold bird': ibid., p. 121

p. 111 'there was a bright little flash . . .': ibid., p. 124

p. 111 'very trim and smart . . .': ibid.

p. 111 'The room upstairs was flooded . . .': ibid., p. 125

p. 112 'There was colour, line, texture . . .': ibid., p. 126

p. 112 'felt like a delivery boy': ibid., p. 127

p. 113 'before my eyes an image . . .': ibid., p. 129

p. 113 'pure Dada creations': ibid.

p. 114 'might have the makings of . . .': ibid., p. 130

p. 114 'liked new experiments . . .': ibid., p. 131

p. 114 'it had to be a rayograph': ibid.

p. 115 'It was trying work . . .': ibid., p. 161

p. 115 'It might have passed for . . .': ibid.

p. 116 'so that the place would . . .': ibid., p. 147

p. 117 'In the true Dada spirit . . .': ibid., p. 145

p. 117 'We hang out with a crowd . . . way with him': Ernest Hemingway, introduction to *Memoirs of Kiki: The Education of a French Model*, p. 45

p. 118 'restless but pleasant . . . diamonds': ibid., p. 57

p. 118 'I love Max Ernst . . .': Dominique Bona, *Gala: La Muse redoutable*, p. 184

p. 119 *Le Taciturne*: ibid., p. 190

p. 119 *'Elle est debout sur . . .'*: Paul Éluard, *'L'Amoureuse'*, *Mourir de ne pas mourir*, in Paul Éluard, *Capitale de la douleur*, p. 55

p. 120 *'Un bel oiseau léger . . .'*: Paul Éluard, *'Mascha riait Aux anges'*, ibid., p. 75

p. 120 'Ask the lady in blue': Bona, *Gala*, pp. 194–5

p. 120 'he dyes and I keep books . . .': Calvin Tomkins, *Duchamp: A Biography*, p. 242

p. 121 'wondrous': ibid., p. 243

p. 121 'a polished surface . . .': ibid.

p. 121 'strange puns': ibid., p. 245

p. 121 'by Rrose Sélavy': eight pages of similar puns appeared in the December issue of *Littérature*, 'that the poet Robert Desnos claimed to have "received" from Rrose Sélavy', Tomkins, *Duchamp*, p. 245

p. 121 'Got a note from . . .': Polizzotti, *Revolution of the Mind* (2nd edn), p. 165

p. 122 'running in from stage right . . .': ibid., p. 168

p. 122 'midway between visionary landscape . . .': John Russell, *Max Ernst: Life and Work*, p. 67

p. 122 'marvellous document of its day . . .': ibid.

p. 122 'more lifelike than . . .': Polizzotti, *Revolution of the Mind* (2nd edn), p. 168

p. 123 'pen and ink drawing . . .': John Richardson, *A Life of Picasso*, vol. III, p. 220

p. 123 'a sort of laundress blue': ibid.

p. 123 'majestic-looking lines': ibid.

p. 123 'Creon . . .': Francis Steegmuller, *Cocteau: A Biography*, p. 299

p. 124 *'Le petit est malade . . ./*The child is ill . . .': Paul Éluard and Max Ernst, *Les Malheurs des immortels*, p. 5

p. 125 *'Regardez ces petits serpents . . .'*: Ibid., p. 15

p. 125 *'En Suivant Votre Cas'*, Man Ray, *Picabia et la Revue littéraire*, no. 7, 1 December 1922

9. The Female Anatomy Explored

p. 128 'a large self-portrait . . .': Giorgio de Chirico, *The Memoirs of Giorgio de Chirico*, p. 112

p. 131 'like a schoolboy . . .': Raymond Radiguet, *The Devil in the Flesh*, p. 130

p. 132 'I don't care whether . . .': ibid., p. 131

p. 133 'It was at this time that . . .': Gertrude Stein, *The Autobiography of Alice B. Toklas*, p. 239

p. 133 'emptied himself of Italy': Gertrude Stein, 'Picasso' (1938), in Gertrude Stein, *Picasso: The Complete Writings*, p. 72

p. 133 'his pleasure in drawing . . .': ibid.

p. 133 'a state of incompletion': Neil Baldwin, *Man Ray: American Artist*, p. 111

p. 133 'LA MARIÉE MISE À NU . . .': Calvin Tomkins, *Duchamp: A Biography*, p. 247

p. 133 'electrical stripping': ibid.

p. 133 'subconsciously I never intended . . .': ibid.

p. 133 'to get away from myself . . .': ibid., p. 248

p. 134 'George W. Welch . . .': ibid., p. 246

p. 134 'Height about 5 feet 9 inches . . .': ibid.

p. 134 'seasoned': Baldwin, *Man Ray*, p. 122

p. 134 'It was automatic cinema': ibid., p. 123

p. 135 'André Gide, dead . . .': Mark Polizzotti, *Revolution of the Mind: The Life of André Breton* (1st edn), p. 191

p. 135 'splendid and diabolical . . .': John Richardson, *A Life of Picasso*, vol. III: *The Triumphant Years, 1917–1932*, p. 231

p. 136 'the centre of all the conflicts . . .': ibid., p. 244

p. 136 'I've left behind my tricks . . .': quoted in Polizzotti, *Revolution of the Mind* (1st edn), p. 195

p. 137 '. . . and what pretty women . . .': Ernest Hemingway, introduction to Kiki de Montparnasse, *Memoirs of Kiki: The Education of a French Model*, p. 48

p. 138 'hoping to do grotesque slapstick . . . in the Quarter': Baldwin, *Man Ray*, p. 109

p. 138 'Oh, well . . .': de Montparnasse, *Memoirs of Kiki*, p. 50

p. 138 'out of focus . . .': Man Ray, *Self-portrait*, p. 208

p. 138 'with the sunrays . . .': ibid.

p. 138 'malaise increases with genius': Richardson, *A Life of Picasso*, vol. III, p. 248

p. 138 'because I am death': ibid.

p. 138 *'Je veux sa jeunesse'*: ibid.

p. 139 'from hotel to hotel . . .': ibid., p. 251

p. 139 'Tomorrow I'll be dead': ibid.

p. 139 *'le veuf sur le toit'*: Francis Steegmuller, *Cocteau: A Biography*, p. 317

p. 139 'Antoine Doline': ibid., p. 325

p. 139 'refloat': ibid., p. 326

p. 140 'Miss Aerogyne . . .': ibid., p. 327

p. 140 'or the yellow and green of . . .': Ernest Hemingway, *A Moveable Feast*, p. 47

p. 140 'In those days . . .': ibid.

p. 140 'Marcel goes straight for beauty': Tomkins, *Duchamp*, p. 255

p. 141 'I was looking to see if . . .': ibid., p. 259

p. 141 'A woman of no importance': Pierre de Massot, *Marcel Duchamp*, p. 41 (and pp. 17–18)

p. 141 '*Rrose Sélavy et moi . . .*': Tomkins, *Duchamp*, p. 251

p. 141 'I have never in my life . . .': Robert McNab, *Ghost Ships*, pp. 15–16

p. 142 'the Boulevard Haussmann has reached . . .': Aragon, *Paris Peasant*, p. 29

p. 142 'giant rodent': ibid.

p. 142 'a big glass coffin': ibid., p. 47

p. 142 'On stage, young ladies . . . start stripping': ibid.

p. 142 'a little palace for . . .': ibid., p. 46

p. 142 'All the world's subterfuges . . .': ibid., pp. 46–7

p. 143 'whole fauna of human fantasies . . .': ibid., pp. 27–8

p. 143 'part ballet, part mime . . .': Richardson, *A Life of Picasso*, vol. III, p. 258

p. 143 'What I want from you . . . music-hall requirements': ibid.

p. 144 'Triumphal!': Bettina Knapp and Myra Chipman, *That was Yvette: The Biography of the Great Diseuse*, p. 303

p. 144 '*Larmes des yeux . . .*': Paul Éluard, '*Sans Rancune*', *Mourir de ne pas mourir*, in Paul Éluard, *Capitale de la douleur*, p. 70

10. *The Surrealist Manifesto*

p. 147 'There's a surreal light . . .': Robert McNab, *Ghost Ships*, p. 35

p. 147 '*Dear Father . . .*': ibid., p. 53

p. 148 'Gala's left with 400 Fr . . .': ibid., p. 54

p. 148 'You alone are precious . . . nothing else': ibid., p. 59

p. 148 'lifestyle modernism': Roger Nichols, *The Harlequin Years: Music in Paris, 1917–1929*, p. 146

p. 149 'open exploration of . . .': Sjeng Scheijen, *Diaghilev: A Life*, p. 391

p. 150 'Bravo, Picasso . . .': John Richardson, *A Life of Picasso*, vol. III: *The Triumphant Years, 1917–1932*, p. 260

p. 150 '*Mercure* caught me unawares . . .': ibid., p. 261

p. 150 '*Les Soirées de Paris . . .*': ibid., also André Breton, *Dossier Dada*, p. 106

p. 150 'It is . . .': André Breton, *Dossier Dada*, p. 106

p. 151 '*assez curieux . . .*': Richardson, *A Life of Picasso*, vol. III, p. 261

p. 151 'the first of the beach ballets': Margaret Crosland, *Jean Cocteau*, p. 69

p. 151 'on a beach which . . .': ibid.

p. 151 'a great arbiter of fashion . . .': ibid.

p. 152 'silly, slight, and without novelty': Francis Steegmuller, *Cocteau: A Biography*, p. 331

p. 152 'a blinding nightmare': ibid., p. 329

p. 152 'like a dumb animal': ibid., p. 330

p. 152 'Had I been cut in two . . .': ibid.

p. 152 'something terrible . . .': Richardson, *A Life of Picasso*, vol. III, p. 253

p. 152 'My name is on the plate!': ibid.

p. 153 'everything is a miracle . . . lump of sugar': ibid.

p. 154 'Gala here . . .': McNab, *Ghost Ships*, p. 83

p. 154 'We should have left . . .': Dominique Bona, *Gala: La Muse redoutable*, p. 223

p. 155 'Max Ernst travels around . . .': McNab, *Ghost Ships*, p. 123

p. 155 'First: Éluard is back . . .': ibid., p. 117

p. 155 'ineluctably moulded . . .': Aragon, *Paris Peasant*, p. 34

p. 155 'Closed on account of . . . owner's death': ibid., p. 41

p. 156 'A screw thread behind my forehead . . .': ibid., pp. 45–6

p. 156 'heads of hair uncoiling . . .': ibid., p. 52

p. 156 'My palette of blondnesses . . .': ibid.

p. 157 'Beautiful, good, right . . .': ibid., p. 123

p. 157 'worried men come there . . .': Jane Munro, *Silent Partners: Artist and Mannequin from Function to Fetish*, p. 209

p. 158 'the laws of an arbitrary utility': *Manifesto of Surrealism* (1924), in André Breton, *Manifestoes of Surrealism*, trans. Richard Seaver and Helen R. Lane, p. 4

p. 158 'We are still living . . .': ibid., p. 9

p. 158 'that dark night': ibid., p. 13

p. 158 'Had I lived . . . enormous metaphors': ibid., p. 16

p. 158 'Paul Éluard . . . always open': ibid., p. 17

p. 158 'asserts our complete *non-conformism*': ibid., p. 47

p. 159 'baptized the new mode . . .': ibid., p. 24

p. 159 'SURREALISM . . .': ibid., p. 26

p. 159 'psychic mechanisms . . . problems of life': ibid.

p. 159 'I believe in the future . . .': ibid., p. 14

p. 159 'secrets of the magical surrealist art': ibid., p. 29

p. 159 'Surrealism will usher you . . .': ibid., p. 32

p. 159 '"You are no longer trembling, carcass" . . .': ibid., p. 47

p. 160 'The Surrealists still see things . . .': Gertrude Stein, 'Picasso' (1938), in Gertrude Stein, *Picasso: The Complete Writings*, pp. 79–80

p. 160 'Picasso only sees something . . .': ibid., p. 80

p. 162 '*Nous sommes à la veille . . .*': *La Revolution surréaliste*, 1 December 1924 (opening page)

p. 162 '*Le surréalisme . . . en faire partie*': ibid., p. 25

11. New Surrealist Perspectives

p. 166 'With the surrealists the *quartier . . .*': Jean-Paul Crespelle, *La Vie quotidienne à Montparnasse à la grand époque 1905–1930*, p. 141

p. 166 'luminograph': Neil Baldwin, *Man Ray: American Artist*, p. 126

p. 166 '*Qu'est-ce que le surréalisme?*': *La Révolution surréaliste*, 15 January 1925, front page (n.p.)

p. 166 '*Le suicide est-il une solution?*': ibid., p. 8

p. 166 'January 1925 . . .': Max Ernst, *Beyond Painting*, p. 4

p. 167 'indispensable objectification of ideas': Mark Polizzotti, *Revolution of the Mind: The Life of André Breton* (2nd edn), p. 207

p. 167 'SURREALISM is not a poetic form . . .': ibid.

p. 167 'the lady of the glove': ibid., p. 205

p. 168 'voice of a heliotrope': ibid. p. 207

p. 169 'ranks of great dusky plants . . .': ibid., p. 134

p. 169 'stirred a mirage . . .': ibid., p. 147

p. 169 'in the hollow of black foliage . . .': ibid., p. 158

p. 169 'In search of pleasure . . .': ibid., p. 159

p. 169 'My life? . . .': ibid., p. 216

p. 169 'Love is a state of confusion . . .': ibid., p. 217

p. 169 'From today onward . . .': ibid. p. 207

pp. 169–170 'as everyone now knows . . .': ibid., p. 209

p. 170 'hooligans': Giorgio de Chirico, *The Memoirs of Giorgio de Chirico*, p. 117

p. 170 'petty delinquents': ibid., p. 119

p. 171 'huge figures in a white mist . . . constructions of insects': Jean Cocteau, *My Contemporaries*, ed. Margaret Crosland, p. 112

p. 171 'the doors by which death . . .': Jean Cocteau, *Professional Secrets: An Autobiography of Jean Cocteau*, p. 102

p. 171 'It is through the things which . . .': Cocteau, *My Contemporaries*, p. 113

p. 171 'only intellectual who . . .': de Chirico, *The Memoirs of Giorgio de Chirico*, p. 118

p. 172 '*non!*': Francis Steegmuller: *Cocteau: A Biography*, p. 389

p. 172 'Radiguet's death literally . . . been sinking': ibid., p. 339

p. 172 'showers, electric baths . . .': ibid., p. 340

p. 172 'I have seen my angel . . .': ibid., p. 159

p. 173 'blood and guts': John Richardson, *A Life of Picasso*, vol. III: *The Triumphant Years, 1917–1932*, p. 282

p. 174 'marvellous elliptical heads . . . ruins with egg-heads': Nancy Cunard (ed.), *Negro*, p. 218

p. 175 'went black': Edmonde Charles-Roux, *The World of Coco Chanel: Friends, Fashion, Fame*, p. 221

p. 175 'The art of the mannequin . . .': Jane Munro, *Silent Partners: Artist and Mannequin from Function to Fetish*, p. 208

p. 175 '*une vaste rigolade*': ibid.

p. 175 'showed the intense, intransigent . . .': Man Ray, *Self-portrait*, p. 223

p. 176 'leaf by leaf . . .': Stephan von Wiese and Sylvia Martin (eds.), *Joan Miró: Snail Woman Flower Star*, p. 56

p. 177 'the void fixed a new starting point . . . is a new force': Marko Daniel and Matthew Gale (eds.), *Joan Miró: The Ladder of Escape*, p. 62

p. 177 'We take this opportunity . . . words and actions': Polizzotti, *Revolution of the Mind* (2nd edn), p. 212

p. 177 'Down with France!': ibid., p. 213

p. 178 '*Je suis mort*': *La Révolution surréaliste*, 15 July 1925, p. 7

p. 179 'The eye exists . . .': André Breton, *Surrealism and Painting*, p. 1

p. 179 'The Marvels of the earth . . .': ibid.

p. 179 'very narrow concept . . . cease to exist': ibid., p. 4

p. 179 'advancing deep into . . .': ibid., p. 5

p. 180 'human heads, animals . . .': ibid., Ernst, *Beyond Painting*, p. 7

p. 180 'by throwing a sponge . . .': ibid., p. 4

p. 180 'human heads, various animals . . .': ibid., p. 7

p. 180 'by widening in this way . . .': ibid., p. 9

p. 182 'At any season . . . a painter': Janet Flanner, *Paris was Yesterday, 1925–1939*, p. xiii

p. 182 'The Pont Neuf . . .': ibid., pp. xiii–iv

p. 183 'The French Exhibition': Baldwin, *Man Ray*, p. 128

p. 183 'gazing blankly and disquietingly . . .': ibid., p. 129

p. 184 '*Anaemic Cinema* presents . . .': Centre Pompidou, Paris (see also Baldwin, *Man Ray*, p. 129)

p. 184 'Out spilled a little world . . .': Roger Nichols, *The Harlequin Years: Music in Paris, 1917–1929*, p. 123

p. 184 'She made her entry . . .': Janet Flanner in Adrienne Monnier, *The Very Rich Hours of Adrienne Monnier*, p. 492

p. 184 'like a revolution . . .': Nichols, *The Harlequin Years*, p. 124

p. 187 'the bird is represented by . . .': von Wiese and Martin (eds.), *Joan Miró*, p. 46

p. 187 'a new fetishism . . . harmony of the universe': ibid.

p. 187 'picture made of a rag cut by a string . . . the only one': Gertrude Stein in Richardson, *A Life of Picasso*, vol. III, p. 310

12. *Surrealists Divide*

p. 190 *tock*: Salvador Dalí, *The Secret Life of Salvador Dalí*, p. 184

p. 190 'one of the capital discoveries . . .': ibid., p. 167

p. 190 'seized with a real vice . . .': ibid.

p. 190 'incomprehensible miracle . . .': ibid., p. 81

p. 190 'That shows genius': ibid., p. 84

p. 191 'A youthful and wide-ranging . . .': Montse Aguer, *Salvador Dalí: An Illustrated Life*, p. 38

p. 191 'as deeply moved . . . Quite right': Dalí, *The Secret Life of Salvador Dalí*, p. 206

p. 192 'At each new canvas . . .': ibid.

p. 192 'soft' (forms): cf. 'soft watches' in Chapter 15 below: Salvador Dalí, 'Surrealist Objects' (December 1931), *The Collected Writings of Salvador Dalí*, p. 231

p. 193 'ridiculous and useless changes . . . in the programme': Serge Lifar, *The Art of the Ballets Russes: The Serge Lifar Collection of Theatre Designs, Costumes and Paintings at the Wadsworth Atheneum*, pp. 194–5

p. 193 'Surrealist exhibition': ibid.

p. 193 'wholly inappropriate . . .': ibid.

p. 194 'a huge plain pale-blue expanse . . .': ibid., p. 197

p. 194 'made of parallel lines . . .': ibid.

p. 194 'The ball at the Capulet mansion . . .': ibid., p. 196

p. 195 'some thirty or forty young men . . .': ibid.

p. 196 'It is inadmissible . . .': ibid.

p. 196 'It may have seemed to Ernst . . . questionable ethics': 'Protest', in ibid.

p. 197 'It is all so . . . entirely banished': ibid.

p. 197 'those canvases . . . assassinate painting': John Richardson, *A Life of Picasso*, vol. III: *The Triumphant Years, 1917–1932*, p. 307

p. 197 'a large-scale boycott . . .': Giorgio de Chirico, *The Memoirs of Giorgio de Chirico*, p. 118

p. 198 'metaphysical': ibid., p. 80

p. 198 'utterly silly': ibid., p. 118

p. 198 'furniture in the open': ibid.

p. 198 'eunuchs and old maids': ibid.

pp. 198–9 'shadowy volumes . . . day of an eclipse': Jean Cocteau: *Professional Secrets: An Autobiography of Jean Cocteau*, p. 93

p. 199 'Cocteau is a *machine à penser* . . .': Richardson, *A Life of Picasso*, vol. III, p. 319

p. 199 'You, who never talk about . . . the window': ibid., pp. 319–20

p. 199 'The Picassos went to the theatre . . .': ibid., p. 320

p. 201 'beautiful as a young god': Ruth Brandon, *Surreal Lives: The Surrealists 1917–1945*, p. 240

p. 201 'she scarcely seemed to touch . . .': André Breton, *Nadja*, p. 64

p. 202 '*Lost Steps?* . . .': ibid., p. 72

p. 202 '*Chasse de leur acier* . . . be death': ibid., p. 73

p. 202 'Close your eyes . . .': ibid., p. 74

p. 202 'For instance, she looks . . .': ibid., p. 77

p. 202 'And the dead . . .': ibid., p. 83

p. 203 'It's not here . . .': ibid., p. 84

p. 203 'her fear aggravated by . . .': ibid., p. 85

p. 203 'That hand . . . that fall': ibid.

p. 203 'One thing, that's all . . . It's over': ibid., p. 89

p. 203 'so pure, so free . . .': ibid., p. 90

p. 204 'I cannot be reached': ibid., p. 94

p. 204 'follow a line . . .': ibid., p. 100

p. 204 'it's like the morning . . .': ibid., p. 101

p. 204 'Time is a tease . . .': ibid., p. 102

p. 204 'suddenly, as I am kissing her . . . very clearly': ibid., p. 107

p. 204 'a free genius . . . as the sun': ibid., p. 111

p. 204 'deciphered like a cryptogram . . . in the streets': ibid., p. 112

p. 205 'For some time . . .': ibid., p. 130

p. 205 'Who am I?': ibid., p. 11

p. 205 *Ce qui manque . . .*: *La Révolution surréaliste*, 1 December 1926 (front page)

p. 206 'ciné-poem': Neil Baldwin, *Man Ray: American Artist*, p. 134

p. 206 'as a whole that still remained . . .': ibid.

13. *Surrealists Explore* l'amour fou

p. 208 'in search of *l'amour fou*': John Richardson, *A Life of Picasso*, vol. III: *The Triumphant Years, 1917–1932*, p. 323

p. 209 'an ever-changing supply . . .': Calvin Tomkins, *Duchamp: A Biography*, p. 272

p. 210 'desastrous': ibid., p. 273

p. 210 'Duchamp married!!!': ibid., p. 276

p. 210 'a charming experience . . . very nice': ibid., p. 277

p. 211 'I shit on the entire . . .': Ruth Brandon, *Surreal Lives: The Surrealists 1917–1945*, p. 246

p. 212 'screaming in terror . . .': Mark Polizzotti, *Revolution of the Mind: The Life of André Breton* (2nd edn), p. 253

p. 212 'the sound of a key . . .': André Breton, *Nadja*, p. 136

p. 213 '"You're being persecuted . . ."': ibid., p. 139

p. 213 'all confinements are arbitrary . . .': ibid., p. 141

p. 213 'the jail . . . of logic': ibid., p. 143

p. 214 'the unrestorable fragments . . .': André Breton, *Surrealism and Painting*, pp. 24–5

p. 214 'a lamp, a bird . . .': ibid., p. 26

p. 214 'they are participating . . .': ibid., p. 33

p. 214 'a man with an open umbrella . . .': ibid., p. 26

p. 214 'Nature rends things asunder . . .': ibid.

p. 215 'An inexorable rain . . .': ibid., p. 25 ('torrential' in some translations)

p. 216 '*Je t'adore à l'égal* . . .': Dominique Bona, *Gala: La Muse redoutable*, p. 239

p. 216 'Enjoy your freedom': ibid., p. 241

p. 216 'Blonde, sensually beautiful . . .': Polizzotti, *Revolution of the Mind* (2nd edn), p. 256

p. 217 'jolts and shocks': Breton, *Nadja*, p. 160

p. 217 'manifesto on the intrusion of . . .': Polizzotti, *Revolution of the Mind* (2nd edn), p. 259

p. 217 'Beauty will be CONVULSIVE . . .': Breton, *Nadja*, p. 160

p. 218 'the new Montparnasse': Jean-Paul Crespelle, *La Vie quotidienne à Montparnasse à la grande époque 1905–1930*, p. 32

p. 218 'Painters and Painting . . .': Tomkins, *Duchamp*, p. 281

p. 219 'the very reason why . . .': Breton, *Surrealism and Painting*, p. 36

p. 219 'a pitchfork in every star': ibid., p. 37

p. 219 'the same ability to bring . . .': ibid., pp. 38–40

p. 220 'Victor Hugo was a madman . . .': Francis Steegmuller, *Cocteau: A Biography*, p. 392

p. 220 'paintings borrow nothing . . .': Jean Cocteau, *My Contemporaries*, ed. Margaret Crosland, p. 111

p. 220 'our age will be called . . .': ibid., p. 109

p. 220 'L'HYSTÉRIE N'EST PAS UN PHENOMÈNE PATHOLOGIQUE': *La Révolution surréaliste*, 15 March 1928, p. 22

p. 221 'Endless games . . .': Brandon, *Surreal Lives*, p. 261

p. 221 'obtained a success in . . .': Nancy Cunard (ed.), *Negro*, p. 87

p. 221 *'en groupe'*: (*'Im Banden'*), Brandon, *Surreal Lives*, p. 254

p. 222 'a poor pastiche . . .': Polizzotti, *Revolution of the Mind* (2nd edn), p. 273

p. 222 'All his friends are metamorphosed . . .': Patrick Waldberg, *Max Ernst*, p. 298 (also described in Guiseppe Gatt, *Max Ernst*, p. 42)

p. 222 '"like" and "like" and "like" . . .': Virginia Woolf, *The Waves*, p. 123

p. 223 *'Quelle sorte d'éspoir . . .'*: *La Révolution surréaliste*, 15 December 1929, front page, also p. 65

p. 223 *'Comment envisagez-vous . . .'*: ibid., p. 65

14. *The Impact of Salvador Dalí*

p. 224 'Good evening, Sister . . .': Luis Buñuel, *My Last Breath*, p. 84

p. 225 'swarthy gypsy . . .': Montse Aguer, *Salvador Dalí: An Illustrated Life*, p. 52

p. 225 'perversions': Salvador Dalí, 'Concerning the Terrifying and Edible Beauty of Art Nouveau Architecture' (1933), in *The Collected Writings of Salvador Dalí*, p. 200

p. 225 'You speak of a rider . . .': Aguer, *Salvador Dalí*, p. 50 (Dalí to Lorca, early September 1928)

p. 225 'the one means of Escape': ibid., p. 53

p. 226 'small things': Dalí, *Collected Writings*, pp. 16–17, 27–28

p. 226 'soft' (forms): most obviously evidenced as the soft watches which appear in *The Persistence of Memory* (1931)

p. 227 'other side of Saint Sebastian's . . . the putrefieds': Salvador Dalí, 'Saint Sebastien' (1927), in *Collected Writings*, p. 24

p. 227 'perfect and pure as a flower': Salvador Dalí, 'Poetry of the Mass-Produced Utility', in *Collected Writings*, p. 57

p. 228 'In the cinema, a tree . . .': Salvador Dalí, 'Art Film, Antiartistic Film' (1927), in *Collected Writings*, p. 53

p. 228 'anti-artistic': ibid.

p. 228 'a kiss inside a taxi': ibid., p. 55

p. 228 'on the deck of . . .': Salvador Dalí, 'Saint Sebastien', p. 22

p. 228 'Careful! . . .': Dalí, epigraph to 'Art Film, Anti-artistic Film', p. 53

p. 228 'art of conception . . . perception': Salvador Dalí, 'The New Limits of Painting' (Part 1, 1928), in *Collected Writings*, pp. 81–2

p. 228 'nothing could be more favourable . . .': Salvador Dalí, 'Reality and Surreality' (1928), in *Collected Writings*, p. 95

p. 228 'the most complete . . .': Salvador Dalí, 'The Photographic Data' (1929), in *Collected Writings*, p. 68

p. 229 'anti-art': Dalí, *Collected Writings*, p. 53

p. 229 'the capturing of . . .': Dalí, 'The Photographic Data', p. 68

p. 229 'quiescent in the electric . . .': Dalí, 'Saint Sebastian', p. 23

p. 229 'sweetly stupid . . .': ibid.

p. 229 'If the Surrealists are called . . .': Werner Spies, *Max Ernst: Collages*, p. 223

p. 230 'Not in the eyes . . .': Anne Umland (ed.), *René Magritte: The Mystery of the Ordinary, 1926–1938*, p. 36

p. 230 '*gradually* something else . . .': ibid., p. 73

p. 231 'blinded, in rags . . .': Luis Buñuel, *L'Âge d'or and Un Chien Andalou*, p. 116

p. 231 'pseudo-intellectual' 'That foul thing . . .': Salvador Dalí, *The Secret Life of Salvador Dalí*, p. 212

p. 232 'I add: Buñuel's *Un Chien Andalou* . . .': Jean Cocteau, *Opium*, p. 115

p. 232 'blood from the soul's body': ibid.

p. 232 'It is this inexpressible thing . . .': ibid., p. 116

p. 233 'something more real than reality': John Richardson, *A Life of Picasso*, vol. III: *The Triumphant Years, 1917–1932*, p. 349

p. 233 'Resemblance is what I am after . . .': ibid.

p. 233 'down to earth': ibid.

p. 233 'never emanates from the foggy . . .': ibid.

p. 234 'pale young girls . . .': ibid.

p. 234 'the Surrealists . . . were right . . .': ibid., p. 350

p. 234 'That's Paul Éluard . . .': Dalí, *The Secret Life of Salvador Dalí*, p. 217

p. 235 'Scirio! Scirio!': Giorgio de Chirico, *The Memoirs of Giorgio de Chirico*, p. 122

p. 235 'eloquent silence': Jean Cocteau, *My Contemporaries*, ed. Margaret Crosland, p. 119

p. 235 'emerging suddenly from . . .': ibid., p. 120

p. 235 'In the grey hour . . . San Michele': Edmond. Charles-Roux, *Chanel*,
 p. 261

p. 235 'the Ballet that altered . . .': Janet Flanner, *Paris was Yesterday, 1925–
 1939*, p. 61

p. 236 'Thus, within four days . . .': Dalí, *The Secret Life of Salvador Dalí*,
 p. 225

p. 236 'writhing with laughter': ibid., p 226

p. 236 (Dalí's) 'case': ibid.

p. 237 'a permanent character of . . .': ibid., p. 233

15. The Long Lens of Surrealism

pp. 238–9 'The Wall Street crash . . . Will Sacrifice': Janet Flanner, *Paris
 was Yesterday, 1925–1939*, pp. 61–2

p. 239 *'L'homme . . . est encore libre . . .'*: *La Révolution surréaliste*, 15 Decem-
 ber 1929, p. 17

p. 239 *'La poésie est une pipe'*: ibid., p. 53

p. 240 'the purity of a diamond': Salvador Dalí, 'The Moral Position of
 Surrealism' (1930), *The Collected Writings of Salvador Dalí*, p. 220

p. 241 'The only difference between . . . not mad': Montse Aguer, *Salvador
 Dalí: An Illustrated Life*, p. 102

p. 242 'the horrible traumatization . . . prophetic time': Christopher Mas-
 ters, *Dalí*, p. 68

p. 242 'To Salvador Dalí . . .': Aguer, *Salvador Dalí*, p. 73

p. 242 *'Un matin, il est là, . . .'*: André Breton and Paul Éluard, *L'immaculée
 Conception*, pp. 17–18

p. 243 *'Vole le sens au son . . .'*: ibid., p. 84

p. 243 *'Ne tue jamais un oiseau de nuit'*: ibid., p. 86

p. 243 'LOVE . . . violent liberation': Ado Kyrou, 'Le Surréalisme au cinéma:
 L'Âge d'or Scandale', introduction to Luis Buñuel, *L'Âge d'or and Un
 Chien Andalou*, p. 7

p. 243 'This will teach you . . .': ibid., p. 9

p. 244 'a true realization . . .': Salvador Dalí, 'The Rotting Donkey' (1930),
 in *Collected Writings*, p. 225

p. 244 'EAT ME!'; 'ME TOO': Salvador Dalí, 'Concerning the Terrifying and Edible Beauty of Art Nouveau Architecture' (1933), in *Collected Writings*, p. 199

p. 244 'surrealist object': Salvador Dalí, 'Surrealist Objects' (December 1931), in *Collected Writings*, pp. 231–4

p. 244 'a minimum of mechanical . . . soft watch': ibid., pp. 231–2

p. 245 'My painting never . . . his theories': Salvador Dalí, *The Unspeakable Confessions of Salvador Dalí*, p. 119

p. 245 'a cancer on the body poetic': ibid., p. 117

p. 245 'stood trial': ibid., pp. 111–17

p. 246 'Montparnasse, 1929': (Ernest Hemingway introduction to) *Memoirs of Kiki: The Education of a French Model*, pp. 58–60

p. 247 'fifty pounds of white ostrich plumes': Flanner, *Paris was Yesterday*, p. 73

p. 247 'The June season . . .': ibid., p. 67

p. 247 'cutting and fitting gowns . . .': ibid., p. 68

p. 247 'The rhythm of Josephine Baker . . .': Salvador Dalí, 'Saint Sebastian' (1927), in *Collected Writings*, p. 23

p. 247 'one of the best in years . . .': Flanner, *Paris was Yesterday*, p. 72

p. 247 'miniaturist': Aguer, *Salvador Dalí*, p. 101

p. 247 'Craftsman, man of art . . .': ibid.

p. 248 'I do not understand . . .': Salvador Dalí, *The Secret Life of Salvador Dalí*, p. 271

p. 248 'NEW YORK DREAM . . .': *American Weekly*, Tate Gallery 1980–82: *Illustrated Catalogue of Acquisitions* (London, 1984), pp. 76–7

p. 248 'street of sixteen mannequin-ladies of the night': Jane Munro, *Silent Partners: Artist and Mannequin from Function to Fetish*, p. 217

p. 249 'grotto': ibid., p. 221

p. 249 'surreal' (hair): described by Dalí as 'completely in accord with the 1900 type of morphology', in Dalí, *The Secret Life of Salvador Dalí*, p. 289

p. 249 'The surrealists still see things . . .': Gertrude Stein, *Picasso* (1938), p. 79

p. 250 'One has only to look . . .': Jean Cocteau, *My Contemporaries*, p. 121

Bibliography

Aguer, Montse, with Carmen Ruiz Gonzalez and Teresa Moner Rubio, *Salvador Dalí, An Illustrated Life* (London: Tate Publishing/Fundació Gala-Salvador Dalí, n.d.)

Apollinaire, Guillaume, *Apollinaire on Art: Essays and Reviews, 1902–1918*, ed. Leroy C. Breunig, trans. Susan Suleiman (New York: Da Capo Press, 1972; 1st published 1960)

—, *Les Peintres cubistes: Méditations esthétiques*, preface by Dominique Dupuis-Labbé (Paris: Bartillat, 2013; 1st published 1913)

—, *Marcel Duchamp, 1910–1918* (Paris: L'Échoppe, 1994)

—, *Selected Poems*, trans., with editorial material by Martin Sorrell (Oxford: Oxford University Press, 2015)

—, *Zone: Selected Poems*, trans. Ron Padgett, with an introduction by Peter Read (New York: New York Review of Books, 2015)

Aragon, *Le Paysan de Paris* (France, Éditions Gallimard, 1926)

—, *Paris Peasant* (London: Picador, 1980; 1st published in UK 1971, trans. Simon Watson Taylor; 1st published in Paris 1924–5)

Avril, Jane, *Mes Mémoires, suivi par Erastène Ramiro, Cours de danse fin-de-siècle*, eds. Claudine Brécourt-Villars and Jean-Paul Morel, with Patrick Ramseyer (Paris: Phebus, 2005)

Baker, Carlos, *Ernest Hemingway: A Life* (London: Collins, 1969)

Baldwin, Neil, *Man Ray: American Artist* (New York: Clarkson N. Potter, 1988)

Baron, Stanley, with Jacques Damase, *Sonia Delaunay* (London: Thames & Hudson, 1995)

Bénédite, Léonce, *L'Idéalisme en France et en Angleterre: Gustave Moreau et E. Burne-Jones* (Paris: Rumeur des Âges, 1998; essays 1st published 1899)

Bona, Dominique, *Gala: La Muse redoutable* (Paris: Flammarion, 1995)

Brandon, Ruth, *Surreal Lives: The Surrealists 1917–1945* (London: Macmillan, 1999)

Braun, Emily, *De Chirico: The Song of Love* (New York: MOMA, 2014)

Breton, André, *Dossier Dada*, ed. Tobia Bezzola (Zurich: Kunsthaus, n.d.)

—, *Manifestes de surréalisme, édition complète* (Paris: J.J. Pauvert, 1962)

—, *Manifestoes of Surrealism*, trans. Richard Seaver and Helen R. Lane (Ann Arbor paperbacks, University of Michigan Press, 1972; 1st published in English by the University of Michigan 1969; originally published as *Manifestes de surréalisme* (Paris: J.J. Pauvert, 1962)

—, *Nadja* (London: Penguin, 1999; 1st published 1928)

—, *Poems of André Breton*, trans. and ed. Jean-Pierre Cauvin and Mary Ann Caws (Boston, Mass.: Black Widow Press, 2014)

—, *Surrealism and Painting*, trans. Simon Watson Taylor (London: Macdonald, 1972; 1st published 1965)

—, *Le Surréalisme et la peinture* (Paris, Éditions Gallimard, 1928)

Breton, André, and Paul Éluard, *L'immaculée Conception* (Paris: Éditions Surréalistes, 1930)

Breton, André, and Philippe Soupault, *Les Champs magnétiques* (Paris: Au Sans Pareil, 1920)

—, *The Magnetic Fields*, trans. David Gascoyne (London: Atlas Press, 1985; 1st published as *Les Champs magnétiques* (Paris: Au Sans Pareil, 1920)

Breton, André, Philippe Soupault and Paul Éluard, *The Automatic Message: The Magnetic Fields, The Immaculate Conception* (London: Atlas, 1997)

Brown, Frederick, *An Impersonation of Angels: A Biography of Jean Cocteau* (London: Longmans, 1969; 1st published 1968)

Buñuel, Luis, *L'Âge d'or and Un Chien Andalou*, trans. Marianne Alexandre (London: Lorrimer, 1968; 1st published 1963)

—, *My Last Breath*, trans. Abigail Israel (London: Jonathan Cape, 1984; 1st published 1982)

Campa, Laurence, *Apollinaire: La Poésie perpetuelle* (Paris: Gallimard, 2009)

Carco, Francis, *From Montmartre to the Latin Quarter* (London: Cayme Press, n.d.)

Caws, Mary Ann, *Salvador Dalí* (London: Reaktion Books, 2008)

Charles-Roux, Edmonde: *Chanel*, trans. Nancy Amphoux (London: Collins Harvill, 1989)

—, *The World of Coco Chanel: Friends, Fashion, Fame* (New York: Vendôme Press, 2005)

Charters, James, *This Must be the Place: Memoirs of Montparnasse*, introduction by Ernest Hemingway (London: Herbert Joseph, 1934)

Chocha, Nadia, *Surrealism and the Occult* (Oxford: Mandrake, 1991)

Cocteau, Jean, *Entre Picasso et Radiguet, sous le direction d'*André Fermigier (Paris: Hermann, 1923)

—, *Jean Cocteau par Jean Cocteau: Entretiens avec William Fifield* (Paris: Éditions Stock, 1973)

—, *Modigliani* (London: A. Zwemmer and Paris: Hazan; vol. 16 in Bibliothèque Aldine des Arts, completed July 1950)

—, *My Contemporaries*, ed. and with an introduction by Margaret Crosland (London: Peter Owen, 1967)

—, *Œuvres complètes* (Geneva: Éditions Marguerat, 1946–51) (vols. I–XI)

—, *Opium: The Illustrated Diary of His Cure*, third impression, trans. and with a new introduction, by Margaret Crosland (London: Peter Owen, 1996; 1st published 1930)

—, *Professional Secrets: An Autobiography of Jean Cocteau, Drawn from His Lifetime Writings*, ed. Robert Phelps, trans. Richard Howard (New York: Farrar, Straus & Giroux, 1970)

—, *Thomas the Impostor* (London and Chester Springs: Peter Owen, 2006; 1st published 1929)

Crespelle, Jean-Paul, *La Vie quotidienne à Montparnasse à la grande époque 1905–1930* (Paris: Hachette, 1976)

J-P Crespelle, *Montparnasse vivant* (Paris: Hachette, 1962)

Crosland, Margaret, *The Enigma of Giorgio de Chirico* (London and Chester Springs: Peter Owen, 1999)

—, *Jean Cocteau* (London and New York: Peter Nevill, 1955)

Cunard, Nancy (ed.), *Negro: An Anthology*, with an introduction by Hugh Ford and a preface by Nancy Cunard (1934) (New York: Ungar, 1984)

Dalí, Salvador, *The Collected Writings of Salvador Dalí*, ed. and trans. Haim Finkelstein (Cambridge: Cambridge University Press, 1998)

—, *Diary of a Genius: Salvador Dalí 1904–1989* (London: Hutchinson, 1966)

—, *The Secret Life of Salvador Dalí*, trans. Haakon M. Chevalier (London: Vision, 1949)

—, *The Unspeakable Confessions of Salvador Dalí, as Told to André Parinaud*, trans. Harold J. Salemson (London: W. H. Allen, 1976)

Danchev, Alex, *Georges Braque, A Life* (London: Penguin, 2007; 1st published 2005)

Daniel, Marko, and Matthew Gale (eds.), *Joan Miró: The Ladder of Escape* (London: Tate Publishing, 2011)

de Chirico, Giorgio, *The Memoirs of Giorgio de Chirico* (London: Peter Owen, 1971; 1st published 1962)

Drot, Jean-Marie, *Les Heures chaudes de Montparnasse* (Paris: Musée du Montparnasse, 2007)

Duchamp, Marcel, *Marcel Duchamp parle des Ready-made à Philippe Collin* (interview given at the Galerie Claude Givaudan, Paris, 1967) (Paris: L'Échoppe, 2008)

—, *Le Processus créatif* (L'Échoppe, 1987; 1st published 1957)

Elger, Dietmar, *Dadaism* (Hong Kong, Cologne, London, Los Angeles, Madrid, Paris, Tokyo: Taschen, 2004)

Éluard, Paul, *Capitale de la douleur: Répétitions – Mourir de ne pas mourir – Les Petits Justes – Nouveaux Poèmes* (Paris: Gallimard, 1926)

—, *Lettres à Gala 1924–48*, ed. Pierre Dreyfus (Paris: Gallimard, 1984)

—, *Livre d'identité*, ed. Robert D. Valette (Paris: Claude Tchou, 1967)

Éluard, Paul, and Max Ernst, *Les Malheurs des immortels* (Paris: Librairie Six, 1922)

—, *Misfortunes of the Immortals* (New York: Black Sun Press, 1943)

Ernst, Max, *A Little Girl Dreams of Taking the Veil*, trans. Dorothea Tanning (New York: George Braziller, 1982; 1st published, 1930)

—, *Beyond Painting: And Other Writings by the Artist and His Friends* (New York: Wittenborn, Schultz, 1948)

—, *The Hundred Headless Woman* (George Braziller Inc., 1981)

—, *Une Semaine de bonté: A Surrealistic Novel in Collage by Max Ernst* (New York: Dover Publications, 1976; 1st published 1934)

Ernst, Max, and Paul Éluard, *Max Ernst peintures pour Paul Éluard*, with an introduction by Patrick Waldberg (Paris: Éditions Denoël, 1969; text and illustrations 1st published in Paris: Gallimard, c. 1926 & c. 1939)

Faerna, José María (ed.), *Ernst*, trans. Alberto Curotto (New York: Cameo/Abrams, Harry N. Abrams, 1997)

Fifield, William, *Modigliani: The Biography* (London: W. H. Allen, 1978)

Flanner, Janet, *Paris was Yesterday, 1925–1939*, ed. Irving Drutman (San Diego, New York and London: Harvest/Harcourt Brace Jovanovich, 1988; 1st published 1972)

Freud, Sigmund, *New Introductory Lectures on Psychoanalysis* (International Psycho-Analytical Library, ed. Ernest Jones, no. 24, trans. W. J. H Sprott) (London: Hogarth, 1933)

Gatt, Guiseppe, *Max Ernst* (London, New York, Sydney, Toronto: Hamlyn, 1970; 1st published 1968)

Hastings, Beatrice, *The Old New Age: Orage – and Others* (London: Blue Moon, 1936)

Hemingway, Ernest, *A Moveable Feast* (London: Arrow, 2004; 1st published 1936)

—, introduction to *Memoirs of Kiki: The Education of a French Model* (London: Tandem Books, 1964; 1st published 1929)

—, *Selected Letters, 1917–1961*, ed. Carlos Baker (St Albans, London, New York, Sydney, Ontario, Johannesburg and Auckland, 1981)

Higonnet, Patrice, *Paris, Capital of the World*, trans. Arthur Goldhammer (Cambridge, Mass., and London, England: Harvard University Press, 2002)

Hooker, Denise, *Nina Hamnett, Queen of Bohemia* (London: Constable, 1986)

Horne, Alistair, *Seven Ages of Paris: Portrait of a City* (London: Pan Books, 2003; 1st published 2002)

Joselit, David, *Infinite Regress: Marcel Duchamp 1910–1941* (Cambridge, Mass, and London, England: MIT Press, 1998)

Jouffroy, Alain, *Picabia* (New York: Assouline, 2002; 1st published Paris 2002)

Kluver, Billy, *A Day with Picasso* (Cambridge, Mass.: MIT Press, 1997)

Kluver, Billy, and Julie Martin, *Kiki's Paris: Artists and Lovers 1900–1930* (New York: Harry N. Abrams, 1994; 1st published 1989)

Knapp, Bettina, and Myra Chipman, *That was Yvette: The Biography of the Great Diseuse* (New York, Chicago and San Francisco: Holt, Reinhart and Winston, 1964)

Lanzoni, Rémi Fournier, *French Cinema from Its Beginnings to the Present* (New York and London: Continuum, 2002)

Lautréamont, Comte de, *Maldoror and The Complete Works*, trans. Alexis Lykiard (Cambridge, Mass.: Exact Change, 2011 (third impression of 1994 edition))

Lorca, Federico García, *Selected Poems*, trans. Martin Sorrell, with an introduction and notes by D. Gareth Walters (Oxford: Oxford University Press, 2009)

Man Ray, *Man Ray* (London and New York: Thames & Hudson, 2006; 1st published 1989)

—, *Photographs by Man Ray, 105 Works, 1920–1934* (New York: Dover, 1979; 1st published 1934)

—, *Self-portrait* (London: Penguin, 2012; 1st published 1963)

Mann, Carol, *Modigliani* (New York and Toronto: Oxford University Press/London: Thames and Hudson, 1980)

Massot, Pierre de, *Marcel Duchamp, magicien du ready-made: Souvenirs, poèmes, critiques*, ed. Paul B. Franklin (Paris: L'Échoppe, 2014)

Masters, Christopher, *Dalí* (London: Phaidon, 2012; 1st published 1995)

Mauriès, Patrick, *Le Style Cocteau* (Paris: Éditions Assouline, 1998)

McNab, Robert, *Ghost Ships* (New Haven and London: Yale University Press, 2004)

Monnier, Adrienne, *The Very Rich Hours of Adrienne Monnier*, trans. Richard McDougall (Lincoln, USA: University of Nebraska Press, 1996; 1st published 1976)

Munro, Jane, *Silent Partners: Artist and Mannequin from Function to Fetish* (Cambridge, New Haven and London: Fitzwilliam Museum and Yale University Press, 2014)

Nemer, François, *Cocteau sur le fil* (Paris: Gallimard, 2003)

Nichols, Roger, *The Harlequin Years: Music in Paris, 1917–1929* (Berkeley, Los Angeles: University of California Press, 2002)

Parisot, Christian, *Modigliani* (Paris: Gallimard, 2005)

Passeron, René, *Max Ernst* (Paris, New York: Filipacchi, 1971, 1980)

Penrose, Roland, *Picasso*, with notes by David Lomas (London: Phaidon, 1971)

—, *Picasso: His Life and Work* (London, Toronto, Sydney and New York: Granada, 1981, 3rd edn; 1st published 1958)

Pepper, Terence, *Man Ray Portraits*, with an introduction by Marina Warner (London: National Portrait Gallery, 7 February–27 May 2013)

Polizzotti, Mark, *Revolution of the Mind: The Life of André Breton* (London: Bloomsbury, 1st edn 1995; 2nd edn 2008)

Proust, Marcel, *Days of Reading*, trans. John Sturrock (London: Penguin Books, 2008)

Quinn, Edward, *Max Ernst* (London: Thames & Hudson, 1977; 1st published 1976)

Radiguet, Raymond, *The Devil in the Flesh* (London: Penguin Books, 2011; 1st published 1923)

Renault, Olivier, *Montparnasse: Les Lieux de légende* (Paris: Parigramme, 2013)

Richardson, John, *A Life of Picasso*, vol. II: *1907–1917: The Painter of Modern Life* (London: Pimlico, 2009; 1st published 1996)

—, *A Life of Picasso*, vol. III: *The Triumphant Years, 1917–1932* (London: Jonathan Cape, 2007)

Russell, John, *Max Ernst: Life and Work* (London: Thames and Hudson, 1967; 1st published 1966)

Scheijen, Sjeng, *Diaghilev: A Life*, trans. Jane Hedley-Prôle and S. J. Leinbach (London: Profile, 2010; 1st published 2009)

Shattuck, Roger, *The Banquet Years: The Origins of the Avant-Garde in France, 1885 to World War 1*, revised edition (New York: Vintage, 1968; 1st published 1955)

Soupault, Philippe, *Last Nights of Paris*, trans. William Carlos Williams (New York: Full Court Press, 1982; 1st published 1928)

—, *Westwego: Poème, 1917–1922* (Paris: Lachenal & Ritter, 1981; 1st published, Librairie Six, 1922)

Spies, Werner, *The Return of the Belle Jardinière: Max Ernst 1950–1970* (New York: Harry N. Abrams, 1971)

Steegmuller, Francis, *Apollinaire: Poet among the Painters* (London: Rupert Hart-Davis, 1963)

—, *Apollinaire: Poet among Painters* (New York: Penguin Books, 1986, 1st, published 1963)

—, *Cocteau: A Biography* (London: Macmillan, 1970)

Stein, Gertrude, *The Autobiography of Alice B. Toklas* (London: Penguin Books, 2001; 1st published 1933)

—, *Look at Me Now and Here I Am: Writings and Lectures 1909–45*, ed. Patricia Meyerowitz (Harmondsworth: Penguin Books, 1984; 1st published 1941)

—, *Paris France* (New York: Liveright, 1996; 1st published 1940)

—, *Picasso: The Complete Writings*, ed. Edward Burns, foreword by Leon Katz and Edward Burns (Boston: Beacon Press, 1985; 1st published 1970)

Tomkins, Calvin, *Duchamp: A Biography* (New York: The Museum of Modern Art, 2014; 1st published 1996)

Turpin, Ian, *Ernst* (London: Phaidon, 1993; 1st published 1979)

Vaché, Jacques, *Lettres de guerre*, with an introduction by André Breton (Paris: Au Sans Pareil, 1919)

—, *Soixante-dix-neuf Lettres de guerre, suivies de deux lettres d'André Breton à Marie-Louise*, ed. Georges Sebbag (Paris: Jean-Michel Place, 1989)

Vlaminck, Maurice, *Dangerous Corner*, trans. Michael Ross, with an introduction by Denys Sutton (London: Elek Books, 1961; 1st published as *Tournant dangereux*, 1929)

Volta, Ornella, *Satie Seen through His Letters*, trans. Michael Bullock, with an introduction by John Cage (London, New York: Marion Boyars, 1989)

Waldberg, Patrick, *Max Ernst* (Paris: Société des Éditions Jean-Jacques Pauvert, 1958)

Wiese, Stephan von, and Sylvia Martin (eds.), *Joan Miró: Snail Woman Flower Star* (Munich, London & New York: Prestel, 2012, 1st published 2002)

Wilson, Simon, *Surrealist Painting* (London: Phaidon, 1991; 1st published 1976)

Woolf, Virginia, *The Waves* (London: Penguin Books, 1992; 1st published 1931)

Exhibition catalogues

Apollinaire: Le Regard du poète (Paris: Musées d'Orsay et de l'Orangerie/Gallimard, 2016)

André Breton, La Beauté convulsive (Paris: Centre Georges Pompidou 25 April–26 August 1991)

Birds on the Wire: Max Ernst, 1921–28 (London: Sotheby's, 13 February–2 March 2017)

Dalí & Film, ed. Matthew Gale (London: Tate Publishing, 2007 and New York: MOMA, 2008)

Bibliography

Dalí/Duchamp (London: Royal Academy of Arts and St Petersburg, Florida: Dalí Museum, 2017–18)

Duchamp, ed. Anne D'Harnoncourt and Kynaston McShine (Philadelphia and New York: MOMA and Philadelphia Museum of Art, 1973)

Max Ernst: A Retrospective (London: Tate Gallery, in association with Munich: Prestel-Verlag, 1991)

Serge Lifar, *The Art of the Ballets Russes: The Serge Lifar Collection of Theatre Designs, Costumes and Paintings at the Wadsworth Atheneum, Hartford, Connecticut/Alexander Schouvaloff* (New Haven, London: Yale University Press in Association with the Wadsworth Atheneum, c. 1997)

René Magritte: The Mystery of the Ordinary, 1926–1938, ed. Anne Umland, essays by Stephanie d'Alessandro et al. (New York: MOMA, 2013–14)

Man Ray, Picabia et la revue 'Littérature', eds. Christian Briend and Clément Chéroux (Paris: Centre Pompidou, 2 July–8 September 2014)

Alexander McQueen, ed. Claire Wilcox (London: V&A Publishing, 2015)

Picabia 1879–1953, Scottish Gallery of Modern Art, Edinburgh/Galerie Neuendorf, Frankfurt-am-Main, 1988 (Edinburgh: National Galleries of Scotland, 1988)

Newspapers

The New Age (London), vols. 15–17 (University of Sussex Library/British Library)

La Révolution surréaliste (nos. 1–12, 1 December 1924–15 December 1929), *Collection complète* (Paris: Éditions Jean-Michel Place, 1975)

Index

Index